6/12

SANTA
MONICA
PRESS

Published by: Santa Monica Press LLC
P.O. Box 850
Solana Beach, CA 92075
1-800-784-9553
www.santamonicapress.com
books@santamonicapress.com

Printed in China

Santa Monica Press books are available at special quantity discounts when purchased in bulk by corporations,
organizations, or groups. Please call our Special Sales department at 1-800-784-9553.

ISBN-13 978-1-59580-060-2

Library of Congress Cataloging-in-Publication Data

Kubernik, Harvey, 1951-
 A perfect haze : the illustrated history of the Monterey International Pop Festival / by Harvey Kubernik and
Kenneth Kubernik ; foreword by Lou Adler ; afterword by Michelle Phillips.
 p. cm.
 Includes bibliographical references.
 ISBN 978-1-59580-060-2
 1. Monterey International Pop Festival (1967 : Monterey, Calif.) I. Kubernik, Kenneth. II. Title.
 ML36.M664 2011
 781.64078'79476--dc22
 2011003278

Cover and interior design and production by Future Studio

Overleaf: Cover of the Monterey International Pop Festival annual

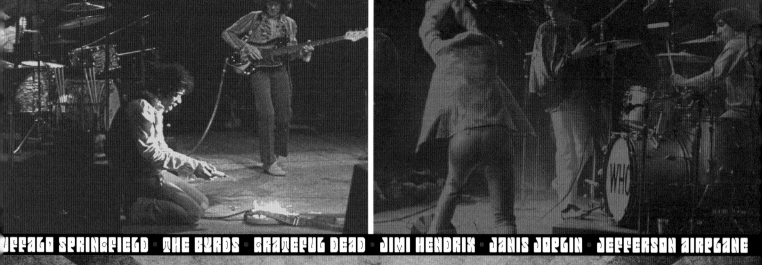

JFFALO SPRINGFIELD · THE BYRDS · GRATEFUL DEAD · JIMI HENDRIX · JANIS JOPLIN · JEFFERSON AIRPLANE

A PERFECT HAZE

THE ILLUSTRATED HISTORY OF THE
MONTEREY INTERNATIONAL
POP FESTIVAL

E MAMAS AND THE PAPAS · OTIS REDDING · RAVI SHANKAR · SIMON AND GARFUNKEL · STEVE MILLER BAND · THE WHO

Harvey Kubernik and Kenneth Kubernik
Foreword by Lou Adler ❀ Afterword by Michelle Phillips

SANTA
MONICA
PRESS

CONTENTS

ACKNOWLEDGMENTS

HARVEY KUBERNIK: For over forty years I have been immersed in the world of Monterey Pop, whether it be working on a high school term paper, attending the movie's premiere at the Fine Arts Theater, or the plethora of interviews I've conducted with performers and attendees since the mid-'70s, that have appeared in numerous magazines and, more recently, on the internet.

During my 1997 interview with Ravi Shankar, he raised the notion that I should assemble a book on the Monterey Festival. So I started a Monterey Pop file. Pre-computer. As UCLA basketball coach John Wooden always said, "Failing to prepare is preparing to fail." Then my brother, Kenneth, joined the team.

Subsequently, many people, music lovers all, have joined our mission and expedition to discover the source of the Monterey International Pop Festival's timeless appeal. We are grateful for their graciousness and generosity:

Dr. James Cushing, Harry E. Northup, Nancy Rose Retchin, Jeff Schwartz, Ron Lando, Stephen J. Kalinich, Elaine Mayes, Robert Sherman, Sandy Gibson, Dave Kephart, Stephen K. Peeples, Chris Darrow, Rosemarie Patronette, George Harrison, Morley Bartnoff, Kara Wright, Ram Dass, Kirk Silsbee, Richard Bosworth, D. A. Pennebaker, Denny Bruce, Jack Nitzsche, Justin Pierce, Roxanne Teti, Tom Johnson, Chip Douglas, Phil Proctor, Tony Fornaro, Lonn Friend, Matt King, Rob Hill, Cynthia Cobb, Megan Perritt, Brian Greene at *Shindig!* magazine, Suyen Mosley, Peter Piper, Harold Sherrick, Vern Fisher, Johnny Black, Biba Pickles, Leah Zak and Ciao Coffee & Tea, Dola Baroni, Matt Carr, Mr. Twister, John Rogan, David Kessel, Scott Schwartz, Kim Tannenbaum, Hal Lifson, Mark London, Kip Brown, Barney Hoskyns, Sylvie Simmons, Eddi Fiegel, Lois Wilson, Gerald Wexler, Arif Mardin, Randy Wood, Jerry Ragovoy, Ray Manzarek, Tim Doherty, Lesley Ficks, Marisela Norte, Lana, Laurette, Holly Prado, Richard Derrick, Kristian St. Clair, Jim Ladd, Bobby Womack, Bob Kushner, Jim Kaplan, Bob Merlis, Gary Schneider, David Leaf, Frazer Pennebaker, Randy Haecker, Tom Cording, Courtney Kaplan, Bill Lynch, Brian Wilson, Paul Body, Nurit Wilde, Roger Steffens, Danny Weizmann, Toby Gleason, Howard Wolf, Frank Orlando, David Berger, Liza Gizara, Amanda Carr, Ali Lewis, Michael Hartman, Danny Eccleston, Mark Blake, *DownBeat* magazine, the Esalen Institute, Joel Selvin, Peter Lindblad, Roy Trakin, Paul Surratt, Greg Strobl, Gary Pig Gold, Michael Macdonald, Jeff Gold, Bob Say at Freakbeat Records, Bones Howe, Chip Monck, Tom Rounds, Jim Dickson, Amber Shoopman, Dean Dean the Taping Machine, Candy Dog, Stanley Pierce, Barbara Versino, Sherry Hendrick, Mick Vranich, Steve Popovich, Rodney Bingenheimer, and to DJ Little Steven Van Zandt for your annual Underground Garage channel radio salute to the 1967 Monterey moments.

A special thank you to the numerous photographers, memorabilia holders, and Monterey memory veterans that aided our quest for authenticity; especially Keith Altham and Andrew Loog Oldham, who never let us forget that it's about being in service to the work.

And then there's the totemic presence of Ralph J. Gleason of the *San Francisco Chronicle*, presiding over the many gifted journalists who caught the magic of the music in words. Thank you, fellow scribes.

My brother Kenneth and I are also deeply indebted to pop culture historian, archivist, and visual artist Gary Strobl, who delivered like Ernie Banks on the baseball field.

We're also grateful for West Point's favorite son, Henry Diltz, who gave us the keys to his own magic photo kingdom. "What else do you guys need?" "Uh, got another unseen picture of Janis?"

David Carr. Your copy editing skills were as invaluable as your unwavering friendship. The legacy of this book will be a testimony to our shared love of the music and the desire to get the details right.

To Marshall and Hilda Kubernik: You were

at The Sands in Vegas, grooving to Frank and the Rat Pack, while we were turning on to Jimi and Otis. We split the difference when Bobby Darin turned hippie. Thanks for letting us follow our hearts.

Another Pisces and UCLA graduate Jeff Goldman of Santa Monica Press commissioned a book to reflect what the authors desired, without a corporate agenda or people-pleasing motives. Also, Kate Murray and Amy Inouye in your company have accommodated our fever dream with patience and good cheer.

I would also like to especially thank the heroic and technical efforts of Howard Frank and the generous support and assistance of Lou Adler in making this book possible. Without access to the Adler archive and his treasured Monterey artifacts and documents, this collaboration would not have become a reality.

KENNETH KUBERNIK: Someone asked me how long I worked on this book. "A lifetime," I replied, hoping not to sound too melodramatic. On that memorable weekend in June 1967, the cusp of my 13th birthday, I should have been rigorously preparing for my bar mitzvah. Instead, my ears were riveted to a puny transistor radio, feasting on KRLA's live broadcast from the Monterey Fairgrounds. "When we return," the DJ breathlessly intoned, "Brian Jones of the Rolling Stones will be talking to our Jim Steck." My mother was screaming from downstairs, "Don't you embarrass me, young man. Practice your haftarah now!" Sorry to disappoint, but I answered to a higher God, one resplendent in fluorescent blond bangs, cashmere turtleneck, and whalebone white shoes, a Vox teardrop guitar slung insolently over his shoulder. He spoke with a soft, Cheltenham accent. "It's a groovy scene here; I dig the vibes," or something akin to that.

Not exactly Maimonides, but I was bloody well chuffed.

And now, so many years later, I'm back in that bedroom (metaphorically speaking), canvassing for signs and wonders of that mystical happening along California's empyrean coast. Like drums along the Mohawk, I can still hear the faint rumble of Buffalo, the revving of an Airplane, the thrashing of Fender Strats, and the far cry of Port Arthur's neediest daughter.

I would especially like to thank the following: MD Tiberi for never dropping the "football"; Jason Smith for knowing where "one" is; Marisa Mercado, who is a writer whether she knows it or not; Melissa Vardey for laughing in all the right places; Alan Watts; the "other" Alan Watts; Jean-Jacques Lebel and Gustav Metzger; the Marotta clan (the Von Trapps of Monterey); the invigorating quiet of the UCLA Research Library; and Mrs. Finkelstein, for being such a mensch.

Kenneth and Harvey Kubernik, June 1967

FOREWORD

The impetus to stage the Monterey International Pop Festival evolved one night in 1967, at Cass Elliot's house. Paul McCartney, John and Michelle Phillips, Cass, and I were discussing, along with other highly inspired issues, the general perception of rock 'n' roll, and that, while jazz was considered an art form, rock 'n' roll was continually viewed as a fad, a trend—and yet both were American-born musical genres.

Not too long after that night, John and I were approached by Alan Pariser and a promoter named Ben Shapiro, who wanted to hire the Mamas and the Papas to headline a one-day blues and rock event at the Monterey Fairgrounds. Later that night—actually, at three o'clock in the morning—John and I had decided, influenced by some heavy "California dreamin'," that it should be a charitable event. Shapiro, who had envisioned a commercial event, eventually decided to leave the project, and we bought the dates from him. John and Michelle, Paul Simon, Johnny Rivers, Terry Melcher, and I put up $10,000 apiece; with six weeks to go, the Monterey International Pop Festival, a three-day non-profit event, was becoming a reality.

We established a board of governors that consisted of Donovan, Mick Jagger, Paul McCartney, Jim [later Roger] McGuinn, Terry Melcher, Andrew Loog Oldham, Alan Pariser, Johnny Rivers, Smokey Robinson, Brian Wilson, John Phillips, and myself.

The offices for the festival were on Sunset Boulevard, in the old Renaissance Jazz Club building. John, Michelle, and I were totally consumed with the festival. We spent all the preceding weeks in the office or in Monterey. The festival's office had a real buzz going through it: David Crosby and Stephen Stills hanging out; Procol Harum's "A Whiter Shade of Pale" being played over and over; Michelle on the phone, selling ads for the program book; John and me on the telephone, talking to managers and potential acts. Alan Pariser would stay on as a producer. Derek Taylor, who personified the perfect English gentleman and had worked with Brian Epstein and the Beatles, was our publicist. Tom Wilkes was hired as art director.

Everyone agreed that the lineup of acts would represent all genres of the immediate past, present, and future of contemporary music, and that all the acts would be treated the same and have first-class travel and accommodations.

For the most part, everyone jumped on very quickly, especially the L.A. groups like the Byrds and Buffalo Springfield. Phil Walden, Otis Redding's manager, knew immediately that Otis would be right for Monterey and Monterey would be right for Otis. He had no doubts at all, before or after. Andrew Oldham suggested Jimi Hendrix. John contacted Paul McCartney, who raved about Hendrix and the Who. Simon and Garfunkel and the Mamas and the Papas were committed. Soon we had commitments from the Butterfield Blues Band and the Electric Flag. Ravi Shankar, who had been

Opposite: Lou Adler and John Phillips

Jann Wenner (*left*) greets John Phillips and Lou Adler arriving at the Monterey Peninsula Airport.

signed by the original producer, and Hugh Masekela added to the international flavor of the festival beyond the English acts. The festival was beginning to take shape. What was missing was representation from Northern California.

There existed a conflict. John and I being "L.A.," and the type of business acumen that we had developed, gave us a reputation for being slick—too slick, in the eyes of the San Francisco groups and their management. Andrew Oldham and I met with Ralph Gleason, the very respected journalist of the *San Francisco Chronicle*, and he gave his blessing to the festival, as did Bill Graham. That opened the door for San Francisco groups like Big Brother with Janis Joplin, the Airplane, and the Grateful Dead to sign on, bringing an innovative and fresh underground feel to the festival.

The April 1967 debut of Tom Donahue's KMPX FM radio station, located in San Francisco, added yet another dimension to the change that was happening in the world of pop music that the Monterey Pop Festival would solidify.

There must have been 1,500 requests from news outlets and journalists to attend. Derek Taylor handled people graciously, even while telling them they weren't getting any press passes. David Wheeler handled our security. The Monterey Police Department had their own security, and the numbers employed were overkill the first day because, in Chief Marinello's mind, the hippies and the Hell's Angels were the same. However, their numbers were lessened dramatically after the first day of "music, love, and flowers."

Our stage manager, Chip Monck, and his crew, which included Al Kooper, were amazing. It's one thing to build a stage; it's another to get 32 acts on and off, changing instruments and keeping the talent and the audience happy. It hadn't been done before.

It was a lovefest from the opening chord of "Along Comes Mary," continued by Otis Redding and his salute to what he called "the love crowd," and ending in a cultural explosion with performances by Janis Joplin, Jimi Hendrix, and the Who.

And it is a source of pride to reflect on the artists that performed free at Monterey on June 16, 17, and 18 in 1967. As John Phillips put it then, "Let's give something back." They are still giving back through the Monterey International Pop Festival Foundation, the first rock 'n' roll charitable foundation and event, which laid the template for Live Aid and Farm Aid. At the conclusion of the festival, David Crosby said, "I hope the artists know what they have here, the power of it to do good. It's an international force."

Lou Adler at Western Recorders, 1966

The Monterey International Pop Festival was, and still is, about the music and the artists who had breakthrough performances there, and how much impact they have had over these many years. It was the first major music festival. It wasn't about the weather or traffic jams. It was and will always be about the music. This book documents the influence of Monterey and just how valuable it was for all concerned: the artists, the music industry, and all those that play, sing, or listen to rock 'n' roll.

LOU ADLER
Malibu, California

MONTEREY OVERTURE: A CIRCUS FILLED WITH LOVE

Alan Pariser was born on third base—he didn't need to hit a triple. The scion to the Sweetheart Paper fortune, Pariser was a sport with deep pockets who doled out adult treats like Dixie Cups at a campfire weenie roast. Living large in the higher climes of Laurel Canyon, he consorted with the newly minted pop aristocracy, granting them unlimited access to his studio-quality sound system, his premium-quality stash (code-named "Ice Bag"), and a seraglio worthy of a Turkish sultan. "If there was an Olympics for groupies back then," recalled record producer Joel Dorn, "Alan

Alan Pariser

would have a whole lot of gold medals. Whatever you needed, it was there at his home."

Pariser had a taste for velocity—speedboats, Ferraris, motorcycles—and wasn't content to watch the action at a distance. In September of 1966, he ventured north to the Monterey Jazz Festival, held at the county fairgrounds, a mile or so inland from the port city's fabled waterfront. It was a salubrious setting, the crisp, early fall air alerting the senses to the musician's quicksilver commands. The venue itself was, ironically, as down-home and cowpoke as the music was urban and sophisticated. Designed for round-ups and cutting horse competitions, the performance pavilion was nothing more than a glorified hitching post, more redolent of snorts and whinnies than the brash sound of the Ellington Big Band or Charles Lloyd's melismatic quartet.

Pariser returned to a Los Angeles that was also confronting some very real political and social divides. The city was still singed by the rage of the 1965 Watts riots. The police department, long a bastion of corruption and venality, struggled to put forward a more respectful face. They succeeded only in replacing kickbacks with head-butts.

The Sunset Strip became the locus of a tug-of-war between mouthy hippies and the bullish blue line. Over the previous two years, a vibrant club scene had surfaced on a stretch of Sunset Boulevard between Crescent Heights and Doheny, including Ciro's, the Trip, the London Fog, and the Whisky A Go Go, all playing a central role in nurturing a field of musical dreams. The Byrds, the

AND CLOWNS AND ANIMALS

Doors, Buffalo Springfield, and Love were among the many bands who found their sound and audience there.

By November of 1966, many older, long-settled merchants along the Strip began to complain about the freewheelin' longhairs who loitered around with mischievous intent. While they feared for their livelihoods, newer businesses catering to a youthful market, like the Bohemian hangout Pandora's Box, welcomed the influx of fresh blood. Things came to a head when the police began to enforce a decades-old curfew law, corralling busloads of teenagers for groovin' after 10:00 PM. Disorder ensued, as well as publishing royalties for a young Stephen Stills, who nailed the moment in song. "For What It's Worth" became the battle cry, its guitar parts locked and loaded like muskets at the ready.

Into this chaos stepped a few wiser, cooler heads led by the Byrds' manager, Jim Dickson. Formerly a recording engineer for Dick Bock's World Pacific Studios and a talent scout for Elektra Records, Dickson had a clear sense of how to bring order to a rapidly unraveling situation: throw a concert. He started an organization, CAFF (Community Action for Fact and Freedom), to help defray the legal expenses of those arrested. On February 11, 1967, CAFF staged its big money event at the Valley Music Theater in Woodland Hills, California. The Byrds, Peter, Paul and Mary, Buffalo Springfield, the Doors, and renowned South African trumpeter Hugh Masekela headlined the event. There was definitely something happening here.

JIM DICKSON: I created the Valley Music Center CAFF event and turned it over to Alan Pariser to run once it was set and all the bands secured. I tried to get the L.A. Sports Arena, but the politicians wouldn't let me.

After the show Hugh Masekela said to Alan, "We gotta do another one." The first idea was to do it in Tijuana. That's where I drew the line. "No. No. No. Do you really want to get a bunch of young kids down in Tijuana? The trouble is enormous." No one argued with me. Monterey would be much better. Beautiful green lawns.

[I said,] "What you should do is talk to Ben Shapiro because he's booked acts for the Monterey Folk Festival. And he'll know whom you'll have to talk to." All I did was steer Alan in that direction to go see Benny.

Jim Dickson

The success of the CAFF benefit fueled Pariser with the enthusiasm to try something like it, but on a much larger scale. Operating out of Shapiro's Hollywood Hills estate, Pariser and his new partner considered their resources and plotted their next moves. They brought separate but equal talents to the table: one had access to money, the other had access to talent. But a third pony would be needed to get them to the finish line.

Enter Derek Taylor—English ex-pat, pop music publicist extraordinaire, and possessor of a Rolodex worthy of J. J. Hunsecker, with cachet to burn. Taylor, a longtime Beatles confidant, was a savvy industry insider who took his afternoon tea with liberal doses of Fleet Street sang-froid. His phone calls were always returned.

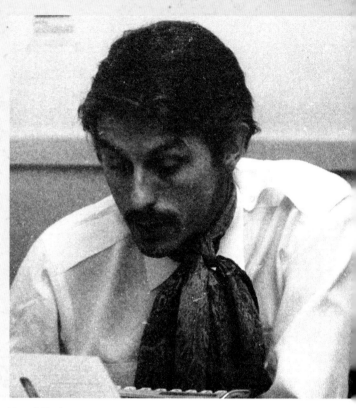

Derek Taylor

DEREK TAYLOR: The idea for the Monterey International Pop Festival came out of the mid-'60s belief that what had been pop music was now a much more serious art form, and could take its place alongside jazz. A man called Alan Pariser attended the 1966 Monterey Jazz Festival, which was quite an established event, and, while smoking a marijuana cigarette, considered the possibility of thousands and thousands of pop fans pouring out on the grounds, instead of these rather stuffy jazzophiles in corduroy. He went to people with money—his family, Harry Cohn Jr. [son of the Columbia Studios movie mogul] and Bill Graham [operator of San Francisco's Fillmore Auditorium and manager of Jefferson Airplane]—and raised $50,000 of "seed money" to put on a pop festival at the Monterey Fairgrounds in Northern California, to be held sometime during the summer of 1967, now known as the "Summer of Love."

In January of that mild winter, Alan and his partner, Benny Shapiro [an agent/manager/producer who represented Peter, Paul and Mary, Miles Davis, and Ravi Shankar], asked me if I would publicize the festival.

Well, I had just decided to drop out of being a Hollywood press agent [for the Beach Boys,

the Byrds, and Chad and Jeremy], which is the lowest form of life, and go home to England [where he would resume working with the Beatles]. It was a time for dropping out. I resisted the notion of having a pop festival until it seemed to me that it would be a very flowery thing to do at this time of flower power.

So, together with Alan Pariser and his friend David Wheeler, I set out to seduce the Mamas and the Papas into topping the bill, because they were the biggest act still touring. The Beatles had retired from the road. I think the Rolling Stones couldn't tour because of a drug problem. So really, the only hot live band that could fill the fairgrounds was the Mamas and the Papas.

During our approaches, John Phillips had the idea of talking to Lou Adler. And somewhere along the line, those two co-opted the show. They said, "We'll do it, and we'll do it for nothing, and all the artists will perform for free, thus making it a benefit. But we're going to take over the running of the show! You can stay as press agent, [Pariser] can stay as a producer [Shapiro was bought out], but from now on it's our show and we'll phone up the biggest stars in the world and we'll get them to Monterey in June." And they did.

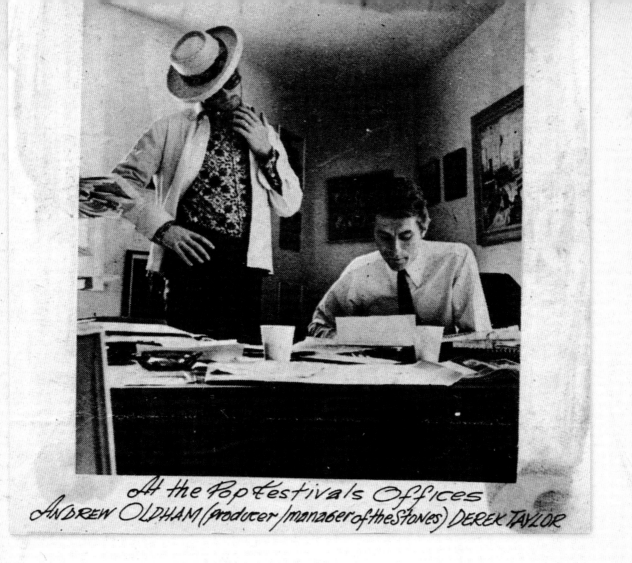

At the Pop Festivals Offices
ANDREW OLDHAM (producer/manager of the Stones) DEREK TAYLOR

By 1967, the name Lou Adler was synonymous with the sound of Los Angeles. A native of East L.A.'s rough and tumble Boyle Heights, he maneuvered through the razor-wire of hucksters and cut-throats operating in the nascent pop music business of the late '50s and early '60s. He had a sixth sense for hits, saw talent where others balked, and moved decisively to produce, publish, and promote a flurry of Top 10 talent that solidified his credentials as a *makher* with big ears. The Everly Brothers, Sam Cooke, Carole King, and Jan and Dean all benefited from Adler's unerring touch. He scored big time in 1965 with Barry McGuire's rococo lament, "Eve of Destruction," for his own Dunhill label. McGuire introduced Adler to his pal, singer/songwriter John Phillips, who, in turn, pitched Adler on his new group, the Mamas and the Papas. Beginning with "California Dreamin'," Adler, Phillips, and company rode the top of the charts for nearly two years straight. It generated a tsunami of wealth, self-indulgence, and the occasional three minutes of pop vocal genius. It was a time of fashionable excess for Phillips and his wife, Mama Michelle, who held court at their baronial digs north of Sunset in Bel Air.

On April 9, 1967, Paul McCartney flew from Denver to Los Angeles on a Lear jet owned by Frank Sinatra. On arrival, he headed straight to the Phillips' for some cultivated relaxation. "Jeanette MacDonald [famed actress and the home's previous owner] had built a room in the house like a pub, which is where all the action took place," recalls Adler. "I had just moved to Bel Air, then John and Michelle followed. The neighborhood accepts me, they sorta accept John and Michelle, and then Brian Wilson moves in and paints his house purple! At that point, we're all suspect."

McCartney was invited to join the newly-formed festival board of directors. His first recommendation was to book the Jimi Hendrix Experience, who were exploding in England at that very moment. Like John and Lou, McCartney believed that rock 'n' roll was more than a fad, that it merited the same respect and platform that jazz had once enjoyed. It was becoming more than crafting catchy tunes; it was informing the way you conducted your life. And what could be more life-affirming than mounting a major festival celebrating this transformation?

JOHN PHILLIPS: We were approached by Pariser, who had secured the dates for the Monterey Fairgrounds several weeks prior to the festival. He wanted to hire the Mamas and the Papas for the biggest price that we'd ever been offered. He'd have had no money left to hire anyone else!

I called Lou Adler to ask what he thought, and we decided on the spot to make it a nonprofit event and give the money to some charity. We knew we had to buy the date from Pariser.

LOU ADLER: Alan Pariser and Benny Shapiro approached John, Michelle, and me for the Mamas and the Papas to headline a one-day, one-night concert at Monterey. We said the Mamas and the Papas would only appear if the festival was for a yet-to-be-named charity and that all of the acts would appear for no fees but full first-class expenses. Simon and Garfunkel completely supported the idea. I think Shapiro and Pariser understood the drawing power of those two acts.

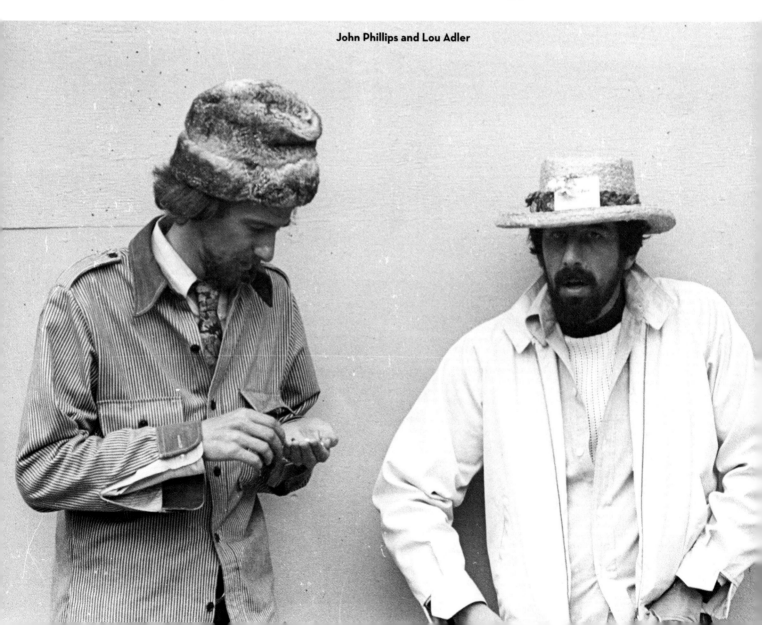

John Phillips and Lou Adler

Benny Shapiro had always envisioned turning a buck on the deal and blanched at the prospect of staging a freebie. So, he put his shares on the table— $50,000 would buy him out. Johnny Rivers, Terry Melcher, Paul Simon, John Phillips, and Lou Adler each ponied up $10,000 and voilà, a nonprofit was born.

Derek Taylor and Alan Pariser remained. Taylor handled all the press with typical aplomb; his willingness to embrace journalists of every stripe—from cubs to Associated Press vets—set the standard for how rock events would be covered for decades to come. Pariser occupied the crucial role of fixer/troubleshooter, his steadying presence underscoring his fierce commitment to an idea he indisputably birthed. Tom Wilkes was brought on as art director, his "Pipes of Pan" logo design hitting the right note between bacchanalian excess and nurturing Mother Earth. Guy Webster, who shot the notorious "bathroom cover" of the Mamas and the Papas' first album, *If You Can Believe Your Eyes and Ears*, was hired as the official photographer.

Benny Shapiro

LOU ADLER: We were now the Monterey International Pop Festival. We met in an office at the Renaissance Club at 8424 Sunset Boulevard . . . The Renaissance was formerly a jazz club. I remember seeing Miles Davis there. Michelle always says that the advance acetate pressing of *Sgt. Pepper* filled the office. There's a little bit of Rashomon here, I remember it being Procol Harum's "A Whiter Shade of Pale."

Anyway, we now had three days booked at the Monterey Fairgrounds—June 16th, 17th, and 18th—and three acts committed: Ravi Shankar (who would be the only act to be paid, as we chose to honor his contract), the Mamas and the Papas, and Simon and Garfunkel.

We assembled a board of directors, even though it never formally met. The directors were: [Rolling Stones manager] Andrew Oldham; John Phillips; Donovan and myself; Roger McGuinn; Terry Melcher; Alan Pariser, of course; Paul Simon; Brian Wilson; and Abe Somer, who played an important part in all the legal aspects. Pariser had great relationships with the artists. Andrew Oldham was our British connection. Andrew and Paul McCartney suggested Hendrix and the Who.

The Making of the Festival

by Derek Taylor

Michelle wondered what the hell was happening with all those faces at the door. After all we'd never come by the house before, Pariser, Wheeler and I and it was four o'clock with no warning or anything. "Come in" she said and did a little backward dance not because she was high but because the heavy door swung inwards giving her no choice but to dance with it or fall over.

John Phillips was there, very full of smiles that afternoon and wary. The more smiles the warier, I thought. Watchful. "What then fellers?" he said. I did the Bullshit British Blurt carried through from childhood, refined on instrusive newspapers, re-learned from watching my own kids: "Well, John, we're having a festival and it wouldn't be one unlessyouchapsperformed."

"I see," he said grinning more than ever and Pariser nearly blew it. I don't remember how but I remember thinking he nearly blew it because he was more nervous than I was, I thought. Maybe not, I think now. Back in the festival office on Sunset Strip, Benny Shapiro was scrounging cigarettes from anyone who had one and pacing up and down and wondering how the delegation was getting on. We needed the Mamas and the Papas you see. Really badly we needed them. Badly? Worse. We either had them or we had no festival.

The trouble was Ben couldn't see how to pay them more than $xxxx and they didn't perform for less than $zzzzz. "Oh," said John. "I see. Well." "Who'd like coffee?" said Michelle and cool Wheeler waited for me and Pariser to say "Wow yes!" and then he nodded a "yes thanks" grin leer and Michelle danced out with those thin little skippety legs while the conversation switched to the carpet and how Jeannette MacDonald must have had a trip planning the house all those years ago. In truth, none of us felt it was fair to pitch Phillips any further till Michelle came back. When she did, Pariser stuttered, "Hey John. We'd really dig you to do the show," and the dancing departed Michelle and she was allwifewoman. "You really have a nerve," she said. "You're making $aaaaaa and you want us for $xxxx and you know we work for $zzzzz."

Pariser took himself on a verbal walk into a black forest of no-way-out and Wheeler did his Southern Californian charm scene and I said "It's not like that at all" but it was and John's smile told us that we all knew it was so. Why not sit it out and wait for the smile to talk. When it did, it said: "Who else did you ask?" and Pariser said, "We have the Grinds and the Wanks and the Humps and the Quims and none of them have contracts yet but that'll be cool, we guess," and so on.

Michelle, wifewomanrealist on-target said: "You come here with no one signed and try to use John. I think it's terrible."

We mumbled and John said "Who has a cigarette?" wondering which of our three to choose we were so fast to please him.

"Simon and Garfunkel are in town," said Alan without relevance since they hadn't agreed to do the festival either on account of *their* offer hadn't been high enough.

"Well I'll tell you what," said John, "If they'll call me or I call them and we both agree to do it together then it'll be cool but that's the only way it'll happen. OK?"

Well OK, we had no choice did we? John said "bye" and the next day we went to the Beverly Wilshire Hotel to see Paul and Art, as some people know Simon & Garfunkel.

Well of course it isn't as quicksilver as the messenger service, just calling on Art and Paul without an appointment, in the middle of a Beverly Hills afternoon and they weren't at the hotel. The reception clerk said: "Sorry sir" and wasn't and didn't mean sir either, for Wheeler has a beard and hair down over the forehead Uncle Godsam gave him to show his clean American intellect.

So we phoned Benny and said Phillips had been very nice and was asking for a pop-summit of Mamas and Papas, Simon and Garfunkel, to do a magna carta signing sort of thing and no-one would regret being involved, you see, Benny. "A mistake," said Benny, and you could almost see the moustaches' twirling. When artists get together they gang up. Well, there it was, we said. We are losers but we did our best.

The next day it was raining and by arrangement we went to the Beverly Wilshire and who should step out of the elevator but Garfunkel and Simon as they are sometimes called alphabetically, if not euphonically. "Hello" I said.

"You are Derek Taylor," said Art (Garfunkel) like a German General during the occupation of Paris. "Certainly," I said and Paul (Simon) said: "We've met haven't we?"

Yes. In New York when we were drinking with the mutual enthusiasm of the Anglophile and an English boozer. We'd got on well then, I recalled and hope the recollection was correct since the pre-Magna Carta conference lay ahead and one needed every tiny seed of friendship to make it flower into a festival.

Art and Paul met Wheeler and Pariser who handed round some good things almost as honied as the conversation. "Wet, isn't it. Yes. It was wet in New York but colder. Nice here. Right. Great, really great. Oh, how was the show at the Carousel? Fine thanks. Very good in spite of the weather."

Pariser said, "You guys are really good considering this festival and wanting to give up your summer vacation." "Well, not at all," said Simon and Garfunkel gazed out of the window at the wet dead palm branches skittering up the boulevards. "Not at all," said Simon again. "It sounds a gas and we've got some ideas."

Great downy warm and wondrous waves of relief
(continued on page 12)

10

Article from the Monterey International Pop Festival annual

curled into the car, blanketing the five of us and Wheeler gripped the wheel in minor triumph. Simon and Garfunkel were so enthused about the show that they had IDEAS!

Up at the house built on the Indian Love Call, Michelle answered the door at the front which was Wheeler and Pariser and me and John went to the back which was Simon and Garfunkel who had wandered, wow and hey what a gas, dig this, man those trees Art. Art stared piercingly here and there along the old-stone path which led to the back.

The tour continued inside the house and out again, beyond the rose arbor through the shrubbery down the steps to a pool fit for Cleopatra and hot enough to steam Satan.

Back in the house on the carpet on which Noel Coward must have camped the lines of "Bitter Sweet" in pre-production demonstration. John said to Paul well here is what I think (which was not what we had thought he thought) and Paul said right. Art nodded and eye-darted first Wheeler and then Pariser at speed but in time for me to focus a return beam which, alas, was not nearly sharp or quick enough to be effective.

In a moment of time it was Us and Them. They were the Masters now and they knew it.

For what John had said he thought and Simon had said right to was that no one would get any money at all for doing the festival and all the profits would go to charity and wouldn't that be great because all the best respected performers in America would want to do something groovy like that without contaminating themselves with money or lies or deceptions or ego-collisions. Just a flower-strewn festival for love.

And for Pariser and Wheeler and me there was no answer to this reasoning because even in a dollar society there is the deep-down-if-you-slice-hard-enough disgust for money and its contagions.

One of us said we would like to know more which was utter rubbish because there it was before us and it was so clean and clear that there was no more except that we were all on festival salary (and also Alan as an investor stood to make a profit of some sort) and how were we going to justify taking money when the performers were doing it for nothing?

Well we never really did explain to this day how it was OK for us on the staff to take money for working in the offices because no one made us (though for a time the guilt was oppressive) explain. I dare say it was assumed we were broke or in debt or something like that. Why else would anyone take money for working for a non-profit organization? Surely only a scoundrel would make a living that way?

Scoundrels or fathers. And since Wheeler and I have seven kids between us we rationalized our salaries that way and we lost no sleep. Alan Pariser, a generous man sacrificed his profits on the altar of goodwill. Next day came the confrontation between the new artists' committee, Ben Shapiro and us. That was a splendid scene. Ben put on a tweed cap of the type worn by Irish trainers

on Grand National day and we drove up to the gate of the garden landscaped on "Rosemarie" and entered the house to meet with Phillips, Michelle, Simon, Garfunkel, producers Lou Adler and Terry Melcher, plus a business manager and a lawyer who wish to remain anonymous but whose names are Phil Turetsky and Abe Somer.

Ben explained his position and the committee queried it. The committee stated their views and Ben questioned them. Turetsky talked dollars and Somer talked law. I asked everyone to be quiet and drank wine. Pariser spoke up for Wheeler and Wheeler said good things about Pariser. Simon said "what do you think Art?" and Art nodded. Adler said "Hi Garbo" to his dog who made no reply. After seven hours, dawn peeped over Bel Air and asked whether anything had been settled.

No.

The conversation was the same the next night but somehow everything was settled. No one knew how. Shapiro remained as director answerable to a steering committee formed out of a board of governors—a board which within a week featured the following names: Lou Adler, Donovan, Mick Jagger, Paul McCartney, Jim McGuinn, Terry Melcher, Andrew Oldham, Alan Pariser, Johnny Rivers, John Phillips, Smokey Robinson, Paul Simon, Abraham Somer, and Brian Wilson.

The day after the decisions meeting, Adler and Phillips moved in to the already-opened offices on Sunset Strip and Ben Shapiro examined his other affairs and found that there were movie projects and concerts which were being neglected because of the Festival. He weighed one against the other, decided in favor of the movie products and concerts and resigned the Festival.

The press were told of the "reasons" for his decision. He later explained to the press that he had left "also" because he was not happy with the new "Top Forty" concept of the Festival. The committee made no answering comment.

Pariser, Wheeler and I watched each other carefully the next couple of days. And learned nothing. Could we work with the new people? Oh yes. We could and we did and there was never an office more full of zest.

Entertainers who have starved and become rich are forever haunted by guilt. Phillips and Adler, Simon, Garfunkel, Andrew Oldham of the Stones, McCartney of the Beatles and all the rest were delighted to have found a way of giving something back to the industry. Their motives were unquestionable—they wanted to be generous, to make a gesture. The spirit around them became unbelievably cheerful and the phones began to ring. Every major pop artist in the world was called. Will you work for the Festival? No one said no. A day after the artists' take-over the Mamas and the Papas, the Beach Boys, Simon and Garfunkel, Byrds, The Who, The Associates, Dionne Warwick, Buffalo Springfield had been firmed. Those who had other dates or vacations planned had switched or cancelled them.

The Beatles designed their own advertisement overnight, colored it themselves from their own paintbox and

(continued on page 14)

12

mailed it in. Charlie Watts of the Stones drew cartoons. Oldham wrote a poem. I wrote this. Ralph Gleason, lean, sardonic trench-coated Conscience of San Francisco Rock examined the Festival's structure, approved it and joined up. Bob Shelton, New York's pop Boswell threw in his lot. Leonard Bernstein sent good wishes.

John Phillips learned a new way of life whereby you get up in the morning and go to bed at night. Lou Adler produced an album by night and administrated by day. Andrew Oldham flew in from England and said ''get the Who and Jimi Hendrix.'' ''That's funny'' we said. ''McCartney said so too.'' ''Oh,'' said Oldham who is his own man. Hendrix and the Who were obtained and we tried for Donovan. He couldn't find a work permit. The Government hid it.

It was cold in the offices and we rented heaters, and drank hot coffee. The mercury soared and we rented coolers and drank iced water. The posters arrived and they were glued on a notice board fronting the strip. The flower children came by night, by stealth and stole them, piece by piece, presumably to make collages to sell to raise money to feed other flower children. Who knows why?

The programme book became not so much a programme, more a pop annual and those record executives who didn't want to spend $1,500 a page on advertising were called and made to feel like lousy snivelling worms. ''Give some of the money back to the kids'' said the artists and the bosses gave.

The large room housing the art department and the lobby at the Festival offices became a clearing house for the pop music scene. Any afternoon you would find a Byrd flying with a Buffalo, a Gentle Soul whispering to a Raider, a Mama typing a letter to a Miracle, a Beatle talking with a Beach Boy, and more flower children than there are Munchkins in Oz. Never since the Sunset Strip marches had so much hair mingled with so many beards.

It was, in other words, a Scene.

In the middle of it, calm and steadfast, sat Jackie and Julie, secretaries whose attitude to a Beatle is the same as to the man from Sparkletts.

The bills were filled and the acts were signed and the booths were settled and the seminars organized. The contracts were drawn up and the visas sought, the work permits juggled, the tax structure established, the transportation tested, the accommodations planned...And then. THEN, someone running a motel far off in Monterey returned checks to a teenager who wanted a room so she could attend the Festival. THEN the chief of police learned of a rumour that all the proceeds were to go to ''hippies''

THEN the Mayor of Monterey began to worry about her city.

THEN as a matter of urgency, the Festival flew in to the city and told her she shouldn't worry. It would all be OK.

But would it? The Mayor and the Police Chief, the motel owners and a man from ''Sing Out—Up with People,'' the Sheriff and the Highway Patrol, the Press and the TV teams, the radio stations and the church, a mother or two, a lot of fathers, maybe even a concealed lawyer, they all wanted to know.

The beards and the long hair garnished with marvelously expensive suits and richly decorated ties, polished boots and a Rolls Royce (bought for six grand of private funds rather than renting a Mustang, who needs it said Adler offhandedly) came to Monterey and told it like it should be and the people of Monterey saw that it was a real proposition and that it could not harm their city or their children. ''Sing Out'' agreed with the Mayor that the Festival people were on the right line. The Chief of Police agreed with the Sheriff that it was manageable. One anxious mother was not convinced, but the Press were and local paper headlines said the Monterey Pop Festival was ON.

Well it's three weeks away as I write and it's on or over as you read so you have the advantage over me. Has it worked? Is it a good Festival?

Adler will return to nocturnal living, John and Michelle will take a vacation, Wheeler grew a few grey hairs and Pariser grew up a little. I grew older (and also a few new enemies) Cass had her baby, David Crosby grew a Zhivago moustache, and Thank you, for listening and buying and being here.

14

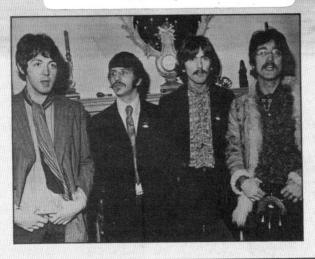

The Beatles and Monterey

Most of this issue of Teen-Set concerns the First Annual Monterey Pop Festival, and this article is no exception.

There was a strong rumor that the Beatles, in full or in part, would attend the big Monterey happening. Had the rumor become reality, this writer's analysis of their connection with the Festival could easily be reduced to a blithery "Oh, my God, they're really **there.**"

Far more than that needs saying, and should any of it irritate anyone reading this, don't get mad at the staff of TeenSet. They just work here. I don't, so please hurl all overly ripe melons in my direction.

In all the advance publicity regarding the festival, the Beatles were mentioned in one respect only. Paul McCartney, it was announced, was one of the sponsors of the intended gathering of the pop clan.

This understatement is equal to saying that some guy named Shakespeare wrote a few plays. The Bard of Avon didn't invent play-writing any more than the Beatles invented pop music, but both polished their respective crafts to a fine art. And, in so doing, made them legitimate forms of expression and far more enjoyable, as well.

It is not just my opinion that none of this, the pop music or the Festival, would have happened had it not been for the Beatles. This is a fact. They didn't just lend their talents to music in general. They supplied motivation and incentive to others whose creativity was being strangled by the stagnant "teen scene" of the pre-Beatle period.

If you don't agree, try an experiment. Picture if you will a pop festival in the year 1962. There would be none of 1967's difficulties, such as where to find facilities large enough to house the event, or how to quarter the thousands of artists and pop devotees who would want to be there.

The 1962 Pop Festival, had it existed, could easily have been held in the town of Elk's Tooth, Nebraska, population 9½. And what a ball it would have been for all those who attended. Both of them.

There were idols before the Beatles, and there were recordings made before they burst into international prominence. But the idols were few and the records too seldom worth the hearing, much less the buying. Too many seemed to be penned by ex-Tin Pan Alley buffs who, having developed a fondness for an occasional meal, were trying desperately to peddle their traditional June-moon-spoon-tune-ad-nauseum formula to a generation they didn't know or understand.

Just previous to the advent of the Beatles, young music (then known as rock 'n roll) was at an all-time low. It was simply too pooped to pop, and teen interest had turned from singers to television stars, most of whom were about as heavy as an egg custard.

Suddenly, there were Beatles. Admittedly, their first efforts were not altogether earth-shattering. I recall no one, fan or critic, marveling at the depth and inventiveness of "I Want To Hold Your Hand," but I do recall a lot of people, myself included, being quite amazed.

Both elements were somewhere this side of great, but there was something unusual, something original and something refreshing about them. Something which had been missing from music for far too long. Fun.

Little did we know, the fun was only beginning.

There's no need to go into what happened next. Everyone knows what happened next. The magic mushroom planted by the Beatles grew to gigantic proportions. New groups sprouted, as did the Beatles' talent. Today they are so firmly rooted in the musical culture of our civilization, anyone who does not recognize their power and their influence is, at best, ignorant, a fool, or both.

The Beatles splintered the door to propriety with a solid working-class first and changed music from a spectator sport to a game everybody could play. At least ninety percent of the artists who performed in Monterey have come into their own since the Beatles. Some of them openly and gratefully admit they came into their own *because* of the Beatles.

Also because of the Beatles, the Festival played host to one of the world's best known classical sitarists, Ravi Shankar. This unexpected and horizon-broadening pleasure is a result of George Harrison's fascination for this complexly beautiful instrument, which brought about his pilgrimage to India and his period of study with Shankar.

I have often wondered what would have happened had the Beatles begun their career with one of their recent compositions. A "Yesterday" perhaps.

I think I've finally figured out the answer to that question.

Their impact would have been greatly lessened had they happened any other way. It wasn't just their lack of pretension, the buoyancy of their music and their obvious love of a good time that made them the Pied Pipers. The Beatles' progress from "Hold Your Hand" to "Day In The Life" was just as important. Maybe more so, because, as Will Shakespeare (you remember him, he once wrote a few plays) put it, their growth served as a spur to prick the sides of their intent . . . their own intent, and that of everyone whose sights were set in a similar direction.

Whether the Beatles actually attended the Pop Festival doesn't really mat-, except to those of us who would ve several right arms just to see them gain for a moment.

They've already contributed more to the event than anyone else in the world. Because of the Beatles, pop is finally something worth having a festival *about*.

Andrew Loog Oldham first met Lou Adler in October 1964 in Santa Monica, California, at the *T.A.M.I. Show*, a pop revue extravaganza filmed for theatrical release. Adler was managing the event's hosts, Jan and Dean, while Oldham was representing the Rolling Stones. Oldham, who fancied himself the gifted offspring of Sammy Glick and Laurence Harvey, was always on the hunt for hit songs and publishing opportunities. He met his match in Adler and the two became fast friends. A year later, Adler introduced Andrew to his newest protégés at his South Beverly Drive office—an unassuming quartet with a pitch-perfect blend of vocal harmonies, singing songs fresh from the pen of their leader, John Phillips. Upon meeting Phillips, Oldham remembers, "I knew my mate [Lou] had his Mick and Keith in one, and that's what was important."

Above: (*left to right*) **Andrew Loog Oldham, Tom Wilkes, John Phillips, and Lou Adler in the Monterey production office**
Below: David Wheeler outside a Monterey area motel

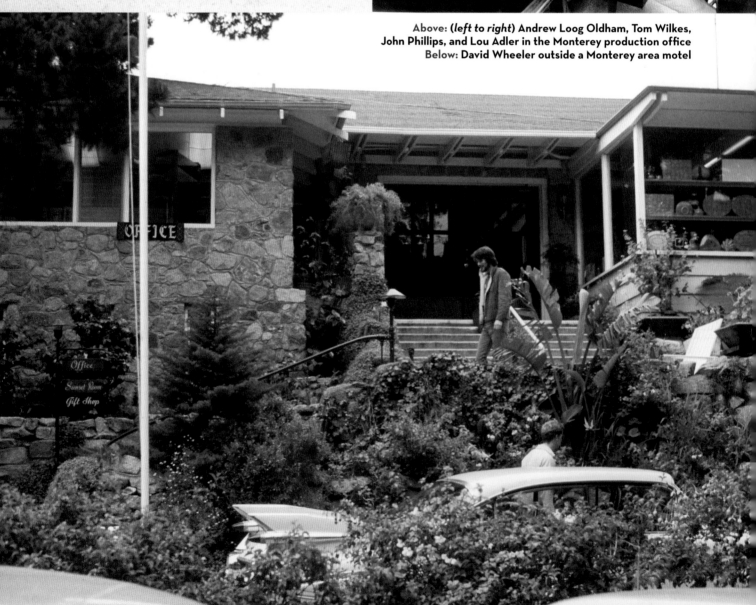

ANDREW LOOG OLDHAM: I was in self-imposed exile from the UK. In late '66, the Rolling Stones had returned to England for a rest after four years on the road. The drugs were working for and against us. I started getting calls from the fuzz warning me about Brian Jones and the condition he was in driving his Rolls-Royce up and down Kings Road. The party was starting to be over. It was definitely over when I got warnings that I was about to be busted. So I let my bottle go and fled England for L.A.

Suggesting the Who had nothing to do with any friendship with [managers] Kit Lambert and Chris Stamp. In fact, we were not really friends at all, just nodding-out acquaintances. We were all too busy. "The Who and Jimi Hendrix." The minute after I'd said it, either John or Lou said McCartney had said the same. As I said, it was obvious.

I'd done my job. Derek Taylor was the worker now. He was incredible. The dream was on. From the *Manchester Evening News*, to the Mop-tops, to Monterey Pop, all his skills were revived and intact.

Derek Taylor thought I might need something to do and kindly suggested I talk to Stephen Stills about becoming involved with Buffalo Springfield. They already had managers, but Stephen and I had a polite little chat on the stoop of the festival offices, both realizing we were riding different waves and were not for each other at this time.

LOU ADLER: We had no real plan other than to expose every musical genre, regardless of what someone might think about a particular act. We wanted music and artists everyone wanted to hear, or should hear, or at least find out about for the first time.

John and I didn't have any struggles; or, I don't recall one time where one of us wanted an act that the other one didn't want on the show. Or vice versa. There was a common denominator, which was to represent all genres regardless of chart position or sales—good or bad. In other words, if it was a pop act, try and get the best pop act. Or an underground act, like the Grateful Dead or Big Brother with Janis Joplin. Or any of the San Francisco groups.

We had six weeks to put the festival together. I think the time worked more for us than against us because, at the time, not a lot of acts were working as much as they are today. Not a lot of tours and no festivals. Also, the fact that we didn't have to go through lawyers and agents and that we could go directly to the manager or, in many cases, the artist. All those things worked for us.

I didn't have to convince myself to do this festival. It had a lot to do with the intrigue of pulling off the negotiations, but it was never calculated. Even the idea to take over the dates was not calculated. We had some dissonant chords and notes when it came to Benny Shapiro, who had a commercial event in mind. When the offer for ten grand was presented, that was big, but I was managing an act that really didn't care. The Mamas and the Papas spent more money on the road than they ever made. Parties and limos always ate up everything. But at no time did John and I sit down and say, "What are we getting ourselves into?" It was a snowball that just kept gathering more snow.

The first phone calls were obviously made to people like Paul Simon, because he was one of the five who put up the money after we bought the date from Benny. Johnny Rivers, he helped finance the festival. He cut the first check without hesitation.

I think Lou Rawls was one of my very first calls. I knew him from Sam [Cooke]. Even after Sam died [in December 1964], I continued my friendship with Lou. He was doing soul music and we wanted representation of that music . . . I had friendships with groups like the Pilgrim Travelers, Alabama Blind Boys, and Johnny Ace. I went on a couple of their tours, not really as road manager, but hanging around. It's a different relationship because you are staying in hotels that they can only stay in. There is a bond as well as a friendship. Lou Rawls' musical arranger at Monterey was H. B. Barnum, who I went to Hollenbeck Junior High School with.

It was a multi-music festival. We never had a conversation about white acts/black acts. The show was to feature music from Los Angeles, San Francisco, Memphis, England, Canada, and Chicago. We wanted Detroit. We tried to get the Impressions from Chicago. Nothing to do with color. It was where the music was coming from and what it represented. Obviously it's also about the culture, but it was music-driven.

We knew what the Who did. We didn't know what Hendrix was going to do to combat whatever the Who was doing. The impact of Janis . . . We had seen her at Winterland and thought

she was phenomenal. But not to the extent she exhibited at Monterey. She rose to the occasion. "This is it. Let me do everything I possibly can."

ART GARFUNKEL: The idea that the kids were going to know that we were doing this for the music's sake, that it wasn't a commercial endeavor—that was the essence of the show. And I liked the idea of taking the money off the table; that gave it a nice feeling. [Paul Simon and I] met in California with John, Michelle, and Lou, and we started talking about the festival and making up a guest list of whom we'd invite. We had a lot of fun coming up with acts: Otis Redding, Buffalo Springfield, all these artists we knew to be great, regardless of what their record companies might say. So we came up with this perfect list, hoping they'd work for no pay, and everyone said yes.

JOHN PHILLIPS: We wanted the shows to start at noon and run all the way to midnight—12 hours of music each day and each night. So we just developed the concept of getting an anchor act for every night, like Simon and Garfunkel the first night, then the Beach Boys, who were replaced by Otis Redding for the second night, and the Mamas and the Papas to close the festival. Then we filled in the afternoons. And no one was getting paid for it. All we were offering was their plane ticket to San Francisco, their expenses while in Monterey, and plane tickets to their next jobs.

MICHELLE PHILLIPS: It was a very foreign thing to tell artists that "we're going to fly you in and pay your expenses, but you're going to sing for free." I mean, some of them were laughing at us, "I've never played for free in my life!" These were *big* people, but John and Lou were very smart. They brought people into the board of governors like McCartney, Simon and Garfunkel, and Brian Wilson. They were smart; they built an infrastructure to draw talent in. They got the names. It was not just Lou Adler and John Phillips saying, "Please do this." It was, *"Us guys* want this to happen." It was like the princes of rock 'n' roll got together and said, "You do this, because it's going to a good cause." What Lou and John really did was get every person they knew to bring in somebody that they knew. We were bantering around names like the Beatles, the Stones, and the Beach Boys.

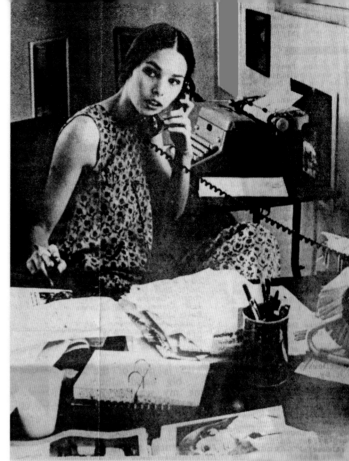

Not many secretaries as good-looking as this one. Mama Michelle helps out in the Festival offices.

DEREK TAYLOR: If we needed 100,000 orchids, we didn't bugger around having a committee on them—we'd buy 100,000 orchids. Okay. We'll fly them in from Hawaii, because that's what we need for Ravi Shankar's concert. A ton of incense—we'll get that from India. And why not? It'll be 1968 next year, and we'll have the Chicago riots, so we can't wait until then.

Adler was a skilled producer. Pariser was a pretty good pull-it-together guy; John Phillips, a dynamic pop star. Chip Monck, the great stage director, came to the Monterey Pop Festival offices and said, "Is there anything I can do to help?" The Byrds and David Crosby came by and said, "Give us a paintbrush and we'll paint the wall." Michelle Phillips went out in those pre-feminist days and bought the decorations and flowers and supplies for the office and volunteered secretarial services. So you had enormous goodwill, lots of money, plenty of space, and the right people at the right time.

JOHN HARTMANN (Co-Manager, Canned Heat): In 1965 and '66, I was at the William Morris Agency; I would book artists on TV to sell their music. Then *Shindig!* came along, and that was my show. I signed Jack Good [the show's producer] to William Morris. When I was standing in the wings watching

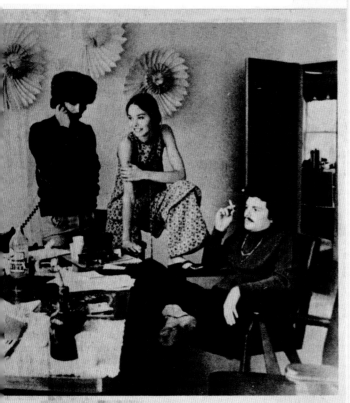

Helping in the Monterey International Pop Festival Office are David Crosby of the Byrds (left), Michelle Phillips of the Mamas and the Papas, and singer Scott McKenzie.

the Rolling Stones perform, I encountered Sonny Bono and then signed Sonny and Cher to William Morris.

Derek Taylor, the Monterey publicist, had been the PR for the first band I ever signed to the Morris Agency—Chad and Jeremy. I was focused on the L.A. music scene and it was [talent buyer] Howard Wolf who made me aware there was something going on in San Francisco.

On October 18, 1966, at Winterland, there was a Bill Graham concert. The bill was Jefferson Airplane, the Grateful Dead, and the Paul Butterfield Blues Band. That afternoon, [co-manager]

John Hartmann (far left)

Skip [Taylor] and I signed Peter, Paul and Mary to William Morris. We met their manager, Albert Grossman, who had the longest hair of anyone. But he wore suits and ties—smooth, smart—and it was a great signing. And that night he was in San Francisco because he was Butterfield's manager. My hair was so short, it looked like it was painted on. Skip and I had black mohair suits, tailored shirts with our initials, French cuffs. We sat there looking at three things that defied everything we knew about show business. We thought we were really smart, but it proved instantly that Howard Wolf was right. We did not have a clue. And those three things were, first, that every guy in the room had long hair. Wow! The second thing we saw were liquid light shows. Wow! But the biggest and most dynamic thing we saw was that three unknown bands sold 5,000 tickets. Wow! This is serious. I learned something that night about rock 'n' roll bands.

Skip and I left William Morris because they wouldn't let us open a San Francisco office once we saw what was going on up there. So we said, "Let's rent a house and sign up all these acts that are gonna be huge. Because if we do, we can make it way bigger if we become a manager." And that was when we started the Kaleidoscope Club. We had the Kaleidoscope well in motion before we left William Morris. In April of 1967 we brought Jefferson Airplane, the Grateful Dead, and Canned Heat together on the same bill at a Kaleidoscope show.

Charlie Greene called me up one day and mentioned he had America's answer to the Beatles—Buffalo Springfield. Charlie Greene, Brian Stone, Skip Taylor, and I then drove to San Diego to see the act. I was in after the first song. It all leads to why the Kaleidoscope was founded and informs Monterey, because when Skip and I came back to Hollywood from San Francisco we attempted an event called Stampede. We'd planned to break Buffalo Springfield there. It would have been the first "Bonnaroo" festival. It didn't happen.

Alan Pariser was a good friend of mine. Alan loved music and was rich enough to function in any community he wanted. He had the best sound system in Laurel Canyon and that's why people went to his house. I lived with him for a year, later on. I met him in the capacity of being an agent, and at nightclubs.

Jim Dickson was a consummate gentleman. A gentle soul and a sweetheart, you know,

and he had a calm, cool demeanor. He was older and wiser, in a sense, and his activism probably made him attractive to the Byrds.

Jill Gibson

JILL GIBSON (Photographer): I remember the first meeting that took place at John and Michelle's house one night to discuss the Monterey Pop Festival, with Lou, Paul Simon, Terry Melcher, and a few others. Something innovative and exciting was in the room. Later, it was interesting to see John and Lou set up the office on Sunset Boulevard for managing the production of the festival. The atmosphere was always very electric. Everyone was busy doing their part. I remember seeing a lot of the top of Derek Taylor's head . . . writing and talking on the phone.

AL KOOPER (Assistant Stage Manager/Performer): The most important thing for people to know is that it was the first rock festival. There were none before. And in the planning stages we had to deal with things that had never happened on a stage before. Not just the logistics. Here's something that I will never forget. The stage manager was Chip Monck, who I knew very well from New York, which is how I became assistant stage manager. I had just left the Blues Project and was recovering from a nervous breakdown. I was staying with my friend, David Anderle, and he brought me over to the Monterey Pop office. "You belong here." And he left me there, and by the end of the day I was helping out Chip, making phone calls and giving him advice about equipment and stuff. So I just went in there every day and worked. And one of the things that came up was that a band was going to play and we're gonna have to set up another band, and it's gonna be 20 minutes at least before another band comes on. What's the audience gonna do? This had never happened before. Chip said, "We're gonna play recorded music." I said, "Is that gonna work? You could have someone on the side of the stage doing a solo thing." "No. Because the equipment shit will cut into their shit." I said, "Okay." It was invented then and it is still going on.

D. A. PENNEBAKER (Filmmaker/Director, *Monterey Pop*): I got a call from Bob Rafelson. "Would you be interested in filming a festival in California?" "Jesus. Of course!" This was like God calling me up and telling me what I was thinking about all along. I had seen the movie *The Endless Summer* long before I went to Monterey. One of my kids was sort of interested in surfing, and I was going to see a film on surfing. But what I saw was a film about California, and it knocked me out, the accents and the lives. That was very interesting and what everybody was thinking about then.

One of the secrets of Monterey was that Lou and John Phillips took the money off the table. I knew they were hatching a real interesting game. Which was, from the beginning, *get rid of the money*. That was the big thing. Get rid of the money. And I could see that that was gonna make it work. It was a very Zen thing. With this type of people, it isn't that the money is the villain. These are people at the top, who are very competitive about being at the top—each wants to be the only one at the top—and the only way you can tell who is at the top is the money.

So, in a way, it's their banner, you know. So, to just say money is an evil thing and to get rid of it is ridiculous. But the fact is, that all of the people performing there were ready to perform for the music. And Lou understood that. He thought that if he could just get that money off the table, out of sight, then it would never come up again. And he was right.

NURIT WILDE (Photographer): I was volunteering and working at the production office on Sunset Boulevard. Lou was an amazing organizer. He

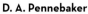

D. A. Pennebaker

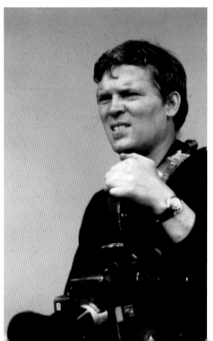

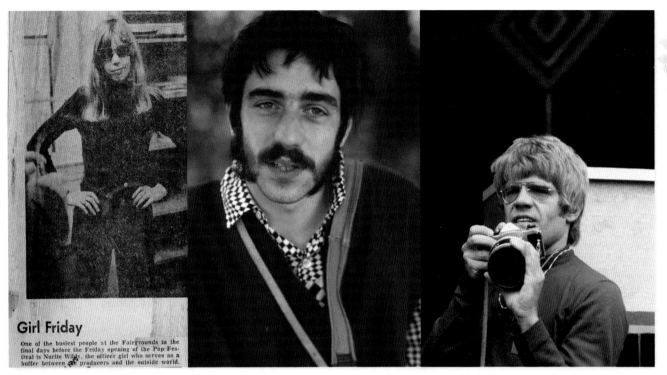

Left to right: Nurit Wilde, Peter Pilafian, and Henry Diltz

was on the phone constantly with various unsundry acts or managers. He did get everything organized so well. Peter [Pilafian] was involved, too.

I was at the office a lot. Alan Pariser also had great dope [laughs]. But there was no blatant use of drugs, or much drugs at all, because Lou and John Phillips were really focused on getting this thing together. Everyone wore patchouli oil and incense was around.

Derek Taylor was great in the office. I liked his accent, of course, because it was a very British accent. He was just really a nice guy and so polite.

John Phillips was charming and very persuasive. He really was a guy who enjoyed power. Aggressive, but the word is "power." So, he enjoyed that role of offering a venue to acts for Monterey. And people really responded to that.

Michelle worked very hard on the festival. I wouldn't say we had a camaraderie. She had her place as one of the Mamas and the Papas. She and I had a history because of John. She was good, and always a nice person. She did not have an attitude. I always thought she was really down to earth. She wasn't intoxicated in her own fame. I always liked her and always thought she was a right-on kind of person. She never seemed to take advantage of her position. Not that I saw.

HENRY DILTZ: (Photographer): I was in the audience as a fan at Newport, and that was folk music: Buffy Sainte-Marie, Judy Collins, and I saw Howlin' Wolf. Then I was in Monterey in 1967 as a photographer after John Phillips asked me to do it. I never thought I was doing something historic. My job was to hang out and take photos of everybody doing what they did because I enjoyed doing it. And it got me around observing and watching. I was used to hanging out with my friends and just documenting all the things that went on around them. And John Phillips knew that, too. Phillips was full of life and a great idea guy. Very good-natured. In 1966 and '67, I photographed the love-ins in Los Angeles, and people just lolling around. Shooting random shots of people who looked good and asking them, "Can I take your picture?"

RODNEY BINGENHEIMER (Audience Member): I was just about to start writing and reviewing for *Go!* magazine then, and talking to Nik Venet about being his intern at Capitol Records. Just before the festival I was handing out bumper stickers in Hollywood and all over Sunset Boulevard about the festival. The Beach Boys were on the billboard on Sunset Boulevard. It was a summit meeting of rock 'n' roll cool.

Derek Taylor fixed everybody up and made sure the right people were taken care of. Which they were. He was really cool about that,

Rodney Bingenheimer and Liz Hudson

and we were covered at the production office. Afterwards we somehow got a free PSA airplane flight to San Jose. We were then to be met by a bus and driven into Monterey. I was with my friends Ed Caraeff, Chris Reed, Carmen Steinseisser, and my girlfriend, Liz Hudson.

ANDREW SOLT (Audience Member): I must have seen the Byrds on Sunset at Ciro's and other clubs over a dozen times in 1965 and '66. I was at UCLA. I saw the Rolling Stones with the Byrds in 1964 or '65. I also went to Europe and London every summer, so I knew about all the English acts. I had *Aftermath* before it came over here. Thank God for Lewin's record shop on Hollywood Boulevard. In 1965, when Bob Dylan played three nights at Long Beach, Pasadena, and Hollywood, I was going to be at all three shows. Even if I had to die to get those tickets.

In 1967, I was on the Sunset Strip at least three nights a week; certainly Friday and Saturday nights. I was so depressed by the news on television and my only passion was music. I saw the billboard on Sunset Boulevard for the Monterey Festival. There were circles and artist names and dates. Every few days there was another amazing artist added. The Association! Jefferson Airplane! The Mamas and the Papas! Otis Redding! My God! What is this thing and where do you get tickets?

So I bought tickets. I said to my friends Steve Brown and Fred Gober, "I'm going to Monterey Pop." I had been to San Francisco before and been to some Golden Gate Park concerts. I used to go to Berkeley, too. And later on I got gassed at People's Park. So I was going up and down. But I only drove through Monterey. Steve had an aunt who lived 17 miles from Monterey and we stayed in a house for five days around the festival. We went to almost every show.

I had no idea, walking by a room on Sunset [the Monterey production office] and seeing a billboard outside when I was a student, that a festival was being planned and then executed in less than two months. What Lou Adler and John Phillips did was that it was the precursor to Woodstock and the big stuff that came about. This thing was naïve, small in retrospect; it was really exciting because it was beautiful and not marred by any negativity. I never thought about the money or nonprofit. I then started reading *Billboard* and *Rolling Stone* and wondered, "How do I get into this world?" [Laughs.]

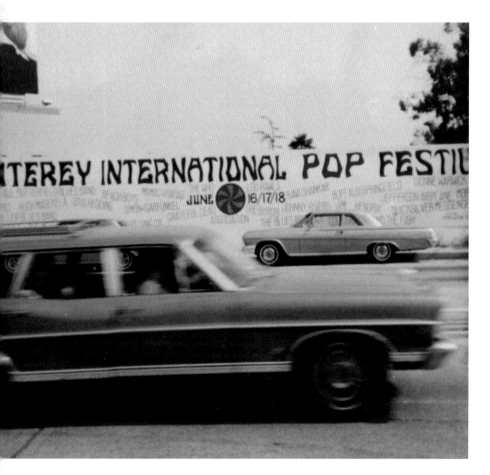

Billboard on Sunset Boulevard

The Beach Boys' last second cancellation has been the subject of much conjecture over the years. The audience fully expected to see them—the avalanche of publicity material always featured them as a major headliner. The "official" reason cited the convoluted travails of Carl Wilson's struggle with the government's Office of Selective Service; he sought conscientious objector status and the Feds weren't buying.

In *Heroes and Villains: The True Story of the Beach Boys*, author Steven Gaines describes an alternative scenario, one that conveys the torments of another Wilson brother, whose fragile psychic state has passed into the realm of legend. After quickly agreeing to perform, the band was suddenly overcome with grave doubts, sensing that their surf sound had become a dated liability. "You know," Brian Wilson told Michael Vosse, who was working on the Monterey committee while acting as a formal liaison for the Beach Boys, "the idea of a show with the Beach Boys and the Mamas and the Papas is okay. But all those people from England who play acid rock—if the audience is coming to the concert to see them, they're going to hate us."

Brian was invited to meet with Alan Pariser, who has handled his fair share of delicate artistic sensitivities. Wilson was moody and on edge.

"After some small talk," Vosse said, "Pariser said casually to Brian, 'I don't even know what you guys are doing. I haven't heard from you in a while.'

"Brian's mouth flew open. He was so insulted. Just at the climax of all this tension, the door flew open and in came a guy who was a chiropractor—a pushy hippie type. He took one look at Brian and said, 'Terrible back, we're going to have to do something about that.' Before Brian knew it, he was on the floor on his stomach, screaming in agony as the chiropractor worked him over. He was absolutely terrified, but too scared to tell him not to do it . . . He was totally humiliated and in pain.

"When Brian left that night Pariser said, 'If I don't see you before then, I'll see you at Monterey.'

"And Brian said, 'I doubt it.'"

Brian Wilson

The Beach Boys were not the only no-shows at Monterey. Dionne Warwick was performing at San Francisco's prestigious Fairmont Hotel and they would not release her for that night to perform down the coast. The Impressions were listed, but no one really knows why they didn't attend. The mind boggles, though, at the prospect of Curtis Mayfield sharing the stage with Otis and Jimi. *Sigh*. Donovan was nabbed by Sgt. Pilcher of the British Constabulary for possession of pot, and had his work visa pulled—"You're out, old cock." Eric Clapton has often commented that Cream wanted to make their American debut at Monterey. But their self-aggrandizing manager, Robert Stigwood, imagined them headlining their own U.S. tour, and so the occasion passed.

The headlining slot on Saturday night was opened up when the Beach Boys failed to appear. It was taken by a young (only 25!) soul singer named Otis Redding, whose star was about to go nova.

In 1967, Redding was voted the number one male vocalist (over Elvis Presley) in England's premier pop music weekly, *Melody Maker*.

Andrew Loog Oldham suggested to Adler that Redding would be a great fit for the festival and contacted Redding's manager, Phil Walden. Walden, a whip-smart good ol' boy from Georgia, was not instantly sold on the idea and turned to Atlantic Records mastermind Jerry Wexler for guidance. Otis had never sung before such a huge, predominantly white audience, and there were legitimate concerns.

ANDREW LOOG OLDHAM: I was close with Phil Walden. I'd met him through my muse, a great lady named Jean Lincoln. She is one of the people who opened the door for me when I was 17 and trying to make a go of it as a PR. Walden managed Otis and I admired the everything out of him. I called him about Otis doing Monterey. Ironically, he was suspicious about the idea and he called Jerry Wexler to see if the whole idea was kosher. Wexler told him it was. And that is how Otis Redding got to amaze everybody, including himself, at Monterey. We all saw the possibilities. You have to remember we were still not long past there being "negro cinemas" in all your major Southern towns, and the attitude, the racism, had kept on going. It was very hard for America to tear away from the way it had been born. Otis Redding at Monterey was a new beginning, a milestone, and the shape of things to come.

ROBERT MARCHESE (Production Assistant): In May 1967, I was at the Monterey Pop production office. I knew John and Michelle; her sister Rusty and her boyfriend, [production coordinator] Peter Pilafian, rented me their place in Laurel Canyon. They were going over potential acts to contact and John asked, "Who should we get?" I rattled off Muddy Waters. "He's working." James Brown. "He's working." Wilson Pickett? "He won't do anything for nothin'." What about Otis Redding? "He won't play in front of a white audience."

Lou Adler and Clive Davis on the cover of *Cash Box* magazine

Apparently, when he played San Francisco around the last New Year's at the Fillmore, he was only politely applauded and was a bit depressed about it. So I told John to talk to his manager, Phil Walden. And at that very moment they had Phil on the phone line and Otis was in his office. Andrew had already clued them in to Otis. So I asked if I could speak to Otis and John said, "Sure." I couldn't believe it because John could be so uptight. So I said to Otis, "If you come to Monterey and do 'Pain in My Heart' like you did when I saw you at the Howard Theater [in Washington, DC] in 1963, you'll kill 'em." [Otis said,] "You see that show?" "Yeah, and that's when you had your hair in a conk." And I'm white! And he said, "I'll be there!"

MICHELLE PHILLIPS: Every day was a groovy feeling. Like you have this crush on a guy and then it becomes a reality. It started to gain momentum with every group we added, like a great ball of yarn getting bigger and bigger. People stopped asking, "Are you really going to pull this off?" *Billboard* came on and then *Cash Box*. It was just a matter of knowing how to get what you wanted. John was a real chameleon. He could be anyone you wanted him to be: businessman, rock star, folkie. Hell, he convinced my father to let me quit high school and go live with him in New York while his divorce was being finalized. Dad just said to "make sure you throw a book at her every now and then." [Laughs.]

The City by the Bay

LOU ADLER: John Phillips and I went up to San Francisco for a preliminary meeting with the Grateful Dead that was arranged by Ralph Gleason and Bill Graham. A couple weeks later, Derek Taylor, Andrew Oldham, and I went to another meeting at Ralph's house. Ralph had done interviews and written about many of the new San Francisco bands. Bill had promoted concerts for most of them, and he had a relationship with John and me, so Ralph and Bill helped bring us all together. They were the musical ambassadors who really made the festival happen.

JOHN PHILLIPS: Through them, we made contact with people like Big Brother and Janis Joplin, Quicksilver, Country Joe McDonald, the Dead—all these San Francisco-based groups who really hadn't yet had much national or international exposure.

ANDREW LOOG OLDHAM: I remember Lou and I flew up from L.A. to San Francisco to meet the resident dean of the scene, Ralph J. Gleason. I think the main purpose of the trip was to get his blessing upon the festival, and thus ease the way for the San Francisco components to know it was kosher to appear. It would also help us deal with the very necessary groups from the Bay Area. The new San Francisco acts . . . I didn't like the bands. To me, they weren't stars. Unoriginal, fueled by drugs and liquor. I couldn't understand the attraction. I like my stars to behave like stars.

Ralph J. Gleason

JOEL SELVIN (author, *Summer of Love*): Adler and Phillips go to Gleason because they see Gleason as the Pope in San Francisco. And he is nonsectarian. There's no question. And Gleason listens to these guys and decides to give them a shot. In doing so he opens the door for these five managers: Ron Polte [manager of Quicksilver Messenger Service], Jules Karpen [manager of Big Brother and the Holding Company], Graham, Bill Thompson [manager of Jefferson Airplane] and Scully. And those are the guys that formed almost a Kabul around the San Francisco music town. Outside of Graham, they're all fuckin' acidheads who're into creating a new order of life and a new order of business. They are interested in a brave new world. Certainly, they are totally suspicious. Polte was a criminal from Chicago. Scully was raised in private schools in Europe and had started taking acid as a college student at San Francisco State, hanging out with these guys who became the Grateful Dead. [Bill] Thompson was a copy boy at the *Chronicle*, whose roommate [Marty Balin] started Jefferson Airplane.

The San Francisco scene was this little cauldron of insurrection. At the time of the festival the only San Francisco group with any real recording experience was the Airplane, who had their second album [*Surrealistic Pillow*] in February. None of the bands had been outside San Francisco. Monterey was beyond the range of the bands. I think the Airplane probably had some gigs at the Whisky A Go Go and gigs up the coast. But Big Brother had never been outside the Bay Area. The Dead had done some dates with Quicksilver in Oregon and Washington.

This parochial event was taking place but whose seismic waves had been felt and also echoed in London. Right? And Adler knew; Adler is a smart, cunning guy, and he knew that the non-profit spin opened them up to everything. Got them the Simon and Garfunkel wrinkle. Got them in with the Beatles. Derek Taylor was essential to everybody and gave credentials to everybody who asked. The Dead were suspicious of this thing all the way through. Even to the point of stealing all the equipment [after their Monterey performance, they notoriously walked away with the backline provided for them]. There was an underlying tension in this whole thing that was part of this culture war.

ANDREW LOOG OLDHAM: We drove from the San Francisco airport to Gleason's house, sat in his living room, took tea, and spoke in general about life and the festival's intentions. I did not take to him; he was like a schoolteacher I was lucky enough not to have. He almost gloated as if he was marking our term papers, which in fact he was. We were only there an hour or so and then we bid Ralph adieu, tacitly thanked him for his blessing, and got back in the limo to return to the airport. It was a Cameron Crowe car shot: the limo pulling away from the leaved suburban street; the leaves were brown. Close-up of two maestros of pop on their way back to where they were thought to belong. Naturally the clothes were great. Lou was bearded and I was growing my first, hoping that it would be more than bum fluff by the time the Monterey Festival began.

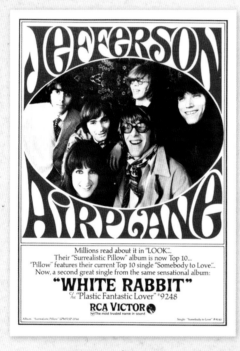

Clockwise from top left:
**Music trade ad for
Jefferson Airplane,
June 17, 1967;
KFRC Big 30 Countdown;
KHJ Boss 30 Countdown**

LOU ADLER: It was a different story with the San Francisco groups. They understood and wanted the festival, but considered L.A. the den of commercialism, and John and I its representatives. They did trust Ralph J. Gleason and they believed Bill Graham. Gleason was a jazz critic for the *San Francisco Chronicle*, but had become an advocate for San Francisco's youth and new music movement, and through Ralph's and Bill's diplomacy, they brought the San Francisco and L.A. contingents together, at least for those three days in June. The Grateful Dead were ungrateful.

PAUL KANTNER (Jefferson Airplane): Jefferson Airplane played at the Monterey Jazz Festival. We were invited because we were the new hip band. They were stretching out that year, which was the nature of the times. Thank God what a great nature that was. Jazz critic Leonard Feather wrote that we "sounded like a mule kicking down a barnyard fence."

By the time we did the Monterey Pop Festival we had a record deal with RCA and an album out that we cut in Hollywood. Years before I had a house in Venice with [David] Crosby [and David Freiberg]. I hung out with the Byrds before I even started a band. I always played an acoustic 12-string as a folkie, so it was just a natural switch over to the electric Rickenbacker.

We had the fortune or misfortune of discovering Fender Twin Reverb amps and LSD in the same week while in college. That's a great step forward [laughs]. We later named a music publishing company Ice Bag, which had nothing to do with cocaine. It was good marijuana—the best of the year, if not the decade. It came packed in ice bags from Alan Pariser.

Before the festival we stayed up at the Zen Center at the Tasajara Hot Springs for several days. Not being Zen, I took my .22 with me and popped cans off rocks over the hill. And they had a great river so you could get whacked out and then go into the steam and bathe in the ice-cold river.

As far as San Francisco being suspect of L.A. and Hollywood people, we always tried to get above that. People didn't like the Doors 'cause they were from L.A. [laughs]. So there's an immediate antipathy. I liked the Doors a lot and we toured with them. I rejected that antipathy within myself. I thoroughly enjoyed L.A. and New York. I could make myself comfortable in either one of those cities.

So many things were going on, you didn't take that kind of notice of them. You just assumed that was going on—"All right!"—and went with it. We didn't analyze it. We didn't think to wonder about it. It was just another thing that was going on along with the music, the clothes, the bookstores, the poets, the artists—there was a plethora of things and you did not have time basically to take it all in. I liken it to white water rafting. There was so much going on, you didn't worry about what was around the next curve, or what you were going to do on the third curve . . . because you were right in the river.

I had friends at Monterey and in the bands from England. I had been listening to Ravi Shankar for years, so I wasn't waiting for him. He played a lot in the Bay Area, even during our folk days in Berkeley. There's no name for what we did. It's not rock 'n' roll. It's not folk music. I don't know what it is. It's just, we all took up and started in folk music and then branched out. Like I say, Fender Twin Reverb and LSD in the same week was a big step forward.

JANN WENNER (Founder and Editor-in-Chief, *Rolling Stone*): I was working as an intern for the Sunday Ramparts in a kind of newspaper they were putting out. I had gotten a job through Ralph J. Gleason as sort of their entertainment editor and music critic. It was a time when the San Francisco rock scene was really taking off.

Ralph used the *Chronicle* as a bully pulpit to defend Bill Graham, defend the Family Dog and the dance concerts. He was just the man on the block there. And took it upon hisself to be kind of the conscience of the scene. People looked to him for his judgement, ideas, knowledge, and opinion, and ultimately for his blessings. Lou [Adler], John [Phillips] knew that if they really wanted to get the cooperation of the San Francisco groups—and at that time they were pretty full of themselves, arrogant in that youthful way and naïve—they were probably prepared to make some accommodations. There was no impulse for anybody to want to show up and play with Paul Simon, or any of these other groups—the Mamas and Papas, for example. So there was lot of suspicion.

Well, I mean, I was definitely of that mindset. I was the "Ramparts" part of it. You know what? It was prejudice, pure and simple. We assumed what we were doing was authentic, not part of the commercial machine. And remember, Jefferson Airplane turned down a Levi's commercial.

And then groups signed with record labels and recorded their albums in Hollywood. [They thought,] "Well, it's not so bad."

We all saw Monterey as a big event and something special. Maybe Ralph saw it as a potential game changer. I don't think we thought of Monterey as a market. We thought of it as the furthering of this great rock movement. Another milestone along the way where we would grow, our voices would be heard more loudly and more nationally and internationally. I mean, everybody knew that was going to happen.

Though the most contentious issues had been put to rest, there was still some grousing from the Grateful Dead camp. Co-manager Danny Rifkin continued to pepper Adler with concerns about logistics, ticketing, staging, and profits generated from the festival.

Reserved tickets were priced from $3.00 to $5.00 for afternoon performances, and $3.50 to $6.50 for evening shows. Considering the range and quality of the acts, this was a bargain by any measure and the tickets quickly sold out. For a buck you could stroll around the fairgrounds. Adler had negotiated with ABC Television for the rights to broadcast a film of the event. The sum: $250,000. The acclaimed documentarian, D. A. Pennebaker, was brought in to oversee the shoot. Rifkin fumed; this screamed "sellout" (although he had no problem holding up Warner Bros. Records for all sorts of budget and creative control demands when cutting their deal). He threatened to stage a free anti-festival on the grounds of nearby Fort Ord. Not surprisingly, a battalion of armed grunts walking point for an infestation of hippies was deemed unworkable. Instead, the Monterey Peninsula College football field was secured for a campsite and performance space.

And there were still the "good burghers" of Monterey to pacify, which required a little less stick and a touch more panache. Monterey, for all its physical and spiritual charms, remained a resolutely conservative enclave, run by an iron-fisted clique of real estate and merchant interests. Its mayor, Minnie Coyle, a sweet-natured grandmother, became alarmed at the prospect of homeless hordes on her doorstep. "If there are people hungry, you feed them," she said. "But don't advertise free food for everyone who wants it. That encourages youngsters to leave home." Police Chief Frank Marinello, was even less forgiving; a plague of locusts was preferable to thousands of vagrants nesting in his pristine climes. The National Guard was only a phone call away and his finger was itching to dial.

It was mid-May when Adler, Phillips, and entourage jetted into Monterey for lunch at the Mark Thomas Inn with the town elders. Phillips didn't need lift; the LSD he took at take-off kicked in right around the hors d'oeuvres. He was primed to play the role of Johnny Appleseed, sowing good tidings and Yankee rectitude to charm even the most

Minnie Coyle and John Phillips

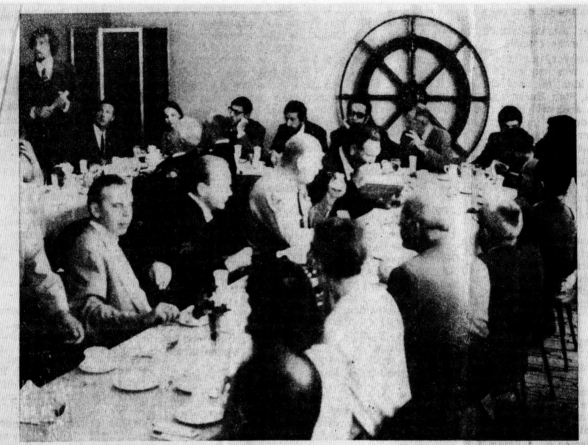

(Herald photos)

Pop Music Festival Luncheon

At the head table sit producers and performers of the three-day Pop Music Festival to be held at the Monterey Fairgrounds June 16, 17 and 18, with their spokesman, John Phillips, standing at far left. They gave a luncheon yesterday at the Mark Thomas Inn for city and county officials and a large delegation of motel owners, all of whom were concerned about arrangements for the affair, and particularly about the housing for the anticipated crowds.

skeptical. He presented the festival's Articles of Incorporation: " . . . charitable, literary, and educational in nature . . . to initiate, sponsor, promote, and carry out plans and cultural and artistic activities . . . " Not exactly *Das Kapital*. Phillips insisted that the "hippie underground" would not benefit from the concerts and that the money raised would primarily provide "scholarships to those who need them in the popular music field." Furthermore, he said, "The show is designed for those in the 19–35 age group. We have omitted acts that draw the real young kids and our publicity has solicited family groups. We haven't invited the sort of acts that inspire acting up on the part of the audience. If that happens, we'll pull them offstage."

Mayor Coyle appointed a Citizens Committee to be headed by Sam Karas. Local football players were hired to serve as security. It was also decided that, given the massive consumption of marijuana expected over the three days, a moratorium on drug busts would go into effect. No sense provoking the blissed-out imbibers into remonstrations; common sense, for once, carried the day. Karas would later declare that Monterey had virtually no security problems. Everyone agreed to be on their best behavior, and the bands played on.

ARTICLES OF INCORPORATION

MONTEREY INTERNATIONAL POP FESTIVAL, INC.

The Articles of Incorporation of Monterey International Pop Festival, Inc. provide that its primary purpose is:

"charitable, literary and educational in nature and is particularly to initiate, sponsor, promote, and carry out plans and cultural and artistic activities which will tend to further national interest in and knowledge and enjoyment of popular music, and to encourage the development and studying of popular music:"

The Articles further provide that the general purposes of the corporation shall be, among others:

(a) To initiate, sponsor, promote, and carry out popular music festivals wherein persons in the popular music field from all parts of the world will congregate, perform and exchange ideas concerning popular music with each other and the public at large; and to make these festivals accessible to the public at large.

(b) To grant scholarships and other aid to needy persons in the popular music field, and to persons studying the popular music field, for the purpose of furthering the study and knowledge of popular music.

(c) To receive financial support from contributions, including, but not limited to, the receipt (by contribution or purchase) of property.

(d) To engage in fund-raising activities and to solicit funds and donations for the purpose of defraying the costs and expenses of the corporation, and furthering and achieving its specific and primary purpose.

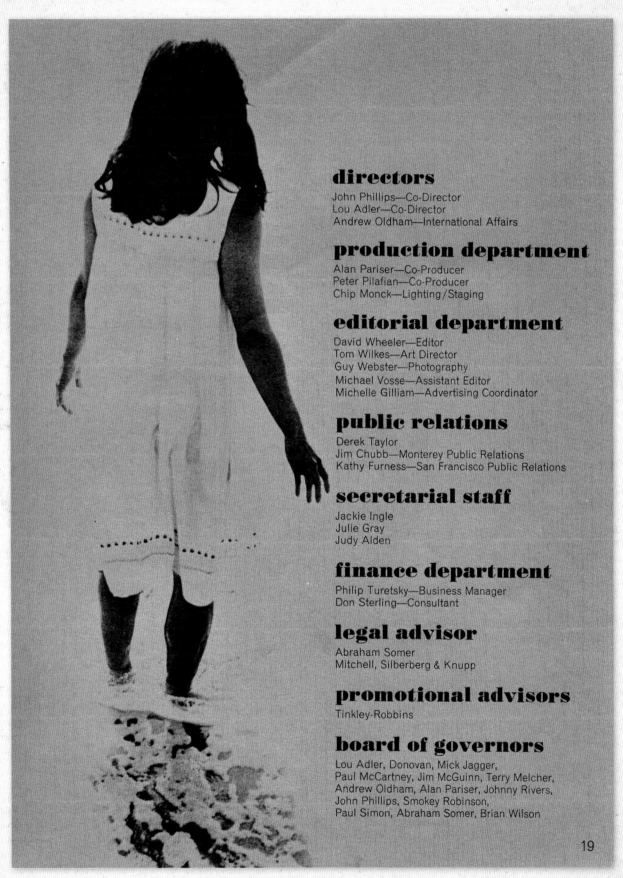

directors
John Phillips—Co-Director
Lou Adler—Co-Director
Andrew Oldham—International Affairs

production department
Alan Pariser—Co-Producer
Peter Pilafian—Co-Producer
Chip Monck—Lighting/Staging

editorial department
David Wheeler—Editor
Tom Wilkes—Art Director
Guy Webster—Photography
Michael Vosse—Assistant Editor
Michelle Gilliam—Advertising Coordinator

public relations
Derek Taylor
Jim Chubb—Monterey Public Relations
Kathy Furness—San Francisco Public Relations

secretarial staff
Jackie Ingle
Julie Gray
Judy Alden

finance department
Philip Turetsky—Business Manager
Don Sterling—Consultant

legal advisor
Abraham Somer
Mitchell, Silberberg & Knupp

promotional advisors
Tinkley-Robbins

board of governors
Lou Adler, Donovan, Mick Jagger,
Paul McCartney, Jim McGuinn, Terry Melcher,
Andrew Oldham, Alan Pariser, Johnny Rivers,
John Phillips, Smokey Robinson,
Paul Simon, Abraham Somer, Brian Wilson

19

Page from the Monterey International Pop Festival annual

WESTERN UNION TELEGRAM

CLASS OF SERVICE
This is a fast message unless its deferred character is indicated by the proper symbol.

W. P. MARSHALL
CHAIRMAN OF THE BOARD

R. W. McFALL
PRESIDENT

SYMBOLS
DL=Day Letter
NL=Night Letter
LT=International Letter Telegram

The filing time shown in the date line on domestic telegrams is LOCAL TIME at point of origin. Time of receipt is LOCAL TIME at point of destination

LA053 DEC273 =L (41).
DE SFA029 PD 1 EXTRA=SAN FRANCISCO CALIF 18 1114A PDT=
JOHN PHILLIPS, MONTEREY INTERNATIONAL POPS FESTIVAL =
 8428 SUNSET BLVD LOSA= 1967 MAY 18

PER CONVERSATION TODAY WITH DEREK TAYLOR, CONFIRMING
PARTICIPATION BIG BROTHER AND THE HOLDING COMPANY
IN MONTEREY POPS FESTIVAL JUNE 17 (SEVENTEEN). WOULD
APPRECIATE TALK CONCERNING ARRANGEMENTS=
 BIG BROTHER AND THE HOLDING CO JULIUS KARPEN MGR==

 =DEREK JUNE 17=

WU1201 (R2-65) THE COMPANY WILL APPRECIATE

WESTERN UNION TELEGRAM

CLASS OF SERVICE
This is a fast message unless its deferred character is indicated by the proper symbol.

W. P. MARSHALL
CHAIRMAN OF THE BOARD

R. W. McFALL
PRESIDENT

SYMBOLS
DL=Day Letter
NL=Night Letter
LT=International Letter Telegram

The filing time shown in the date line on domestic telegrams is LOCAL TIME at point of origin. Time of receipt is LOCAL TIME at point of destination

=(46).
1967 MAY 24 PM 5 00

LA121 0A277

O SFGJQRI PD 3 EXTRA=SAN FRANCISCO CALIF AR 24 NFT
LOU ADLERLCARE MONTEREY INTL CO POP FESTIVAL
 8428 SUNSET BLVD= LOSA=

CONFIRMING GRATEFUL DEAD FOR JUNE 18TH IN MONTEREY=
 DANNY RIFKIN=
 THE GRATEFUL DEAD=

ATRONS CONCERNING ITS SERVICE

WESTERN UNION TELEGRAM

CLASS OF SERVICE
This is a fast message unless its deferred character is indicated by the proper symbol.

W. P. MARSHALL
CHAIRMAN OF THE BOARD

R. W. McFALL
PRESIDENT

SYMBOLS
DL=Day Letter
NL=Night Letter
LT=International Letter Telegram

The filing time shown in the date line on domestic telegrams is LOCAL TIME at point of origin. Time of receipt is LOCAL TIME at point of destination

LA055 SSM141 L TBA015 1967 APR 148).
(L SFA128) PD (VIA TB SVCD NSN 848)=SAN FRANCISCO CALIF APR
JOHN PHILLIPS, MONTEREY INTL POP FESTIVAL= 20 1205P PST=
 8428 SUNSET BLVD LOSA=

WE GRACIOUSLY ACCEPT YOUR INVITATION FOR JEFFERSON
AIRPLANE TO APPEAR AT THE MONTEREY FESTIVAL SOMETIME
OVER WEEKEND JUNE 16, 17, 18. WE WILL DONATE OUR SERVICES
UPON THE SAME BASIS AS ALL OTHER GROUPS APPEARING. WISHING
YOU MUCH GOOD MUSIC. BEST=
 BILL GRAHAM MANAGER JEFFERSON AIRPLANE=

WU1201 (R2-65) THE COMPANY WILL APPRECIATE SUGGESTIONS FROM ITS PATRONS CONCERNING ITS SERVICE

WESTERN UNION TELEGRAM

CLASS OF SERVICE
This is a fast message
unless its deferred char-
acter is indicated by the
proper symbol.

W. P. MARSHALL
CHAIRMAN OF THE BOARD

R. W. McFALL
PRESIDENT

SYMBOLS
DL=Day Letter
NL=Night Letter
LT=International Letter Telegram

The filing time shown in the date line on domestic telegrams is LOCAL TIME at point of origin. Time of receipt is LOCAL TIME at point of destination

LA101 SSA307 L LLS306 (16).

(A MCA236) PD=FAX MACON GA 3 413P EDT=
=MONTEREY INTERNATIONAL POP FESTIVAL, ATTN JOHN PHILLIPS=
8428 SUNSET BLVD LOSA (WH): 1967 MAY 3 PM 2 29

=THIS CONFIRMS THE APPEARANCE OF OTIS REDDING,
BOOKER T AND THE MGVS AND THE MARKEYS AT THE MONTEREY
INTERNATIONAL POP FESTIVAL ON JUNE 17TH.
THE ABOVE MENTIONED WILL PERFORM WITHOUT FEE.
THE FESTIVAL WILL FURNISH FIRST CLASS ROUND TRIP AIR
TRANSPORATION FOR SEVEN PERSONS FROM MEMPHIS, TENN.
AND FOR TWO PERSONS FROM MACON, GEORGIA. THE FESTIVAL
WILL ALSO FURNISH HOTEL ACCOMMODATIONS FOR THE NINE
PERSONS= PHIL WALDEN=

WU1201 (R2-65) THE COMPANY WILL ITS PATRONS CONCERNING ITS SERVICE

WESTERN UNION TELEGRAM

CLASS OF SERVICE
This is a fast message
unless its deferred char-
ac indicated by the
proper symbol.

W. P. MARSHALL
CHAIRMAN OF THE BOARD

R. W. McFALL
PRESIDENT

SYMBOLS
DL=Day Letter
NL=Night Letter
LT=International Letter Telegram

The filing time shown in the date line on domestic telegrams is LOCAL TIME at point of origin. Time of receipt is LOCAL TIME at point of destination

LA131 PA630 (57).

P NA418 PD=NEW YORK NY 19 751P EST=
JOHN PHILLIPS, CARE MONTEREY INTERNATIONAL POP FESTIVAL=
8428 SUNSET BLVD LOSA=

1967 APR 19 PM 5 15

THIS WILL CONFIRM THE APPEARANCE OF SIMON AND GARFUNKEL
AT THE MONTEREY INTERNATIONAL POP FESTIVAL=
MORT LEWIS=

WESTERN UNION TELEGRAM

CLASS OF SERVICE
This is a fast message
unless its deferred char-
ter is indicated by the
proper symbol.

W. P. MARSHALL
CHAIRMAN OF THE BOARD

R. W. McFALL
PRESIDENT

SYMBOLS
DL=Day Letter
NL=Night Letter
LT=International Letter Telegram

The filing time shown in the date line on domestic telegrams is LOCAL TIME at point of origin. Time of receipt is LOCAL TIME at point of destination

LA055 AA317

A ACRA285 TDN23 =LONDON 64 3 1649 VIA ITT =
LT =ANDREW OLDHAM FESTIVAL OFFICE
=8428 SUNSET BOULEVARD LOSANGELESCALIF === 1967 MAY 3 AM II 3

WHO ACCEPT PERFORM EVENING JUNE 17TH OR 18TH MONTEREY =
INTERNATIONAL POP FESTIVAL WITHOUT FEE FOR CHARITY SUBJEC
TO =FESTIVAL COMMITTEE PAYING 6 FIRST CLASS RETURN AIR
FARES PLUS =ALL INTERNAL TRANSPORT ACCOMMODATION AND
LIVING EXPENSES PLUS =WAGES LOCAL ROAD MANAGER STOP
AIR TICKETS TO ARRIVE UK =BY JUNE FIRST REGARDS =
KIT LAMBERT AND THE WHO ===

NO. TO
BY 656-1466

COL 8428 17TH 18TH 6 =KIT LAMBERT AND THE WHO

NEWS FROM

MONTEREY INTERNATIONAL POP FESTIVAL

8428 SUNSET BLVD. / LOS ANGELES / (213) 656-1440
A NON-PROFIT ORGANIZATION

The Monterey International Festival of Pop Music -- run as a non-profit organization by a top pop Board of Governors including a Beach Boy, a Beatle, a Byrd, a Miracle, a Papa, a Stone -- announces that the three day event in June will feature the following performers:

The Association / The Beach Boys / The Mike Bloomfield Thing / The Blues Project / The Buffalo Springfield / Paul Butterfield Blues Band / The Byrds / Canned Heat / Jimi Hendrix Experience / Impressions / Jefferson Airplane / The Mamas & Papas / Hugh Masekela / Steve Miller Blues Band / Moby Grape / Laura Nyro / Lou Rawls / Johnny Rivers / Ravi Shankar / Simon and Garfunkel / Dionne Warwick / The Who / and others to be booked.

All talent appearing in the Festival have agreed to perform without fee. The Festival opens at the Monterey State Fairgrounds, California, with an evening concert on Friday, June 16. Afternoon and evening shows on Saturday the 17th and an afternoon and evening show on Sunday the 18th.

The five concerts are expected to attract a vast audience during the weekend and there is no doubt that the talent will comprise the most impressive array of performers in the history of popular music.

For Immediate Release!

NEWS FROM

8428 SUNSET BLVD. / LOS ANGELES / (213) 656-1440
A NON-PROFIT ORGANIZATION

The Following Artists Will Perform:

FRIDAY NIGHT/JUNE 16/9:00 P. M.

The Association
Buffalo Springfield
Grateful Dead
Jimi Hendrix Experience

Laura Nyro
Lou Rawls
Simon and Garfunkel

SATURDAY AFTERNOON/JUNE 17/1:30 P. M.

Big Brother & The Holding Company
The Mike Bloomfield Thing
Paul Butterfield Blues Band
Canned Heat
Country Joe and The Fish

Hugh Masekela
Steve Miller Blues Band
Quicksilver Messenger Service
...and many surprises...

SATURDAY NIGHT/JUNE 17/8:15 P. M.

The Beach Boys
Booker T & The MG's
The Byrds
Jefferson Airplane

Hugh Masekela
Moby Grape
Otis Redding

SUNDAY AFTERNOON/JUNE 18/1:30 P. M.

Ravi Shankar

SUNDAY NIGHT/JUNE 18/7:15 P. M.

The Blues Project
The Impressions
The Mamas and The Papas

Johnny Rivers
Dionne Warwick
The Who

Other Names Will Be Added.

May 22, 1967

For Immediate Release!

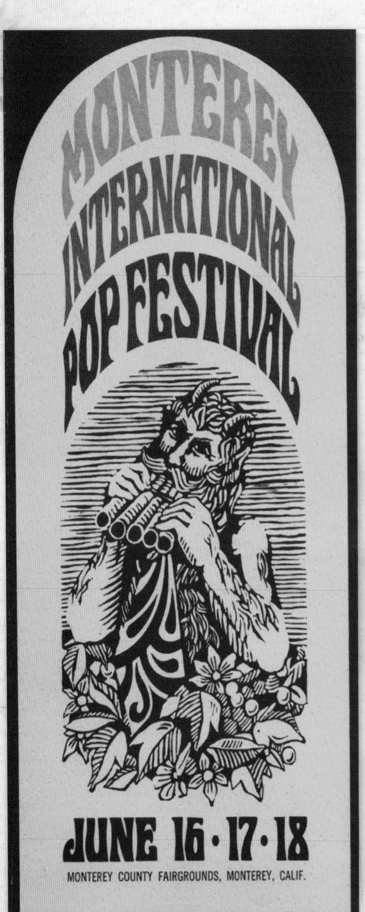

MONTEREY INTERNATIONAL POP FESTIVAL

JUNE 16·17·18

MONTEREY COUNTY FAIRGROUNDS, MONTEREY, CALIF.

MONTEREY I

THE FOLLOWING ARTISTS WILL PERFORM...

FRIDAY NIGHT / JUNE 16 / 9:00 P.M.

The Association
Buffalo Springfield
Grateful Dead
Jimi Hendrix Experience
Laura Nyro
Lou Rawls
Simon and Garfunkel

SATURDAY AFTERNOON / JUNE 17 / 1:30 P.M.

Big Brother & The Holding Company
The Mike Bloomfield Thing
Paul Butterfield Blues Band
Canned Heat
Country Joe & The Fish
Hugh Masekela
Steve Miller Blues Band
Quicksilver Messenger Service
...and many surprises...

SATURDAY NIGHT / JUNE 17 / 8:15 P.M.

The Beach Boys
Booker T & the MG's
The Byrds
Jefferson Airplane
Hugh Masekela
Moby Grape
Otis Redding

SUNDAY AFTERNOON / JUNE 18 / 1:30 P.M.

Ravi Shankar

SUNDAY NIGHT / JUNE 18 / 7:15 P.M.

The Blues Project
The Impressions
The Mamas and the Papas
Johnny Rivers
Dionne Warwick
The Who

(Program Subject to Change Without Notice)

Event material

ERNATIONAL POP FESTIVAL

a few words for those planning to attend

Be happy, be free; wear flowers, bring bells—have a festival.

1. HOUSING—No problem. For ten years, whatever the festival, substantial housing has easily been provided for every guest.

More than 3000 hotel and motel units are available in the Monterey-Carmel-Pacific Grove-Seaside area. In addition, there are several hundred accommodations within fifteen miles of the Festival grounds.

For accommodation reservations and information, write now to Monterey Peninsula Chamber of Commerce, Box 189, Monterey, California: (408) 375-2252.

2. CLOTHES—Be your own boss. Come as you please, wear what you like. Dress as wild as you choose. But remember that it's sometimes cool in the evenings. Maybe you should bring a blanket and sunglasses.

3. SEATING—A matchless hi-fi sound system means that everyone in the new 7000-seat main arena can hear equally well. The sound also carries well beyond the arena into the strolling areas.

4. TRANSPORTATION—The Monterey County Fairgrounds are only a mile from downtown Monterey—a ride of less than a quarter-hour; as little as five minutes when traffic is light. The fairgrounds are also situated five minutes from airline, bus and train depots.

5. EVERYONE'S FESTIVAL—Bring the family. This is a festival for all. Everyone. Children of all ages and adults of all attitudes—everyone is welcome at the Monterey International Pop Festival.

6. EXTRAS—There are 24 acres of cheerful lawns studded with hundreds of oak trees and family picnicking is encouraged. A tremendous variety of food and drink will be available at very reasonable prices.

In addition to the five main concerts, there will be a number of exhibits, booths, workshops to appeal to every member of the family—including a children's playground.

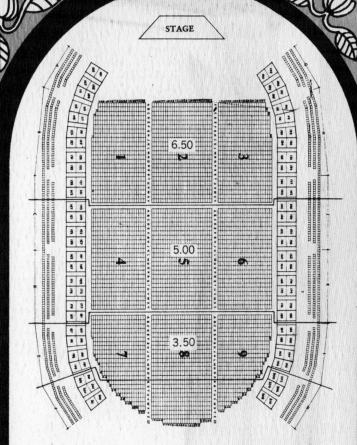

❀ prices ❀

	Eve.	Mat.
Orchestra Sections 1-2-3 Side Boxes 101-143 & 100-142 Bleachers A-B-C-G-H-J	6.50	5.00
Orchestra Sections 4-5-6 Bleachers C-D-J-K—Side Boxes 145-183 & 144-182	5.00	4.00
Orchestra Sections 7-8-9 Rows A-P Bleachers E & L—Side Boxes 185-199 & 184-198	3.50	3.00
Orchestra Sections 7-8-9 Rows R-ZZ Bleachers F & M—Side Boxes 200-210 & 201-211	3.50	3.00

Check or money order must be enclosed with order; also a self-addressed, stamped envelope.

Event material

Monterey International Pop Festival

FAIRGROUNDS FACILITIES.

Fairgrounds Rd.

Highway 68.

Main Gate.

Parking.

Second Gate.

Gate To Arena.

Main Arena.

Legend.

1. Closed Circuit T.V.
2. Giant Buddha & Grassy Picnic Area.
3. Moog Synthesizer.
4. Amp & Gretta Manufactures.
5. Photo & Painting Gallery. Flower Booths.
6. Projection Room Lou Whitney Pres.
7. First Aid.
8. Impromptu Stage for Original Jams & Variety Acts.
9. Childrens Playground & Baby sitters
10. Food Area.
11. Festival Administration Offices.
12. Craftsman Booths.
13. Press.
14. Eating Patio Organic & Exotic Foods.
15. Seminar Buildings.

Chapter 1

MONTEREY GETS READY FOR ITS CLOSE-UP

Among the many "firsts" attributed to the Monterey Pop Festival was the quality of its stage production. Sound reinforcement, lighting, and backline were all conceived and executed by a team of engineers, technicians, and musicians collaborating in an unprecedented fashion. Audio innovator Abe Jacobs built a stentorian PA (David Crosby at sound check: "Finally, a *great* sound system"); Chip Monck, the "voice" of Woodstock, coordinated the lights; and the legendary Wally Heider manned the recording console. Their accomplishments set the standard for all subsequent rock music festivals and mega-tours. From the Isle of Wight to Coachella, from the Rolling Stones' *Exile '72* tour through U2's *Zooropa*, it all began here.

The venue at the Monterey Fairgrounds

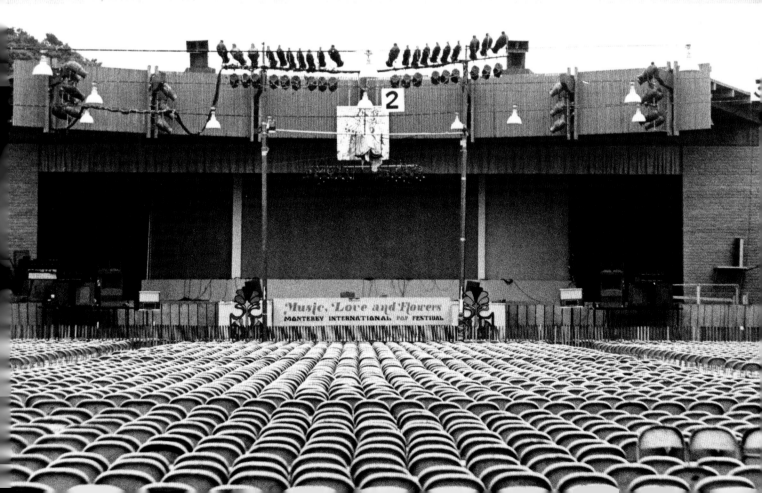

LOU ADLER: What we set out to do was the best possible concert ever, not only for the audiences, but for the musicians. I'd been in the music business since 1957 and had worked with every kind of hall manager. I was all too familiar with how acts were treated: the dressing rooms were toilets, there wasn't a restaurant open by the time the show was over. The accommodations were, "Oh, I'm sorry, the guy forgot to make them," and all the rest.

So our idea for Monterey was to provide the best of everything—first-class sound equipment, sleeping and eating accommodations, transportation—services that had never been provided for the artist before Monterey.

After that weekend, artists would demand and get preferential treatment. That's one of the side benefits of Monterey Pop—it taught the acts what it meant to perform under the right conditions and how to demand the right conditions in the first place. It was the first time any of this was done this way. But we started from scratch and worked by instinct. When we moved onto the Monterey Fairgrounds nothing was there, not even a proper stage. Everything had to be built on site. We set up a camp, established a communications center, and assigned a crew equipped with walkie-talkies to canvass the entire fairgrounds. We brought in Chip Monck as stage manager, and he brought in a construction crew. He was amazing. He'd say, "I can't do this unless . . . " and then he'd create whatever was needed. He built a stadium within a bullring.

The transportation crew we organized included not only cars and drivers for all the acts, but scooters, motorcycles, bicycles—whatever it took to get around. We had clean-up crews and an arts committee to oversee the crafts and food booths and displays.

We set up an on-site aid clinic, the first of its kind, because we knew there would be a need for medical supervision, that we would encounter drug-related problems. We didn't want people who got themselves into trouble and needed medical attention to go untreated. Nor did we want their problems to ruin or in any way disturb other people or disrupt the music. If someone got into trouble they were taken care of as quickly as possible by a volunteer first-aid team, led by Dr. Bowersocks of Monterey.

We established our own security, super-

Peter Pilafian

vised by David Wheeler. With Wheeler as the liaison, our security worked with the Monterey police. They never expected the spirit of "music, love, and flowers" to take over to the point where they'd allow themselves to be festooned with flowers.

PETER PILAFIAN (Event Coordinator): I had the assignment of interviewing all the would-be vendors and determining how to set up the fairgrounds, booths, decorations, and so on. I was dealing with a constant stream of sort of hippie-entrepreneurs, who all wanted booths at the festival. I wanted to create a nice atmosphere.

AL KOOPER: I had a great idea for introducing the artists. It came from the Randall's Island Jazz Festival in 1960, which was also one of the most memorable nights of my life. Everybody that I liked was on the bill and I had to go see this. The MCs of the concert were Lambert, Hendricks, and Ross. They were set up on the side of the stage and they would introduce every act with the Ike Issacs Trio backing them up. The headliner of the show was John Coltrane. So all these great people played: Cannonball Adderly, Horace Silver, Maynard Ferguson, Art Blakey. Orgasm after orgasm. They were on the side of the stage and doing singing introductions. "John Coltrane . . . " and on the same note they were holding, Coltrane started playing on the soprano. Spotlights from the ceiling came down on him. People went fuckin' crazy. I thought that was the greatest intro I ever saw. For Monterey I suggested this could be something to do. But it got knocked down.

CHIP MONCK (Stage Manager): Alan Pariser steered me to Monterey. I had a lot of fun at his house and it basically wasn't all surrounding drugs. The reason I have a Sears trash compactor is because he had one. Alan said to me, "I'm doing this festival." "Can I do it, please?" "Sure." Then it began.

Derek Taylor was fantastic. He had a fuckin' lever and a fulcrum and could get fuckin' anything done. I was sitting there with Al Kooper and David Anderle came in—he was involved in transportation—and we devised a wagon system with a white clothesline that would tie down all of the gifts from Fender. Everything was gifted. And then the fuckin' Grateful Dead ran off with the backline.

I was there three weeks before the festival just to get a feel for the arena. I was frightened because this was the big time and I was always on the lookout for an idea. There are four things I can bring to a show: color, angle, intensity, and timing between the designer and operator. I was pushed to the limit at Monterey . . . or maybe I pushed myself.

Pennebaker . . . I had no meeting with him before the festival. No "what stock are you gonna use?" They didn't have the cameras then that could shoot in the fuckin' dark. We were in the formation of an industry. It was tough. I had two lighting guys with me and a guy from Samuelson lighting company. And we were rebuilding their stuff and [froze] their rental department. "You may not rent anything. All of it is mine. Give back all the rentals that you have that are not being used for a week. Pull them all back. Somebody will pay those people

for the loss of those instruments for that week."

I was dosed with acid by Owsley [Stanley]. You see Simon and Garfunkel in red light onstage. It was the only color that registered in my head. And then Pennebaker had to color correct it later for the film. I'm sure he was just standing there at the event with his fuckin' mouth open. "What the fuck is going on?"

With some of the acts at Monterey—Jefferson Airplane, Otis Redding—there was a light show onstage. It was very difficult because [lighting designer] Josh White and I had never gotten along. That background should have been mine. The light show should not have been turned off. Not at that time and not in that culture. The Fillmore was filled with it and it had to be there. And therefore the only thing I could do was backlight the shit out of the performers.

Monterey was underlit. But I also had headlights to deal with and we didn't have a ground cloth. It should have been black. It shouldn't have been wood that had once upon a time been polished because I was getting a bounce on the screen. The first thing I should have done is buy from Rose Fabrics in New York an inordinate amount of black canvas. And whether it was stapled or sewn and tucked correctly, it should have been a black cloth.

The most important thing is that the music worked—never lose sight of that. I don't get caught up in the other things. "Hey, this looks good. This looks interesting. This is gonna be tough. This is gonna be easy. Let's get on with it. Come on, Al." It's just another step up from Newport.

Left to right: Chris Hillman (*far left*), Peter Tork, and Chip Monck

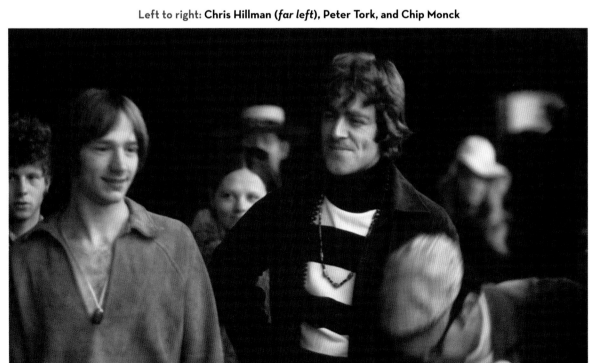

Candice Bergen

TOM O'NEAL (Photographer): I was a photographer in Monterey when I discovered that Terry Melcher, a guy I went to grade school with, was on the concert's board of directors. Amazing! And that they were coming to town in advance of the concerts. You know, maybe Terry could introduce me to Lou. "I'd like to take some pictures and get a photo pass." Everything was very loose. The paper even said what time they were gonna be there. I stood out in front. I would never do this today. A limo pulled up but there was no Terry. I think Johnny Rivers, John and Michelle, and Lou. "Hey Lou. Take a look at this." It was a photo of the Mamas and the Papas with a neat effect I had done to it. "That's kind of cool." "You can have it if you'd like." "Come on in." So, I was in the room with the police chief and the mayor. I was standing next to Michelle—God, was she gorgeous. I was a fly on the wall. I said to Lou, "I'd love to get some shots at Monterey." "Go see Derek Taylor and tell him I want you to have a pass." I made a beeline and met Derek in person, who was already on site. And he got me in. Derek was very gracious to me.

I had never been in a situation before with dozens of photographers in the photo pit. At the Fillmore, where I'd seen the Airplane and the Dead, Bill Graham wouldn't let me. Believe me, I tried. I didn't know how to do it or know about lighting. The stage was seven feet high—too high, when you were up against it. I just stuck my camera up in the air and prayed.

I did run into Terry Melcher. He had on this big black overcoat with a high collar. He looked awesome escorting Candice Bergen, her hair pulled back in a ponytail. "Tom!" she exclaimed. I knew Candy from the fourth grade.

BONES HOWE (Producer/Engineer): I got a phone call from Lou and John Phillips from the production office and they asked me to come over for a meeting. They wanted to discuss the Monterey Pop Festival. I had heard about it through the grapevine. I had been in the office before, when it was the Renaissance Club. I came to town in 1956, and by '57 I was mixing jazz records. I did a lot of stuff for Dick Bock at Pacific Jazz.

I went over and sat down and Louie said to me, "Here's what I want you to do. I'm gonna hire the Association to come up and be the opening act." I gave him them Pat Collecio's number, who managed them. "And the Mamas and Papas will close the show. What I want you to do is do the sound for the Association and the sound for the Mamas and Papas because you know how they are supposed to sound. The rest of the festival, you are on your own." I asked for a place to stay. Lou put my wife Melanie in a honeymoon suite at a dumpy motel and the bed was shaped like a heart [laughs].

Musically it was amazing and so many different things happened. And the thing I got from the festival was "Wedding Bell Blues." I heard Laura Nyro's record on KHJ and then saw her sing live. I got to meet her and talk to her a little bit. After "Stoned Soul Picnic," it was easy. I hooked her up with the Fifth Dimension and the hits just rained like Hershey's Kisses.

BILL HALVERSON (Recording Engineer): Wally Heider asked me to come to the Monterey Pop Festival as sort of his second engineer. The year before, we had done the Otis Redding *In Person at the Whisky A Go Go* album. I had been a horn player and he let me mix the horns through an Ampex mixer. We also set up the stuff for the Beatles at the Hollywood Bowl in 1965. The Capitol

Bones Howe

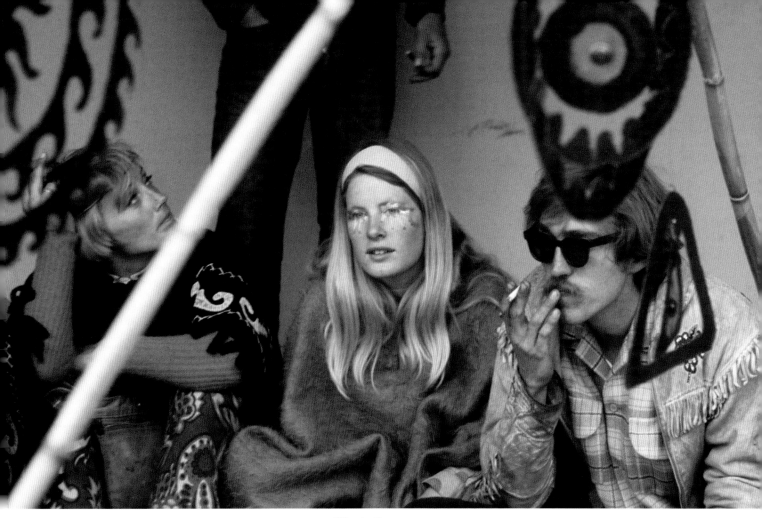

"Hippies"

engineers came in and got in the truck but we set it up. We brought the truck in. I had been around some noise.

Lou and John talked to Wally about Monterey and said it was a nonprofit thing and no one was going to make any money. And Wally did it for expenses. And, Wally was really on a shoestring those first couple of years, and what happened was when Cream's *Wheels of Fire* went through the roof, then we were up there to San Francisco every other weekend for everybody from [Janis]

Bill Halverson

Joplin to Jefferson Airplane. And then we started to charge and he made some money.

At Monterey, we weren't in the recording truck but down these stairs in a basement type thing. When Wally saw Keith Moon destroy his drums . . . He pushed me up to the stage to protect his Shure microphones, even though they were cheap.

Part of what helped preserve Monterey and helped the guys who got the tapes later was that Wally always used Scotch tape. He could not stand Ampex tape. For him it was only Scotch tape at 15 ips through a Frank De Medeo-designed, Bill Putnam-built Universal Audio 4-track, 12-position tube console.

At Monterey there were no proper sound checks. We were guessing. You sort of have an idea where they're gonna be and you zero it in the first couple of minutes of the first tune. Wally taught me not to make any radical moves, 'cause when you are mixing it you have to "unradical" the exact same spot. Which is impossible. So you just ride herd on it unless something breaks—and then you sit and fix it.

CHARLIE O'DONNELL (KRLA DJ): The Who and "Happy Jack." Don't forget on Sunday night the Who, along with Johnny Rivers and Dionne Warwick and the Mamas and the Papas, will appear at the Monterey Pop Festival. KRLA will have reports from the scene . . . It's three minutes past 8:00 in the morning on the *Charlie O Show*. Now, Procol Harum with "A Whiter Shade of Pale."

RICHARD BEEBE (News Reporter): *KRLA News* brought to you by Pennzoil. The UN General Assembly called into special session to deal with Middle East crisis by U Thant . . . setback for hippie love-in . . . 8:15, 61 degrees heading for a high of 75 in Los Angeles . . . now traffic conditions . . .

That Grand Canyon hippie love-in is all washed up. For one thing, sponsors were afraid about what might happen if border guards in Arizona found the usual supply of dope that follows such a crowd, not to mention peyote plants. And besides, there's no food or water facilities within 80 miles of the proposed place. Meanwhile, L.A. County supervisors are worried that the Diggers' free food service at Ferndell [Park] will attract Frisco hippies that are, in the words of Supervisor Debs, "Outrageous." Richard Beebe, *KRLA News*. Now it's time for Scott McKenzie and "San Francisco" on the *Charlie O Show* . . .

CHARLIE O'DONNELL: This weekend is the biggest in pop music history. It's the Monterey International Pop Festival. KRLA is there: DJs Reb Foster, Dick Moreland, Bill Slater; newsmen Jim Steck, John Land, and Bill Wood; and special radio triage observers Phil Proctor and John Carpenter. Stay

Verbatim transcriptions from KRLA's June 16th broadcast

tuned to KRLA for complete coverage of the Monterey International Pop Festival. Listen as KRLA's festival weekend salutes the Monterey Festival with the Buffalo Springfield and "Bluebird" . . .

[After playing "Windy" by the Association] Appearing live tonight at the Monterey Pop Festival is the Association. KRLA will be on hand to report all the action all weekend long . . . It's 27 minutes before 9:00 in the morning on the *Charlie O Show*. Weather forecast for Monterey, in case you're headed that way: overcast skies with a high of 70 . . . Revised the forecast for Monterey if you're going to the Pop Festival—overcast skies with a high of 58. Now it's time to "Light My Fire"—the Doors on KRLA . . . big time!

JIM STECK (News Reporter): United Nations General Assembly emergency session is called. Soviet Premier Alexei Kosygin and Charles De Gaulle talk things over in Paris . . . 12:15 PM and 64 degrees, headed for a high of 75 in Los Angeles . . . Victorville: actor John Drew Barrymore has been placed on three years probation on a narcotics conviction. He was in possession of equipment used for smoking marijuana—cigarette papers . . . Monterey, California: thousands of persons are on their way to the International Pop Festival, which gets underway today. Estimates on how many people will flock to the three-day affair range from 200,000 down to 50,000. Visitors can expect fog, overcast through Saturday, clearing in the afternoons. The highs both days will be between 55 and 65 and a low tonight of 50. Be sure to wear warm clothing . . . Currently it's 64 in Los Angeles. Jim Steck, *KRLA News*.

ALEX DEL ZOPPO (Sweetwater): Most of our band and another carload of friends (stoners all) drove up there in two ratty cars, my Falcon Sedan Delivery and my bud Carlo's old Ford. We got to Monterey the night before, and found a spot near the fairgrounds where there were all sorts of cool hippies wandering around, befriending one another. After hanging with strangers for a while,

and not being well prepared for this trip at all, we just slept in and under our cars. The next morning, we washed up in a nearby stream, where Albert drank some of the cold water and said, "Man—that is some *sweet water*." We didn't know it then, but the name of our band was born.

We found our way onto the fairgrounds and wandered among the colorful crowds of

Alex Del Zoppo

young folk. It was like we had arrived at the big rock candy mountain, or maybe Oz itself. We had never seen this many beautiful hippies in one place, and it truly felt like home—everyone was in such a peaceful headspace that we all felt we were among old friends.

Although we didn't get into the arena where the acts performed, we could hear them fairly well while walking around the perimeter, looking at trippy clothing booths and at all the other peaceful people doing the same, radiating harmonious bliss upon one another.

CHRIS MANCINI (Audience Member): I read about the festival in the *Hollywood Reporter* and phoned my dad's secretary, who called Lou Adler, and I got tickets. My dad [composer/arranger Henry Mancini] dug rock 'n' roll. I took him to see Cream at the Whisky A Go Go. He wasn't going to tell me not to go to a rock festival with my best friend. I wore a Nehru jacket with sunglasses. We got a hotel room with two beds and then another dozen other people crashed in our room beginning the first night. Owsley Stanley and Jefferson Airplane were staying at our hotel.

PEGGY LIPTON (Audience Member): I was 21 and went up to Monterey with my best friend, Allan Warnick. Allan and I stopped at a motel and Stephen Stills and David Crosby were rehearsing in one of the rooms. I loved Buffalo Springfield—I used to see them at the Whisky—and I loved the Byrds, who I saw at Ciro's. I even dated their drummer, Michael Clarke. I adored him. One of the reasons I went was because the Byrds were there.

We would take uppers and make love beads for three days. I remember walking on the fairgrounds, seeing all the booths, and realizing that everybody around me had probably taken acid. I do remember feeling that until I got high enough and relaxed enough, I felt very uncomfortable in my body. Either you were high on pot or you had dropped acid or mushrooms. We might have been a little paranoid, but we were all on the same spaceship. And that's what I think made it different. You know what I mean? [Laughs.]

PAUL BODY (Audience Member): There was something in the air; I could feel it. The world was changing—AM radio was slowly giving way to FM. We had heard about the Monterey Festival on the jungle drum [rumor]. I had a job at the *Los Angeles Times* selling subscriptions. I couldn't get the time off, so I quit. It wasn't the last time I did something crazy like that. Remember, it was the "Summer of Love" and we thought we could do anything. So we drove up there in a Chevy Impala with Marsha Smith at the wheel, Judy Gooler riding shotgun and me in the back—I mean, I think that's how we rolled. We had no tickets, but we had enough money to see either Jimi or the Who. Luckily for us they ended up playing on the same night. Once we got there, we scored a parking place on one of the main streets. That's where we slept for the next few nights. We ate in the car, too. I am pretty sure we cleaned up in a nearby gas station bathroom. I remember all the townspeople being very friendly, no bad vibes at all. And that every time we looked around we'd see a psychedelic-painted Mini Cooper and imagined that John Lennon was inside.

Peggy Lipton

Just Like Tom Joad's Blues

It's no surprise that when the Monterey History and Maritime Museum opened a special exhibit on Monterey Pop in 2001, many of the volunteer docents were incensed. The docents were usually either retired military or longtime locals—or both—and they were taken aback by the celebration of what they considered a black spot on local history. In protest, several threatened to quit their post, and a few even went so far as to say that if the director did not take the exhibit down, they would do it themselves.

The 1967 Monterey International Pop Festival, herald of the new zeitgeist, was squeezed into a sleepy, tight-knit community whose fortunes relied on blue-collar fishing families and a historic military presence. This was not an ideal match. Already, the God-fearing people of Monterey were opposed to the expository "antics" of John Steinbeck during the Depression and war years. They were, at least, puzzled by his Pulitzer Prize-winning fame and, at most, vociferously opposed to it, going so far as to hold a book burning of *The Grapes of Wrath* right in front of the library in his hometown of Salinas in 1939.

Descending like locusts onto this quiet seaside town were the most feared and hated of outsiders: hippies. Who were these long-haired weirdos? Certainly not hard-working, stand-up citizens. Definitely not clean-cut, patriotic soldiers. These hippies agitated against the war, didn't work, played music, and did drugs. No wonder they were reviled. Perhaps more disturbing, they presaged an inevitable future path for a town that had thrived in the Depression, but had since collapsed under the weight of its own success, when the famous sardines were fished nearly out of existence.

In June 1967, young idealists camped in parks and green spaces all over town for the Pop Fest, and many didn't bother to strike their tents after the momentous "happening." Who could

Monterey Bay

resist the spellbinding coast, from Santa Cruz to Big Sur, with a laid-back ocean village in the middle? Jack Kerouac, Henry Miller, and Hunter S. Thompson had already woven the siren call to the Central Coast. Abandoned canneries and sagging Victorian houses became communes, and coffee houses and vegetarian cafés sprouted up in between.

In 1967, Monterey struggled quietly. Throughout the 1970s it became an extension of the cultural breakdown that had taken root in San Francisco: adult theaters, seedy bars, Black Panthers, anti-war demonstrations, and escalating sex, drugs, violence, and mayhem outside the gates of Fort Ord. The pages of the *Monterey Herald* teemed with daily stories of assault in Seaside, often victimizing Fort Ord recruits en route to Vietnam. Counterculture came to define Monterey, and locals were angered. Tourism was one thing, but this was an outright coup.

What began as a hippie takeover played out over time as the same old ritual of gentrification. By the 1980s, the world calmed down again. Investors bought up the old canneries and Victorians. Hippies grew up and became homeowners. In the end, Monterey solidified as that charming tourist town people come to visit, but can't afford to live in.

Ironically, the rise of the counterculture was just another cycle of Monterey as an artist colony. Bohemians first infiltrated in the late 1800s. These included painters, poets, actors, and writers like Robert Louis Stevenson, Jack London, and Robinson Jeffers. Carmel was built by artists. The seeds of the Monterey Jazz Fest were sown in the 1930s at Doc Ricketts' famous Cannery Row "brawls." In 2001, the docents that were Monterey's salt of the earth (and sea) found themselves facing the same battle their predecessors had. Monterey has always attracted dreamers and poets. Perhaps it was the *place* that made Monterey Pop *happen*.

—MARISA MERCADO, Monterey History and Art Association Collections Curator

The Diggers were on hand to provide food for all.

53

Sitting on Top of Mount Tam

The "Summer of Love" has many embarkation points: the be-ins, the love-ins, George Harrison's stroll through Golden Gate Park, Matthew Fisher's ethereal organ introduction to "A Whiter Shade of Pale." Another contender, long subsumed by its proximity to the Monterey Pop Festival, was the little-known but

significantly memorable KFRC Fantasy Fair and Magic Mountain Music Festival, otherwise known as "Mount Tam." This two-day affair, held at the Sidney B. Cushing Memorial Amphitheater on Mount Tamalpais in Mill Valley (about an hour and change north of Monterey), served as a tasty appetizer for the Monterey festival held exactly one week later.

Presented by San Francisco's powerful Top 40 station, KFRC, the festival was originally scheduled for the weekend of June 3–4, but inclement weather led to its postponement. The organizers booked a veritable goulash of pop, soul, and psychedelia: the Fifth Dimension, the Doors, the Seeds, Tim Buckley, Kaleidoscope, P. F. Sloan, and the 13th Floor Elevators. Dozens more took to the outdoor stage before an enthusiastic audience of 15,000 over the course of the two days. With each ticket costing just two dollars and transportation to the remote location provided by "Trans-Love Bus Lines," Mount Tam was, arguably, the first rock festival. And like its big brother Monterey, it was a charitable undertaking; all proceeds went to the Hunters Point Child Care Center, and all the musicians donated their time and fees. The festival program included the following copy:

" . . . A gathering of beautiful things created and collected by the artisans and craftsmen of northern California . . . a variety of 'happenings.' When you arrive at the Fantasy Fair, you will be

The Trans-Love Bus Lines

immediately surrounded by color and motion, the good vibrations of thousands of people flowing with the natural beauty of Mount Tamalpais. The major happening is you . . ."

In recognition of Buckminster Fuller, a "Geodesic Dome Light Chamber" was constructed, along with a giant slide and tree swings. Under a brilliant blue sky, the flower children gamboled about like monarch butterflies, flitting from bloom to bloom.

TOM ROUNDS (KFRC Program Director): Mount Tam leads to the Monterey Festival and that came through Mama Cass. We were all friends. Renais and Cyrus Faryar, who played at Mount Tam and Monterey, were in L.A. and were buddies with Cass. So Cass told John Phillips about Mt. Tam. And John and Lou Adler were the prime movers and shakers of Monterey. So that's how Adler and Phillips got to me. I do remember getting together with Lou at Monterey. We promoted the Monterey Pop Festival. It was not a station promotion. We were involved in some way—maybe public service announcements.

MEL LAWRENCE (KFRC Radio): My job, because I had experience in producing concerts in Hawaii, was to oversee all the operation of the Magic Mountain Mount Tamalpais Festival. Tom and I selected the venue because it had a wonderful amphitheater. And we wanted to do an outdoor festival, do it over several days and include a lot of groups, and make it very eclectic in some ways and very mainstream in some ways. Just meld it all together. And make it a benefit, so the station could do something good and get some promotion.

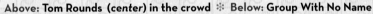

Above: Tom Rounds *(center)* in the crowd ❊ Below: Group With No Name

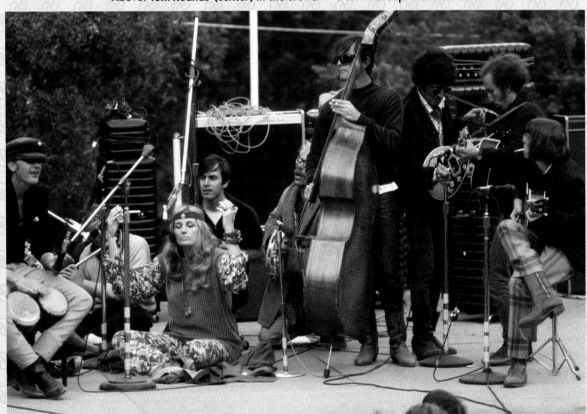

Above: **The Fifth Dimension** ❖ Below: **"Easy Riders"**

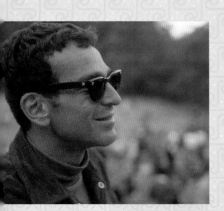

Mel Lawrence

Lou Adler and John Phillips came up to the Mount Tamalpais Festival site and wanted to know a lot of questions on how we put things together, how we handled traffic, how we did the staging. It was just before the Mount Tam Festival. And Tom Rounds and I met with them. "Well," they said, "we're gon-na start doing this. Can we count on you to help out after your festival?" "Sure." And, basically, what I did was that I took my crew from Mount Tam and brought it up there to Monterey to build the outside facilities—the campgrounds, the fences, all the shitty stuff. I had been to the Monterey Jazz Festival and knew the fairgrounds and logistics.

Mount Tam and Monterey set the tone and gave people the opportunity to know what they were going to experience. When we did the Magic Mountain music festival, nobody had heard

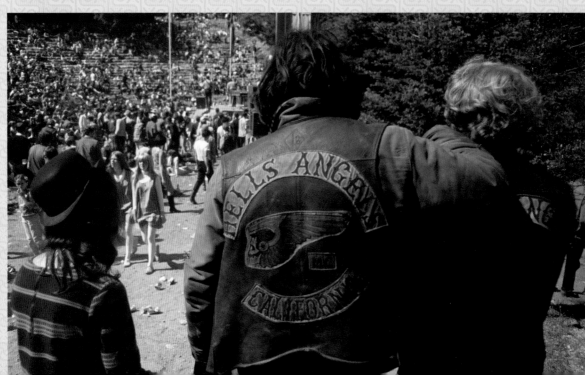

of this before. We were like the Wright brothers, for Christ sakes. Notice in photos the way they dressed. It was formal in a lot of ways, like going to a recital. A week or 10 days later, Monterey came and loosened things up, really showing some professionalism in its staging. For example, Chip Monck piping in music between groups, which calmed the audience. "It's okay for us to get together. This is very cool. Even though there are certain things going on all over the place, we're dealing with it." And then the Miami Pop Festival [in 1968] came along and brought the concept of having two stages with activities between them—that sort of thing. By the time of Woodstock, we were able to handle it pretty good.

**Above: Tim Buckley and Carter Collins
Below: The Doors**

RAY MANZAREK: Hippies! Thousands of them. Light and love. The new generation of the "American Tribe." All races, all sexes, all colors, and the new religion. The worshipers of the *sun*. And they had come to rock! And rock we did. What an amazing June. The Doors were on the rise and "Light My Fire" was racing up the charts. It would become number one in mid-July in what has come to be known as the "Summer of Love." And this—Mount Tam—was the early preview. This was the warm-up, the pre-show in San Francisco. And, man, the colors, the neo-gypsies, the vibe, the love, the dancing, the bands, the volume, the beauty of that great golden orb in the sky made for a most remarkable weekend. We thought the *new age* had begun. We were going to change the world. We were the new Christian mystics. We were going to bring the secret truths of that heart-master from the Galilee of two thousand years ago into the twentieth century. There we were, loving each other as ourselves and knowing that a new day had dawned. The Age of Pisces had ended and the Age of Aquarius was dawning—the new age that we so violently fight the birthing of today. The new age that will merge science, religion, philosophy, and art. No disparities. No boundaries. All one. I can only hope that the young people of this early twenty-first century can find the great love and togetherness and music that brought us together in the early summer of 1967. And I wish them the experience that a generation of acid heads had in that sweet June on Mount Tam.

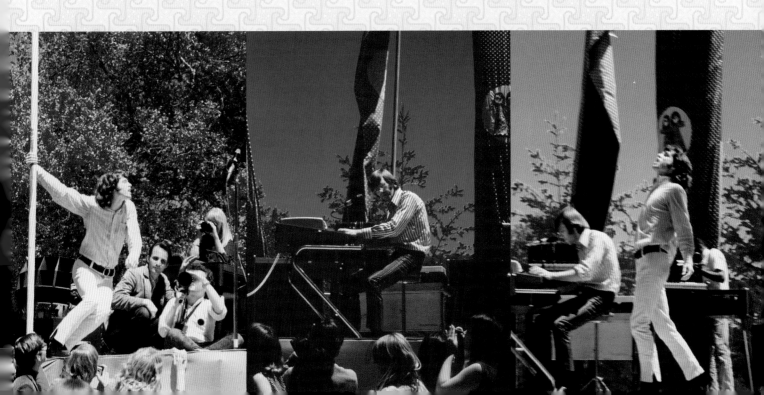

The following bands performed at both Mount Tamalpais and the Monterey International Pop Festival:

✳ **Canned Heat**
✳ **Moby Grape**
✳ **The Byrds**
✳ **Jefferson Airplane**
✳ **Group With No Name**
✳ **Hugh Masekela**
✳ **Steve Miller Blues Band**
✳ **Country Joe and the Fish**

The Byrds with Hugh Masekela (*far left*)

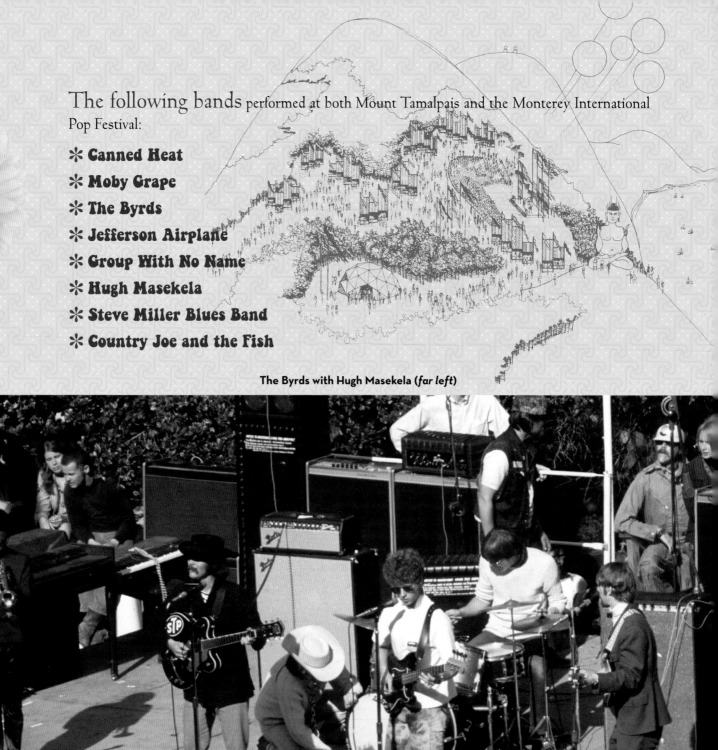

Clockwise from top left: Jack Casady and David Crosby; Hugh Masekela; Jefferson Airplane

JEFFERSON AIRPLANE

RADIO STATION KFRC
415 BUSH STREET
SAN FRANCISCO, CALIFORNIA

DEAR SIRS:

THIS WILL CONFIRM OUR PROMISE TO YOU TO APPEAR AND RENDER OUR SERVICES AS PERFORMERS AT THE "KFRC FANTASY FAIR AND MAGIC MOUNTAIN MUSIC FESTIVAL" ON JUNE _____, 1967, AT _____ O'CLOCK ____.M., AT THE MOUNTAIN THEATER, MT. TAMALPAIS STATE PARK, MARIN COUNTY, CALIFORNIA. WE UNDERSTAND THAT THE "FAIR" IS A CHARITABLE EVENT TO BENEFIT THE ECONOMIC OPPORTUNITY COUNCIL'S HUNTER'S POINT CHILD CARE CENTER PROJECT, AND THAT NO COMPENSATION WILL BE PAID TO US. WE ALSO UNDERSTAND THAT TRANSPORTATION WILL BE AVAILABLE FROM THE SAN FRANCISCO INTERNATIONAL AIRPORT TO THE FAIR AT _____ O'CLOCK ____.M. ON THE ABOVE DATE.

WE WILL PERFORM FOR AT LEAST ____80____ MINUTES AT THE FAIR. WE WILL INDEMNIFY AND HOLD YOU HARMLESS FROM ANY CLAIMS OR EXPENSES ARISING OUT OF OR IN CONNECTION WITH ACTS DONE BY US OR ANY MATERIAL FURNISHED BY US. THE LISTING OF CREDITS, PUBLICITY AND ADVERTISEMENTS, IF ANY, FOR THE FAIR SHALL BE DETERMINED BY YOU IN YOUR SOLE DISCRETION.

WE ACKNOWLEDGE THAT YOU ARE RELYING ON OUR PROMISES TO APPEAR AND PERFORM AT THE FAIR, AND THAT YOU WILL INCUR EXPENSE, MAKE COMMITMENTS, ETC., IN RELIANCE UPON OUR PROMISES.

DATED ~~APRIL~~ MAY ____4____, 1967 AT SAN FRANCISCO, CALIFORNIA.

JACK CASADY _Jack Casady_
NAME – PRINTED SIGNATURE

MARTY ~~#~~ BALIN _Marty (Hard Face) Balin_
NAME – PRINTED SIGNATURE

GRACE SLICK _Grace Slick_
NAME – PRINTED SIGNATURE

JORMA KAUKONEN _Jorma (Steadfast Panther) Kaukonen_
NAME – PRINTED SIGNATURE

SPENCER DRYDEN _Spencer Dryden_
NAME – PRINTED SIGNATURE

(KNOWN AS ~~THE~~ "____JEFFERSON AIRPLANE____")

PAUL KANTNER _happy Paul Kantner_
NAME – PRINTED SIGNATURE

TR/LS

Jefferson Airplane confirmation letter to perform at the Magic Mountain Music Festival on Mount Tamalpais

Monterey House Band

The untold story of 1960s rock is the often-uncredited role that studio musicians played in the records that were the soundtrack to the era's youth. When rock music asserted itself to become the dominant force in the '60s music marketplace, record producers realized they had a problem. While an untutored teenage band might sign a contract and be the faces on the album cover, the studio end product had to be musical, and it had to be creative. Enter the professional musician.

In the Hollywood studios, Phil Spector became a focal point for many directions and trends. As much as any other producer, the Wrecking Crew—the small group of bankable, hit-making studio hands—coalesced at Spector's pre-Beatle sessions. The collective experience of the Spector crew included horn players whose roots stretched back to the big band era, like trumpeter Ollie Mitchell and trombonist Lew McCreary; modern jazz musicians, like guitarists Barney Kessel and Herb Ellis; and all-purpose drummer Hal Blaine, who played klezmer at Jewish dances and a bump-and-grind beat for strippers. It was McCreary who coined the term "Wall of Sound" for Spector's monolithic sonic productions.

When the details of the Monterey Pop Festival were being ironed out, record producer Lou Adler knew that a house band of professionals would be needed to back headliners like Lou Rawls. He engaged arranger H. B. Barnum, Rawls' musical director, to contract a midsize band. Barnum assembled trumpeters Ollie Mitchell and Fred Hill, trombonists Lew McCreary and Lou Blackburn, saxophonists Teddy Edwards and Jim Horn, pianist Larry Knechtel, guitarist Mike Deasy, vibraphonist Gary Coleman, bassist Joe Osborn, and drummer Hal Blaine. "That's a good combination," Horn contends. "With two of each horn you get a good sound. You've got it all covered that way."

Although the band backed Rawls and the Mamas and Papas, and some of them augmented Johnny Rivers' set (for which songwriter Jimmy Webb sat in on piano), they did a fair amount of waiting around. Horn clarifies: "We didn't rehearse or anything, we were just on-call. Lou had charts, which was helpful. But most everything else we just kind of felt our way through. We were told that we'd be playing with this one or that one so we had a couple of hours to walk around and see what was happening before we had to be back onstage. We just had to be loose and ready for anything. For example, we were told with very little notice that Janis Joplin was going to want horns on a couple of songs."

The atmosphere of Monterey Pop made an impression on Horn; he recognized that a major change was underway. "Monterey made a statement. It was great to be up there, even when you were just part of the audience. It was a whole new thing. People were smoking out in the open, women walked around without their tops, children were running around naked and there was an overall feeling that everybody hated the war. It was definitely a monumental shift in the culture that we saw happen that weekend. It was the period of flower power and burning draft cards. We got the sense that there was suddenly a new way to live. There was a feeling: *Why are we fighting? Can't we all be peaceful?* It was good that it came out and it was good for the country. But it was a very short period of time and it never happened again. Look at Woodstock—that just turned into a big mess."

—KIRK SILSBEE

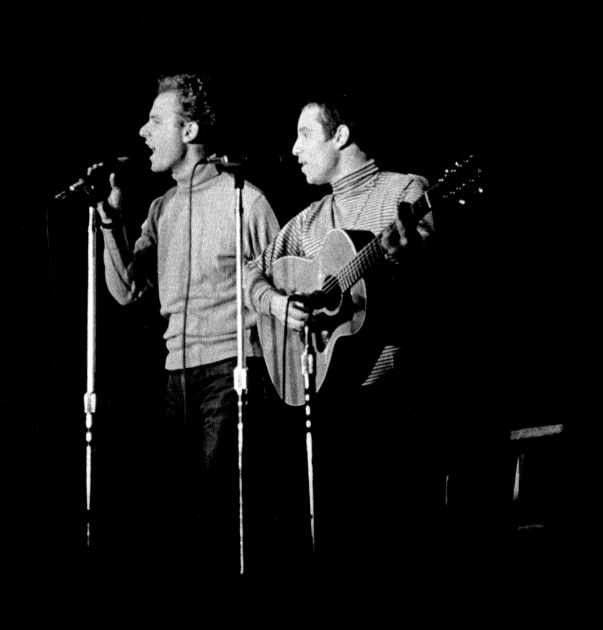

Chapter 2

FRIDAY NIGHT

A wise man once said that there are a million ways for a good idea to go wrong—and only one way for it to go right. Alan Pariser had a vision and it took him and his confederates over and beyond any rainbow they could have imagined. And now, as fans paraded through the Monterey Fairgrounds, soaking up the lysergic sights and sounds, the improbable made way for the inevitable. "Oh look, there's Dennis Hopper, and Candice Bergen, and . . . Sammy Hagar? (Yes, the head-banger-in-training crashed for a day or two and was thoroughly transformed.) Police Chief Marinello stood resolute but disarmed, his officers succumbing to the overtures of ripe young sun-maidens blowing bubbles.

As the afternoon's welcoming warmth gave way to evening's enveloping chill, it was time to hunker down, wrap yourself up in a dream (and a comforting blanket), and let the music reign.

First up: The Association. Distinguished by their tight vocal harmonies and radio-friendly melodies, this L.A. group was dismissed by the snob set as nothing more than the Four Freshman with Telecasters and mustaches, a featherweight sop to the Sunset Boulevard hit factory. But would you rather your band be the fetish of record swap meet halibuts, or have the second-most-played song ("Never My Love") in the history of friggin' radio?

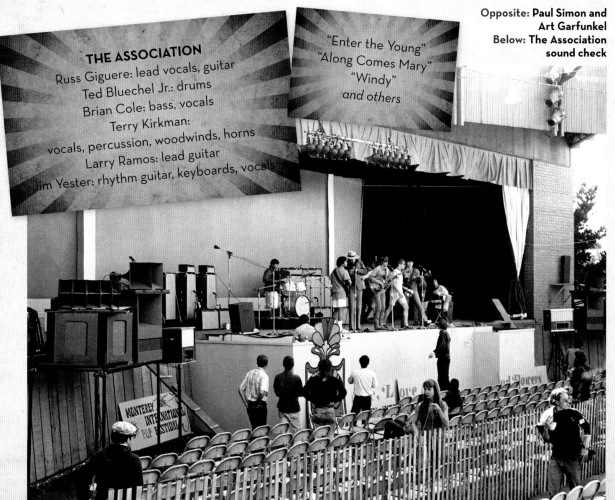

THE ASSOCIATION
Russ Giguere: lead vocals, guitar
Ted Bluechel Jr.: drums
Brian Cole: bass, vocals
Terry Kirkman:
vocals, percussion, woodwinds, horns
Larry Ramos: lead guitar
Jim Yester: rhythm guitar, keyboards, vocals

"Enter the Young"
"Along Comes Mary"
"Windy"
and others

Opposite: **Paul Simon and Art Garfunkel**
Below: **The Association sound check**

Above: Brian Cole and Jim Yester ❊ Below: Alan Pariser delivering posters

ALAN PARISER: I remember when the curtain went up on the Association. David Wheeler and I started hugging and dancing, laughing our asses off behind the stage because we couldn't believe we'd pulled it off. Lou Adler worked his ass off, too. Lou pulled a lot of strings to make it happen.

DEREK TAYLOR: It was only in that moment, when the first bars of the Association's first song on the first night came across the untried sound system—I mean, tried in the sound check—but, suddenly, *bang*! There they were, and the festival was on!

TED BLUECHEL JR: We had done festivals before, really large concerts, 20-minute sets, usually sponsored with an AM radio station. I remember I had a screaming headache driving up to Monterey from Zuma Beach, where I lived.

We got to our hotel as quickly as possible 'cause we were scheduled to open as well as do the sound check. I set up my drum set and went backstage to get dressed and I was ready for the introduction. I ran out and Hal Blaine, who was in the Monterey house band, thought my drums were the house set of drums. So he had totally disassembled my drums and moved everything around

the way he liked it. So we're in this frame of mind—"Let's hit it!" [Laughs.] And I turned to Brian Cole, the bass player. "Stall and give me a few minutes. I have to put my drums back together so I can reach them." The way we performed is that I would sit in one spot and try not to move my head around so I could be consistent on the vocal microphone. So I was basically moving my arms and we finally had seven or eight minutes to get things together. That was the first part of the Monterey Festival, and then we jumped into our show.

Jim Yester would tell you this as well, and I would swear to this, but there was always a little jealousy from Bay Area music folks. I would introduce myself: "Hi, I'm Ted. We're performing." But I felt we were being treated like second-class people by the other bands.

And this would extend a little bit from the Mamas and the Papas, too. Cass and I had talked, had our arguments. I liked hanging out with Denny, who was very nice. But there was always this little bit of jealousy of our ability to make better vocals than they could. The Mamas and the Papas had a great sound because Cass' voice was so remarkable. And John was okay. But there was always a little bit of jealousy and I could never figure out why. There's no room for it. Grow up. We were up there on the heels of a big hit record, *Windy.* I never ever tried to get snooty about it or think, "I'm really hot shit." It takes a lot of luck.

JIM YESTER: I felt the festival was a big step in healing the rift between the L.A. and San Francisco bands, and it was very cool. I certainly felt no angst from any of the San Francisco bands. I think it had been going on when we went up there in 1965, '66, with the Beach Boys at Longshoremen's Hall, and kinda got a cold shoulder. Listen, we were "heads" like everybody else and just as crazy as everybody else, but we took care of business. We stayed at the same motel as some of the bands, and right next door was Pearly. She was very down-to-earth, played with all the kids. Earlier we had performed with Quicksilver at the Fillmore West. In fact, Moby Grape's bass player at the time, Bob Mosely, was my brother-in-law. He and I both married two sisters.

Terry Kirkman

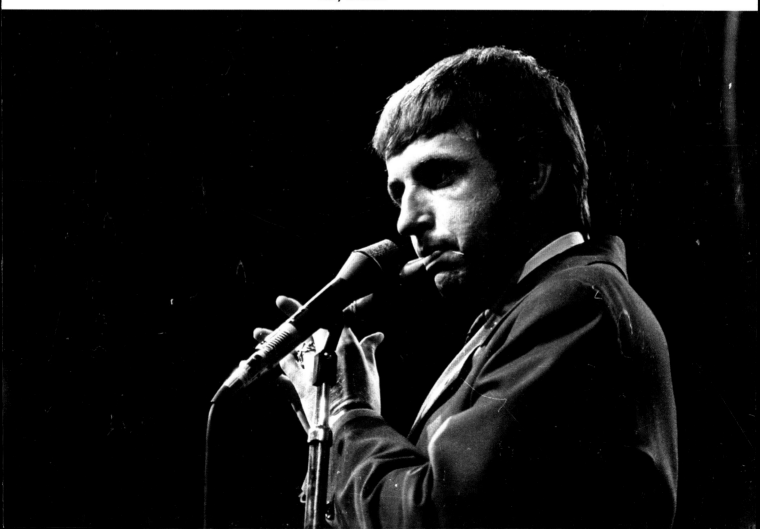

The Paupers came courtesy of manager Albert Grossman, who smelled opportunity with the acuity of a jackal. "You want Paul Butterfield and Mike Bloomfield? Fine, but you gotta take this Canadian outfit with three drum sets. Make the room!" For all his bluster, Grossman could spot talent from deep space. The Paupers were a wildly inventive unit, years ahead of what would become the "progressive" wing of the rock scene, employing effects units and a multi-percussive attack that sounded like a freight train screaming across your face. They became the darlings of New York's Café A Go Go scene, recorded two albums for MGM, and toured extensively. Sadly, they soon disappeared like so many luckless explorers of the Northwest Passage, but not before leaving a rousing footnote to the festival.

THE PAUPERS
Skip Prokop: drums
Dennis Gerrard: bass
Adam Mitchell: guitar, percussion, vocals
Chuck Beal: guitar, percussion

"Magic People"
"Think I Care"
"Tudor Impressions"
"Simple Deed"
"Let Me Be"
"Dr. Feelgood" (with bass solo)

Dennis Gerrard

ROBERT CHRISTGAU (*Esquire*): Dennis Gerrard is the most expressive bassman I've ever heard in a rock band, one of the few to explore the kind of facility the electric bass was invented to provide—and he kept going, his eyes half-closed and showing nothing but white, and after a couple of good stretches he got scattered applause. Then he appeared to finish and was cheered enthusiastically. But Gerrard wasn't through yet. He turned to the amplifier, doubling the chord so he got shuddering interference on every note, and played some more, not so well this time, but very intensely, perhaps even hoking it up consciously, and now, although the whole solo was turning into an exhibition, the place really broke up, unable to withstand the impulsion of its own excitement.

SKIP PROKOP: When we were informed by Albert that we were going to be playing the Monterey Pop Festival, all you had to do was start thinking about all the names that were going to be there. We were incredibly excited and knew that this was going to be the big time—the first of its kind. We had played shows as the opening act but nothing remotely like Monterey.

It was our first visit to the West Coast. I definitely remember hanging out backstage. I met John Phillips and Michelle. He told me, "We're really looking forward to hearing you. Because you're going to be the next big thing." The funny thing

was, I met Brian Jones, who came in with this long coat. He walked up to Albert and said, "Where's it happening?" And Albert looked at him—he could be mean, funny, and ridiculous. "Under the sea." Jones just walked away [laughs].

We walked out onstage and it was nothing but total chaos. First of all, we didn't realize that our bassist, Denny Gerrard, was tripping on acid. He tuned his bass about a quarter of a tone or half a tone sharp. I held the music right in place on drums, but if you are playing with someone with an out of tune instrument, you're gonna hear it right away.

Second, within a few minutes of starting he blew his amp up. Chuck's Echoplex snapped, the tape snapped. So instead of hearing a big monster delay sound you had nothing. Then *his* amp blew up. So what we had was Adam on rhythm guitar, me on drums. That was the instrumentation. It was awful. It was a disaster. No one booed or heckled. But we were there on such a wave of "These guys . . ." Albert had laid the groundwork for word of mouth—"This is the band that is gonna walk away with this festival."

There was a sense of total letdown, because we had watched audiences everywhere we played just go nuts for the band. It was total equipment failure. Grossman didn't chew us out after. "You know, shit happens."

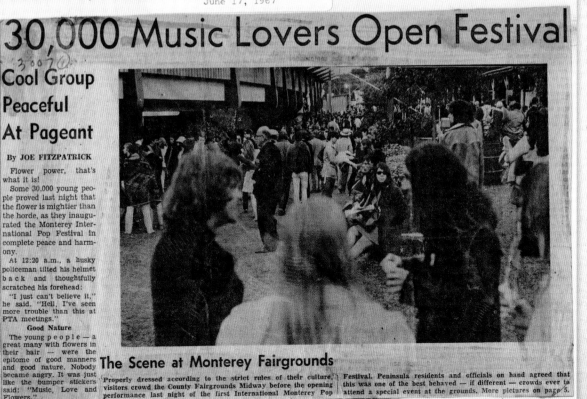

30,000 Music Lovers Open Festival

Cool Group Peaceful At Pageant

By JOE FITZPATRICK

Flower power, that's what it is!

Some 30,000 young people proved last night that the flower is mightier than the horde, as they inaugurated the Monterey International Pop Festival in complete peace and harmony.

At 12:20 a.m., a husky policeman tilted his helmet back and thoughtfully scratched his forehead:

"I just can't believe it," he said. "Hell, I've seen more trouble than this at PTA meetings."

Good Nature

The young p e o p l e — a great many with flowers in their hair — were the epitome of good manners and good nature. Nobody became angry. It was just like the bumper stickers said: "Music, Love and Flowers."

The Scene at Monterey Fairgrounds

Properly dressed according to the strict rules of their culture, visitors crowd the County Fairgrounds Midway before the opening performance last night of the first International Monterey Pop Festival. Peninsula residents and officials on hand agreed that this was one of the best behaved — if different — crowds ever to attend a special event at the grounds. More pictures on page 5.

Singer Lou Rawls followed, his rich, burgundy voice burnishing the night air. There was, un-deniably, the scent of Vegas showroom trailing after his canned intros and overworked arrangements. He remained, however, the consummate professional, bringing ballast and integrity earned through a lifetime of riding hard roads that justified his presence. And besides, could anyone else there claim to have shared a microphone with Sam Cooke?

LOU RAWLS
Lou Rawls: lead vocals
H. B. Barnum: arranger, conductor
Gil Overhorn: piano
Francois Vaz: guitar
Bobby Haynes: bass
Mel Lee: drums

"Love Is a Hurtin' Thing"
"Dead End Street"
"Tobacco Road"
"On a Clear Day"
"Autumn Leaves"
and others

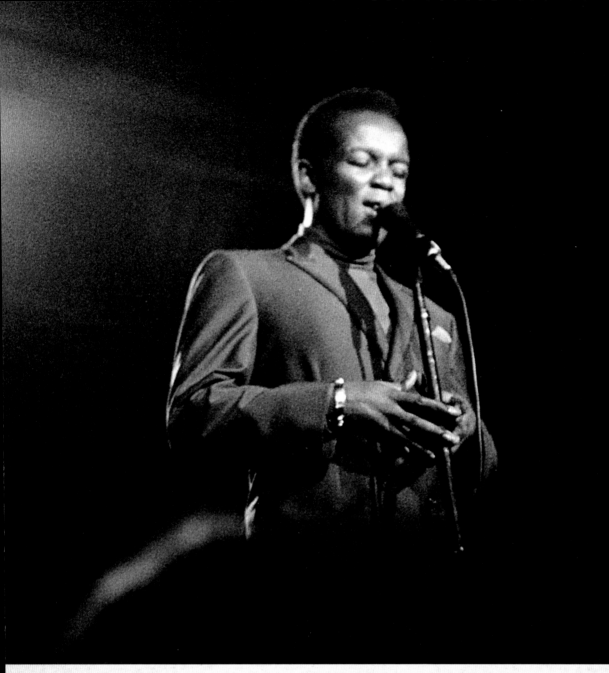

Lou Rawls

JOHNNY RIVERS: I loved Lou Rawls, who Nik Venet signed to Capitol Records when he was playing at Pandora's Box, and he was always great. Again, Lou came out with a suit and tie, kind of an old jazz and blues guy. How could you not love him? He was always a great entertainer.

LOU RAWLS: The Monterey organizers bent over backwards and went out of their way to make it work. Boy, I mean, from jump street, it was one big party! It was just amazing. Just to look out there at that enormous crowd of people and realize that two or three times as many were waiting to get in and get close enough to hear and be part of it. It was exciting, like electricity in the air.

Monologue music is what I did. They call it rap music today. I started doing that back in the '60s. It was just a commentary on life. Some of the other big name artists were doing political protest and stuff like that, but I was telling stories about life in general, how people loved and were living. "Tobacco Road" and "Dead End Street" were not political per se, but about the standards of living. Politics created the Tobacco Road and Dead End Streets of the world.

Beverley

Just as folk music was taking hold in America, so did England turn a hungry eye on its own troubadour traditions. Bert Jansch and Ralph McTell, among others, transformed the "busker" of yore (i.e. singing for your supper) into a captivating persona that held its own against the glitter of pop music. BEVERLEY, barely out of her teens, arrived in London with an acoustic guitar, a lyrical voice, and a precocious talent that endeared her to her musical elders. She signed a deal with the progressive record label, Deram Records, and producer Denny Cordell, who himself would soon be chart-topping with Procol Harum's "A Whiter Shade of Pale."

It was onstage at Les Cousins folk club that Beverley caught the attention of another ambitious singer/songwriter, who would soon open doors to America and an improbable booking at the Monterey Festival—Paul Simon. She later married and performed with cult figure John Martyn, a leading light of the '70s British alt/folk movement. But her enchanted weekend on the West Coast remains an indelible memory.

BEVERLEY: Paul Simon discovered me at the club Les Cousins, or maybe it was I who discovered him [laughs].

I came to America from London to visit with Paul and Artie [Garfunkel] as their guest. I spent months with them, going 'round to all their gigs. Well, frankly, I was having a scene with Paul, and we were quite intimate. Paul always knew what he wanted; he loved his rock 'n' roll, he swung, and he had soul. He loved to dig in the roots.

Paul and Artie were very cool, very funny, and always respectful to me. They had me sing on their *Bookends* LP, which was cut in New York at CBS Studios. And they invited me to play at Monterey.

America was so big—cars, colors that I had never seen before. It was everything I had imagined and more. It was even bigger than Scotland! I'd never been around anything as big as Monterey; so much hipper than Carnaby Street. None of the festivals in England compared to this. On Friday night I did three songs, two of them my own—"Sweet Joy" and "Sweet Honesty," which I performed just with my guitar. I also played a Donovan song called "Picking Up the Sunshine," which he

wrote for me to sing that was done with the Monterey house band. That was it. You had three songs to make an impression.

I remember meeting Janis Joplin. She slapped me on the back like a guy and said, "Write your own stuff, huh?" She was drinking a bottle of Southern Comfort and asked me if I would like to join her. No thanks!

I remember seeing Otis Redding close-up. We were staying at the same hotel. He was very smart and beautifully turned out. I saw the '67 Stax tour of England with Otis, and I'm still recovering from it [laughs].

I knew Jimi Hendrix, Eric Burdon, and the Who from the London club scene. They were mates. I knew Mitch Mitchell, Jimi's drummer, from when we were at drama school together—called the Corona. He was a very good tap dancer.

I had seen the destruction of instruments from bands like the Move before. That was the "in" thing at the moment with the Brits. They were all doing it. That's why the Who did it and Hendrix had to think of something else—like burning down the house!'

Johnny Rivers took a lot of heat for charting with songs closely identified with the black experience. How dare he cover Chuck Berry, the Four Tops, and Smokey Robinson? Rivers' only crime was being sincere. Hell, even Barry Gordy Jr. later complimented Johnny for his version of "Baby, I Need Your Lovin'." And don't ever diminish the importance of the guitar riff to "Secret Agent Man," as era-defining as an Aston Martin DB5 and Yardley Cosmetics.

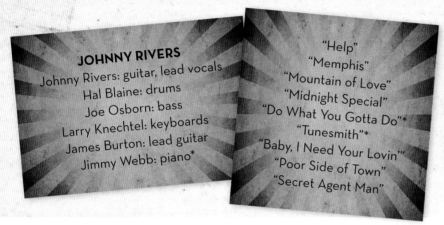

JOHNNY RIVERS
Johnny Rivers: guitar, lead vocals
Hal Blaine: drums
Joe Osborn: bass
Larry Knechtel: keyboards
James Burton: lead guitar
Jimmy Webb: piano*

"Help"
"Memphis"
"Mountain of Love"
"Midnight Special"
"Do What You Gotta Do"*
"Tunesmith"*
"Baby, I Need Your Lovin'"
"Poor Side of Town"
"Secret Agent Man"

Johnny Rivers and festival attendee

JOHNNY RIVERS: Driving north on Highway 101, I had never seen so many VW buses painted with paisley and flowers, cars, trucks, and lots of out-of-state license plates. People were from everywhere. The vibe was very mellow. It was a gathering of tribes and hadn't really gotten to the wild hippie stage yet. Everyone was just digging on the music.

Jimmy Webb was in my band for Monterey on keyboard, and we worked on my set and the charts before we went up there. Hal Blaine, Joe Osborn, and Larry Knechtel were not available for rehearsal 'cause they were booked up. But what we did do was stay at the Highlands Inn up there, just south of Carmel, and got one of those banquet rooms the day before, and it was the first time we ever played that stuff.

Paul Simon came around in the evening just before the Paupers played to all the performers, asking everyone to make sure they did not go over their allocated time limit because he didn't want to cut his own set with Art short, because of curfew.

Johnny Rivers

Eric Burdon used Monterey to introduce a brand-new incarnation of THE ANIMALS. The blues boy from Newcastle had supped deeply from the American South, from Broadway's Brill Building, and now turned his appetite toward an acid-laced approach: atmospheric and extemporaneous, supplanting the rigor of the blues form with something more idiosyncratic. John Weider's swooping violin served as the musical lynchpin and captured the audience's full attention. *This* was new.

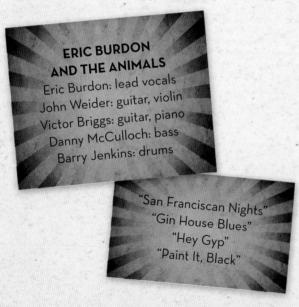

**ERIC BURDON
AND THE ANIMALS**
Eric Burdon: lead vocals
John Weider: guitar, violin
Victor Briggs: guitar, piano
Danny McCulloch: bass
Barry Jenkins: drums

"San Franciscan Nights"
"Gin House Blues"
"Hey Gyp"
"Paint It, Black"

Eric Burdon

Eric Burdon and John Weider

ANDREW LOOG OLDHAM: I do not think I suggested Eric Burdon, even though I loved Johnny Weider. It was nothing to do with Eric and the New Animals covering "Paint It, Black," either. It was just obvious. I think I was too much of a snob to suggest the Animals, and anyway, for a while, with Mickie Most they'd had more hits than us. It turned out to be Eric's coming to America and his Tom Wilson period that was so wonderfully productive. And from that, did we not get War?

ERIC BURDON: I departed London Heathrow for New York, spending one night in New York City, then onward to Monterey the next day. I traveled with Brian Jones, Jimi Hendrix, Mitch Mitchell, Noel Redding, Chas Chandler, and Jimi's management personnel. Upon entry into the U.S. I realized that, because of Brian's flamboyant clothing (he dressed like an old lady in lace and linen clothing), we were immediate targets. So as we were in the immigration line, we did an about-face to the men's room, where we consumed every illegal substance we were carrying between us—which was quite

a lot! On checking into the Mayflower Hotel, we spent the whole night in the elevator, never making it to our rooms.

The festival was wonderful. I just remember how much the people applauded "Gin House Blues" and "Paint It, Black," with John Weider on guitar and electric violin. Everyone in the band stepped up to the plate and we managed to leave the stage to applause. But, honestly, I was glad when the performance was over . . . I could get back to the party backstage.

VIC BRIGGS: The whole thing was very special for me and John. We loved the John Handy album *Live at the Monterey Jazz Festival.* Before Monterey Pop we did a college tour and we worked up some pretty outlandish stuff: John Coltrane's "My Favorite Things," songs by John Handy, and Eric singing a lot of road stuff, like "Tobacco Road" and "Hey Gyp."

On our first tour we played at the Monterey Fairgrounds on March 22nd of 1967. The police came and knocked on our hotel door and gave us a full-on, sirens-blaring escort to the fairgrounds. We then heard from Eric that he was trying to get us on the bill for the Monterey International Pop Festival. My head about exploded. I was so excited.

We went onstage and kicked off with "Every Day I Have the Blues," the Jimmy Witherspoon thing that was our standard opening number. It took off and it felt good. After an extended version of Rolling Stones' "Paint It, Black," witnessed by Brian Jones sitting right down in front, we went into "Gin House Blues," then presented our homage to San Francisco to an authentic northern California crowd.

We had played "San Franciscan Nights" a couple of times in Italy, just for the sake of getting it onstage and being familiar with it. And this was the first time we knew that an audience would get it, and that it was gonna make a big splash at Monterey. We finished with "Hey Gyp," complete with psychedelic guitars and a long vocal improvisation from Eric, and the crowd roared their approval.

Ralph J. Gleason of the *San Francisco Chronicle* wrote in his review that "the Animals were good but eclectic." I wondered, what the hell did that mean? Was there some problem in drawing on different sources? A couple of weeks later I spoke to Ralph on the telephone and asked him

what he meant by that, but only got some mumbled platitudes in response. [Laughs.]

JOHN WEIDER: We had been to America before Monterey Pop. To me, it was going to be just a festival. It was civilized and sophisticated. Everyone was sitting down, enjoying the beautiful weather. It was well-organized by John Phillips and Lou Adler. To me, it was an enlarged festival, like the Richmond Jazz and Blues Festival we had in England. So I wasn't aware of it being a game changer. I talked to Brian Jones, which was nice, and then we played "Paint It, Black." It was Eric's idea to do the song, initially. And it was probably Eric's idea to

have me do a violin solo. I had not started writing songs yet. We wrote a lot of songs together later in Laurel Canyon.

The writing session for "Monterey" was up at Eric's house. I just sat down and the chord changes and the melodies came out really naturally, even though I had never written a song before. It was very casual. He didn't even call them lyrics. "Here's my book of poetry. See what you can come up with from these." And, for some reason, out of the blue, came "San Franciscan Nights," "When I Was Young," "Good Times," and "Sky Pilot," all written in one afternoon. It was divine inspiration.

Vic Briggs

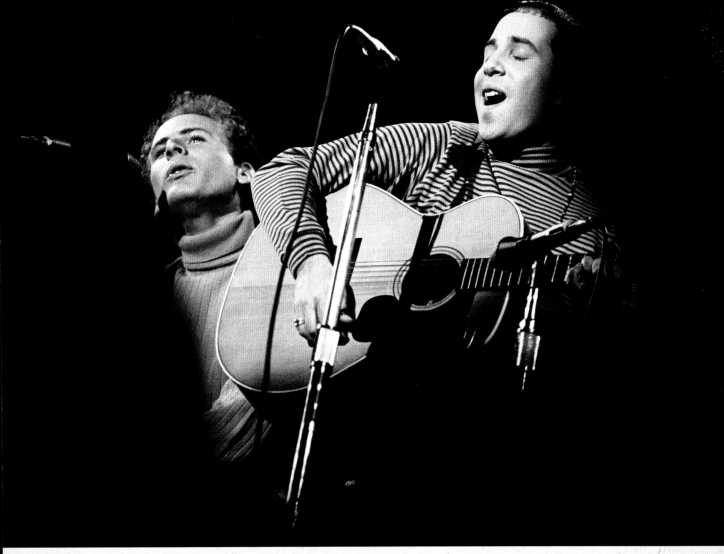

Art Garfunkel and Paul Simon

Simon and Garfunkel—street-corner harmonies, doo-wop, Tom and Jerry—a different kind of inner-city blues. Simon pitched songs and Garfunkel pondered architecture. Paul wandered off to England and returned with a bogus accent and a surprise hit, "The Sounds of Silence." With Artie, he'd found an ideal counterpoint; full-throated sweetness laced with a sly hint of carnality. The songs were smart, like literature, and often infused with an aching sense of loss. It felt good to hurt while they sang those ineffable melodies.

SIMON AND GARFUNKEL
Paul Simon: guitar, vocals
Art Garfunkel: vocals

"Homeward Bound"
"At the Zoo"
"The 59th Street Bridge Song
(Feelin' Groovy)"
"For Emily, Whenever I May Find Her"
"The Sounds of Silence"
"Benedictus"
"Punky's Dilemma"

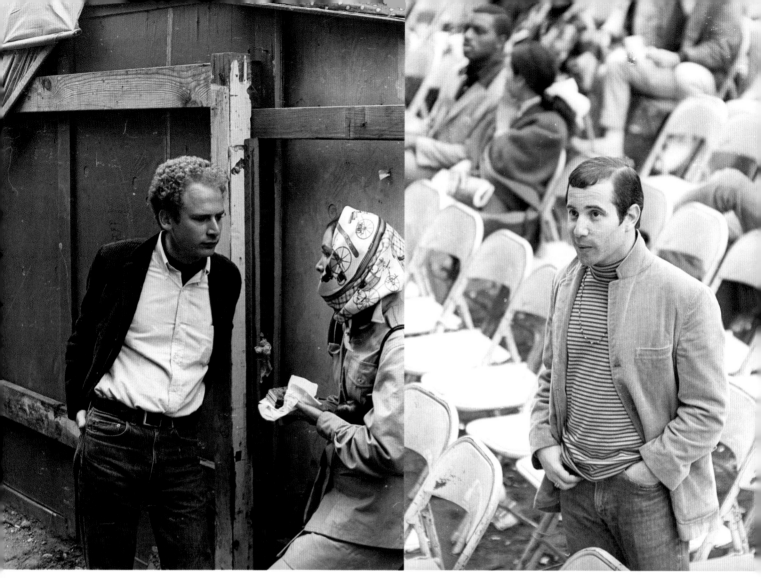

Left: **Art Garfunkel** ✳ Right: **Paul Simon**

LOU ADLER: Paul Simon took a position from the beginning. He was on the board of directors and he had an interest in the festival because he put up $10,000 dollars—$10,000 in 1967. He also had an interest in what we were trying to do. He understood and came aboard right away. We knew him for a while. They were the only act you listened to just for those vocals. Paul played acoustic very well. Interesting, Al Kooper's quote about how many rock guitar players were at Monterey—and he cites Paul Simon. The vocals were so beautiful, and the setting was just right. I mean, that first night it was really dark, and the purity was what you heard.

ART GARFUNKEL: We closed the first night around one in the morning. Excellent California weather, balmy, beautiful—it was delicious. As the whole weekend unfolded, the audience was more than normally supportive. They were really into the fact that it was an unprecedented kind of show, and they were joyous. To me, the aspect that was paramount was that the performers were not getting paid, that we were there for the love of it.

PAUL SIMON (introducing "The 59th Street Bridge Song [Feelin' Groovy]"): I had to make this adjustment from being relatively unknown in England to a semi-famous type of scene here, and I didn't really swing with it. It was a very difficult scene to make. Very unhappy. All the four songs I was writing were very down, depressed types of songs until about June last year. I started to swing out of it, got in sort of a good mood, and I remember comin' home one morning about six across the 59th Street Bridge in New York. It was such a groovy day, really, a good one . . .

Opposite: Paul Simon and Art Garfunkel

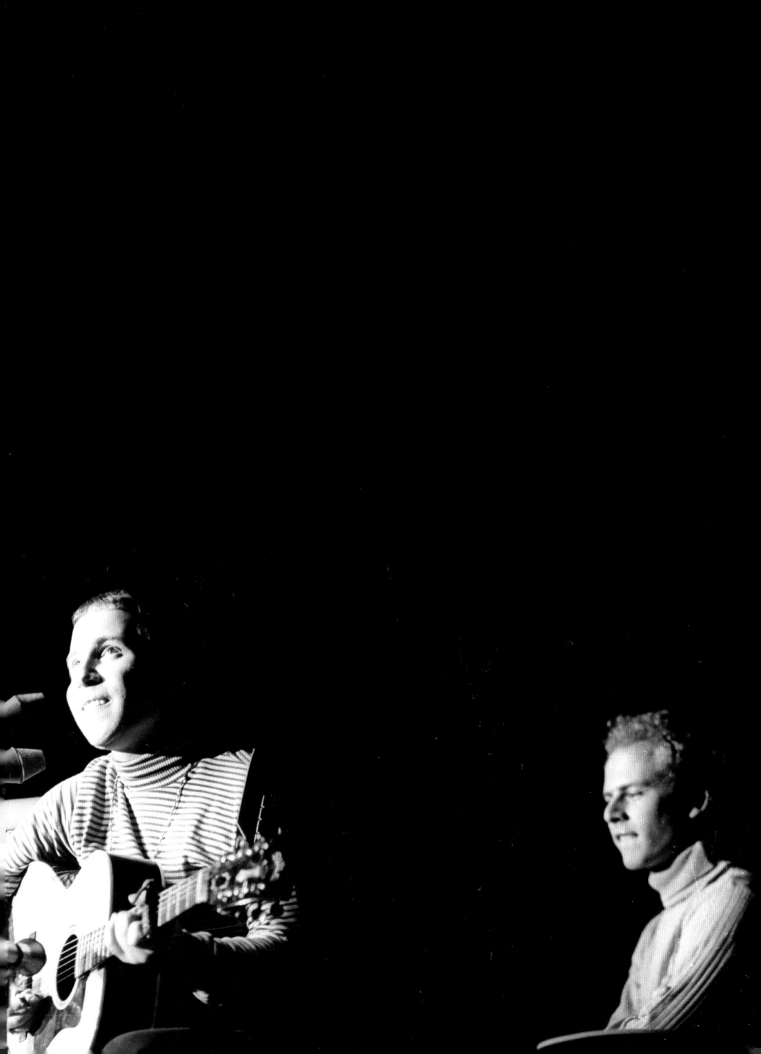

Clockwise from top left: **Flower Power; David Getz (Big Brother and the Holding Company), Cass Elliot, and Lee Kiefer; festival vendors; Jill Gibson, Lou Adler, and Tom Donovan**

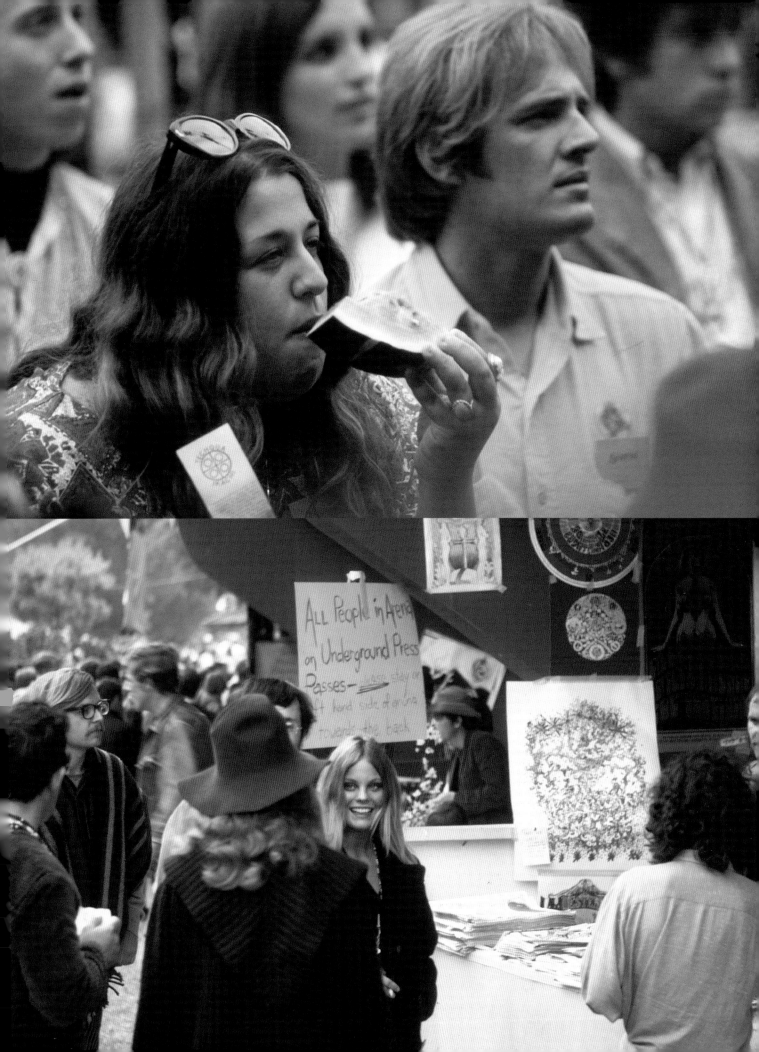

All People in Arena
on Underground Press
Passes—please stay on
left hand side of arena
to wards the back

Keith Altham Planes West to Cover America's Monterey Pop Festival

Venerable English journalist Keith Altham, writing for the *New Musical Express*, parlayed his unique access into a words-eye view of Monterey. His unexpurgated diary appears throughout this book.

We drove to London Airport in Animals manager Mike Jeffery's Rolls Royce while he dictated a few last-minute instructions to his assistant, Tony Garland—"Ring Brian Jones and ask him if I can have my record player and LPs back." We picked up Jimi Hendrix and manager Chas Chandler at their flat and continued to the airport, where Jimi ransacked the book stalls for a science fiction novel.

The strange thing about Jimi is that everyone looks at his incredible appearance with a mixture of surprise and amusement, but those who take the trouble to say "Hello"—like the elderly gentleman at the Passport Control—find him charming and conversational.

Jimi makes friends quicker than most people make enemies. The air hostess on the TWA jet we took was apparently delighted with her unusual charge and spent some time sitting next to him and talking about beat groups.

On the plane over, the main source of amusement were the various taped music channels played through earphones, and every so often Jimi would throw up an assortment of fingers indicating a new delight on a particular channel. He seemed to get a perverse enjoyment from Bing Crosby, Al Jolson, and Durante. But more genuine was his interest in the Bach tapes.

Arriving at Kennedy Airport, we were met by a long, sleek black Cadillac, and station WMCA on the car radio featured Spencer Davis extolling the virtues of milk shakes. Without pausing to check in at the Buckingham Hotel, Jimi shot down to the Colony record centre, just off Broadway, and bought half a dozen LPs by people like the Doors and the Mothers of Invention. He must have music in his room the whole time.

LIKE SOHO

In the evening we visited Jimi's old stamping ground, the Village, which looks rather like Soho

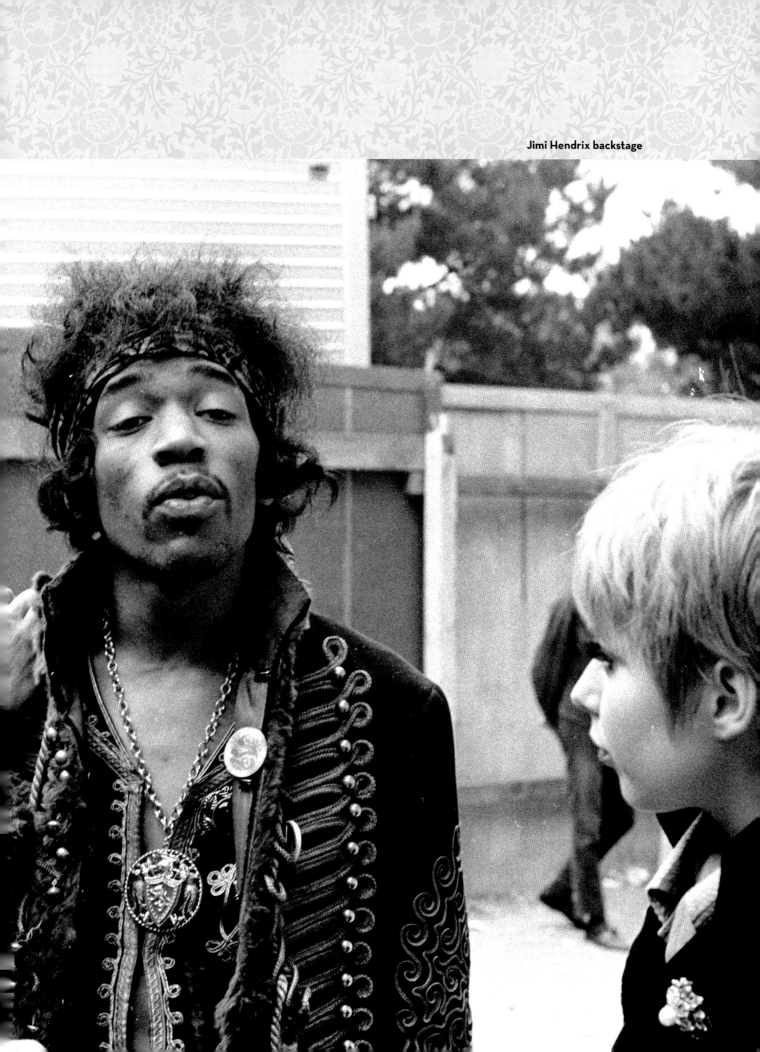

Jimi Hendrix backstage

with all the roofs off and the people spilling out into the open. Jimi pointed out the Club Wha, where he used to gig with people like Dylan. We ate at a restaurant called the Tin Angel, met a couple of the Mothers, and moved on to the A Go Go Club, where we stumbled on what, as far as I'm concerned, was a phenomenon.

The man concerned is a folk singer called Richie Havens. He sings with every nerve, emotion and feeling in his body until the sweat runs down his dark face and forms drops which glisten on the edge of his beard. He sings of love and war and hate. Occasionally he breaks into light conversation with the audience, of things that matter. "I see they've stopped that war in the Middle East—I'd like to know what we have to do to stop the one in Vietnam." Someone in the audience suggested: "Send over 12 Israeli officers!"

THURSDAY

We left for San Francisco, and our departure was marked by one of those spectacular last-minute appearances by manager Mike Jeffery, who appears dramatically everywhere at the last minute and disappears just as dramatically. Jimi had a little sulk when he discovered I had left his *Mad* magazine in my room at the hotel, but he got over it.

We stayed overnight in San Francisco and early the next morning set out to find an "indestructible" guitar for Jimi. "I need a Fender," explained Jimi. "It gets used pretty hard in the act and they are the only make which will stand up to it." We failed to get the model Jimi wanted, but somehow he later acquired a guitar in Monterey. It was the wrong colour but he remedied that by spraying it white and drawing swirling designs all over it with a felt pen.

We arrived on Friday morning at the motel—flying out from San Francisco. Also staying here is Dylan's manager, Al Grossman, who assures us that Bob is fully recovered from his accident and we can expect a new single soon. The motel has become a kind of festival circus in the last few days, with Animals on motorbikes—Vic Briggs has acquired a monstrous, great car which he just leaves parked outside his room and never drives.

Barry Jenkins keeps pointing his camera at anything that moves and Noel Redding and Mitch Mitchell from the Experience plunge in and out of the pool with hot and cold running girls in tow.

Peter Tork

FRIDAY'S OPENING SHOW SETS SUCCESS SEAL

After only one day of the first Monterey Pop Music Festival organised by musical giants—Andrew Oldham, Lou Adler, John Phillips and assisted by that genteel PR Derek Taylor—it is quite obvious that they have an enormous success.

Those not appearing on the show last night but present in various guises were Micky Dolenz dressed as a red Indian chief, Byrd Dave Crosby as a cowboy, Brian Jones in a mind-shattering gold lamé coat festooned with beads, crystal swastika, and lace (he looks like a kind of unofficial king of the festival) and Peter Tork, who came most emphatically as Peter Tork. Jones—gliding ethereally about among the fir trees on the picturesque fairgrounds decorated with huge coloured balloons, lights, fruit stalls and booths selling all kinds of "beautiful" things, told me: "I don't think the Beatles will be coming now—I rang Brian Epstein last night and he says they are recording over the weekend." Just before we came over, I played tenor sax on one of the new tracks they have cut and Paul sat in on one of our sessions. "This is really a great scene here—all the kids are so nice. The people are so polite and just come up and talk to me and say they like the way I'm dressed."

In spite of Brian's prophecy everyone is hoping the Beatles will arrive, most especially

Micky Dolenz, who told me how much he loved the *Sgt. Pepper* album.

By 9:00 on the opening night there were about 8,000 official spectators and 2,000 unofficial in the auditorium. Milling around the grounds and booths outside were approximately another 10,000 and those who could not even get into the grounds must have numbered 20,000.

The whole atmosphere is one of gay Carnival, where everyone wears a bright-coloured scarf, gay hats, or brilliant swirling patterns on their dresses. John Phillips officially announced the festival open at 9:15 AM, and the Association took the stage.

The PA equipment here sounds like an 8-track system and is about the best I've ever heard. The Association provided some slick patter and good harmonies with numbers like "Cherish," "Windy," and "Along Came Mary." The Paupers, who followed them, have a fantastic bass player and some interesting sounds—they shot to fame here while playing gigs with Jefferson Airplane.

The first of the English representatives was Beverley—a good friend of Donovan and Simon and Garfunkel. She sang prettily and was well-received. Peter Tork made a surprise appearance to introduce Lou Rawls, a big blues artist here

whom he knew from his old days playing in the Village. He was well-appreciated by the rhythm and blues enthusiasts and had one couple grooving in the stage pit to something I'm told is a new dance—the Funky Broadway!

Frankly, I did not expect to enjoy the new Eric Burdon with the new Animals—I was too fond of the old one—but it was a revelation! With a group called the Headlights doing unbelievable psychedelic lighting effects behind them, which pulsated to their music, they were rapturously received. Out here on the West Coast, Burdon is regarded as the last of the British "big ones" from the big boom period—apart from the Beatles, that is. His great strength is that he believes devotedly in his new progressive music with just the sincerity which he once felt for the blues scene. His is a musically honest group and, as one member of the audience said to me, "He's getting to the truth, and that's what I'm here for."

Simon and Garfunkel poured beautiful sounds into the night, like "For Emily, Whenever I Find Her" and "Homeward Bound"—they deserve far greater recognition in Britain.

Also on the show was Johnny Rivers with a beard!

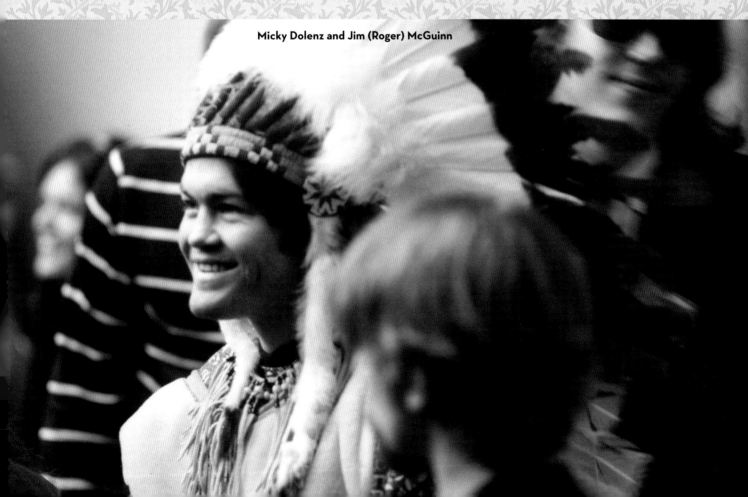

Micky Dolenz and Jim (Roger) McGuinn

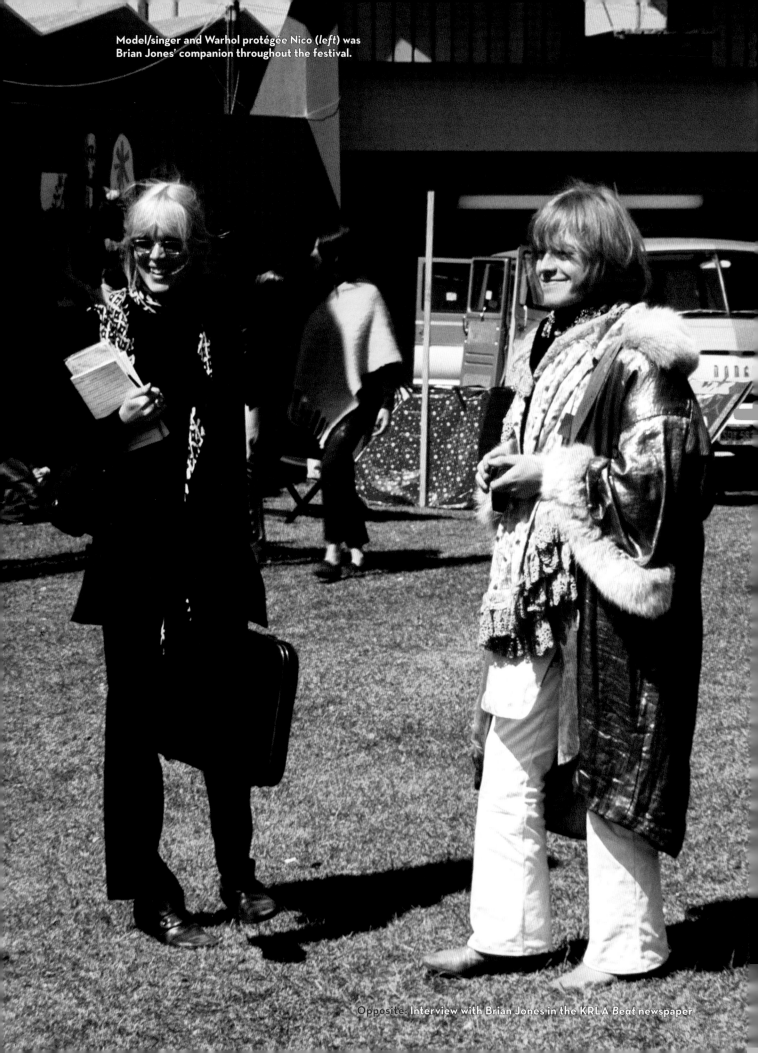

Model/singer and Warhol protégée Nico (*left*) was
Brian Jones' companion throughout the festival.

Opposite: Interview with Brian Jones in the KRLA *Beat* newspaper

BEAT: Can you comment about what's happening this weekend in Monterey?

Brian: *Very groovy scene. We've been very busy recording. I just came away for a few days and it's so nice to get on someone else's scene. It's a very beautiful scene happening here.*

BEAT: A lot of people have been sort of critical of this kind of happening in this country. The uptight people.

Brian: *They're frightened of trouble but I don't expect any trouble, do you? It has been wonderful. I have been walking freely amongst everybody. Yesterday I was walking through and joining rings of kids and fans. You know I've never had a chance to do that much before. People are very nice here. I like it.*

BEAT: Would you like to see this kind of thing happen all through the world?

Brian: *We have had one in London and there are going to be more. But of course it should happen. I think it's wonderful. The new generation's expressing itself. This is one way of expressing itself.*

BEAT: Do you like what's happening with the new generation?

Brian: *Yes, very much. There's lots of hassles but things always have to get worse before they can get better. There are mistakes on both sides.*

BEAT: What about the Stones—what's happening with them?

Brian: *We record practically all the time as the Beatles do. We just got about a week off so I came over here with Andrew (Andrew Oldham, Stones' manager). The others have sort of split to various places, I think, I'm not quite sure. But nobody seemed to get it together to come over here. I wish they had 'cause they have missed a very nice scene.*

BEAT: What do you think about the Beatles new album?

Brian: *It's great. It's too much. It's really good. I did a Beatles' session the other night, actually. On soprano saxophone, of all things. I've taken up playing reeds again. I used to play reed instruments. I bought a soprano saxophone the other day and ever since I have been doing sessions on it. There are soprano saxophones on the Stones' records, future Beatle records. You know, it's a funny thing—you get hold of something and put it on everyone's records. It's great. There's a very nice recording scene going on right now in London.*

BEAT: There have been rumors that the Stones and Beatles are going to record together. Could you comment on that?

Brian: *It would be at a certain stage. It would be a very nice thing. We are getting very close as far as work is concerned. Whether actually we could—well we could work something out together. From one point of view it might not be a very good thing because our direction is slightly different from theirs. Lack of distinction because of the joining up of the two might be lost. That's the only thing that could spoil it, I think. There will certainly be schemes. We spend an awful lot of time with each other now. We've got a lot of mutual ideas.*

BEAT: It certainly would be wild from the standpoint of a combination of sounds. It would seem to me that you would come up with something really unique.

Brian: *It's happening already. As I said, I did this Beatle session—mixed on a Beatle session, various things. Paul's done a couple of ours. You know, it's already happening.*

BEAT: It's taking that direction, anyway.

Brian: *Yeah, and that's not a bad direction.*

BEAT: We're glad to have you in Monterey.

Brian: *It's nice to let people know we're still functioning. Still around—still on the scene—still doing all we can.*

BEAT: How long are you going to be over here, Brian?

Brian: *I'm just going to be here for a very few days. Just a little break from recording and everything.*

BEAT: Are there any immediate plans for coming back over after the court stuff is cleared up?

Brian: *No, not at the moment but everything's going to be all right. The big job at hand is to get the L.P. done and we're spending an awful lot of time on it this time. It's going to be more of a production. We've really put some thought into it because people are still liking our albums so we're trying to really give them something that will take them on a stage further. And, so that they will take us on a stage further.*

We feel at the moment that our important work is to be done in the studio rather than in baseball halls and stadiums around the country. You see, once you've been around the country once or twice people have seen you and it's a question of what's to be gained by going around again. But, there's a lot to be gained by letting them share our progressions because we are progressing musically very fast.

BEAT: You're in a position to please yourselves more now, aren't you?

Brian: *Well to a certain extent that's always been true. But, we can't really please ourselves. We have too large a public who depend on us to be able to please ourselves.*

BEAT: That's the best costume I've seen at the Festival. It's beautiful—a work of art.

Brian: *Well, it's Old English and European stuff.*

BEAT: Did you fly here?

Brian: *Yes I flew in the other night. I came by New York and Los Angeles. I spent about one hour in New York and five minutes in Los Angeles. Then I was flown straight out here on a jet. The Mamas and Papas, I think, own it or rent it or something.*

BEAT: Any schedule after the Festival?

Brian: *I've got a few things to take care of at home so I might be leaving as soon as the festival is over. On the other hand, I might just take in Los Angeles and New York on the way back and look up a few old friends. It's nice to come over here. I'm glad I came.*

BEAT Photos: Ed Caraeff

BEAT: There's a Love-in scheduled for Los Angeles soon. Have you heard about that?

Brian: *It's such a different scene over here from back home. You have more of a problem or at least it's more accute over here than we do.*

BEAT: Which problem is that?

Brian: *The whole problem of social change which is going on around the Western world right now. It's going on in the Eastern world too, but in a different way. We won't talk about that.*

BEAT: Do you think the Pop Festival would look like this or have an atmosphere like this if it had been held in London rather than in California?

Brian: *Yeah. We've had a similar affair in London and there are going to be more. I would like to see these affairs become a regular part of young community life because I think these people here—from what I've seen so far—are acting as a community. They have the community spirit, the community feeling. I haven't seen any signs of any trouble or any emnity. It's very nice. People are showing each other around and it's very beautiful. I'm glad I came. I'll have lots of nice things to say when I get back home.*

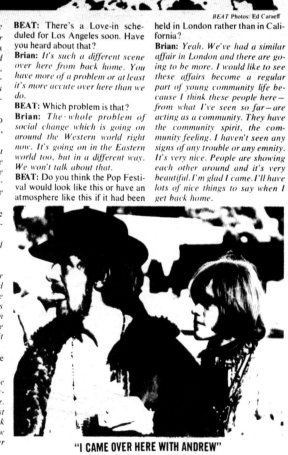

"I CAME OVER HERE WITH ANDREW"

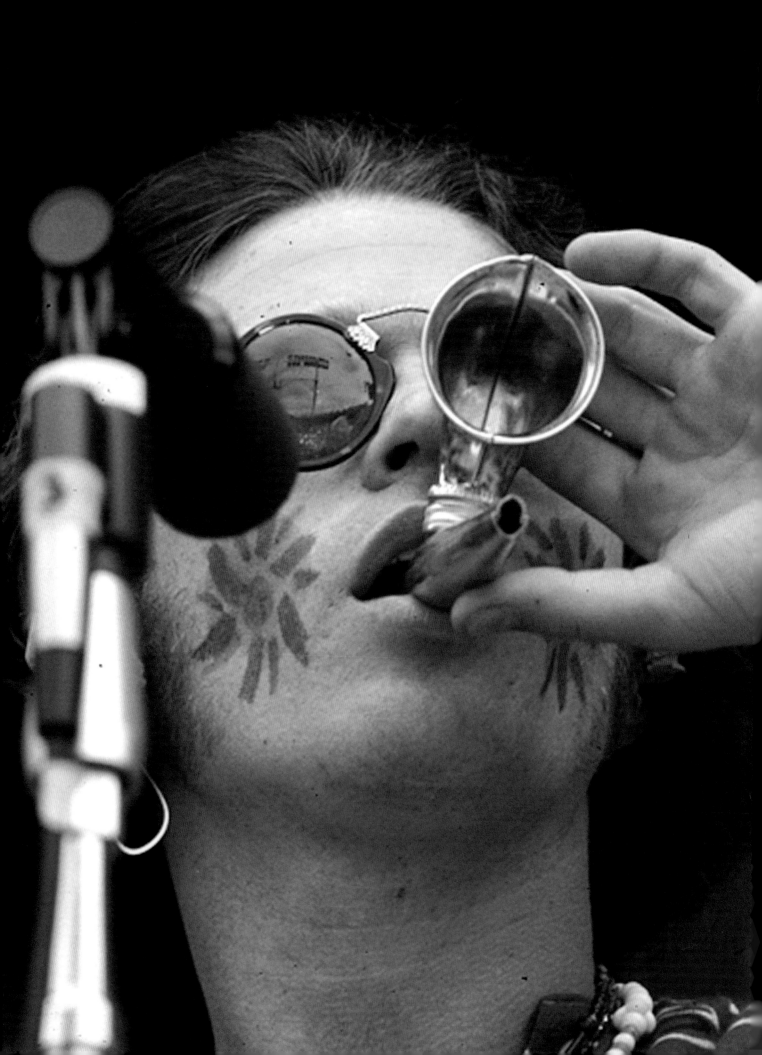

Chapter 3

SATURDAY AFTERNOON

The sun finally broke through the pervasive marine layer. Mixed with the sticky-sweet aromatics of burning incense and lit joints, the air hung hot and heavy. The day was given over to the blues—six of the eight bands set to perform trafficked in a style found strutting along Michigan Avenue, South Side of Chicago. That only a couple of black musicians performed the entire afternoon, led some to question the authenticity of what they heard: middle-class white boys having a go at fried chicken and waffles.

CANNED HEAT
Bob "The Bear" Hite Jr.: lead vocals
Al "Blind Owl" Wilson: guitar, harmonica, vocals
Harry Vestine: rhythm guitar
Larry "The Mole" Taylor: bass
Frank Cook: drums, percussion

"Rollin' and Tumblin'"
"Dust My Broom"
"Bullfrog Blues"
and others

Opposite: Country Joe McDonald
Below: Canned Heat

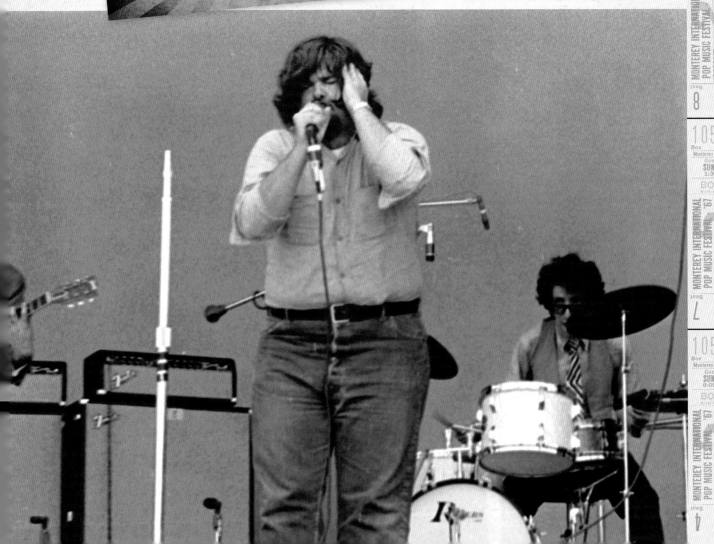

Purists aside, let no one question the commitment made by all the groups to find meaning in the blues. CANNED HEAT was the first act up. In due time they would become the uber-boogie band, charting regularly and earning kudos for their tasty amalgam of country bottleneck gravy with a side of urban punch. They were received politely, a comfortable kick-start to a long day's journey into one-four-five.

Left: Frank Cook ❋ Right: Larry Taylor

PAUL BODY (Audience Member): The rest of the afternoon we spent digging the music. It was sort of a bluesy afternoon. Some Southern California boys, Canned Heat, they were pretty good and they were just getting popular at this time. I had seen them on *9th Street West*, a local L.A. dance show that spring. I remember that they had crazy nicknames like Larry "The Mole" Taylor and Al "Blind Owl" Wilson and the drummer Frank Cook had Dylan's hairdo. You could tell that they studied their record collections endlessly.

JOHN HARTMANN: Canned Heat got on the Monterey bill because we had a little heat on around a record we put out and Derek Taylor was helpful. My band was breaking wide open. I had just found out about Monterey Pop. I told Derek we would love to play Monterey. "We're very hot." And he said, "Look, there's only one slot, and that's for the opening act to start the whole thing off in the morning." "We'll take it."

Canned Heat worked really well because "The Bear"

DownBeat magazine

was a star and he was surrounded by good players. And when "The Bear" sang, here was a 300-pound guy moving around like a 200-pound guy. He was dynamic as a performer. After the Monterey festival, Canned Heat was playing up to five gigs in one day. And then there were all the festivals, like Woodstock.

LARRY TAYLOR (Bassist, CANNED HEAT): I remember Monterey pretty much. We were on Liberty Records. We did songs from our first album that day: "Rollin' and Tumblin'," "Dust My Broom" and "Bullfrog Blues." Alan Wilson brought in "Rollin' and Tumblin'" for our first record. Frank Cook was the drummer in this version of Canned Heat and he was a much lighter drummer than Fito [Adolfo "Fito" de la Parra, their long-standing drummer] but not necessarily any less musical. You gotta realize that back then, even at Monterey, blues had been played before and was an influence on everybody. Al was more of the country, and I was the city blues, the urban blues, like Henry [Vestine], because he was a record collector and would go down to the South and canvass for records. And Frank was sort of in between with jazz in the beginning. And then Bob [Hite] had the material and the ideas he brought in.

To Canned Heat, Monterey was a booking, just like the week before at that Mount Tam show. It was a gig. At Mount Tam it was like an AM radio thing and a week or so later it felt like Monterey had more to do with FM radio. At Monterey I saw some new things and figured, "That's what it is, this is where it's going." You didn't think about things then. You just did it. [Laughs.] You showed up for the gig and you went on the road and you played all these festivals.

What happened next has long since passed into American folklore, kith and kin to John Ford's *Liberty Valance*: "When the legend becomes fact, print the legend." A homely young girl walked onto the stage with fright in her eyes. Her bandmates looked equally hard-scrabbled, like gaunt tumbleweeds with brutish side-whiskers. But then they started to play, the guitarists taut and twining, the singer's voice so gritty, it could seed a pearl in a bayou oyster bed. Over the course of 20-odd minutes, BIG BROTHER AND THE HOLDING COMPANY pinned back the ears of a disbelieving audience with a volley of 12-gauge musical buckshot. Lead singer Janis Joplin drove the band with a glorious fury, kicking and braying like a barnyard mule in heat. She concluded to a rapturous ovation, the audience all too aware of their presence at the birth of a star. Her trajectory was meteoric and tragic, a perfect recipe for the blues.

BIG BROTHER AND THE HOLDING COMPANY
Janis Joplin: lead vocals
Sam Andrew: vocals, guitar
James Gurley: lead guitar
Peter Albin: bass
David Getz: drums, percussion

"Down on Me"
"Combination of the Two"
"Harry"
"Road Block"
"Ball and Chain"

Janis Joplin backstage

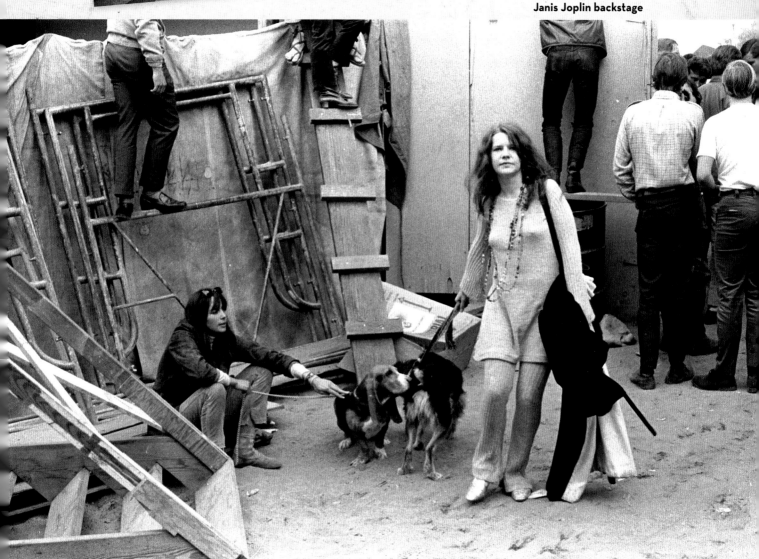

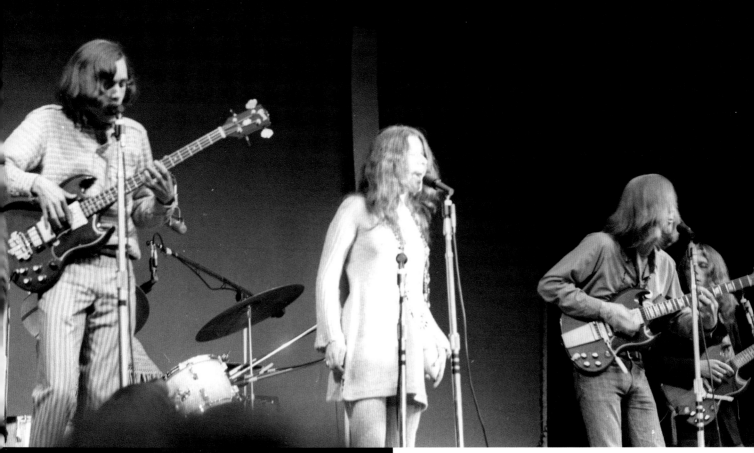

Big Brother and the Holding Company

Chet Helms onstage

CHET HELMS (Introduction): Three or four years ago, on one of my perennial hitchhikes across the country, I ran into a chick from Texas by the name of Janis Joplin. I heard her sing, and Janis and I hitchhiked to the West Coast in 50 hours, probably the fastest trip across the country we ever made. A lot of things have gone down since, but it gives me a lot of pride today to present the finished product . . . Big Brother and the Holding Company.

ROBERT CHRISTGAU (*Esquire*): The first big hit was Janis Joplin of Big Brother and the Holding Company . . . who may have been the best rock singer since Ray Charles—that means since the beginning, brother—with a voice that was two-thirds Bessie Smith and one-third Kitty Wells, and fantastic stage presence. Her left nipple stood erect under her knit pants suit, looking hard enough to put out your eye as she rocked and stomped and threatened any moment to break the microphone, or swallow it.

JOHN PHILLIPS: Janis was so nervous, it was crazy. Backstage, Lou Rawls was telling her, "It'll be fine, it'll be fine. Don't worry about a thing." She was rattling, just shaking. But then, as soon as she hit that stage, she just stomped her foot down and got real "Texas."

HENRY DILTZ: She was up there wearing a see-through top, looking nubile and sort of like one of R. Crumb's *Zap Comix* babes. And she was just totally on fire and sang with every ounce of emotion she had. I'd never seen such intensity on a stage before. Haven't since.

Opposite: Janis Joplin

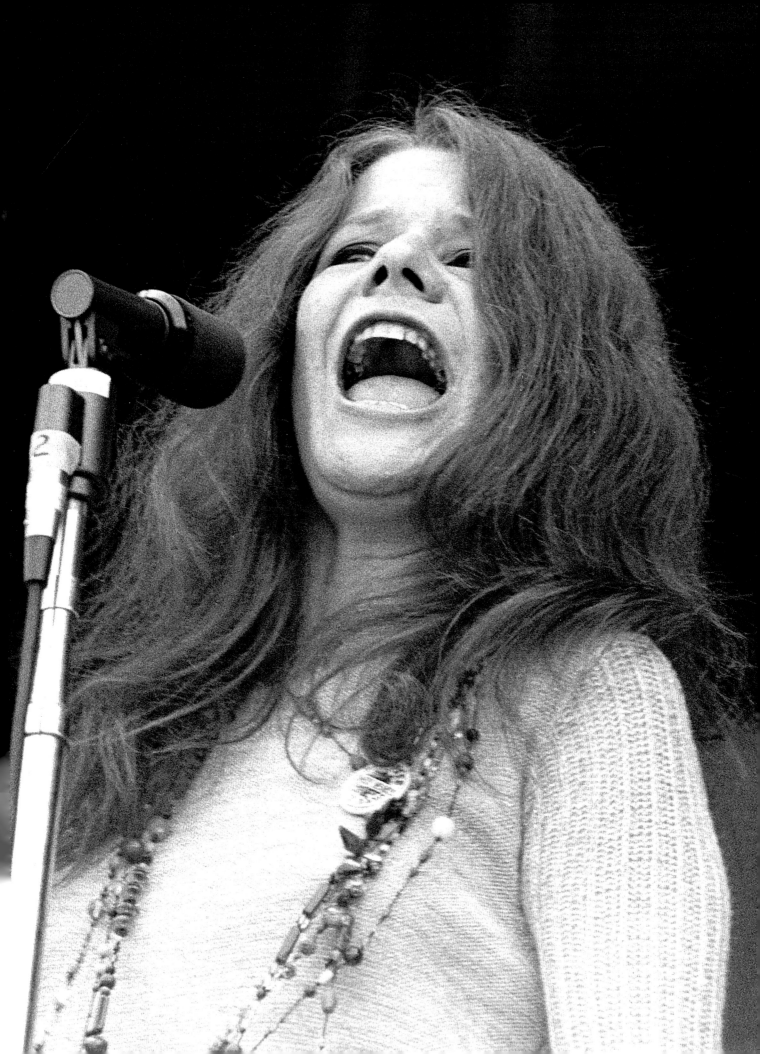

GRACE SLICK: She had that rasp which I wish I had. And she had soul, which is a matter of revealing rather than concealing. She pulled open her skin and said, "Here I am."

PETER ALBIN: She had a variety of moods, a variety of personas. One minute she'd be off in a corner reading a Kurt Vonnegut book or the *Wall Street Journal* or the *New York Times*, and some other time she'd be partially undressed with a bottle of Southern Comfort, reading a *Zap Comix*.

RAVI SHANKAR: There was something so gutsy about Janis Joplin, like some of those fantastic jazz ladies like Billie Holliday . . . that sort of feeling. I was so impressed by her.

SAM ANDREW: Of course, the big story for us was the introduction of Janis to the big world, and that went well enough. People who had never heard/ seen her understood suddenly what she was about. Some of those big-time Los Angeles professionals suddenly knew that they were in deep water when they heard Janis sing "Ball and Chain." This was no "wear flowers in your hair" song.

I liked playing "Road Block" at Monterey. There is a kind of gospel, off-time feel to the song that I found very interesting. I have been trying to get [bassist] Peter Albin, who wrote the tune, to do this song for years, but so far no go . . . maybe when we're 80. "Combination of the Two" was a song that I had written a while earlier. The "two" were [promoters] Chet Helms and Bill Graham.

In the song, I was trying to make the point that the scene needed a visionary, someone who could make the trains run on time. It would take a combination of the two to make the counterculture work. Of course, as often happens, in the actual playing of the song a sort of rapturous ecstasy took over and the lyrics became almost totally lost. I tried to describe what it felt like to be at the Avalon Ballroom or the Fillmore Auditorium. So, the song, which had begun as an almost philosophical observation—the complexity of describing an experience—became, in performance, a raving chaos. Janis Joplin lifted the chorus of the song into the level of pure feeling.

RANDALL HARRIS (Audience Member): I was with some school friends from Occidental College and heard about it on KPPC-FM from Pasadena. "That sounds like fun!" Somebody said, "I'll drive!"

We got in the car and drove the 450 miles to Monterey from Eagle Rock. We had heard about Big Brother and the Holding Company and really wanted to see them. The doors were open, the fences were down, and we got in. We plopped down on the fairgrounds. "This is great!" There might have been 10,000 people for that show but it seemed like 110,000. We then found some seats. Big Brother looked very small from the distance I was at, but they were still fantastic!

Ralph Gleason (*in hat and sunglasses, far left*) in the audience

Festival attendees

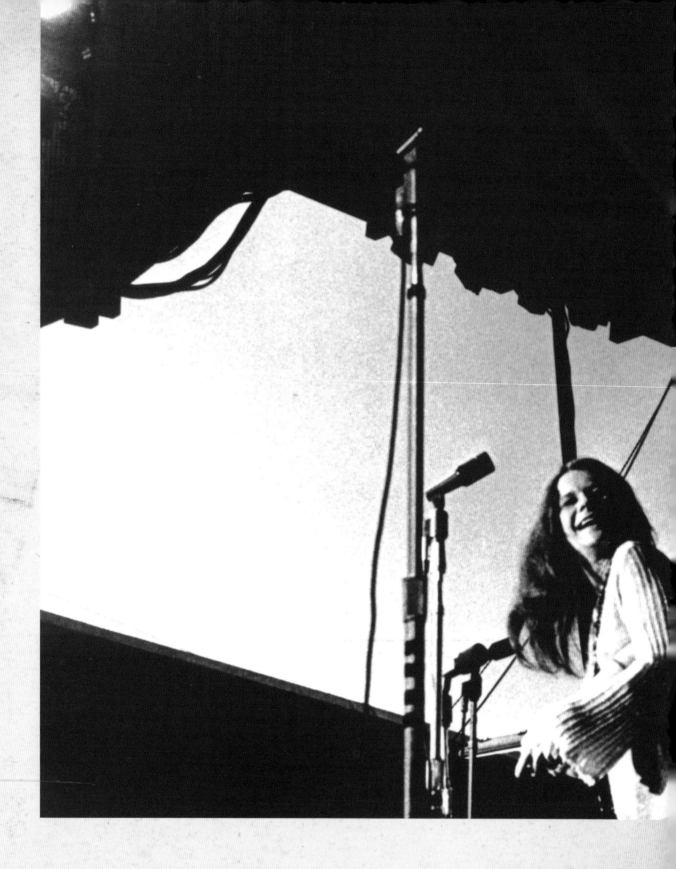

Backstage, there was trouble afoot. Just prior to curtain the group's manager, Julius Karpen, refused to let Pennebaker and his crew shoot their performance. He contended that by relinquishing artistic control, they were at the mercy of the filmmaker's "commercial" designs, and that they wouldn't play ball with Hollywood. (This complaint was really getting tired.) Joplin was devastated; she knew this was a career moment and turned to Lou Adler for help. If she would sign the releases,

Publicity still of Big Brother and the Holding Company from *Monterey Pop*

he would allow for a repeat performance on Sunday night. Albert Grossman, smelling blood in the water, circled around the frantic singer and lunged. "Do it," he counseled. The band wavered, but ambition prevailed. Karpen had badly misplayed his hand and folded. Soon Janis was ensconced in Grossman's stable.

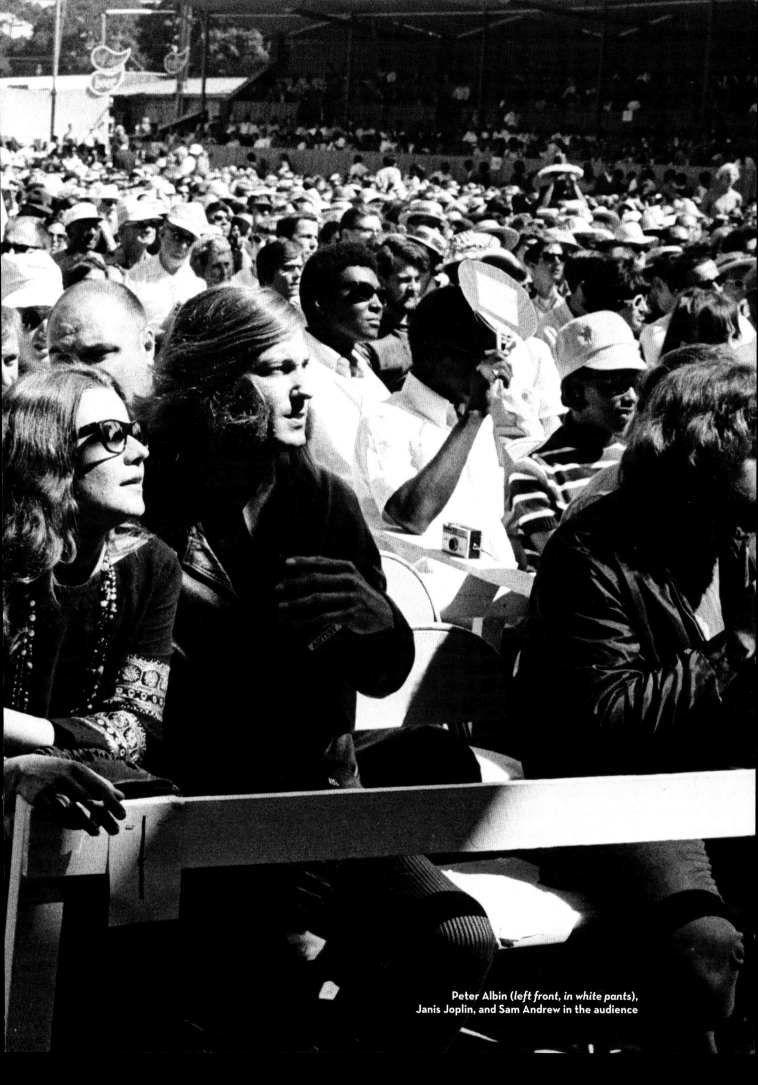

Peter Albin (*left front, in white pants*),
Janis Joplin, and Sam Andrew in the audience

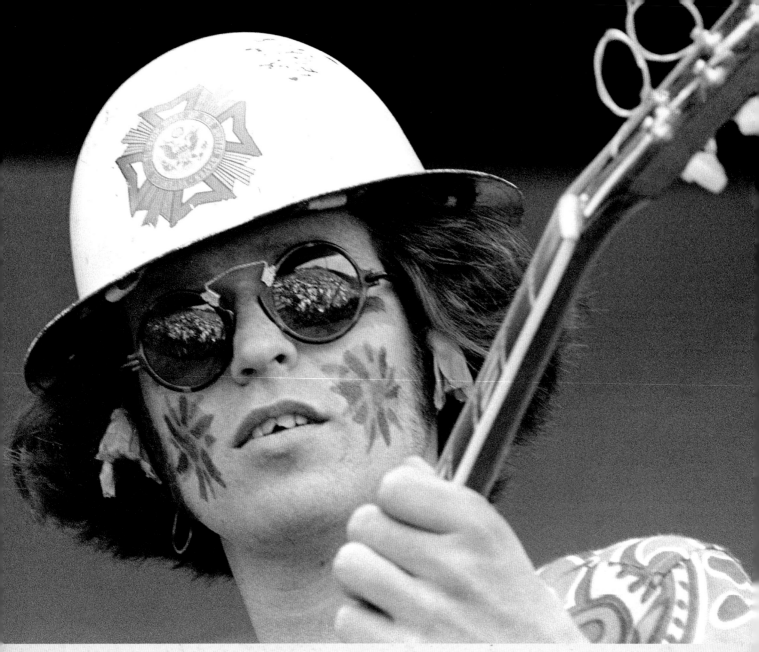

Country Joe McDonald

Country Joe and the Fish had the unenviable task of following Big Brother. No worries, though; a few hits of STP (a kind of industrial strength acid) was their tonic for performance anxiety. Flanked by the calliope swirls of David Cohen's Farfisa organ and the stinging guitar lines of Barry Melton, singer Country Joe McDonald—an old lefty forged in the crucible of Berkeley activism—held forth with beatific calm, his face a painted road map to the land of peace and love.

COUNTRY JOE AND THE FISH
Country Joe McDonald: lead vocals, guitar
Barry Melton: lead guitar
David Cohen: keyboards
Bruce Barthol: bass, guitar
Chicken Hirsch: drums, percussion

"Not So Sweet Martha Lorraine"
"Fixin' to Die Rag"
"The Bomb Song"
"Section 43"

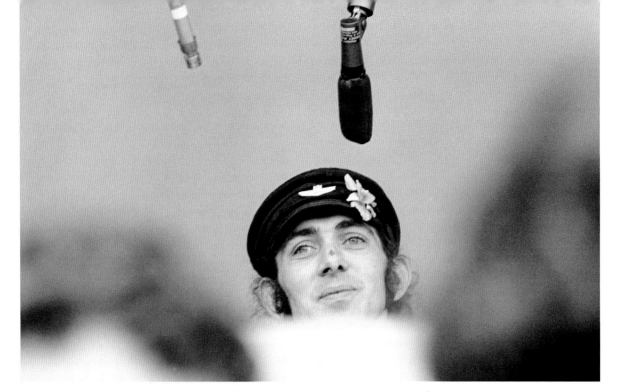

Above: **Chicken Hirsch** ※ Below: **Bruce Barthol**

COUNTRY JOE McDONALD: I considered myself a hippie then and even now. I think we collectively expanded what was permitted in terms of content and sound in American pop music. This extra energy lifted the music to a new level and made it very threatening to the status quo. But eventually, the business saw it as an opportunity and got on board. Things have never been the same since.

I was quite stoned on Owsley's new drug STP and spent a night wandering around with [German singer/model] Nico. David Cohen, our keyboardist, did take acid onstage when we sang "The Acid Commercial." I thought we played great and the audience loved it. "Not So Sweet Martha Lorraine" was a tune that just popped into my head one day. It followed the verse/chorus/bridge format, which was unusual for us. And it was also beyond the typical romantic lyric. It treated women in an intellectual fashion that I thought was really new.

I believed that it was important to have a stage presence and really deliver—we weren't trying to be hip . . . we really were! I believe that the northern California bands were the best and most original and that everyone else tried to imitate us. And, for the most part, failed.

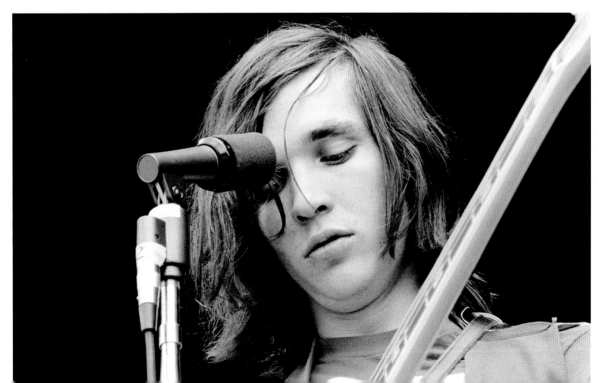

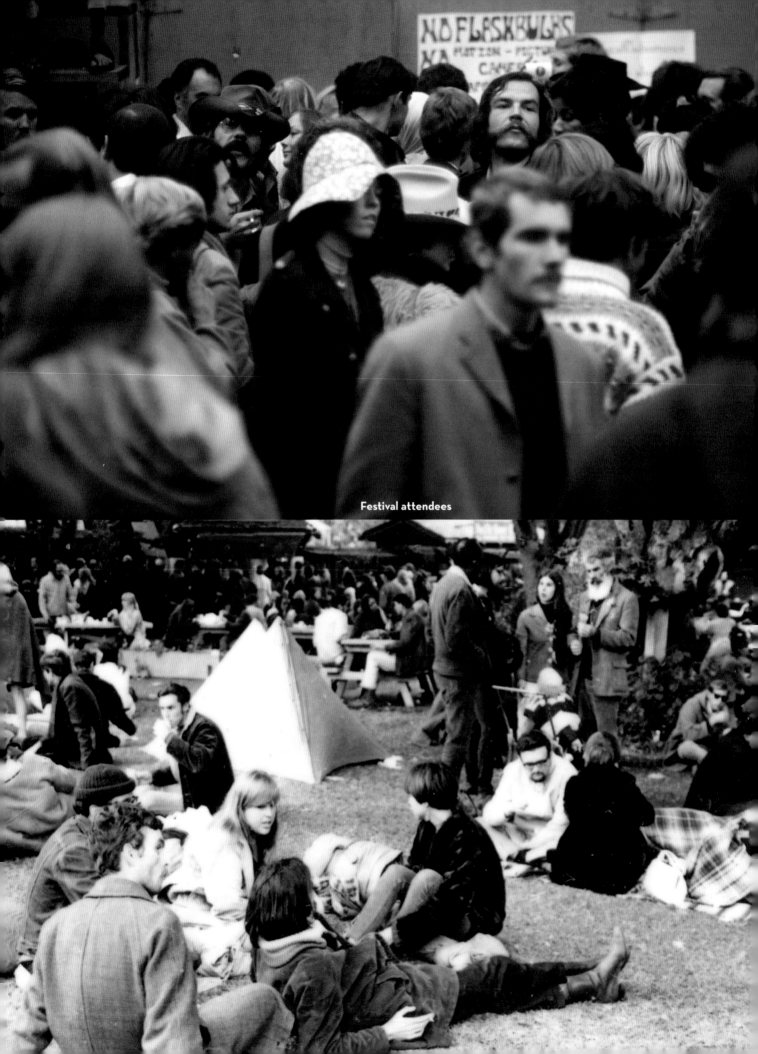

Festival attendees

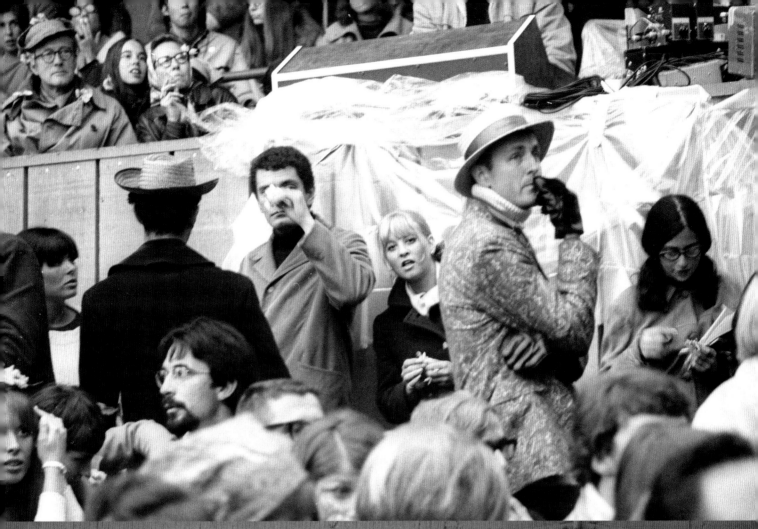

NO FLASHBULBS
NO MOTION - PICTURE
CAMERAS
NO TAPE
RECORDERS
IN THE ARENA

NOBODY allowed
until 1ᵖᵐ
for NO Reason!

Notice! NO PARKING

Above: David Crosby and Al Kooper ✳ **Opposite: Harvey Brooks and Al Kooper**

Al Kooper was a cocky young songwriter/session musician hanging 'round the hothouse that was midtown Manhattan's studio and publishing scene. It was during a Bob Dylan recording session that Kooper had his first brush with rock immortality. Against the strict admonitions of Tom Wilson, the session's producer, Kooper hunched down behind an imposing Hammond Organ and cobbled together a series of phrases and chords for "Like a Rolling Stone," voted by *Rolling Stone* magazine as the greatest rock 'n' roll song of all time. In 1967, he had an acrimonious departure from the Blues Project, and temporarily relocated to the West Coast. Serving as production supervisor Chip Monck's first lieutenant, Kooper hadn't planned on playing at the festival, but a window of opportunity opened and an all-star pick-up band ran down some soulful grooves.

AL KOOPER
Al Kooper: lead vocals, organ
Harvey Brooks: bass
Elvin Bishop: guitar
Billy Davenport: drums

"I Can't Keep from Cryin'"
"(I Heard Her Say) Wake Me, Shake Me"

AL KOOPER: Well, I really wanted to play and they did give me a slot as a favor for being "assistant stage manager," but I did ask for it. But I had to get a band. So I just asked various friends if they would sit in with me. There was no rehearsal. It was just talked about backstage: "Let's do this. Let's do that. This is what the chords are." It's very painful for me to watch it. I had to give them permission to use it. Initially I thought it was a train wreck. The audiotape was un-mixable. My wife, Susan, said, "Put it out. You look fabulous."

When I was playing, the Blues Project arrived at the site, and they were very unhappy to hear me doing "Wake Me, Shake Me." The only person in the Blues Project who was talking to me was Andy Kulberg, and he came over and said, "Boy, are they pissed off that you did that song." I

said, "Why?" That's, like, mine. It wasn't, like, something they wrote. I brought it into the band. I arranged it. So I don't understand why I can't play that. It's so water under the bridge.

RICK WILLIAMS (Audience Member): Al Kooper had some Butterfield/Electric Flag backing players—Elvin Bishop and Billy Davenport from Butter, and Harvey Brooks from Electric Flag. Al played at least some Blues Project material, which had to have been a little weird for the Project guys. I think he was intro'd as "the Al Kooper Thing." As for the Blues Project, I hadn't figured out that Al was not in the band until their set, when it was clear that he'd been replaced by a young black keyboardist/vocalist with whom I was totally unfamiliar. Later learned he was John McDuffy.

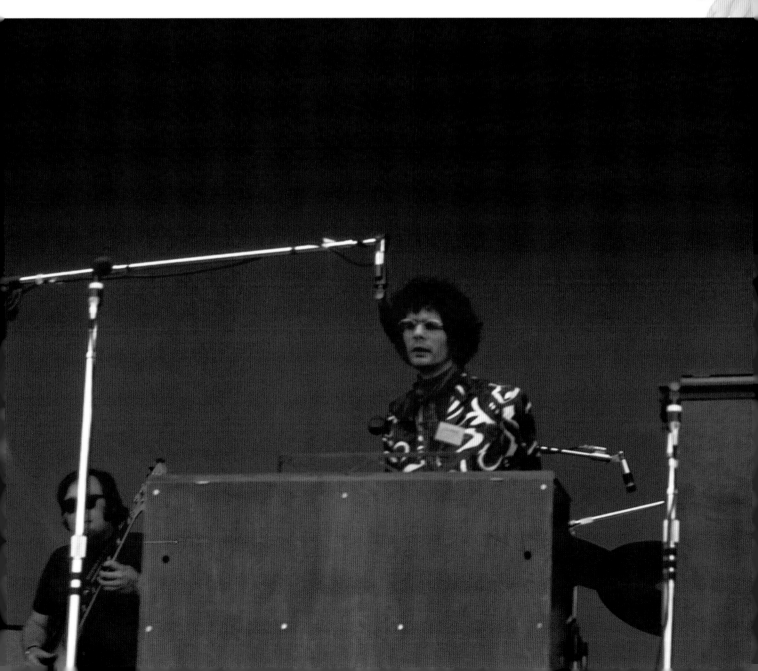

Paul Butterfield had recently lost the services of his blistering lead guitarist, Mike Bloomfield. His rhythm guitarist, Elvin Bishop, held the spotlight now and handled it with grace. But this was Butterfield's time to shine, channeling such heroes as Little Walter and Sonny Terry. Writing for *Newsweek* magazine, Michael Lydon cited "Butter" for his "haunting, looping sound . . . as it broke a small solo of just a few notes into tiny bits and experimented with their regrouping."

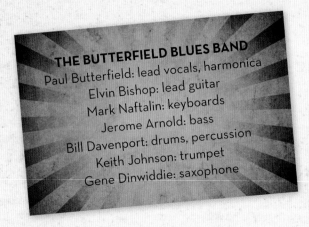

THE BUTTERFIELD BLUES BAND
Paul Butterfield: lead vocals, harmonica
Elvin Bishop: lead guitar
Mark Naftalin: keyboards
Jerome Arnold: bass
Bill Davenport: drums, percussion
Keith Johnson: trumpet
Gene Dinwiddie: saxophone

"Look Over Yonders Wall"
"Mystery Train"
"Born in Chicago"
"Double Trouble"
"Mary Ann"
"Droppin' Out"
"One More Heartache"
"Driftin' Blues"
and others

Below: The Butterfield Blues Band ❋ **Opposite: Paul Butterfield**

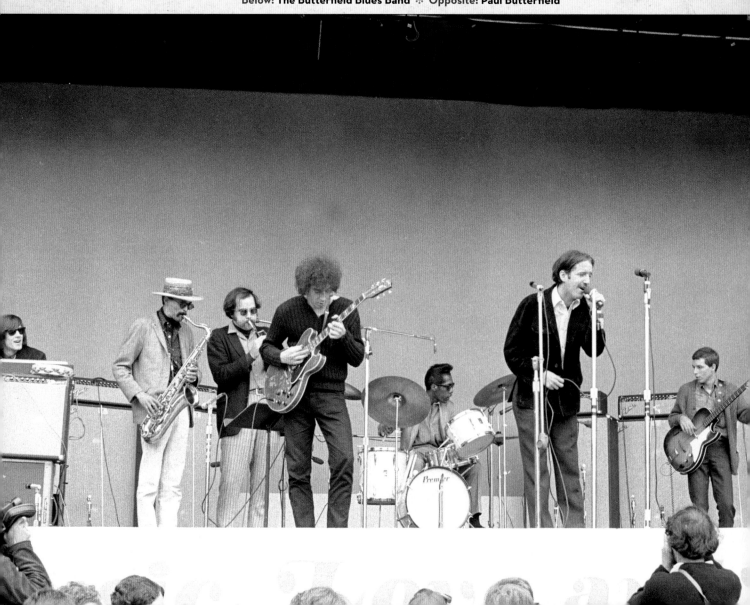

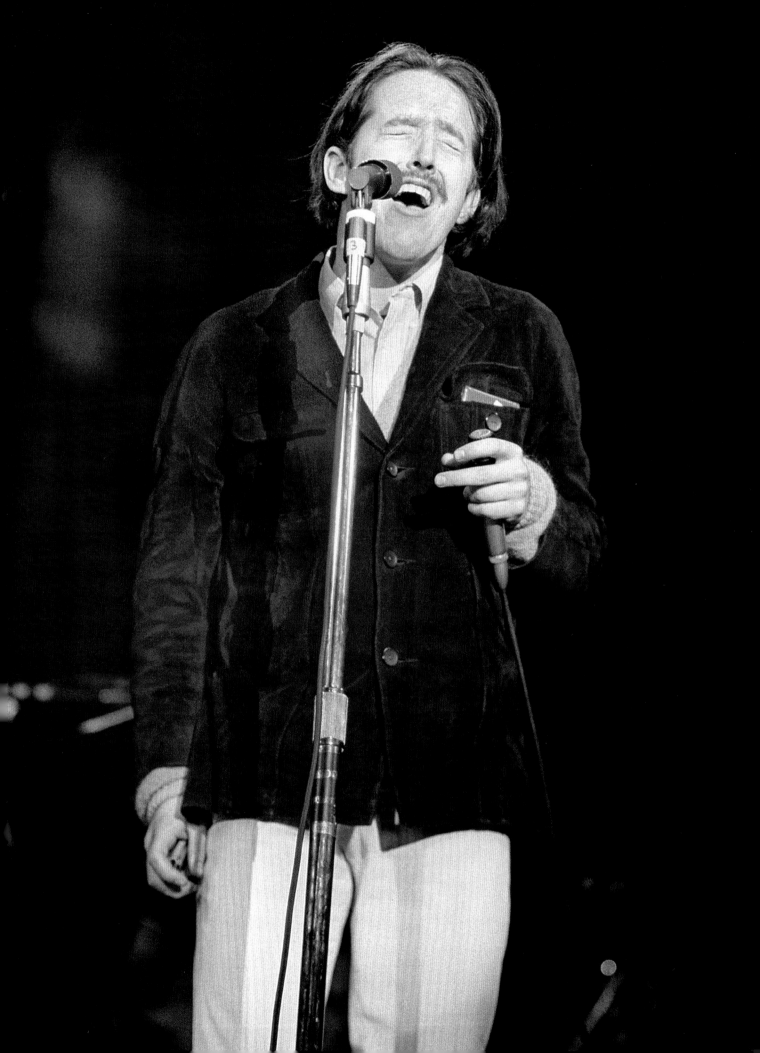

AL KOOPER: Paul Butterfield was the real thing. Like Mike Bloomfield said, there was no black or white. Paul could have been a tuna fish; it wouldn't have made any difference. He *was* the blues.

STEVE MILLER: Elvin, Jerome, Mark, and Paul— they were killer. Paul was at his peak; he had it all going. He'd just had a big write-up in *Time* magazine as the "blue-eyed soul player" who played great harmonica. Paul was great regardless of color, race, or anything. Paul got a lot of attention because he was white. Monterey Pop was the height of it.

The Butterfield Blues Band

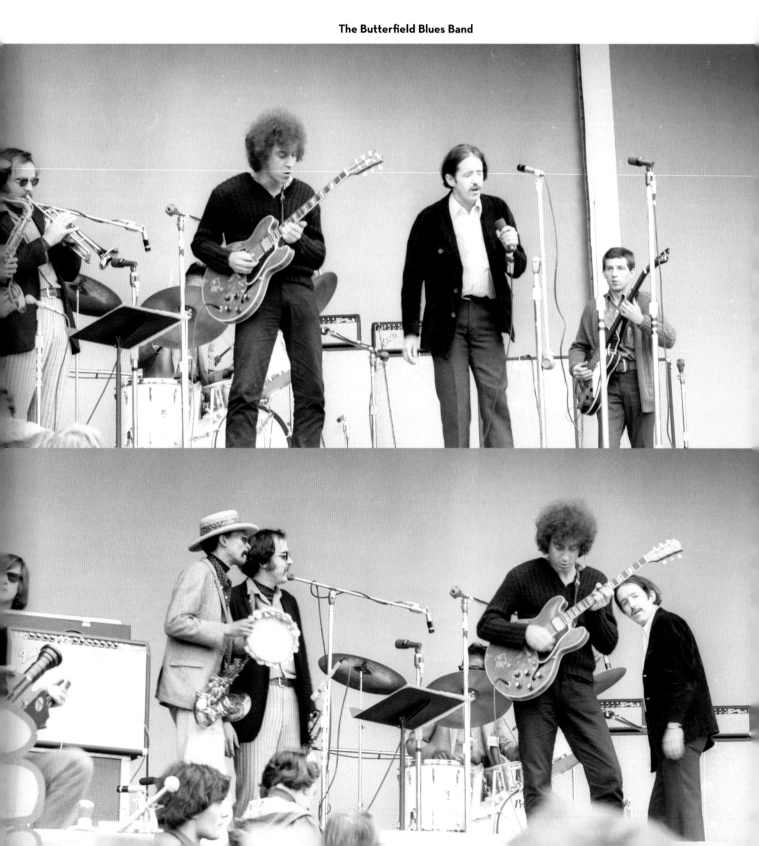

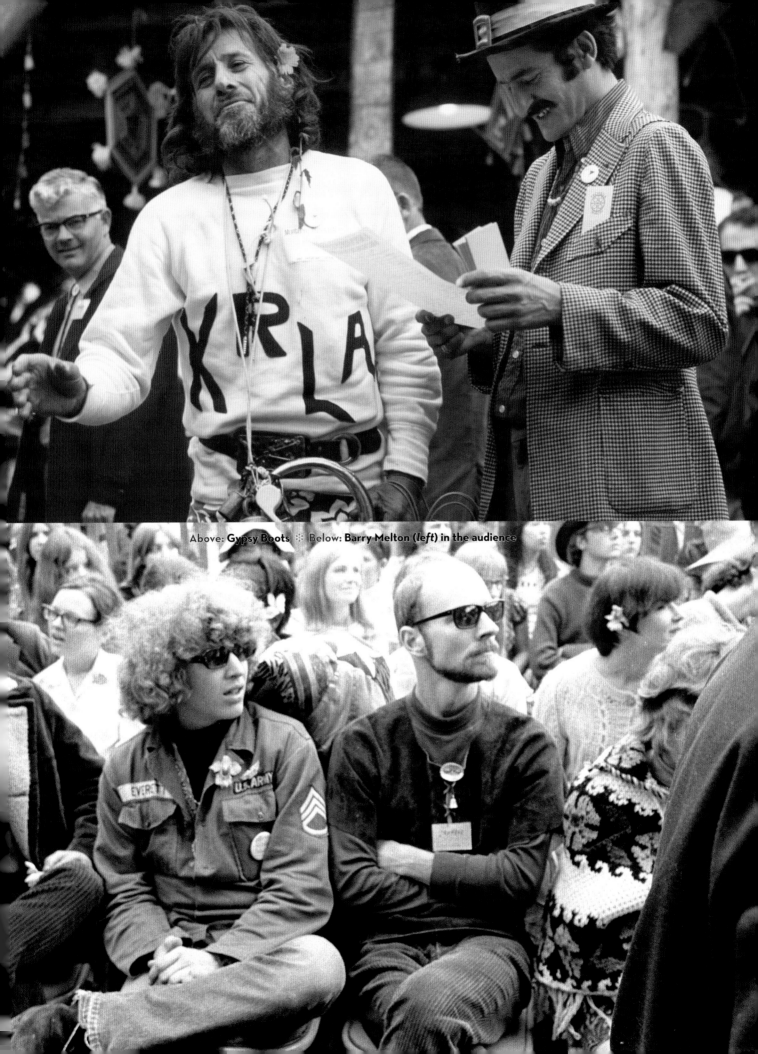

Above: **Gypsy Boots** ⁚⁚ Below: **Barry Melton (***left***)** in the audience

Quicksilver Messenger Service lived the hippie ideal—a commune in Marin County where all manner of musicians, old ladies with babies, dope dealers, and human driftwood coalesced into a barely functioning whole. It wasn't exactly the Spahn Ranch, but it bordered on the hairy edge of calamity—both professional and personal. The group had chops; guitarists John Cipollina and Gary Duncan could whip up a gripping frenzy. They were probably the best "unsigned" band in the Bay Area. A deal was waiting, provided they could rouse themselves from their narcotized state, stand, and deliver. The original "jam band," Quicksilver was stymied by the time constraints placed on them at Monterey, and their winning blend of country, rock, and folk ideas never congealed.

QUICKSILVER MESSENGER SERVICE
Gary Duncan: guitar, vocals
Jim Murray: vocals, harmonica
John Cipollina: guitar
David Freiberg: bass, vocals
Greg Elmore: drums

"Dino's Song (All I Ever Wanted to Do)"
"If You Live"
"Acapulco Gold and Silver"
"Too Long"
"Who Do You Love?"

Gary Duncan

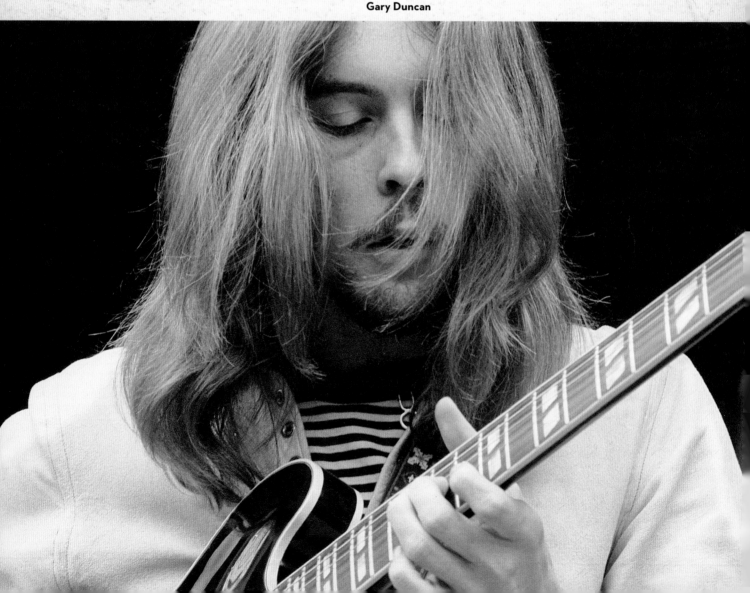

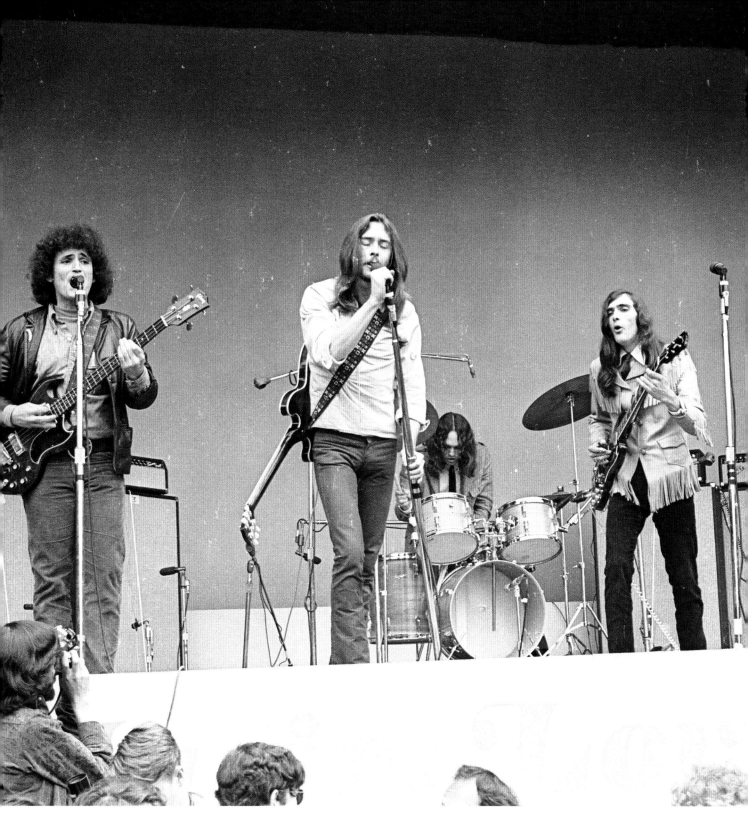

Quicksilver Messenger Service

GARY DUNCAN: I wasn't aware until later that there was that much media/label attention on the show . . . I don't know if we got signed because of our performance or not. I would assume not because we didn't play that well, in my opinion. But it was evident that someone had spent a lot of money to put it all together. Every band had a brand new set of Fender amps, which immediately went into our own trucks and we kept them . . . along with Hammond Organs and whatever else we could "liberate" from the stage after our set. There was a new backline for every act and nobody seemed to care where the other stuff went . . . that is a lot of gear that just "disappeared."

Steve Miller, the "Space Cowboy" of a decade later, struggled with equipment woes and, as a consequence, his elaborate blues reveries failed to ignite. Miller had, with the assistance of sound engineer John Meyer, concocted an elaborate tape delay/special effects unit to be triggered by foot pedals. It was daring and years ahead of the rack mounts of elaborate gear employed by every kid with a whammy bar today. His manager, Harvey Kornspan, following the all-too-familiar pattern of San Francisco bands never missing an opportunity to miss an opportunity, prohibited Miller from being filmed. In this instance, perhaps it was for the best.

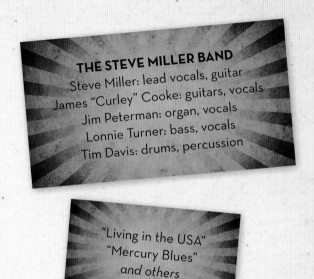

THE STEVE MILLER BAND
Steve Miller: lead vocals, guitar
James "Curley" Cooke: guitars, vocals
Jim Peterman: organ, vocals
Lonnie Turner: bass, vocals
Tim Davis: drums, percussion

"Living in the USA"
"Mercury Blues"
and others

COUNTRY JOE McDONALD: Steve Miller's music has a certain sound to it that's a lot like synthesizers now, sort of like the Les Paul and Mary Ford experiments with tape loops and slap percussion machines. At Monterey, Steve was taking a real risk. I remember watching him from the audience, very amused, and thinking, "Well, there's Steve with that tape machine again!"

STEVE MILLER: I'd been working with these guys for eight or nine months, having them set up a sound system that would let me run a tape recorder and use pre-recorded sound effects. I was

actually playing and running a tape recorder with my foot. I'd use one effect, then go to another one. I was so ridiculous!

I remember being really happy to be at Monterey, really excited. It was the first event I'd attended that was organized in such a really first-class way from top to bottom. They took care of all the musicians beautifully—put us up, fed us, had a transportation crew take us back and forth. They had the logistics down—possibly as well as it's ever been done. I don't think it's ever been surpassed. It was just all positive and came together and worked. It really was just wonderful to be included.

Below and opposite: Steve Miller

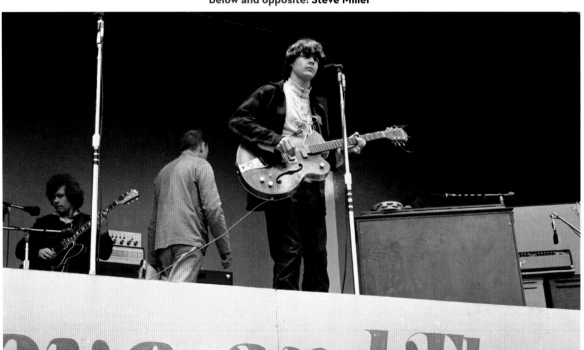

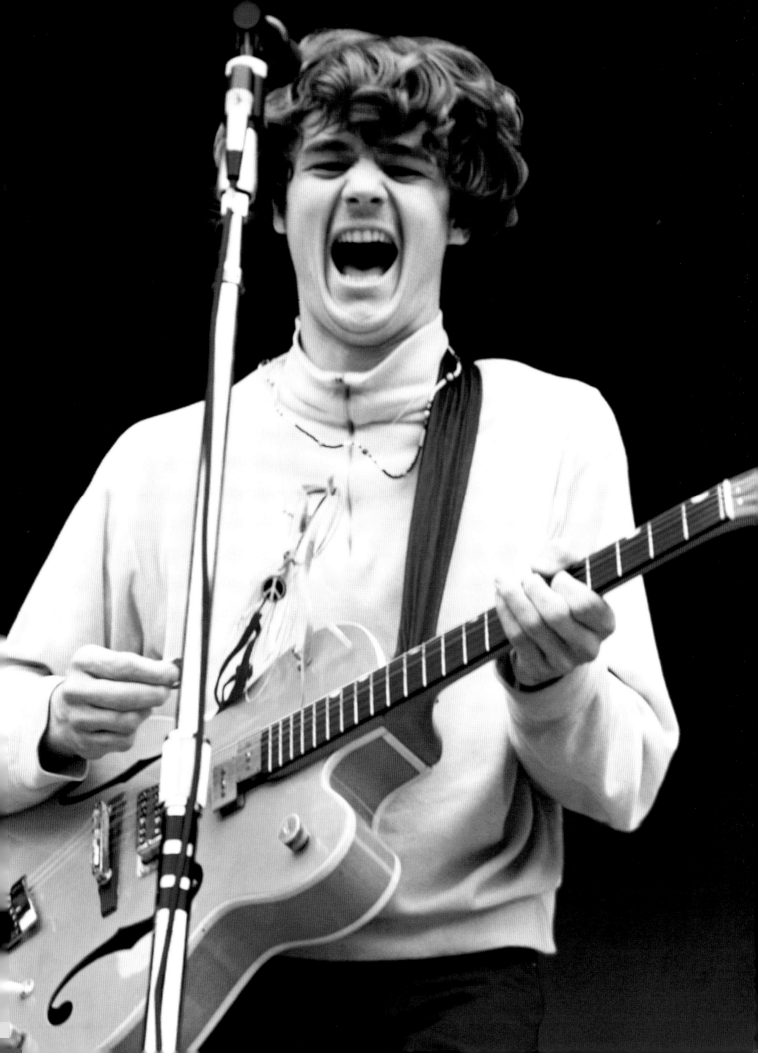

The afternoon finally concluded with—and this is in the official program—THE MIKE BLOOMFIELD THING. Posterity recalls them as THE ELECTRIC FLAG, but that name was agreed on just days before the gig. The "Thing" was the brainchild of Mike Bloomfield, the preternaturally-gifted, Chicago-born guitarist who had left Butterfield's band to pursue his vision of an Albert King-style blues with Stax-infused horns. Yes! Bloomfield had ridden shotgun on Dylan's *Highway 61 Revisited* album, jammed with all the serious cats and was quickly emerging as America's answer to England's "guitar gods," Eric Clapton and Jeff Beck. Albert Grossman signed him for management, of course, and took his proverbial pound of flesh in the form of Bloomfield's publishing. Keith Richards, no stranger to bad paperwork, would wheezily offer that that's the price of an education.

Bloomfield brought his players to Los Angeles to woodshed. They were immediately recruited to score the soundtrack to director Roger Corman's latest opus, *The Trip*, an amusingly psychedelic bug-out starring Peter Fonda and Bruce Dern, and written by Jack Nicholson. It makes for a wonderful footnote but seriously distracted the band from its primary focus. And so, when it came time to make their world debut at Monterey, the cumulative weight of expectations and lack of preparedness took its toll.

THE MIKE BLOOMFIELD THING
aka THE ELECTRIC FLAG
Mike Bloomfield: lead guitar, vocals
Nick Gravenites: lead vocals
Barry Goldberg: organ
Harvey Brooks: bass
Buddy Miles: drums, percussion, vocals
Peter Strazza: tenor sax
Herbie Rich: alto sax
Marcus Doubleday: trumpet

"Groovin' Is Easy"
"Over Lovin' You"
"Nighttime Is the Right Time"
"Wine"

Below: Buddy Miles
Opposite: Mike Bloomfield

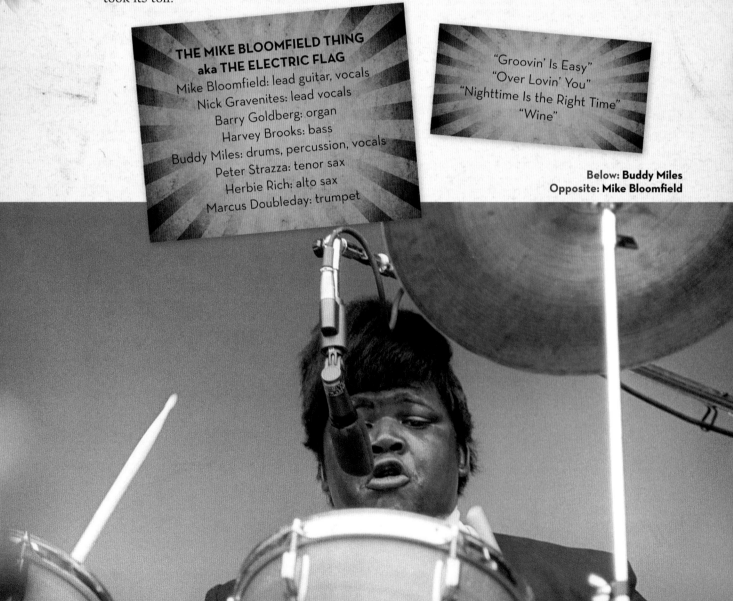

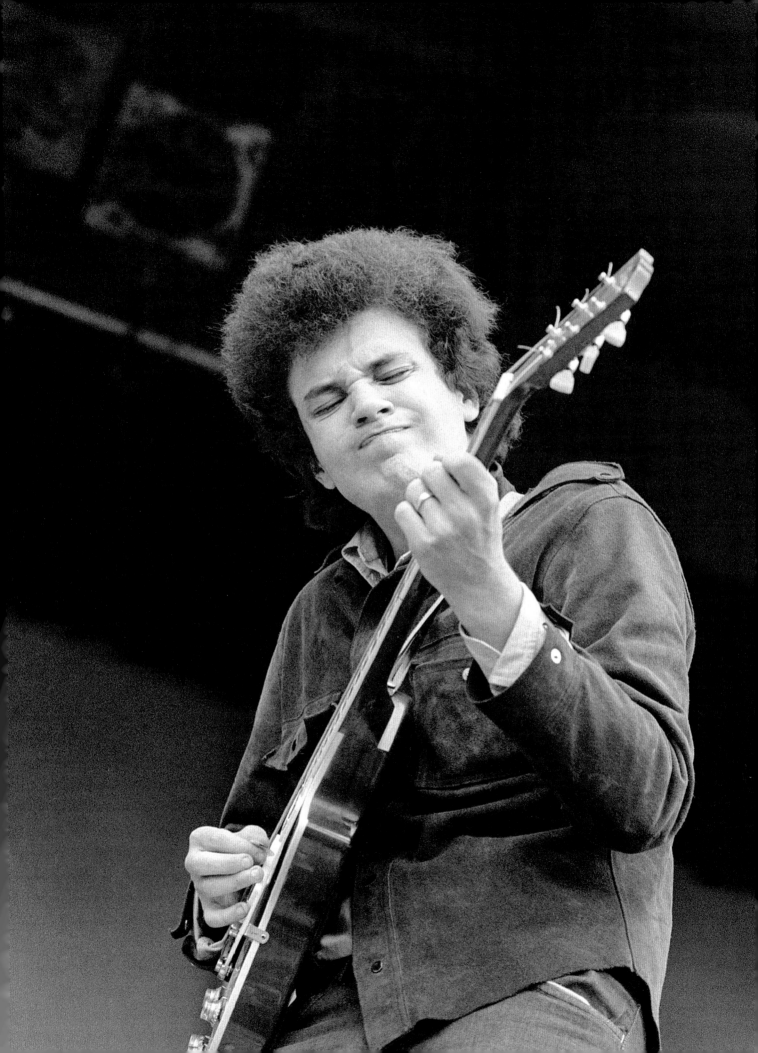

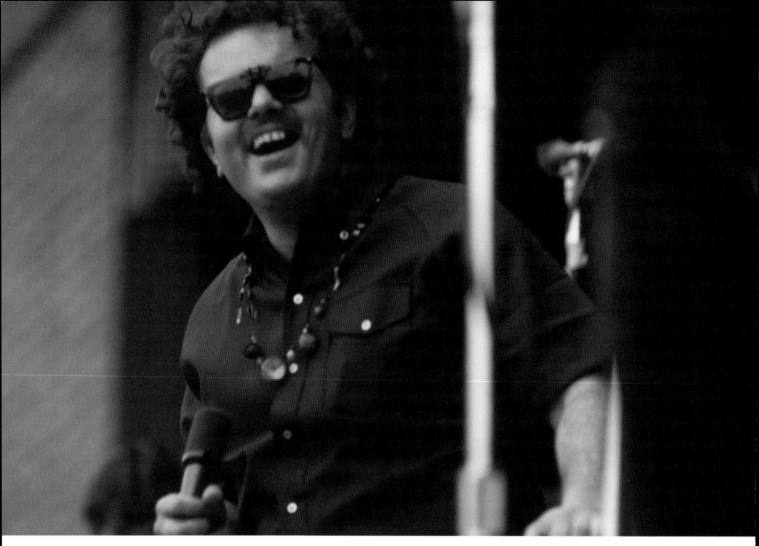

Nick Gravenites

MICHAEL LYDON (*Newsweek*): Its set was an astounding masterpiece of chaos with rapport. Drummer Buddy Miles, a big Negro with a wild 'do, who looks like a tough soul brother from Detroit but is actually a prep-school-educated son of a well-to-do Omaha family, sings and plays with TNT energy, knocking over cymbals as he plays. Barry Goldberg controls the organ, and Nick "The Greek" Gravenites writes the songs and does a lot of the singing. The group was, for the acts present as well as the audience, a smash success. The Byrds' David Crosby announced from the stage Saturday night that, "Man, if you didn't hear Mike Bloomfield's group, man, you are out of it, so far out of it."

LEAH COHEN (KUNKEL) (Cass Elliot's sister): I knew Michael Bloomfield, who was

debuting his Electric Flag band. In fact, it was at their sound check the day before, in the afternoon. I was wandering around the seats and Michael Bloomfield, who was onstage, sort of bent down, put his hands over his eyes, squinting, and yelled out, "Leah? Leah? Is that you? Come on up onstage and sit on my face." I was mortified. [Laughs.]

HARVEY BROOKS: Monterey was a great experience. I remember sitting in a room with Brian Jones and Hendrix and Bloomfield and a few other people. Everybody was tripping on a little acid and talking about how groovy everything was . . . and then someone stole my Fender jazz bass from the stage. That brought me back to reality.

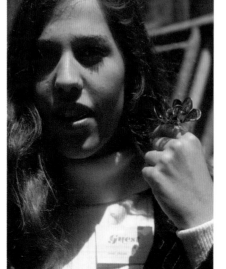

Leah Cohen (Kunkel)

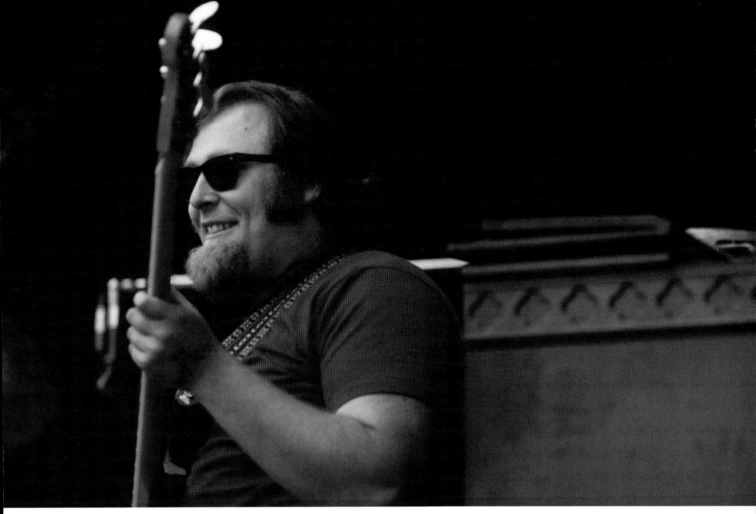

Harvey Brooks

BARRY GOLDBERG: Before Monterey, I was in a blues band with Steve Miller, the Goldberg-Miller Blues Band in Chicago. And we played with Paul Butterfield. Then Michael Bloomfield and I later started woodshedding this new concept after he left the Paul Butterfield Blues Band in 1966. We found Buddy Miles at a rock 'n' roll show when he was playing with Wilson Pickett. He blew our minds, and we all went out to San Francisco, where Nick had a house for everybody. Nick had this friend, Ron Polte, the writer of "Groovin' Is Easy," who had this electric flag that I rigged up to my Leslie organ speaker. When we put on the tremolo, it started waving. That's how we became the Electric Flag.

At Monterey, it was a relief that we were received so well because nobody knew what was gonna happen. That was a big deal. We could have blown it. But we came through. We were going to make a record and the beginning of everything we worked for, to have a successful set, to see Michael burning, to see the whole thing in orbit. The horn section worked, and Buddy sang and played his ass off. No one fucked up and did their own

thing. To this day, everywhere I go I hear somebody say, "The Electric Flag changed my life," or, "That band was something different." I've had a record label owner want me to do another Flag album because we were his favorite group. So it wasn't a band that stayed together, but what it did and for the short time it lived it really made its mark on American music.

JERRY WEXLER (Atlantic Records): Michael has this sort of naïve puppy love quality about him. I went up to Michael and his group, maybe they were the Michael Bloomfield Thing, or the Electric Flag by then. They were so good, and so I said to Michael, "We'd like to sign you up. This kind of music deserves to be on Atlantic." Michael says, "I'll have to ask Albert [Grossman]." The next day he comes up to me and says, "Gee, Jerry, I'm sorry, we can't sign with you because Albert says Atlantic steals from the niggers," naïvely quoting his manager. "Give Albert my thanks," I said, as we had a strong reputation for good royalty payments and fair dealing.

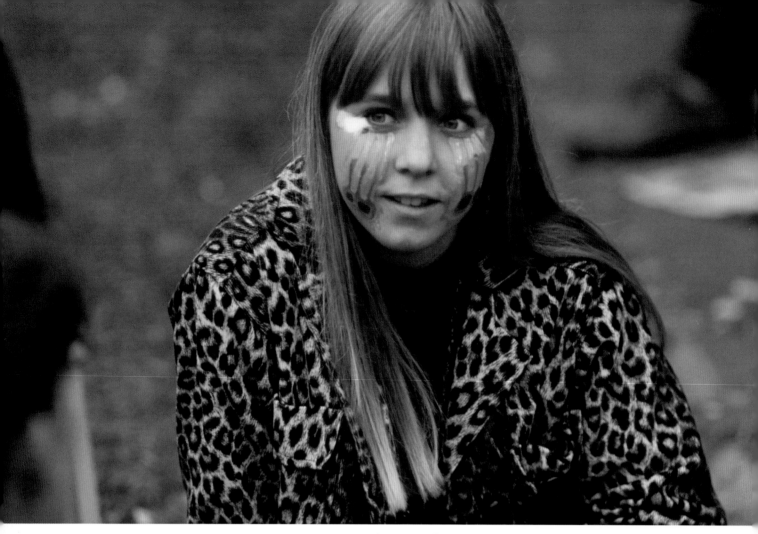

Audience member

Later, in the early 1970s, I eventually produced an album with the Electric Flag. That's not the only confrontation I had with Albert. I found him to be the most obnoxious piece of low life I had ever met in the music business. Let me tell you my take on Albert. He would speak in mysterious tongues and it would amount to unintelligible babble. And he would look at people and had them so scared they had to pretend that he was communicating. He wasn't saying shit and they didn't know what the fuck he was talking about.

All credit to Clive Davis because he grabbed up what was potential rock superstar sales with those groups that he signed. He was smart enough to do that. It didn't interest me—maybe I wasn't smart enough to hear it—and so I missed out. He put his label at the cutting edge of rock, although I bid on the Electric Flag and nearly hooked one fish.

MIKE BLOOMFIELD: I was jacked up on adrenaline. It was the end of a long afternoon, and we were the last act to play, and we were scared

shitless. Everybody we saw were old friends of ours, and it was their greatest hour.

Then Butterfield came on. He had horns. He was better, he was just—we couldn't follow any of them. And then we came out, and we weren't very good. We really weren't. We were too nervous. First number, digging my pick in and getting it caught in the string—oh, it was just so terrible. But they loved us. What a lesson that was. I learned then that if you looked like you were getting it on, even if you were terrible, they'd love you. I was saying to Barry, "What's wrong? What's happened to us?"

I have to disassociate myself from the hype. Monterey Pop was the perfect example of hype. It was a long blues afternoon. The crowd had sat through endless bands, starting with Canned Heat . . . and they all sounded great. And this was the Electric Flag's first major gig. Probably the biggest gig we ever played. And we played rotten, man. I ain't jiving you. We really sounded lousy. And the people loved it. And I could see—oh my God, the hype, the image, the shuck, the vibes.

Keith Altham's Continuing Diary

The second act of "Music, Love and Flowers" was performed today and warm rain is falling intermittently upon these fair grounds, where blues and jazz bands are blowing electric feelings out upon the Californian air to the enthusiastic thousands.

Most impressive of the bands playing this afternoon were Paul Butterfield, the Electric Flag (led by breakaway "Butterfield" guitarist Mike Bloomfield on lead guitar), and Big Brother and the Holding Company. The latter boasts a vocalist who sounds like a female Eric Burdon. This is no mean feat when you realize the girl moves and sounds like the old Eric Burdon but manages to retain her femininity. Quite a girl is Janis Joplin. By evening, the festival officials were looking a trifle worn and Derek Taylor (who but an English man could have handled the American press with such a mixture of literate charm) had resorted to a sign in his office window reading, "I cannot relate to your problem" and left for other parts.

The performance began well with Booker T. and the MGs presenting some inspired organ material. Then we got the Byrds. Pleasant were the sounds of "My Back Pages" and "Eight Miles High."

Jefferson Airplane explained convincingly with music why they are one of the most important West Coast groups to recently emerge. Soft and lovely sounds from vocalist Grace Slick.

Otis Redding topped the bill, and deservedly so—he tore the stadium apart with a power-packed delivery of numbers like "I've Been Loving You Too Long," "Satisfaction," and "Try a Little Tenderness."

Left: Janis Joplin ✳ Right: Grace Slick

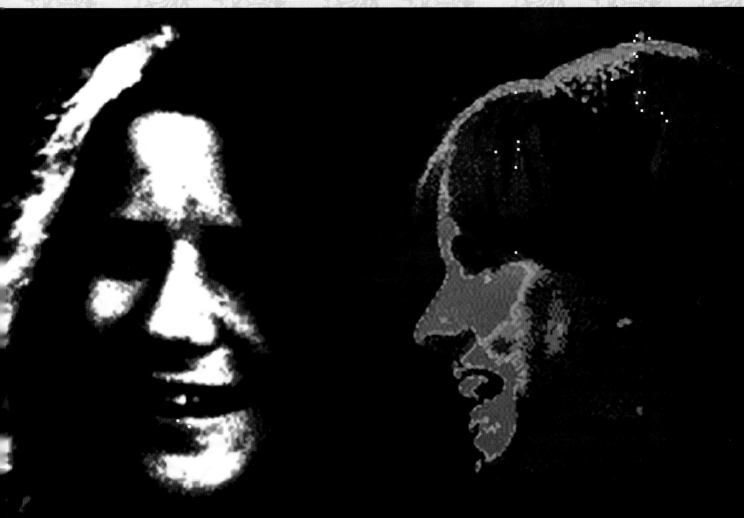

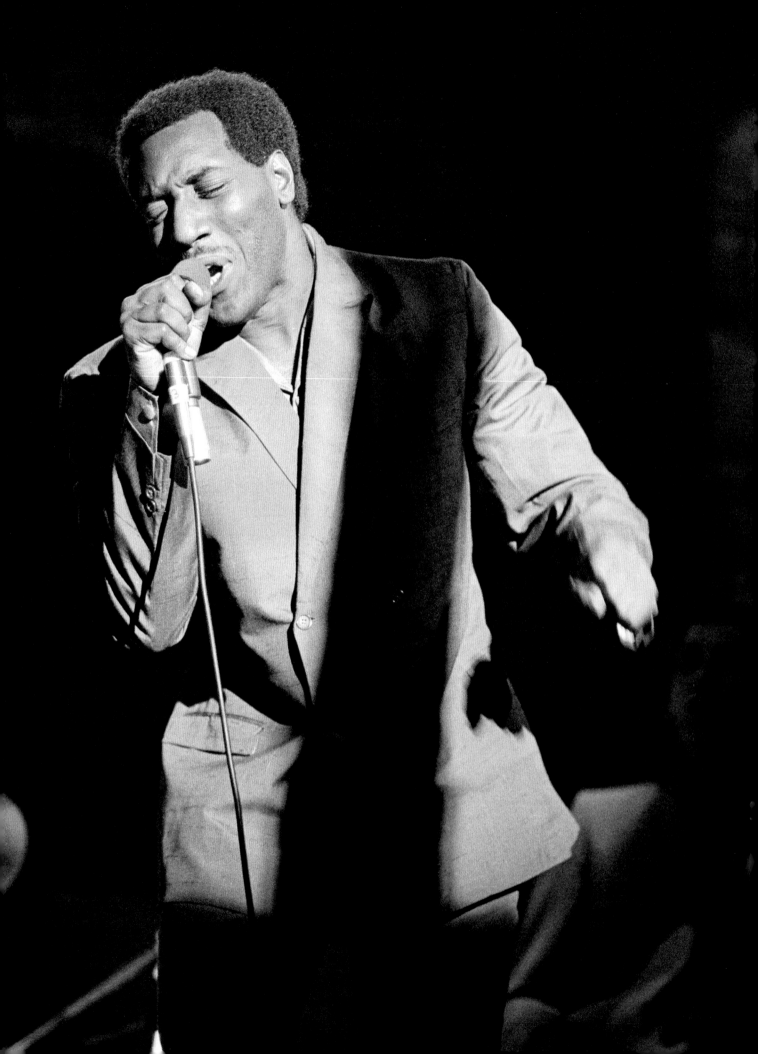

Chapter 4

SATURDAY NIGHT

Reconvening at sunset, 8,500 enthusiasts were primed for something special, something magical, something to justify hour eight on "Monterey Purple."

Moby Grape, a quintet from San Francisco, had just issued their self-titled debut recording for Columbia Records. They offered a fluid weave of three guitars and dulcet harmonies. Skip Spence, their putative leader, had once held the drum chair in Jefferson Airplane; here, he was the featured songwriter and guiding presence. Alas, they fell victim to the vagaries of being the opening act, running quickly through their set, over and out. They were not helped by an escalating rumor that drove the audience to distraction: ladies and gentlemen, the Beatles were in the house! It seems ludicrous in retrospect, but Beatle sightings were all the rage back then. With the release of *Sgt. Pepper's Lonely Hearts Club Band* the previous week, and given McCartney's well-advertised membership on the festival's board of directors, was it really impossible to imagine them arriving at Monterey to secure their status as primus inter pares? So pervasive was the Beatle buzz that the Monkees' Peter Tork was deputized to come onstage and put the rumor to rest. (This happened on Sunday night, just before the Grateful Dead came on, and underscored the popular belief that the Fabs were stalking the grounds like phantoms about to materialize.)

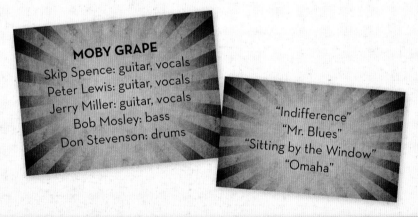

MOBY GRAPE
Skip Spence: guitar, vocals
Peter Lewis: guitar, vocals
Jerry Miller: guitar, vocals
Bob Mosley: bass
Don Stevenson: drums

"Indifference"
"Mr. Blues"
"Sitting by the Window"
"Omaha"

Music, Love and Flowers
MONTEREY INTERNATIONAL POP FESTIVAL

Opposite: Otis Redding ✳ **Above: Festival bumper sticker**

PETER LEWIS: Our debut album had just come out. We all went to a party thrown by Columbia Records head Goddard Lieberson. He had a turtleneck sweater and a little gold chain, with his hair combed down in front, and he didn't have long hair. So he was trying to look cool. And he had a party at his hotel, where I jammed with Paul Simon for a while. Janis was there because they wanted to sign her. She couldn't get arrested before Monterey. Her trip was, "One day everyone is kicking your ass, and then the next day everyone is kissing it. It does something to you."

JERRY MILLER: We played first on Saturday night because everybody was arguing. Nobody wanted to play first and I said that would be fine for me. Not the best position for breaking into show business! We were perfect. We played everything exactly right. Had we played later at any time on that show, we could have done the same as anyone else. Our original spot, opening for Otis Redding later in the evening, was given to Laura Nyro.

I saw Hendrix before his set, sitting in the dressing room, hanging out with Brian Jones. I was sitting right in front of Jimi when he came onstage. It was wonderful, especially with a pipe coming from your right and a pipe coming from your left. Pretty soon you're sitting there spinning. We sure had a good time. And Jimi got to see me, too. We were both left-handed guitarists, just a couple of schmucks from Seattle. [Laughs.]

BOB MOSELY: Tom Smothers introduced us at Monterey and Columbia paid for our rooms. Our album had just come out. I got to meet Brian Jones and talk to him for a while. I had lunch with Jim (Roger) McGuinn. We talked about recording techniques, about getting a hotter sound on guitar. He got such a good sound on his 12-string. He was telling me about peaking the needles, peaking the source, getting the right compressor, which I tried later and it worked. And we used the same Columbia studio in Hollywood. We stayed at the Tropicana on Santa Monica Boulevard. I had a TV that I rented and a girl that I rented. [Laughs.]

DON STEVENSON: Being a drummer in a band with three guitarists, I think, made me more sensitive. If it's a power trio, you're like a lead drummer. If it's a traditional band, you've got to worry about spaces as much. With the intricacy of three guitars,

I think it made me a little more sensitive to the music. I always liked playing funky shuffles. But when you have one guy [Lewis] who is a finger picker, Skippy, who would float in and out, and Jerry, who could tear it up, you had this situation where you don't want to get in the way of all that. And I kind of learned where you really have to consider the space rather than fill the space.

What I loved about Skip was that he would play guitar like a drummer. He was a drummer. He would just play rhythms, and not on two and four, but rhythms that played around inside

the patterns. And he was very ethereal. You would think it would be very difficult to have three guitars, but Skip always wound his way in and out of the picking and lead guitar parts, winding his way inside of everything that created this great tapestry. He was brilliant. Honest to God, he could have been Bob Dylan. He had that kind of insight, that kind of an edge. He didn't see things the same way that you and I might.

**Right: John Phillips, Tommy Smothers, and Mason Williams
Below: Moby Grape**

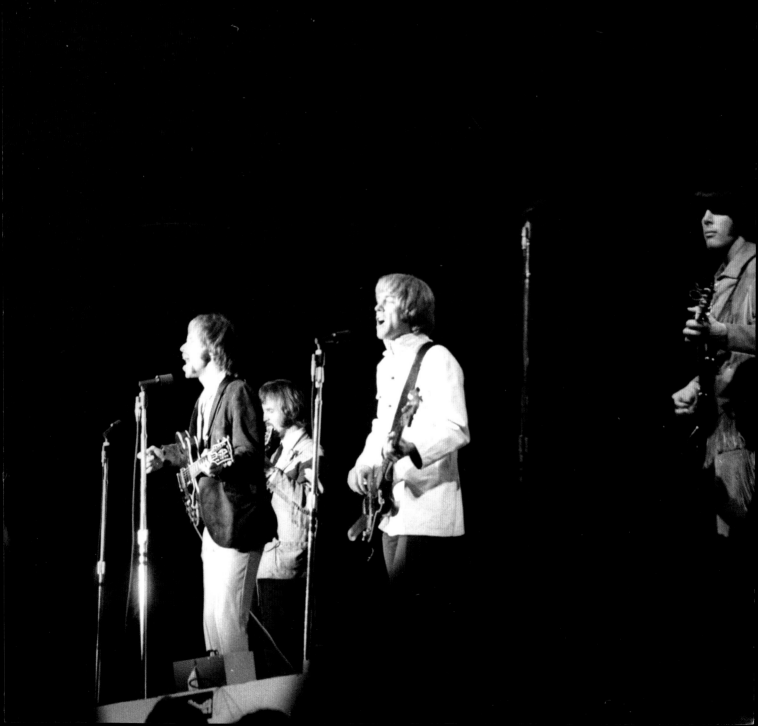

Trumpeter Hugh Masekela had just entered pop consciousness with his blazing turn on the Byrds smash, "So You Want to Be a Rock 'n' Roll Star." It was a bold move to include the native South African—an early experiment in what would later become the much-derided "crossover artist" genre. His set, featuring conga master Big Black, served up extravagant readings of other recent pop hits that fell on mostly indifferent ears. Masekela, briefly married to "Mama Afrika" Miriam Makeba, was fluent in the bewitching jazz rhythms of *kwela*, the sound associated with the black townships of Johannesburg, where he was raised. Had he drawn more deeply from that flavorful well, he might have made the impression he desired.

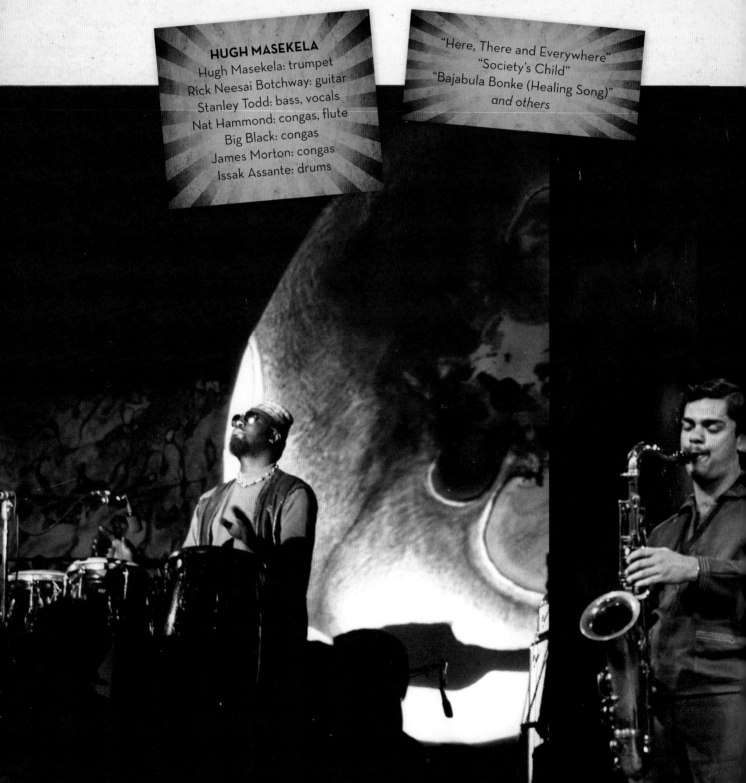

HUGH MASEKELA
Hugh Masekela: trumpet
Rick Neesai Botchway: guitar
Stanley Todd: bass, vocals
Nat Hammond: congas, flute
Big Black: congas
James Morton: congas
Issak Assante: drums

"Here, There and Everywhere"
"Society's Child"
"Bajabula Bonke (Healing Song)"
and others

LOU ADLER: Hugh was originally from South Africa, and his presence and music added to the international flavor of the festival. His performance surprised the audience. He and his band generated a great deal of excitement and electricity. Up until then, people had thought of him as a solo trumpet player and not really in the context of [leading] his own band.

CHRIS HILLMAN: Hugh Masekela at Monterey was one of the highlights, and recording with him was one of the highlights of my life. We were playing with all these South African musicians way ahead of Paul Simon, and one of them was a piano player called Cecil. And he was the great inspiration for me to write "Have You Seen Her Face." There was something that connected with me and that was where I came out of my shell, with that session. I came home and wrote "Time Between Us" and wrote songs that entire week after that session. And Hugh, we were working with Letta Mabulu, so some of that carried over to Monterey. And at Monterey we played "So You Want to Be a Rock 'n' Roll Star" with Hugh.

Opposite: **Big Black** ❋ Below: **Hugh Masekela**

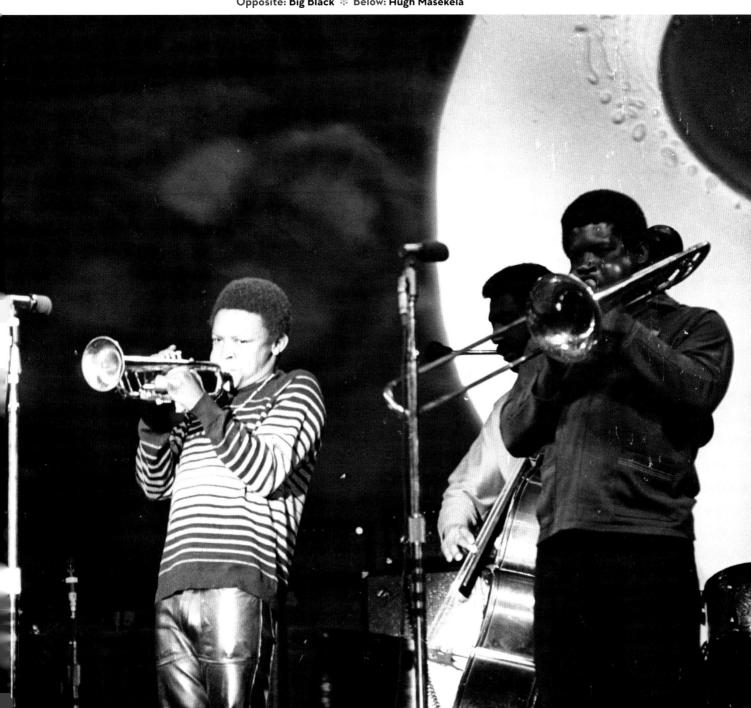

Above: **Jim (Roger) McGuinn and Chris Hillman in the audience** ❊ Opposite: **Michael Clarke**

The Byrds had been America's great hope against the English "beat group" invasion since the release of "Mr. Tambourine Man" in June of 1965. Their studio recordings were sonically charged, chiming with supple vocals, deft arrangements, and Roger (née Jim) McGuinn's signature Rickenbacker 12-string guitar. Live was another matter; absent producer Terry Melcher's firm grasp on the reins, they often floundered, inattentive to the details that distinguished them.

Self-absorption, though, was never in short supply. David Crosby had embraced pop stardom with a breathless enthusiasm usually reserved for young girls receiving ponies on their tenth birthdays. Mr. Toad had nothing on the wild rides Crosby embarked upon, aided and abetted by the finest dope and even finer women. As he sauntered onstage at Monterey, resplendent in a Russian fur hat (evincing Czarist sympathies?), he seemed tone deaf to the music and the setting. He had been secretly plotting to join the Buffalo Springfield as Neil Young's replacement (swapping one diva for another) and chose his final performance with the Byrds to clear the rafters of his over-heated imagination. As his bandmates stood by, seething in silence, Crosby nattered on about the Kennedy assassination, evoking a wing-nut's trifecta of the Warren Report, the grassy knoll, and vast media cover-up. For all his feigned outrage, Crosby appeared immune to the irony that he, himself, was conspiring against the very musicians who had made his grandiosity possible.

HENRY DILTZ: I knew the Byrds as fellow musicians. I was with the MFQ, did some sessions with Phil Spector, and also played on Bob Lind's "Elusive Butterfly" that Jack Nitzsche arranged. I know Al Kooper has said that, during the Byrds' Monterey set, you could see the group breaking up onstage and there was a lot of tension between McGuinn and Crosby. Roger was really steamed when David sat in with the Springfield. It was a different sort of Byrds set from what I'd seen over the two years before. To stand there and watch McGuinn play that Rickenbacker 12-string was mesmerizing. It just put me into a place, and the harmonies . . . Those were the songs we heard on the radio every day, driving down the Sunset Strip. I do know that at Monterey there was tension in that group. Crosby was rubbing them [McGuinn and Hillman] the wrong way, somehow.

PEGGY LIPTON: The Byrds' set was a failure. The sound wasn't right. And there were a lot of problems that I know frustrated Lou because I could see him onstage going crazy. Let's face it; the Byrds were a heavily produced studio group. You had to be Jimi Hendrix, the Who, or Ravi Shankar, whose simplicity had the power to cut through. Or the Mamas and the Papas, who Lou put together like facets of a diamond. Lou was a sound freak and would not stop until he got it just right.

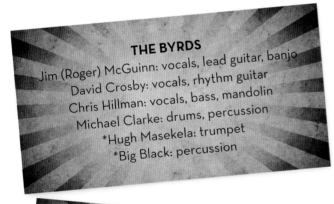

THE BYRDS
Jim (Roger) McGuinn: vocals, lead guitar, banjo
David Crosby: vocals, rhythm guitar
Chris Hillman: vocals, bass, mandolin
Michael Clarke: drums, percussion
*Hugh Masekela: trumpet
*Big Black: percussion

"Renaissance Fair"
"Have You Seen Her Face"
"Hey Joe (Where You Gonna Go)"
"He Was a Friend of Mine"
"Lady Friend"
"Chimes of Freedom"
"So You Want to Be a Rock 'N' Roll Star"*

JIM (ROGER) McGUINN: You can see our set on YouTube, with David talking about the Kennedy assassination. "Renaissance Fair," our opener that I wrote with David, was the perfect song for the festival. We had just recorded it. We were doing new material and not relying on our hit records. "Hey Joe (Where You Gonna Go)" was in the set, and it was Crosby's favorite song, and he always had this feeling that he knew the song before it was a hit. The Leaves and Love, I think, did it before the Byrds. But Crosby knew the song way before them. He always felt cheated on that. I like "Lady Friend," one of his songs. I didn't know David was going to sit in with Buffalo Springfield. What was happening was that we were not happy with each other, like a marriage breaking up. He was really upset because we didn't do his song, "Triad." That was the big bone. He wanted to be the lead singer of the Byrds, you know, the head Byrd. That wasn't happening. To his satisfaction, we were sharing vocals equally.

At Monterey I was trying to be a trooper, like Bobby Darin taught me, and try and soldier on and do it. "He Was a Friend of Mine." I was surprised by David's Kennedy rant onstage. I mean, first of all, I wasn't sure I agreed with it. My feeling was that it was not professional—an inappropriate moment. We did Chris' "Have You Seen Her Face" and Dylan's "Chimes of Freedom," that we did earlier at Ciro's, and to this day it's still in my own repertoire. I think it's a great song. I love the poetry and imagery of it, you know, and it has some political feeling but it is ambiguous. You can read whatever you want into it. Hugh Masekela had played on our record of "So You Want to Be a Rock 'N' Roll Star," and I had toured with Miriam Makeba. So I knew who he was. It was always wonderful to play with someone of Hugh's caliber on the session and at Monterey, where he joined us on trumpet along with Big Black, the percussionist. The song was a satirical jab at how they make teen idols. That was what it was all about.

CHRIS HILLMAN: Monterey was presented as an idea, not through a booking agent, but by Alan Pariser, and then later Lou Adler and John Phillips. I played the Monterey Folk Festival in 1962, or '63 with the Golden State Boys, aka the Hillmen. The Gosdin Brothers, Don Parmley, and myself. Then Alan came up with this idea, then Benny Shapiro, and Lou took it over with John Phillips. I asked, "Why are we doing this for free? Who gets the money?" "Well, it's going to charity." I'm glad to know where it ended up and now I feel better. It never bothered me. [Laughs.] I appreciate it. So, we took the booking. I remember driving up to Monterey in my 1965 silver Porsche. McGuinn and Crosby were already there. Michael Clarke was driving up in his newer Porsche, hit a deer, and almost totaled his car. We got to Monterey and the whole weekend was wonderful. I don't know where to begin.

Relations with David were so strained at that time; it was getting to the end of the deal. Here was this beautiful weekend, this diverse lineup—Otis Redding to Ravi Shankar—and our set was a

David Crosby

disaster. Crosby, you know, I mean, you could almost see in the [film] footage where Roger and I were walking away from him. He was ranting about the [John] Kennedy assassination. When I finally saw the footage a few years ago and saw our performance, and we're doing "Hey Joe" a hundred thousand miles an hour, and David had obviously ingested a few things in the LSD area. He was so unconnected to Roger, Michael, and me, no groove—just shut up and sing. Do your music. Don't do that stuff.

But what really, really upset me was the performance. I mean, oh my God. That was so bad. End of story. I was up there, I was part of it. End of story. I was such a shy little kid back then, I wish I had been as assertive and a little more confident. I would have probably straightened Crosby out a little more, 'cause nobody did. We didn't have a captain of the ship, in all due respect to Roger McGuinn. Roger was the Byrds, and he has every right now to go out and do that entire catalog onstage. Roger's great quote was, "We were a band of cutthroat pirates, stabbing each other in the back." You don't go into a platoon in combat without an officer. That's where you get decimated. We did that. We allowed that thing to happen.

Gene [Clark] had just left and had so many good songs that lent themselves to the Byrds' concept that when he was gone, we continued to do those songs. My theory is that when Bill Wyman left the Rolling Stones, they never sounded the same to me. We recovered and did a lot of great things after Gene left, but he was a very integral part of the original five people.

At Monterey we did Dylan's "Chimes of Freedom." I didn't realize how beautiful that lyric was until years later. And you gotta give ol' Jim Dickson credit—he instilled in us the concept of depth and substance. He said, "Do you think you're gonna be able to listen to this 20 years later?" And here we were, yelping about "Mr. Tambourine Man" when he brought it to us. "Chimes of Freedom," the version we did on that first album, was the band. It's just one of Dylan's beautiful songs. And he was just peaking then.

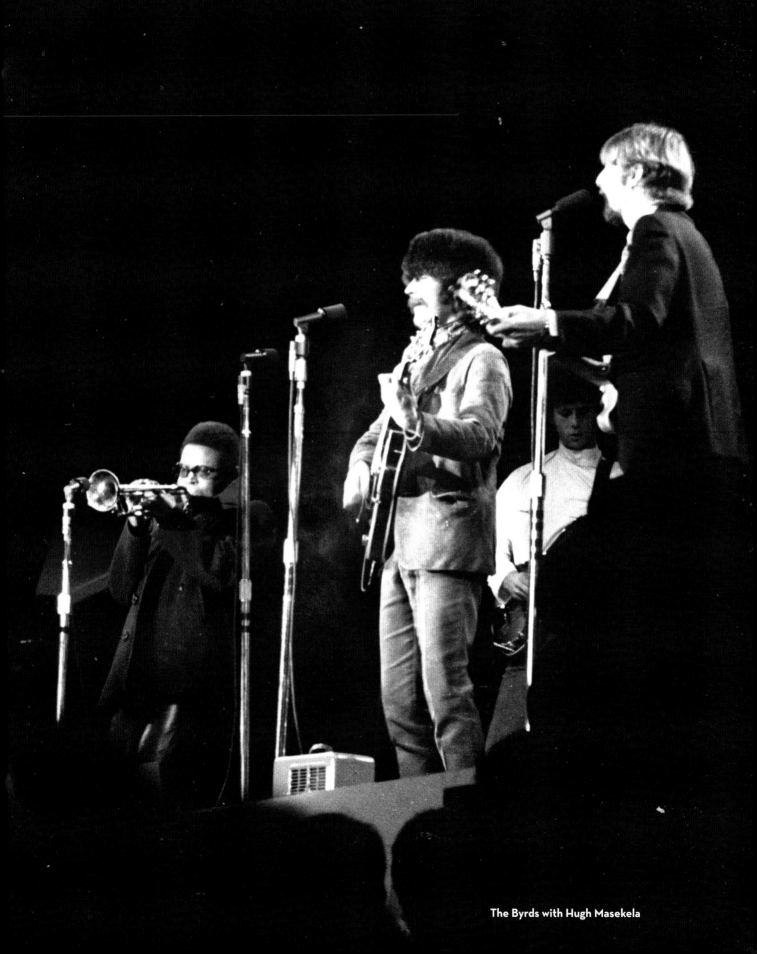

The Byrds with Hugh Masekela

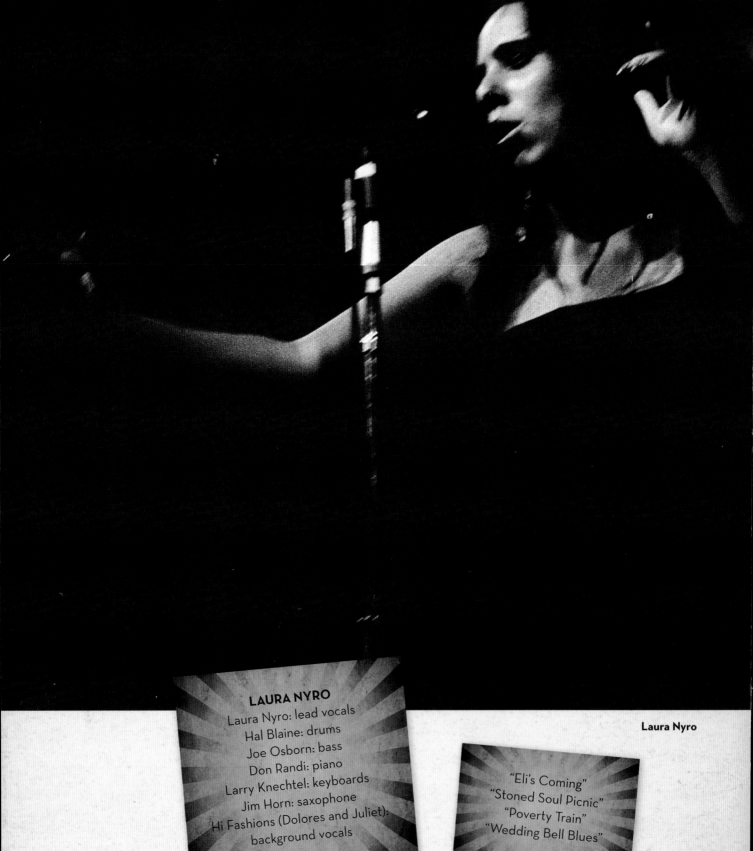

LAURA NYRO
Laura Nyro: lead vocals
Hal Blaine: drums
Joe Osborn: bass
Don Randi: piano
Larry Knechtel: keyboards
Jim Horn: saxophone
Hi Fashions (Dolores and Juliet): background vocals

Laura Nyro

"Eli's Coming"
"Stoned Soul Picnic"
"Poverty Train"
"Wedding Bell Blues"

Laura Nyro, nineteen years old, a neurotic "old soul" befitting her half-Italian, half-Jewish heritage, was Lou Adler's personal choice for the festival. She seemed to perfectly fit the mandate to introduce new and deserving talent. Within the last year she had recorded her debut for Verve/Folkways Records, *More Than a New Discovery (The First Songs)*, showcasing an alarmingly mature take on romance and recrimination, the warp and woof of the pop libretto. Her music had a little bit of soul, a dash of the blues, and that uncanny Brill Building sensibility that fit all the girl composers— Carole King, Cynthia Weil, Ellie Greenwich—like hip-hugging capris. Adler had just covered Nyro's "Stoney End," (later a big hit for Barbra Streisand) with the Blossoms for his Ode label.

If Janis Joplin's career was made at Monterey, Nyro's nearly concluded before it even began. She had almost no performing experience when she accepted the booking. She had the backing of L.A.'s stellar session elite, the "Wrecking Crew," but even they needed more than one cursory rehearsal of Nyro's hand-crafted charts. It's long been an article of faith that she was heckled mercilessly by the audience, who did not appreciate her black, off-the-shoulder evening gown with Goth appointments. It also didn't help that she smoked who-knows-what with the gang backstage. Reviews were unforgiving. For years after, Nyro proudly remembered Monterey as a necessary ass-kicking that ultimately helped her develop as an artist and performer. But in 1997, audio and video evidence was unearthed by Adler and Pennebaker that demanded a revisionist take: the "boos" were actually cries of "beautiful" from the audience. Take a belated bow, Ms. Nyro.

D. A. PENNEBAKER: She wasn't booed off stage. No. No heckles and boos. On the DVD we have "Poverty Train." The saddest thing is that she came to me when we were editing the original film and said, "Don't put me in the film." "Why?" At that time we hadn't decided everything—just the form of the film. But not all the details and who would be in. And Laura said, "I felt very uncomfortable and I thought that people didn't want me there." She felt like the bandit. It didn't suit her. Lou and I even discussed doing an additional little film with her. I talked to her about it and she was almost ready to do it. And then she died.

ELAINE MAYES (Photographer): Laura Nyro was a soulful blues type but got lost at Monterey because she was not from San Francisco. Compared to Janis, Laura was very subtle. Laura was in the wrong place at the wrong moment. She did not appear to be a hippie, and the San Francisco crowd rejected anything traditional—unless it was black, from the South, or maybe from the Midwest.

MICHELLE PHILLIPS: I only saw the last three minutes of Otis' set . . . I wanted to kill Laura Nyro [laughs]. After she came off the stage I could see that she was really, really upset and in tears. I just

grabbed her by the hand, put her in one of the limousines in the back, and said to the driver, "Let's go for a ride" so I could calm her down. And I think we were smoking a joint and I was telling her that she was great, and she said, "No, they hated me and I looked like an idiot up there." I was just trying to do the sisterly thing. I was chilling her out and came back to catch the tail end of Otis—the one act I was just dying to see.

Elaine Mayes

Jefferson Airplane, above all others, had come to define the sound of the "Summer of Love," the first San Francisco band to triumph in the national charts. Beginning with their unusual name (the smart money sussed it as a drug paraphernalia reference), the band presented the yin and yang of two lead vocalists—the erotically menacing Grace Slick and the melancholy Marty Balin. Guitarist Paul Kantner conducted the febrile support team: Jack Casady, bass; Spencer Dryden, drums; and lead guitarist Jorma Kaukonen, whose spiky filigrees were as asymmetric as his Finnish surname. Their music hewed and churned to some weird internal logic that only they could access; drug-addled, certainly, but rife with allegory and a knowing that inferred wisdom. They were the new elders of the rock nation, and the expectations of the audience were as high as the band.

There was nothing surrealistic, however, about their performance. From the opening salvo of "Somebody to Love," through the long and winding "The Ballad of You and Me and Pooneil," they conveyed a self-confidence born of technical mastery and a trustworthy intuition. Jefferson Airplane were the (Acapulco) gold standard, and their journey to the interior of the creative mind invited acolytes and smoking caterpillars alike.

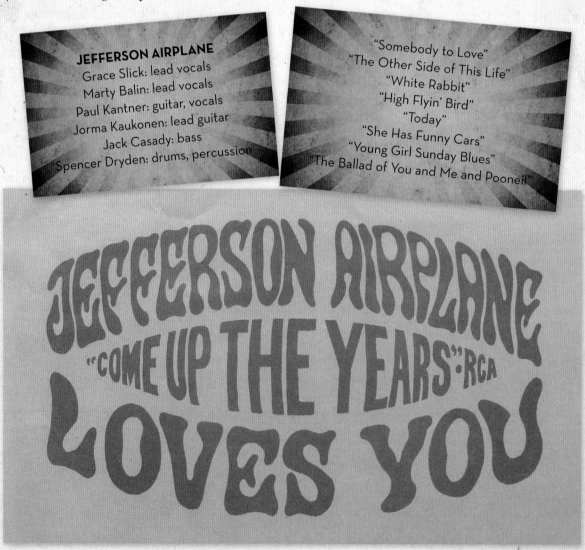

JEFFERSON AIRPLANE
Grace Slick: lead vocals
Marty Balin: lead vocals
Paul Kantner: guitar, vocals
Jorma Kaukonen: lead guitar
Jack Casady: bass
Spencer Dryden: drums, percussion

"Somebody to Love"
"The Other Side of This Life"
"White Rabbit"
"High Flyin' Bird"
"Today"
"She Has Funny Cars"
"Young Girl Sunday Blues"
"The Ballad of You and Me and Pooneil"

JEFFERSON AIRPLANE "COME UP THE YEARS" RCA LOVES YOU

Above: **Festival bumper sticker** ❋ Opposite, top to bottom: **Grace Slick; Marty Balin**
Overleaf: *(left to right)* **Chip Monck, Paul Kantner, Grace Slick, Marty Balin, David Crosby, and Jack Casady**

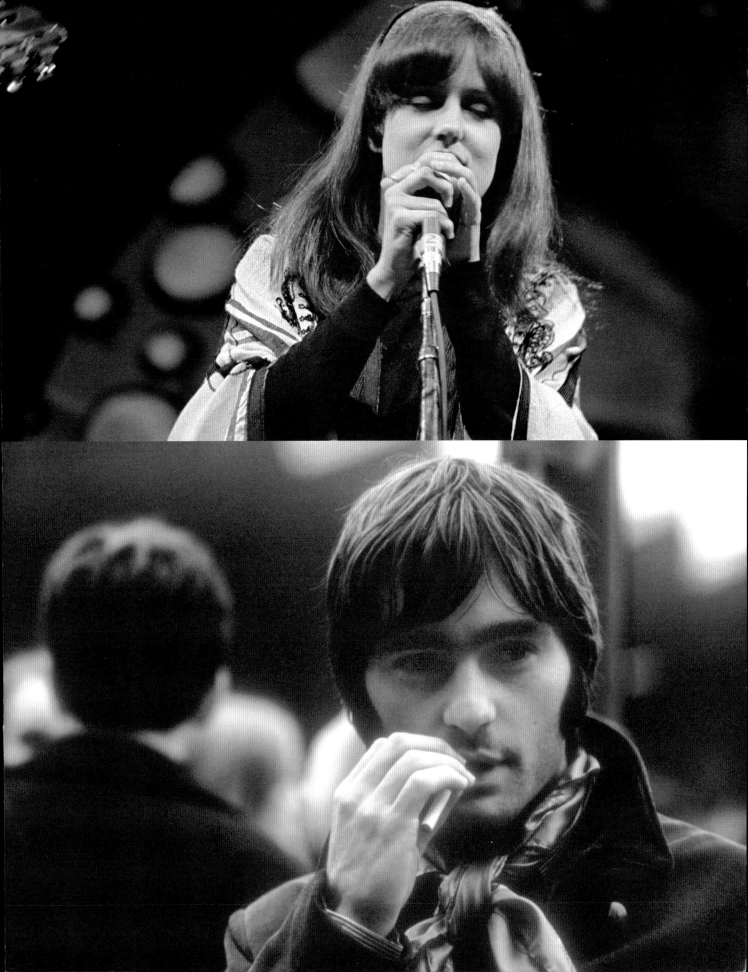

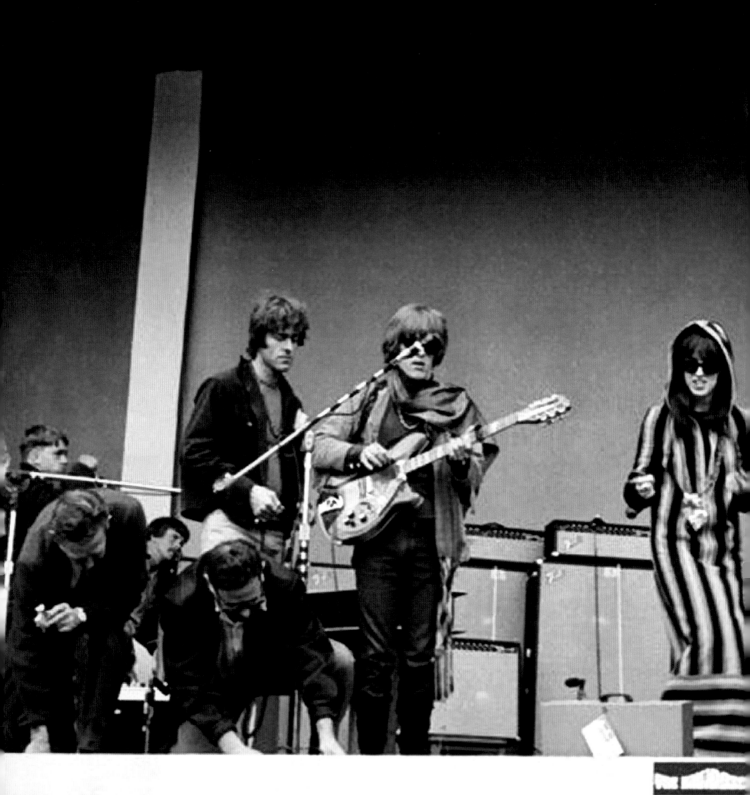

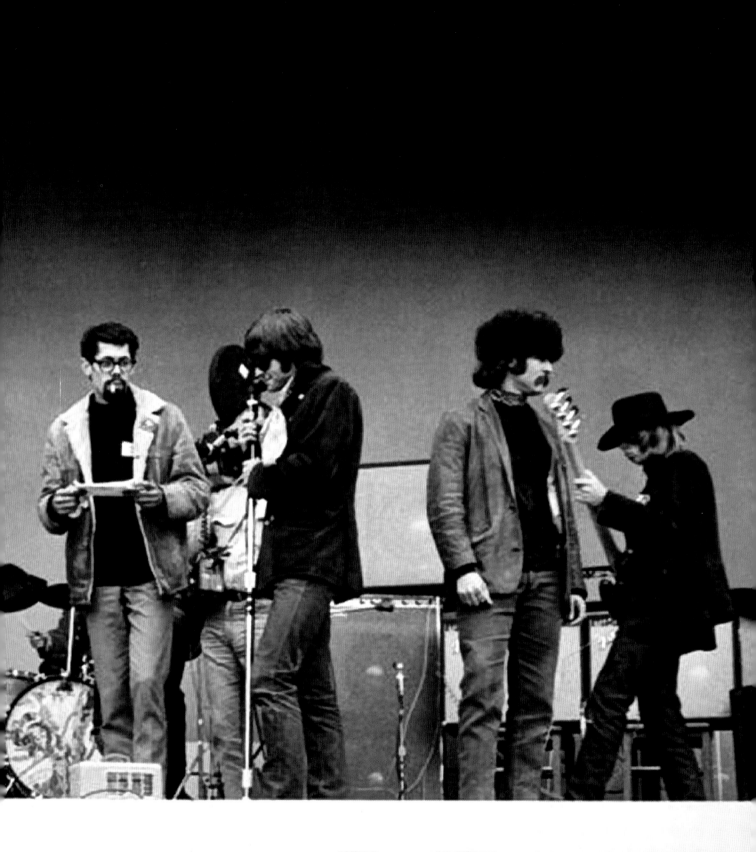

and Flowe

IONAL PAR FEST

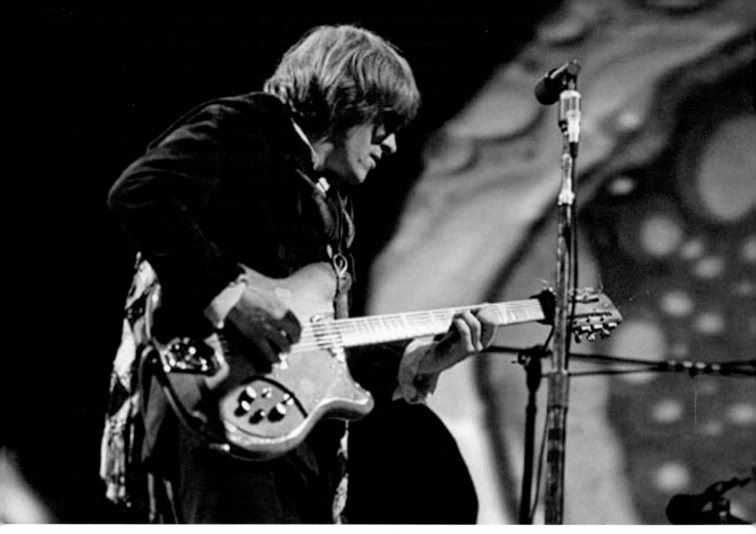

Paul Kantner

MICHAEL LYDON (*Newsweek*): Before they came on, the question hung: are the Airplane as good as their reputation? They thoroughly proved themselves. As they played, hundreds of artists, stagehands, and hangers-on swarmed onto the stage, dancing. Grace Slick, in a long, light blue robe, sang as if possessed, her harshly fine voice filling the night. In a new song, "The Ballad of You and Me and Pooneil," they surpassed themselves. Playing largely in the dark, the light show loomed above them, its multi-colored blobs shaping and reshaping, primeval molecules eating up tiny bubbles like food, then splitting into shimmering atoms. The guitar sounds came from outer space and inner mind, and while everything was going—drums, guitar, and the feedback sounds of the amplifiers—Marty Balin shouted over and over the closing line, "Will the moon still hang in the sky, when I die, when I die, when I die . . . "

JACK CASADY: In retrospect, Spencer [Dryden] was the best drummer we had. He could manipulate his drums. He had more of a jazz background. He was used to getting different sounds out of the drums. It gave a lot of variety to the beat. Grace was a very accurate singer. Marty and Paul would drift over the beat and improvise a lot. And although Grace had improvisation to her voice, she'd approach the beat correctly—right on time. They had radically different styles. At times the blend of their voices would work out magnificently. That was one of Paul's main inputs to the band—he tried to keep the vocal harmonies happening. He liked to work with harmonies and the blend. Paul's ability and desire to write about what was going around him, circumstances beyond emotional relationships or a nice tidy love song. Instead, Paul would write about news events, while Grace tended to write the curious thought patterns that would go on in her head. She would get more abstract. Grace's songs were always very interesting, chord-wise. She composed on a piano and is a very good piano player. Her mental patterns would bring images to mind that possibly you hadn't thought of before. Both Jorma and I developed a unique style of playing because Grace would give us chordal patterns and say, "Do anything you want with them." Then,

when we would come up with our contributions, she would take off on that and expand her song. It would come back around again as something different.

ART GARFUNKEL: When Jefferson Airplane went onstage, they were working with their light show in a rear-screen projection. The light show was one of these bubbles-under-a-microscope things, but it worked. And they played with their backs to the audience, as if they were in love with their own light show. I just thought it was so cool to be so hang-loose about your audience that you didn't even come to the lip of the stage and play for them. Your music held the audience transfixed.

PAUL KANTNER: The set at Monterey—we did what we wanted to do. I mean, Grace spent a whole year not doing "White Rabbit," if I'm not mistaken. I had seen Grace perform it with the Great Society. I saw them playing it down at a club on Broadway, actually. I liked Grace from the very start. I thought she had something. Apparently she did.

We had a lot of songs, so it didn't matter. We did Fred Neil's "The Other Side of Life." I did it in 2010. When I was a folkie I did several Fred Neil songs. He didn't do too many tunings. He'd tune down the low D, basically. Might do an open key occasionally.

"Somebody to Love." I'm still not tired of playing it. I'm still fascinated largely by the metaphysic, if you will, of the music itself. And why it affects people the way it does. How such a relatively simple combination of elements, be it a large orchestra, or a simple three-piece rock 'n' roll band, is able to communicate emotion to people. That connection still remains a mystery to me. If I understood it, it might ruin the whole thing, you know. But being able to manipulate it as we do is always fascinating to me. One of the reasons I started a band was to meet girls—still a good reason. It beats giving guitar lessons at a guitar store. I did that, too.

"Today," Marty and I worked up together. We wrote several things in those days. He'd bring a piece and I'd bring a piece and we'd put them

Jorma Kaukonen

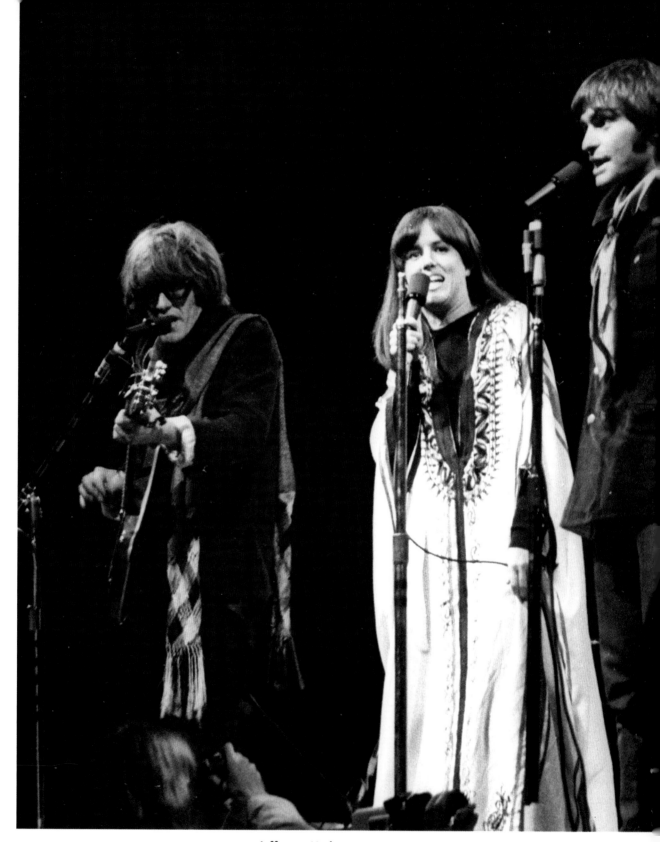

Jefferson Airplane

together and weave them. And they fell together in the studio. [Jerry] Garcia played on the track in the studio. When we took it out onstage and did it with our group, it became piano driven.

In all the bands that came out of San Francisco, not very many had good singers. We had the luxury of having both Grace and Marty in our band. Just the texture of their voices was so very attractive.

The nature of our whole band was six very different people, musically and personality-wise. Jack wasn't so much a blues player as an orchestral

something or other. Jorma was blues—Gary Davis. Grace was Grace. Marty was Marty from show biz. At Monterey, Spencer Dryden had replaced Skip Spence. He was an amateur guitar player, and we needed a drummer. And he just wanted to be in a band. "I'll be the drummer." And he had a good energy to him, although he wasn't disciplined. Spencer, on the other hand, was very jazz-oriented and knew a lot of licks. And neither of them was the drummer I would want. But it worked out pretty good. So who is to complain?

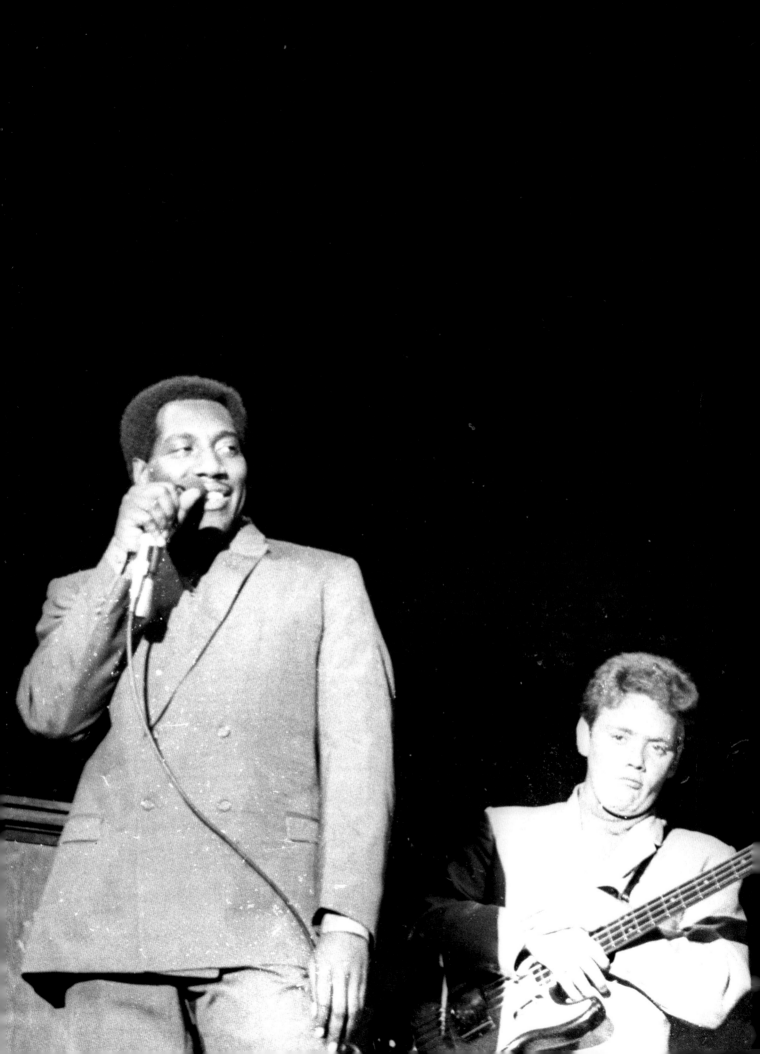

The midnight curfew was looming as the air turned damp from a light rain, as if the gods were perspiring in anticipation of what was to come. A bucking bronco from Dawson, Georgia, was pacing anxiously by the side of the stage. OTIS REDDING had recently returned from a tumultuous tour of Europe that cemented his status as the most exciting R & B/soul singer in the business. He was finding a whole lotta respect everywhere he went. His manager, Phil Walden, recognized, however, that America remained a house divided; working the "chitlin' circuit"—performing before primarily black audiences—lent cachet, but no real cold hard cash. Jerry Wexler, the Atlantic Records label chief, concurred, and encouraged Walden to accept the Monterey gig as a foothold into the exploding white rock market. Further, he helped to defray the cost of bringing Redding's crack studio team out from Memphis to ensure maximum impact. But it was getting late and some in the crowd decided to head for the exits. Moments later, they raced back to their seats as if swept up in a tidal force.

His backing band, the elegantly succinct BOOKER T. AND THE MGs, with THE MAR-KEYS' horns, stood at the ready as Redding struck right at the festival's telltale heart, shouting, "This is the love crowd, right? We all love each other, right?" before launching into Sam Cooke's "Shake."

No one image conveyed the totality of the Monterey experience quite like Otis Redding and the Stax/Volt Revue, pouncing on the backbeat as the liquid light show transmuted behind them like Morpheus under a demon's spell. Sharkskin-suited, razor cut-groomed, and pulling four-to-the-floor, this heaving music machine assailed the facile construct of a racial-cultural chasm. As fans clustered at the stage front, Redding was crowned the king of the Day-Glo coalition. However transient, it was a gut-bustin' coronation.

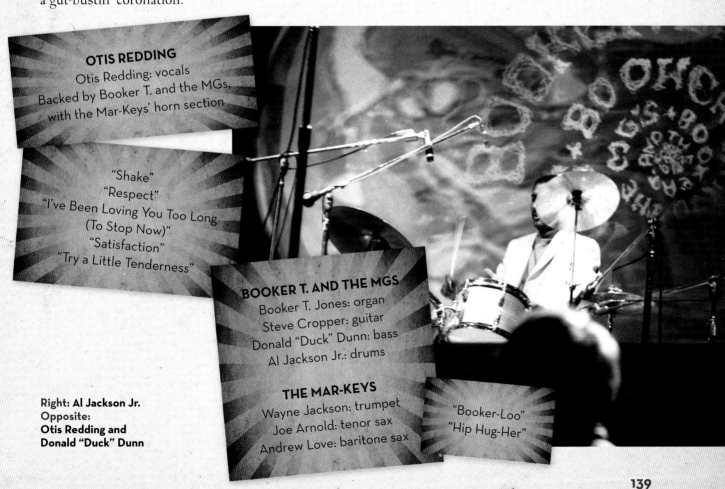

OTIS REDDING
Otis Redding: vocals
Backed by Booker T. and the MGs,
with the Mar-Keys' horn section

"Shake"
"Respect"
"I've Been Loving You Too Long
(To Stop Now)"
"Satisfaction"
"Try a Little Tenderness"

BOOKER T. AND THE MGS
Booker T. Jones: organ
Steve Cropper: guitar
Donald "Duck" Dunn: bass
Al Jackson Jr.: drums

THE MAR-KEYS
Wayne Jackson: trumpet
Joe Arnold: tenor sax
Andrew Love: baritone sax

"Booker-Loo"
"Hip Hug-Her"

Right: Al Jackson Jr.
Opposite:
Otis Redding and
Donald "Duck" Dunn

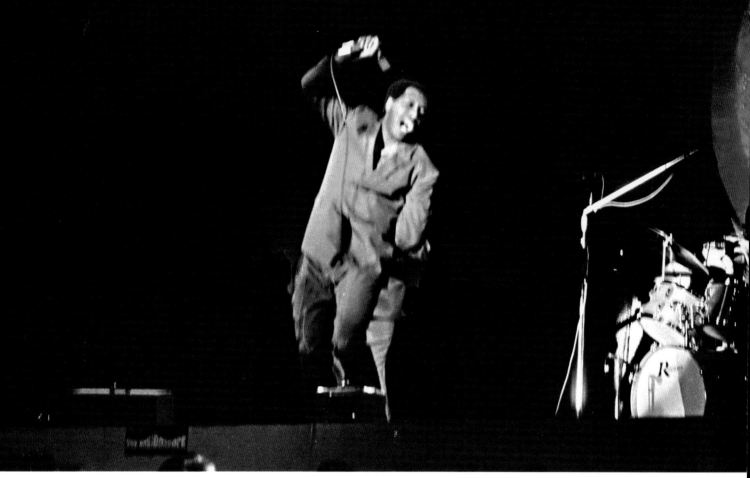

Otis Redding

JOAN BAEZ: I just sort of blew in from New York, just waitin' around to see Otis.

JANIS JOPLIN: He grabbed the audience by the lapels and made them listen. He's the most insistent singer I've ever seen. He wouldn't let you talk to anybody next you, or make out with anybody. You had to pay attention. I paid attention!

ERIC BURDON: Man, when he went onstage, backed up by the Stax house band, he melted like ice cream in the sun, his hand in the air, flashing a peace sign, saying, "This is the love crowd, isn't it?" And the audience went nuts. He dove into his set and lived up to his name as the best soul singer ever. I recall being in front of the stage, in the drizzling rain, standing next to a remarkably familiar face from the British screen (who shall remain nameless), and without any words passing between us, we were suddenly holding hands. She turned and presented me with a long-stemmed pink rose, which I promptly devoured.

ZELMA REDDING: (Wife) When Otis came back, he said to me how the festival had put five years onto his career.

PHIL WALDEN: Otis didn't have to burn a guitar. He didn't have to tear up an amplifier. He didn't even have to get down on his knees. He just got up there and performed his music.

CHRIS HILLMAN: I thought Otis Redding was unbelievable. Side note: he played the Whisky A Go Go and Michael Clarke and I went, sat down with him, and he bought us a drink. Sweet man. I remember watching Otis Redding and Sam and Dave at the Whisky, and that was just a whole other level of professionalism. We took everything so laissez-faire out here. We weren't entertainers. We weren't supposed to be a Las Vegas act. But that would have taken the whole mystery out of the Byrds or the Springfield, or any of those bands. But those guys were real professionals. They moved, they danced, and went into songs. One of my favorite

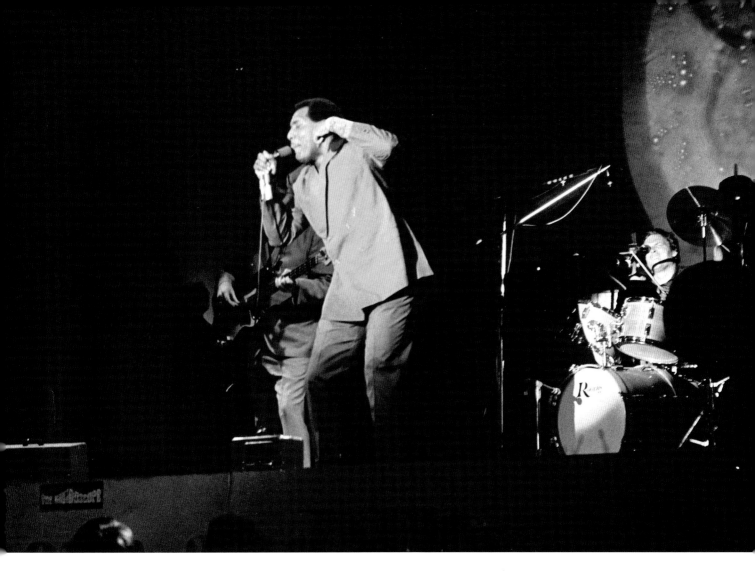

albums of that era, *James Brown Live at the Apollo*. That record is so good, you're almost there in the audience listening to that record. And that's how tight the Otis Redding band was at Monterey.

AL KOOPER: I watched Otis Redding disarm the audience. He was fantastic. The audience sort of didn't know him and he hadn't played in front of white people before. It was great. "This is the love crowd." Shit like that. They gave him a lot of love. And he had one of the greatest bands in the history of rock 'n' roll behind him. I'd seen Al Jackson before. He was like the Charlie Watts of black music.

JACK CASADY: There was so much love in the man, so much giving. He had this chance to perform in front of an all-white audience. He didn't try and make it safe, just a Memphis singer with his Memphis soul band. These guys had been heroes to me, in a certain way. I never emulated their style as musicians, but their music was absolutely part of me. Al Jackson gave me some of the best

advice any musician's ever given me about beat and rhythm. Onstage, Otis would goose it up, and Al would be right there. Now, that's different than speeding up because you're nervous. He had it under control—he did it with a controlled manner of excitement. This was not a Motown act. They represented something slicker, more thought out. The Motown acts weren't as raw and didn't project sexual overtones like Otis did. Plus, his band was racially mixed. That was something fairly unheard of in the South. And they were one of the best bands in the world. They made almost all the tracks for Stax-Volt Records. People in the music business or who paid attention to music knew about them. They mirrored what was going on in the times. So there was a different kind of "integration" at Monterey. It was the meltdown of a lot of stereotypes for people.

WAYNE JACKSON: Initially it was going to be Otis and his guys who went on the road with him. It was Jerry Wexler who said, "No. They want to hear the

sound of Stax." The UK audience knew it as the Stax/Volt band—the Mar-Keys and Booker T. and the MGs. They loved Otis Redding like we all loved Otis, but the band at Stax was the diving board he jumped off of. You can tell the horn sound. Me, Andrew Love, and Floyd Newman sound a certain way. All those records had that in common. All those records had Steve Cropper's guitar, Al Jackson's drums, Duck Dunn's bass, and Booker's organ. Those things are very distinctive and that made up Stax sounds. And that's where Otis came from. So Jerry Wexler was really hip to say that.

When I was with Otis, he was on another energy track. He was like a 16-year-old boy with a hard-on all the time. Because all he could think about was writing a song and getting into a studio. That was his life.

JERRY HELLER (Booking Agent): Monterey was the first festival I had gone to, but I had been dealing for a couple of years with George Wein at the Newport Festival. I was handling Otis and just met him through Phil Walden, a colorful character, who was his manager. I had never seen Otis live before, only on film from the Olympia Theater in Paris. And Otis was a big man. He was like Aaron Neville. He could just blow you away with his sheer power and intensity of his voice and his lyrics. The reason I was at Monterey with Otis was that I said to Joe Glaser, my boss at Associated Booking, "This guy can be a major, major pop star." This guy can be a big rock 'n' roll star.

After Monterey I called Bill Graham and Otis did the Fillmore West. We made arrangements to play a number of dates. I talked to promoters, Wolf and Rissmiller in L.A., and guys all over the country who were my guys, to book Otis. I was going to get him real money. We were really positioning him. But remember, he had already done the Stax/Volt Revue in Europe, and look at the hits he had written already.

ANDREW LOOG OLDHAM: When Otis came onstage, you forgot about the logistics. We knew we were taking one small step forward for mankind. Phil Walden, his manager, was in heaven. He knew he'd just graduated from buses to planes.

JERRY WEXLER: Otis' show at Monterey astonished me. He nailed that audience of weed heads in a way that was astonishing to me, because that was not his core audience. He nailed those hippies! That was unreal. "This is the love crowd." At Monterey, part of the deal was that I got to watch Booker T. and the MGs, Cropper, Duck, and Al Jackson in front of the audience. Naturally, we brought Booker T. and the MGs out there to be his backing band. A very loud, fantastic rock band went on before them, I think Jefferson Airplane, you know, with the 20-foot Marshall amps and all of this, so it was roaring.

Now Booker T. and the MGs open their show with their little Sears Roebuck amps, and you know what, it quieted down. The way you control a noisy crowd is—if you are good—you play soft. You don't try and out-volume them. So they had it set up and were so good, they commanded so much attention, and when Otis came on the crowd was ready. Listen, not only did I like Steve Cropper as a guitar player, I consider him a monumental road map to a new kind of way of guitar playing. Something he and Cornell Dupree, the only two I knew that could do it, to play a kind of rhythm and lead at the same time. When he played, there would be a little turnaround, a little obbligato, a little sting, a little fill, and it was single string.

STEVE CROPPER: At Monterey, we didn't have to do sound check, rehearsal, nothing. Just plug in and go out there and play. Our clothing was different than the flower children. And that was the start of "be yourself and do your own thing." It was freedom from teachers, from home, from parents, from society. That's how that all got started. It was all around the Vietnam time; we felt very governed by the government, that they were gonna tell us what to do, when to do it, where to do it, and how to do it, because of the [military] draft.

Everything Otis touched, he made it his own, like Sam Cooke's "Shake." All of those things, you listen to them, and it's sort of like a great actor, like if Gene Hackman takes a part, or if James Stewart takes a part, they become that character. And at the time you watched it, you became part of them. You know what I'm saying? You don't think about somebody else doing it.

Otis had found his audience, and Monterey helped him cross over to a wider white pop market. They already knew how big he was in Europe, and Europe was not an ethnic rhythm and blues audience. It was more general. He was big in France and he was big in England. Phil Walden

and Atlantic wanted that same kind of recognition over here, and they were finding it very difficult to get pop radio play. No problem getting R & B play whatsoever. So we knew what we wanted to do. Without question, the Stax/Volt tour itself, of England and Europe, changed everybody's life. It changed the musicians and the executive end.

BOOKER T. JONES: That was a different time on planet earth. When we flew into Monterey, the atmosphere was unlike any I had ever experienced in any city or town before. I don't remember seeing any police cars. I remember a free feeling that I had never known could exist in America. For instance, a hungry person could walk into a restaurant and get a meal without paying, with no problem. It seemed as if the city was open, totally open. I was moved by it, because that was such a special time for the human race. It was amazing to see that. It was amazing to see even Hell's Angels being helpful and nice! The whole city was like that, and it spread to everyone there. And it really affected me. Otis melded the blues style with the Sam Cooke style and the Little Richard style. All those styles were there in Otis. No other singer did that. And we were working with him and felt really special to be makin' music with him.

Otis Redding and Booker T. and the MGs

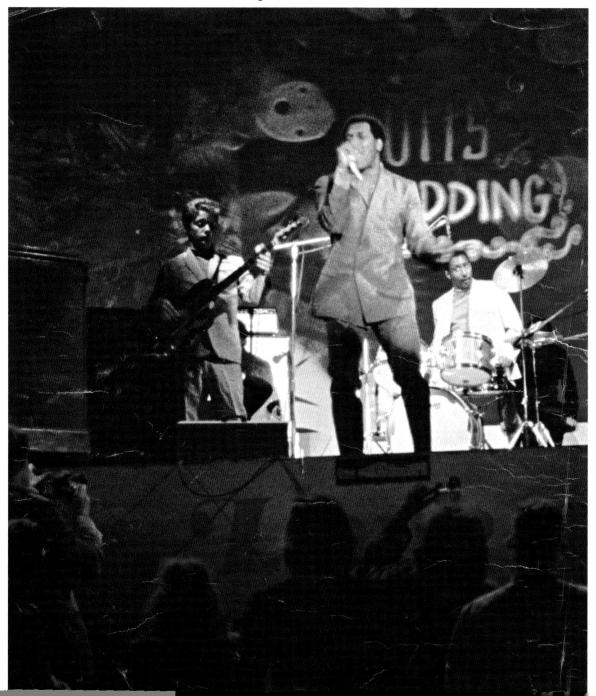

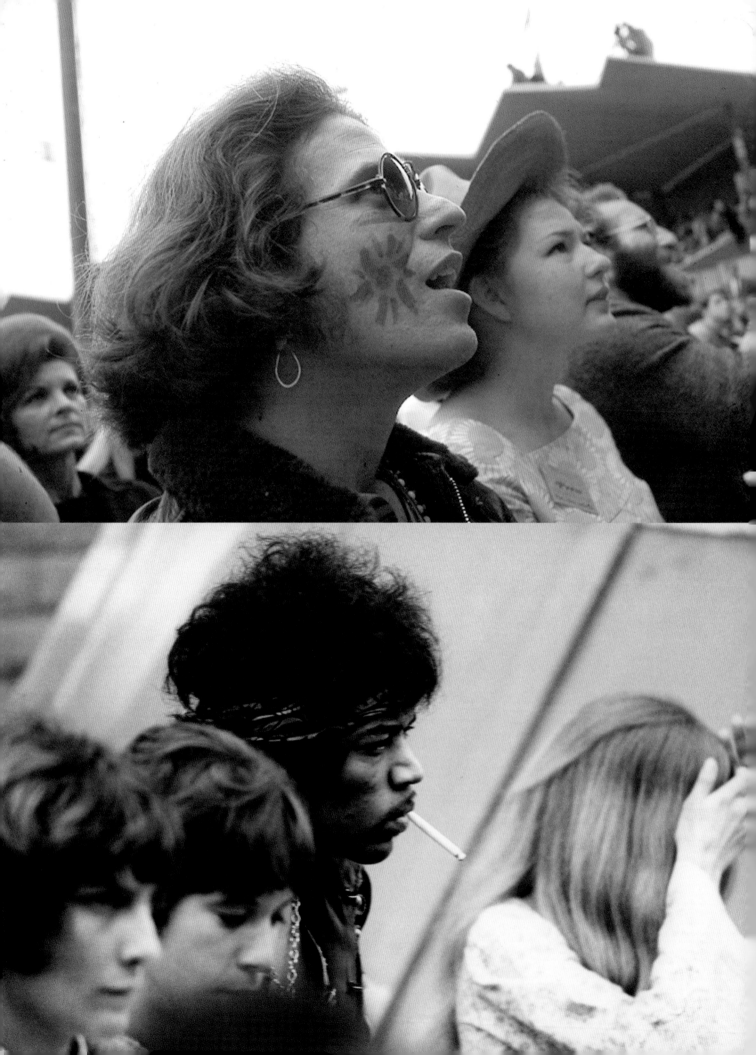

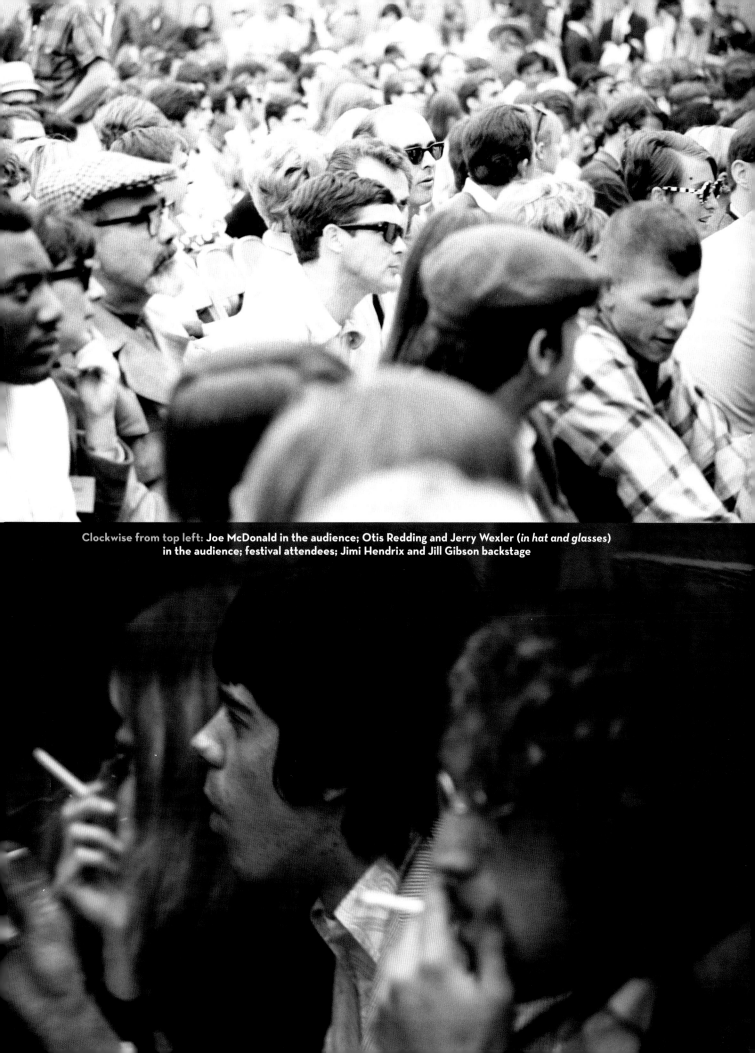

Clockwise from top left: **Joe McDonald in the audience; Otis Redding and Jerry Wexler** (*in hat and glasses*) **in the audience; festival attendees; Jimi Hendrix and Jill Gibson backstage**

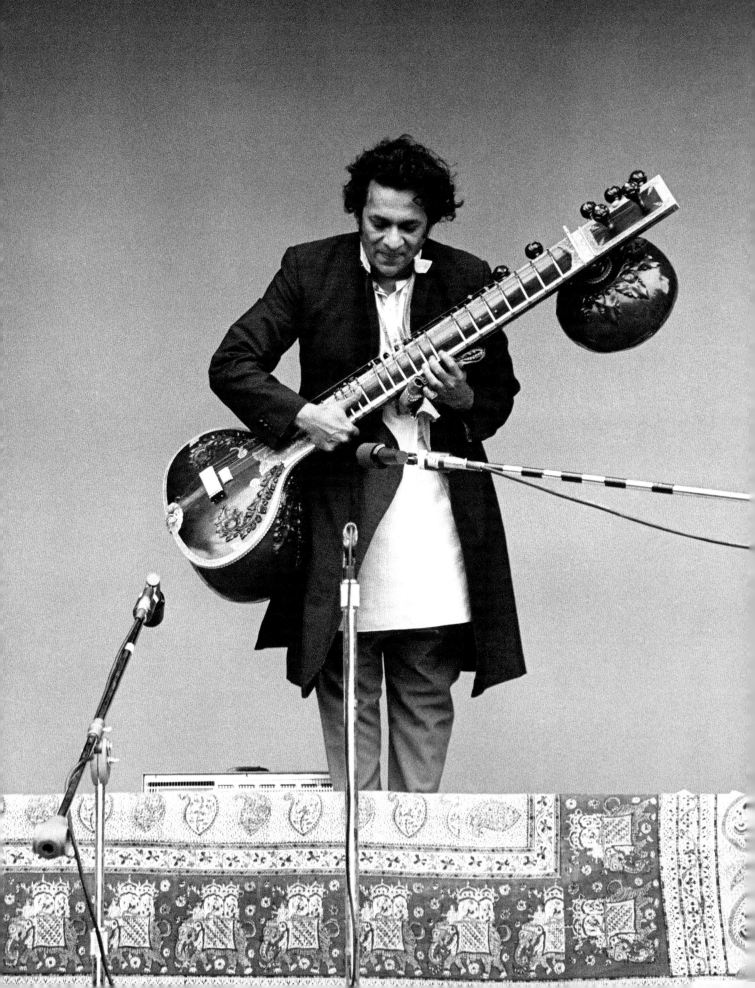

Chapter 5

SUNDAY AFTERNOON

On Sunday, September 11, 1966, the Rolling Stones performed on *The Ed Sullivan Show*. Besides the general astonishment of seeing them on national television, there was the added *frisson* of spotting Brian Jones, grinning devilishly beneath his blond fringe, thrumming the sitar, that voluptuously-shaped, multi-stringed instrument from India, during their performance of "Paint It, Black." John Lennon would later scoff that "everything we do, the Stones copy four months later." Yes, it was on the Beatles' 1965 LP *Rubber Soul* that George Harrison first introduced this exotic taste from the Indian subcontinent to eager young Western ears. But Jones had captured the spotlight—"so that's what it looked like"—and his own obsession with classical Indian music and its foremost practitioner, RAVI SHANKAR, became the latest signpost of cool.

Soon, the mysteries of cumin and cardamom, of saris and sarods, began to infiltrate the Cloroxed sanctity of America's bedroom communities. Johnny Carson, stuffed uncomfortably into the newly-fashionable Nehru jacket, quipped about yogis and gurus and the search for enlightenment ("all hail Carnac, seer from the mysterious East") to his drowsy demographic while their children planned a great escape along the hash routes to Goa, the ultimate "magical mystery tour."

Ravi Shankar was the only artist who performed at Monterey to receive payment. Benny Shapiro had produced his concert at Los Angeles' Dorothy Chandler Pavilion in May and was committed to making him the centerpiece of the festival. His fee—$5,000—was honored out of respect for Shankar's status as a world historical musician. He first played in America in 1956, and began recording for the Los Angeles-based label, World Pacific Records, in 1957. Shankar's musical interests were ecumenical; he sought out Western classical collaborators (most famously, violinist Yehudi Menuhin) and agile jazz men like saxophonist Bud Shank and bassist Gary Peacock. Given the paramount role improvisation played in the *ragas* Shankar interpreted, it was not surprising that he identified so strongly with the self-expressiveness common to all great jazz artists. "Bird" was back, albeit with a pungency more redolent of the Bay of Bengal than the smokehouses of Kansas City.

RAVI SHANKAR
Ravi Shankar: sitar
Alla Rakha: tabla
Kamala: tamboura

"Raga Bhimpalasi"
"Raga Todi-Rupak Tal" (7 Beats)
"Tabla Solo in Ektal" (12 Beats)
"Raga Shuddha Sarang-Tintal" (16 Beats)
"Dhun in Dadra and Fast Teental" (6 and 16 Beats)

Opposite: Ravi Shankar

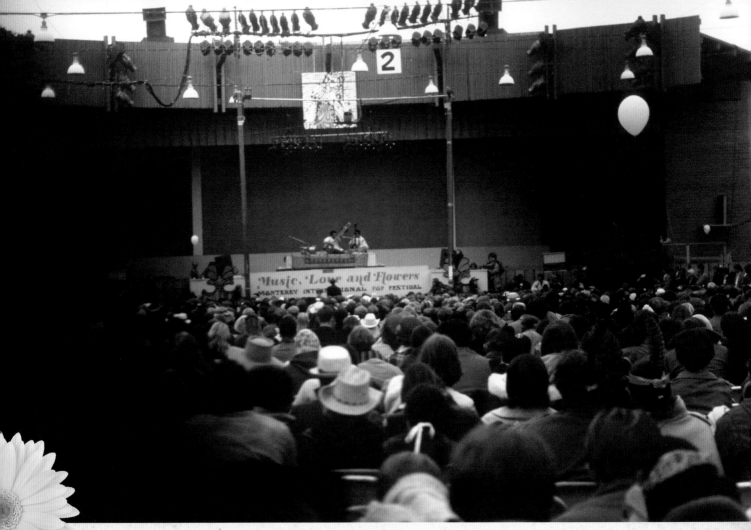

Above: **Ravi Shankar performs for the Monterey audience** ✳ Below: **Brian Jones in the audience**

Sunday afternoon was damp and dreary, with threatening skies casting a pall. But shortly after 1:30, Shankar, tabla virtuoso Alla Rakha, and the feline Kamala, on tamboura, took their traditional positions on an ornamental rug, the air perfumed with soothing sandalwood. They began to tune, and tune, and tune some more, eliciting a patient, drifting calm reminiscent of Mother Ganges herself. Over the next three hours, 7,000 listeners sat transfixed by the succulent twang of the sitar, the incessant drone of the tamboura, and the puckered tub-thumping of the tabla drums. There was a rigor and discipline at work that mesmerized like the feral dance between the cobra and the mongoose. It was exhausting and revitalizing in equal measure, the audience showering Shankar with flowers and rapturous applause at the conclusion. Brian Jones smiled sweetly.

MICHAEL LYDON (*Newsweek*): It was all brilliant, but—in a long solo from the 16th century—Shankar had the whole audience, including all the musicians at the festival, rapt. Before he played, he spoke briefly. The work, he said, was a very spiritual one and he asked that no pictures be taken. The paparazzi lay down like lambs. He thanked everyone for not smoking, and said with feeling, "I love all of you, and how grateful I am for your love of me. What am I doing at a pop festival when my music is classical? I knew I'd be meeting you all at one place, you to whom music means so much. This is not pop, but I am glad it is popular."

RAVI SHANKAR: Monterey, to me, was like a revelation, completely new. I had met George [Harrison] before that, and that started the whole big hullabaloo, as you know. I saw the whole folk movement that started in England. That's when I started seeing all the strange dress and the smell of patchouli oil, the hash and LSD. To me it was a

Right: **George Harrison and Ravi Shankar at the Esalen Institute in Big Sur**
Below: **Ravi Shankar and Kamala**

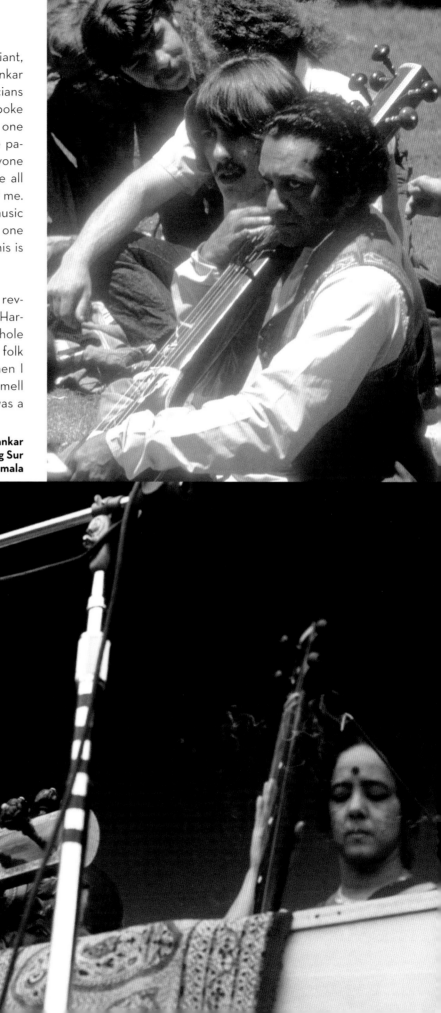

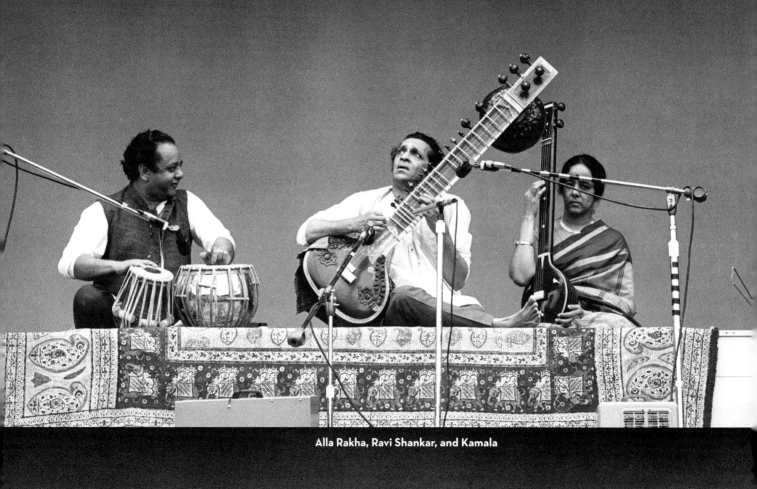

Alla Rakha, Ravi Shankar, and Kamala

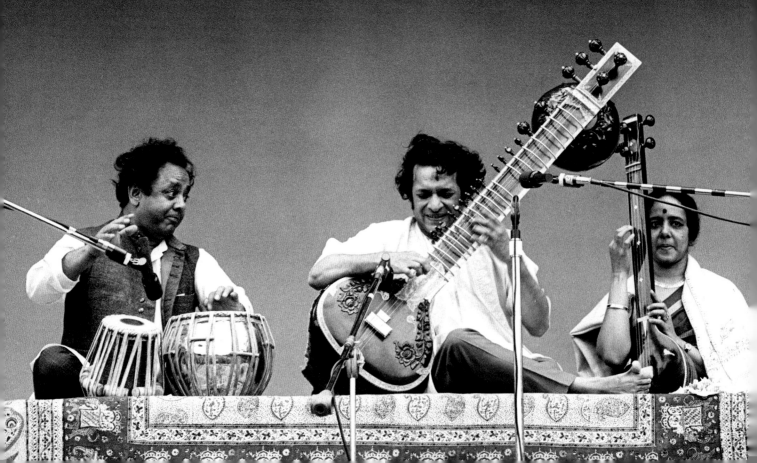

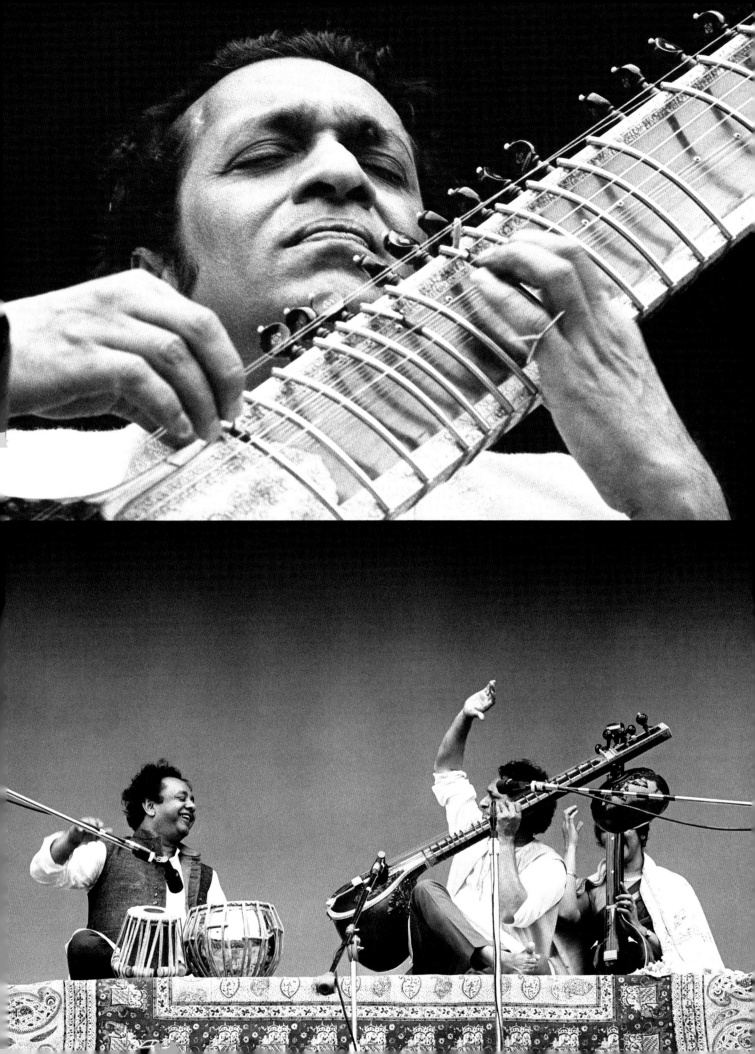

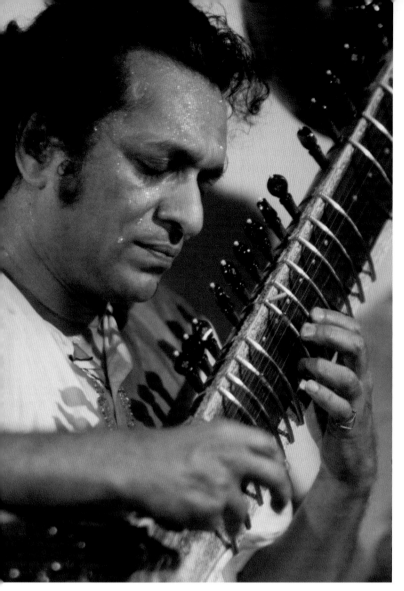

Ravi Shankar

impressed; it is one of my memorable performances. I didn't plan for this. I was grateful to God that I was sitting in the atmosphere without anyone disturbing me. It drizzled for a few minutes and then it stopped. So, it was cloudy and there were flowers from Hawaii and, you know, what atmosphere! After my set, it was crazy. I have never felt such a commotion of this sort. I was so pure, in spite of the fact that there were many people who were also strong. But it didn't matter, because the whole atmosphere was so clean and beautiful and I could give my best. That's all I can say.

BILL HALVERSON: On Sunday, Wally [Heider] went back to his motel as Ravi Shankar was about to perform. "It's just a sitar player. You can do it. Don't worry about it." I was helped by Grover, our maintenance guy. When I started to set up—and you can see it in the *Monterey Pop* film—there is the regular stage and then this platform. And I go to put microphones up there and Ravi's people come up to me and go, "No. You can't put anything up here on the platform. We blessed it, and it's sacred, and you can't put anything up here." "But we're gonna record." "It doesn't matter. You can't." So, when you look at that, you see that the microphones are down on the stage and not on the platform, and the mike stands and the microphones are just sorta leaning in. I had no idea what I was doing; that it sounds so good was just the gods smiling down on us.

JIM (ROGER) McGUINN: I was sitting in front to see Ravi Shankar. And we were into him because of his records on World Pacific, which was a very cool label. I met Dick Bock. I knew Benny Shapiro, who was a friend of Dick's, and Benny was the catalyst to getting us signed to Columbia. And, we turned the Beatles onto Ravi. He was one of the few artists I actually went out into the audience for. I didn't go out in front a lot, and that actually goes back to when I worked with Bobby Darin earlier in the '60s, when

new world. Anyway, I had been performing in the United States since 1956, including Carnegie Hall. My first fans were jazz buffs and jazz musicians and average American people. So, a decade later, I arrive in Monterey and see butterflies and colors and flowers with peace and love. It was fantastic. I was impressed, but everyone was stoned. But that was all right and I was meeting all these beautiful people. It was one day before my concert and I went to hear the whole thing. That, to me, was the real experience. One night, I heard Otis Redding. He was fantastic.

The next day, in the afternoon, we set up a special section between 1:00 and 3:00 PM, where there would be no one in front of me and after me. It was cloudy, cool, it had rained a little, and that's when I played and it was like magic. Jimi Hendrix was sitting there. [Jerry] Garcia was there. I remember a few names. All of them were there and you can see on the film what magic it had. I was so

he had me come backstage one night after his gig at the Copacabana about people and other performers talking when he was onstage. I was sensitive about being a [fellow] performer and not going out front. But I sneaked out to see Ravi. [Laughs.]

HENRY DILTZ: Ravi Shankar was our hero. All you ever heard in Laurel Canyon before the festival in the afternoon was his music and incense burning. It was just the soundtrack to our lives. At Monterey, everyone was in a trance. Not just the audience, but the others artists in the crowd, like Michael Bloomfield and Hendrix, were really getting into it, too.

MICHELLE PHILLIPS: No one was smoking, no cell phones [laughs]. It was three hours of uninterrupted meditation in the afternoon. It probably had a great effect, but first of all it was dark in the sense that most people had their eyes closed . . . I'm not sure if it would have mattered if it was day or night. It was just being in the presence of those musicians. The Beatles had sort of introduced it to us, but we had never heard Ravi Shankar in concert. But this was something new to the entire audience. It was as a kind of "born again" experience.

JERRY DE WILDE (Photographer): He was so easy to photograph because he's so animated. It wasn't like somebody up there just playing music. Ravi was really emotionally and physically involved in his music. And the audience couldn't move. I had never experienced that before. Not like this. I had seen spiritually uplifting opera at the Met, in New

Kamala

York in the '50s. I remember seeing Louis Armstrong and Coltrane, as he was gravitating toward more meditative music. Thelonious Monk, Bill Evans, and Miles are in that same group. I could say the same for Hendrix. Armstrong said there's only two kinds of music, "good and bad." You know . . . and better. [Laughs.]

MICKY DOLENZ (The Monkees): But to be honest, it wasn't just Ravi Shankar. It was the tabla player, Alla Rakha, and Kamala on tamboura. Being a drummer myself, I remember the time signatures and the rhythms. This guy was playing in 13/7 or something crazy like that. I was blown away. Right after Monterey, during the height of the Monkees' thing, I built a home studio and spent thousands of dollars. I bought tablas and a sitar (and a maple-neck Stratocaster) at Wallichs on Sunset and Vine.

Alla Rakha, Ravi Shankar, and Kamala

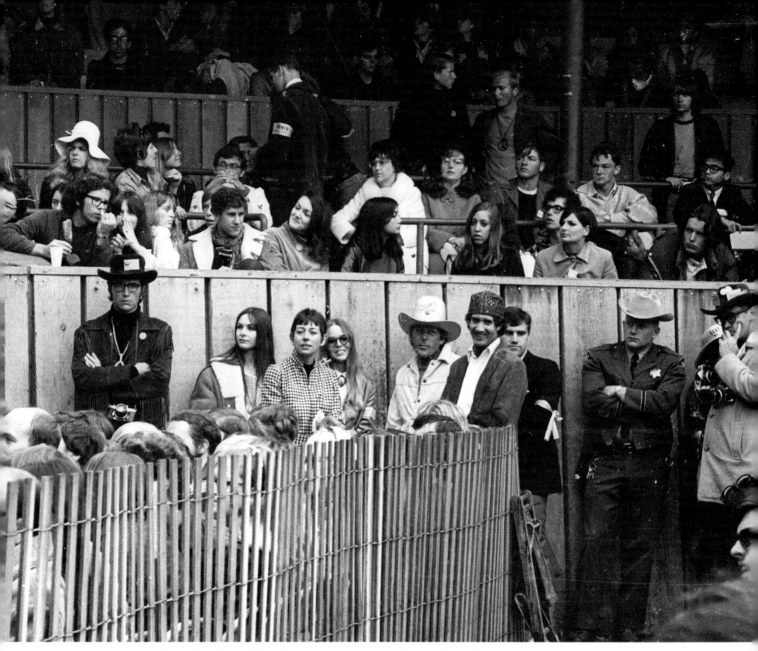

Above: (*standing, left to right*) John Stewart of Kingston Trio, unidentified woman, Joan Reynolds (*in plaid jacket*), Michelle Phillips, Nick Reynolds (*in white cowboy hat*) of Kingston Trio, and Rodney Bingenheimer (*standing with hands on railing, upper right-hand corner*) ❊ Opposite: Photos from Lou Adler's scrapbook

BARBARA VERSINO (Audience Member): It was my junior year of high school and my friend Richard and I heard about the festival on KSAN. His parents let him have the car for that weekend. We went with our friend, Scott. It was a gentle atmosphere and we were little kids compared to a lot of the people there. I remember we bought a big bag of cherries and walked around and shared them with people we didn't know.

We already had tickets for Sunday night, but then we got tickets through a friend I had known from hanging out on Telegraph Avenue. He came running up and had two tickets for Ravi Shankar for that afternoon. I had no idea who he was.

I knew about the sitar instrument from the Beatles' *Revolver* album, but the opportunity to see that kind of music was very new here. I was transported. It was life-changing. I wasn't high on anything, no marijuana or LSD [laughs]. Ravi's music went into my soul. It had this power and hypnotic sense about it, and I just wanted it to last forever. I realized that there was more to music than rock 'n' roll.

To this day I can remember what I wore: a green dress that I bought at Cost Plus, sandals from India Import, a white knitted shawl, and a string of blue glass beads. I didn't bring a jacket with me! On the drive home, we were all quiet and the car radio played the Beatles' "A Day in the Life."

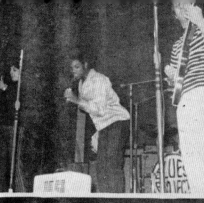

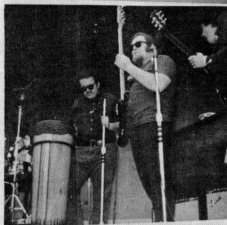
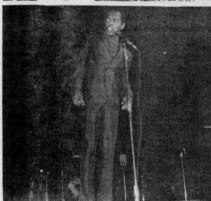
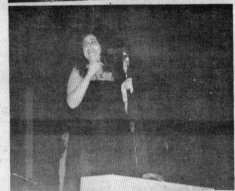

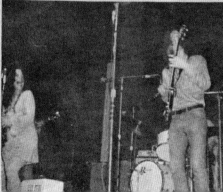
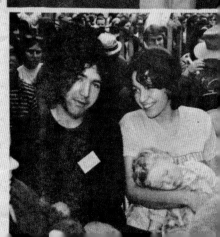

photo's by

Hal Marshall

Vic Briggs had established himself in the bustling London R & B scene as a guitarist of exceptional taste and versatility. In 1966, he joined the New Animals, Eric Burdon's reinvention of American blues with a splash of psychedelia. Songs like "Sky Pilot," and "When I Was Young," were visceral and musically adventurous in ways the "Boom Boom" version of the band could scarcely imagine. As he explains in this deeply felt reflection of his experiences at Monterey, Briggs's exposure to Eastern music and mysticism would transform his life profoundly. He left the insanity of the rock 'n' roll lifestyle to pursue a spiritual path, changed his name to Vikram Singh Khalsa, then to "Antion (Meredith)," and moved to Hawaii and, later, New Zealand, where he has lived for years, pursuing a life in native music and contemplation. By his own reckoning, this amazing journey began at Monterey.

VIC BRIGGS: One of the highlights of the festival weekend was Ravi Shankar's concert on the Sunday afternoon. About an hour before the performance, I made my way into the enclosure in front of the stage with prime seating reserved for festival performers. Since I was the first person in the arena, I made sure I got the best seat in the house, then sat and watched as the seats around me filled up.

The weather was gray and miserable, with the hint of a light drizzle falling—typical Monterey Peninsula summer weather! The same conditions prevailed for most of the weekend.

The fairgrounds were situated in the flight path of the Monterey Airport. Every 10 minutes or so, a light plane or passenger jet took off with a roar that blotted out most of the sound from the stage. The cloud cover was so low that the offending monsters were all but invisible; occasionally a dark shape could be glimpsed through the clouds.

Finally, Raviji took the stage, accompanied by Alla Rakha, his longtime musical cohort, on tabla. As someone who has done plenty of awful gigs, I know well the look on the face of an artist who does not want to be at a place where he has committed to perform. Raviji had that look.

He sat down on a carpet-covered dais in the middle of the stage and began to tune his sitar. Incense was burning on the stage and a small electric heater had been placed near the musicians. Every time a plane roared across the sky, Raviji looked up with utter contempt on his face, and then resumed tuning. I happened to glance at my watch when he came onstage, then again when he was ready to play. He tuned his sitar for a full half

hour. It seemed to me that he was procrastinating. He was not acting like a man who was ready or even wanted to play.

Then magic happened. As he reluctantly finished tuning and put down his sitar, the crowd stood as one and gave him an ovation. The energy shifted. Raviji gave the first hint of a smile and said, "If you liked the tuning so much, perhaps you will

World Pacific Records ad welcoming
Ravi Shankar's U.S. tour, March 1967

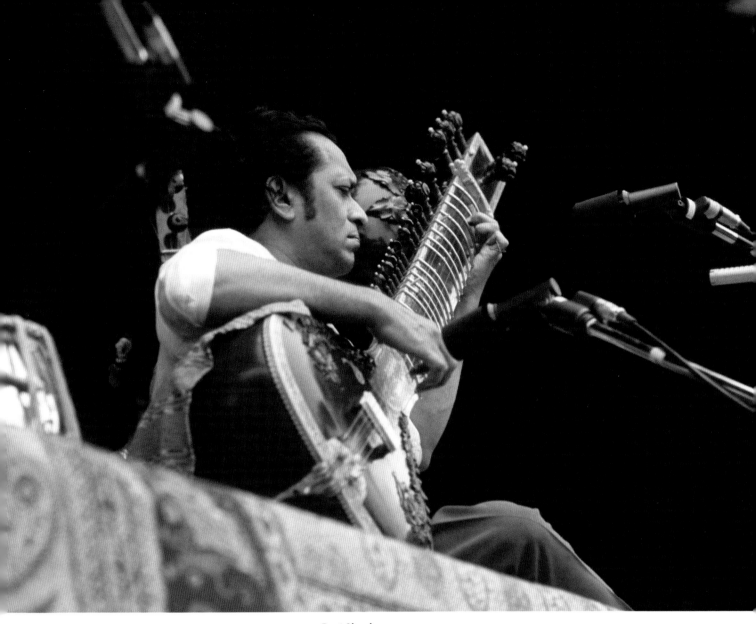

Ravi Shankar

enjoy the music."

As is customary in Indian classical concerts, he began with a formal interpretation of an appropriate *raag*. In this case it was Raag Bhimpalasi, a powerful raag, suited to the afternoon. As he played the *alaap* (the long melodic introduction), you could see him beginning to relax. He would still glare at the sky as an occasional plane impinged upon the music.

One raag followed another and the rapport between audience and performers grew deeper by the moment. Finally, during a *sawal-jawab* (musical question and answer) exchange between Raviji and Alla Rakha, a plane flew overhead. This time, instead of glaring, the two of them were having so much fun that they both just shrugged their shoulders, laughed, and carried on with the music.

The final composition, a *dhun*, done in the traditional Thumri style, built to a climax so intense as to be almost unbearable. A few minutes later the performance finished and the crowd rose to their feet. There were standing ovations, flowers, and tears. And a wonderful feeling that, just maybe, the world could be healed through music.

The next morning we arrived at the Monterey Airport to catch a flight back to L.A. There, also waiting, were Raviji and Alla Rakha. At that point in my young life, I had been around so many of the top names in the music business that I was not easily impressed. But seeing Ravi Shankar up close, I was quite starstruck and felt more than a little nervous. I approached Raviji and told him how much I enjoyed the show. After he thanked me, I found myself at a loss for words. He graciously continued the conversation by asking me where I was from and we made polite conversation for a few minutes.

LISA LAW (Photographer): My husband Tom and I lived at the Castle in the Los Feliz area of L.A., which was a sort of upscale flophouse for itinerant musicians—Dylan, Lou Reed, and Mike Bloomfield were among the "flopees" at different times. In 1967 we moved to Marin and hung out in the Haight-Ashbury, documenting everything that was going on, me with my camera and Tom writing for the *Oracle*. We were involved in a lot of events that were happening in the Panhandle as well, concerts and feeding the hungry with the Diggers.

The first music festival was the Fantasy Fair at Mount Tamalpais. Tom and I set up our teepee and it became the trip tent for those who needed a place to get away from the activity of the concert. We did that at Monterey Pop, too.

**Clockwise from top left:
Victor Maymudes; Stanley Amos,
Carol Wayne, and Nina Wayne;
a "trip tent"**

David Wheeler, Victor Maymudes, Nina Wayne, Tom, and I met with the chief of police early in the morning of the concert, and that's when we discussed working with the crowd, rather than busting anybody.

The day of the concert, the head of the department, who worked with Chief Marinello, made a unilateral decision. What he did was buy a bunch of daisies and when he met with his officers in the morning, he said, "We're not going to

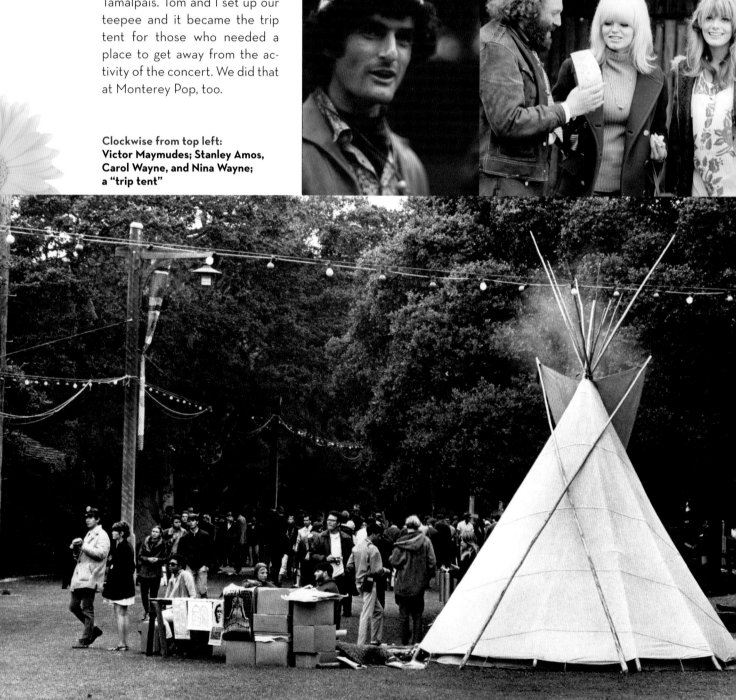

A Happy Chief

(Herald photo)

Monterey Police Chief Frank Marinello was so pleased
about the trouble-free Pop Festival weekend he found
time for a little turnabout play in taking a picture of
a Herald photographer who was trying to photograph
the chief. See Page Five for photo coverage of the

bust anybody unless they are out of hand or out of line." He had them wear flowers in their helmets and on their bikes. "This is going to be a love-in," he said. And this man made Monterey Pop what it was. Without his decision, it would have not been that way. There were only two busts, and they were redneck cowboys who were loud and drunk and bothering the hippies.

I didn't take many photos because I was helping the tripsters. Most people were high on either pot or acid. We were there to calm people down who were tripping out. The teepee was like a womb. There was a fire inside so that when people came in, they became peaceful and didn't freak out.

Monterey was the first time people were really conscious of music. I believe that psychedelics, LSD, mushrooms, and cannabis had a lot to do with that. It changed the way songs were written and the way people listened.

Monterey was big, and I'm sure Mount Tam and the Human Be-In influenced it. I was only involved in a little bit of the preparation for Monterey Pop, and the only group that I photographed was Ravi Shankar. I was looking forward

to his appearance. That's why I went over to the stage. I was near Tom, who was having a very electric experience, as was almost everyone else.

TOM LAW (Audience Member): I was at the teepee but left to check out Ravi Shankar. That was unbelievable for me because Owsley had passed around some acid. There was a moment when he was playing this morning raga kind of a thing and these Navy jets, three of them, you heard them coming in the distance with this beautiful music, and then all of a sudden they were right over the whole place. This devastating, crashing, blatant, obnoxious noise, and then they went soaring. They were basically buzzing the festival. Right?

So Ravi just leaned back and let them go, and as the noise started to fade from those jets he came in with this magic. And it wasn't just all the psychedelics we were on. Believe me. He just came in with peals of beauty and dripping music like you never heard before to counteract that. It was such an improvisational moment in the history of the world, I think. To me, I'll never forget it. He was bringing the East to the West. He was also counteracting the ugliness of war with the beauty of music, you know. It was unbelievable.

I think Monterey and Woodstock are joined, and not only because Ravi played at both—Monterey didn't have the problems Woodstock had, the weather and the huge impact of all those people. Monterey was the beginning of those concepts that we took to Woodstock: to treat people responsibly, with the expectation that they would act responsibly in return.

On my 50th birthday, Mel Lawrence reminded me that we sat around for a couple of hours at Monterey smoking hash with Jimi Hendrix. [Laughs.] It was good hash. There was camaraderie with people like Mel and Chip Monck. We can talk like it was yesterday. I mean, there's no space that has to be conquered between us.

Tom Law

Artwork from the Monterey International Pop Festival annual

"Purple Craze"

Augustus Owsley Stanley III, the scion of a prominent Kentucky patriarchy (his grand-father was a U.S. Senator), occupied a unique niche at Monterey Pop: chemist-in-residence. More specifically, the legendary "Bear" had brewed a special batch of LSD—designated "Monterey Purple"—for this lofty occasion. No one who attended the festival would deny that these little treats were as central to the experience as the music itself. They were gobbled like after-dinner mints, harmless (mostly), cortex-tickling delights that pulled the entire weekend into an Escher-like focus.

Owsley was the Julia Child of the astral traveler set, having famously catered Ken Kesey's epochal Kool-Aid acid tests with "99.99 percent pure White Lightning." His stature as a counterculture icon rivaled that of his musical colleagues, a liberator of the mind who taunted authority with his mercurial escapades.

In later years, Owsley retreated into the high grass (currently somewhere in Australia), loath to face a public enamored of his prescriptions for better living through psychotropic chemistry.

In October 2007, Scott Beale, blogging on the Laughing Squid website, received a surprising post from the "underground man" himself. Responding to the pervasive urban legend that he named his handiwork after Jimi Hendrix's "Purple Haze," Owsley wrote to set the record straight.

OWSLEY STANLEY: The whole "Purple Haze" thing is nonsense. I have no idea what Jimi meant by the line, nor when he wrote it, but I do know that the acid at Monterey was not it. We called the purple acid tabs, pressed specially to be given away at the Monterey Pop Festival, "Monterey Purple." Jimi did seem to enjoy it—he jammed all night long in the long shed after I was able to organize a guitar and restring it for him.

I cannot speak of acid today, but in our time, acid of this quality was not the kind of thing which would attract the term "haze." To call it that would have been misleading. It was *clarity*, squared.

"Easy as A-B-C"

Mike Marotta, as stout and sure-handed as a tugboat captain, was an unlikely confederate for the festival organizers. A longtime resident of Monterey, Marotta owned and operated ABC Music Center, your one-stop shopping destination for instruments, sheet music, lessons, recordings, and tickets to any and all things musical around the peninsula. Marotta himself was an accomplished accordionist, long-established on the local "casuals" circuit and an esteemed member of the city's business elite. Very little happened around Monterey without Mike Marotta knowing which end was up.

ABC Music Center had provided the backline (amplifiers, keyboards, drums, etc.) for the Monterey Jazz Festival, so it wasn't surprising when Marotta got the call to assist the Pop Fest. His children, impressionable young teens, went gaga at the prospect of their music heroes coming to their quiet, insulated community. Marotta sat on the planning commission, which, after much wheedling documented earlier, finally gave permission to go ahead. And though the fairgrounds were administered by the state, the locals had all the quotidian responsibilities: policing, fire, outdoor lodging, and a raft of other headaches that were cost, not profit, centers to the area's economy. Holding his nose ("goddamn crap music"), Marotta enlisted his sons to hump the gear—a phalanx of Fender Dual Showman Amps. (The Grateful Dead absconded with a portion of the backline after their Sunday evening gig, a juvenile act of not-so-petty larceny that clearly contradicted the entire ethos of the event. Rock Scully claims to have returned the equipment a month later. Quicksilver Messenger Service appears to have kept theirs.)

Judi Marotta, Mike's daughter, recalls fondly her three days as an usher with "unlimited backstage access. My God! Janis Joplin went nuts when she lost her hat and no one could console her. I found this ratty coonskin cap and it was the missing hat. She was so grateful.

"What I remember most is the smell—the hippies smelled! Remember, I was going to a Catholic girls school. I was so sheltered. And seeing girls with no bras, smoking pot . . . I was like that deer in the headlights.

"Monterey was a tiny town; no one ever went to San Francisco. I mean, we knew the music. We had transistor radios and Dad had the store, so we were really exposed to music. But the festival was a *really* big deal. And here it is, over 40 years later, and we're still talking about it. Right, Dad?"

Mike Marotta, with an eye forever on the ledger, takes dead aim: "Glad we didn't provide backline to the Who. We knew their act—made 'em bring up their own amps."

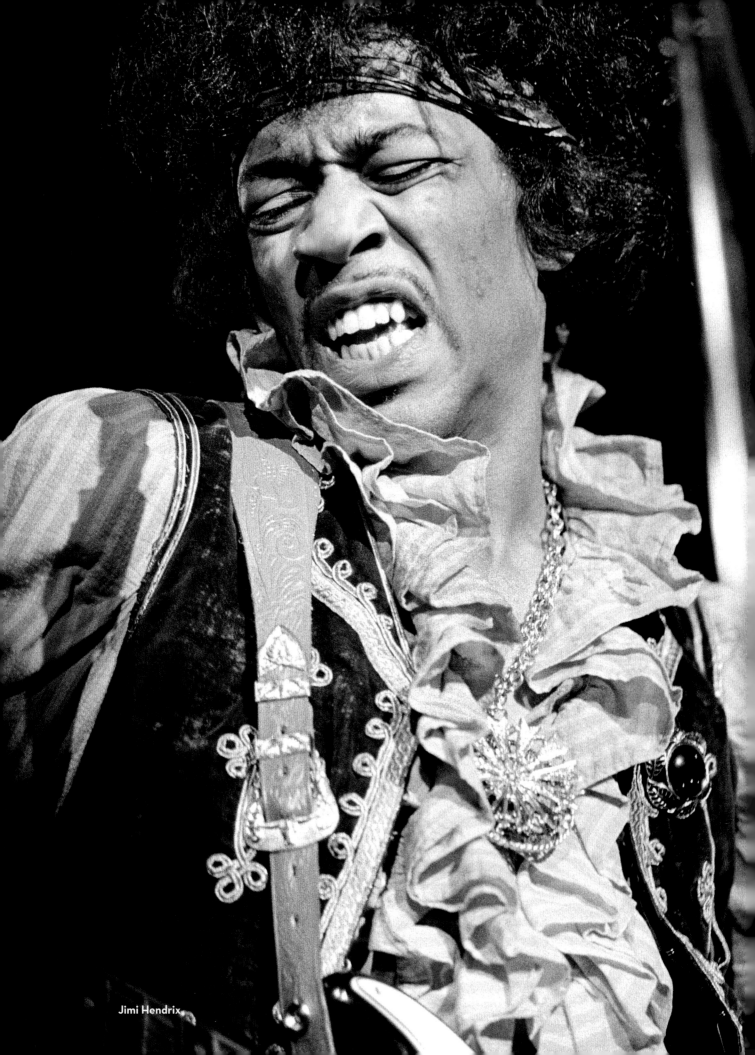

Jimi Hendrix

Chapter 6

SUNDAY NIGHT

The festival was now in its stretch run as the audience gathered for the final concert. Opening acts had fared poorly each day and THE BLUES PROJECT was no exception. Out of New York, they fashioned a hybrid of city blues and trippy jams, as seen through the prism of a Greenwich Village habitué on acid. Al Kooper had founded the band, and his leaving left them without a pivotal focus. Bassist Andy Kulberg doubled on flute and his composition, "Flute Thing," a sort of free-form wallow for flute, tape echo, and endless riffing, was the centerpiece of their brief set. Guitarist Danny Kalb generated a fusillade of notes where maybe one or two well-chosen ones may have sufficed. Second guitarist Steve Katz did not carry the animus toward Kooper that the others did and, by the end of the year, rejoined him in a new outfit: Blood, Sweat and Tears.

THE BLUES PROJECT
John McDuffy: keyboards, vocals
Danny Kalb: lead guitar
Steve Katz: rhythm guitar, vocals
Andy Kulberg: bass, flute
Roy Blumenfeld: drums

"(I Heard Her Say) Wake Me, Shake Me"
"Flute Thing"
and others

Left to right: Steve Katz, Andy Kulberg, John McDuffy (*on keyboards*), and Danny Kalb

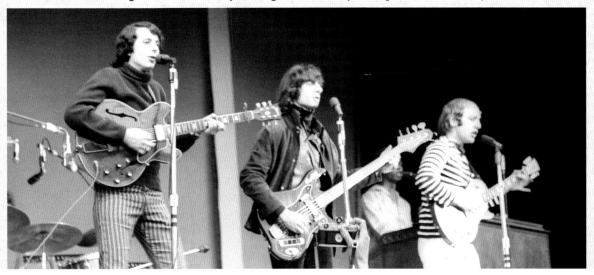

HENRY DILTZ: I'd seen the Blues Project at a small club in Greenwich Village a couple of years before Monterey, when I was hanging out with the Lovin' Spoonful and starting to take lots of pictures. Al Kooper was still in the band. I thought they were explosive onstage even back then. So it was great to see them play in front of such a large audience on the West Coast, and give the California hippies a real taste of New York underground white-boy blues.

Janis Joplin had asked for, and received, a reprieve by Governor Adler. And it dawned on the other members of Big Brother and the Holding Company that this was an opportunity not to be forfeited. Cutting their previous show in half, they barnstormed through "Down on Me" and "Ball and Chain" with rasping authority, the afterglow of Saturday's performance still fully evident. Cass Elliot's gap-mouthed response to Joplin's anguished delivery was captured for posterity by Pennebaker's roving camera, and it puts a resounding exclamation point on being a witness to history.

BIG BROTHER AND THE HOLDING COMPANY
(REPRISE)
Janis Joplin: lead vocals
Sam Andrew: vocals, guitar
James Gurley: lead guitar
Peter Albin: bass
David Getz: drums, percussion

"Down on Me"
"Ball and Chain"

D. A. PENNEBAKER: Janis' manager at the time, Jules Karpen, told me to aim my cameras at the ground and to not film her first set. I then went to Albert Grossman, who I knew, and said, "Albert, do whatever you have to do. But we've got to have her in the film. She's the life of this ol' party." And they arranged for her to do another shorter set the next day that we could film. I was stunned by the performance. Jesus . . . Janis was like somebody coming to life right in front of you. It was such an amazing effect. And even in the first set I shot some stuff. I wasn't supposed to. And their guy was kind of watching me. I couldn't *not* shoot her, especially after I heard "Combination of the Two." So the manager disappeared, and the next thing I knew Janis came out and said, "I'm gonna do it again and you can film me this time." So we did. I never met the guy. I don't know if he wanted to shake Lou down for some money or if he and the band didn't want to be in the movie initially.

Below: Jack Casady and Janis Joplin ❊ Opposite: Janis Joplin

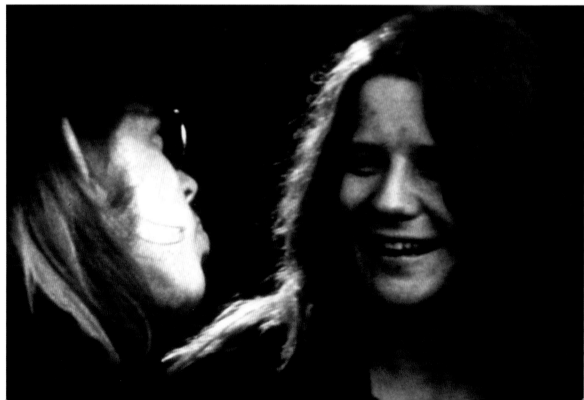

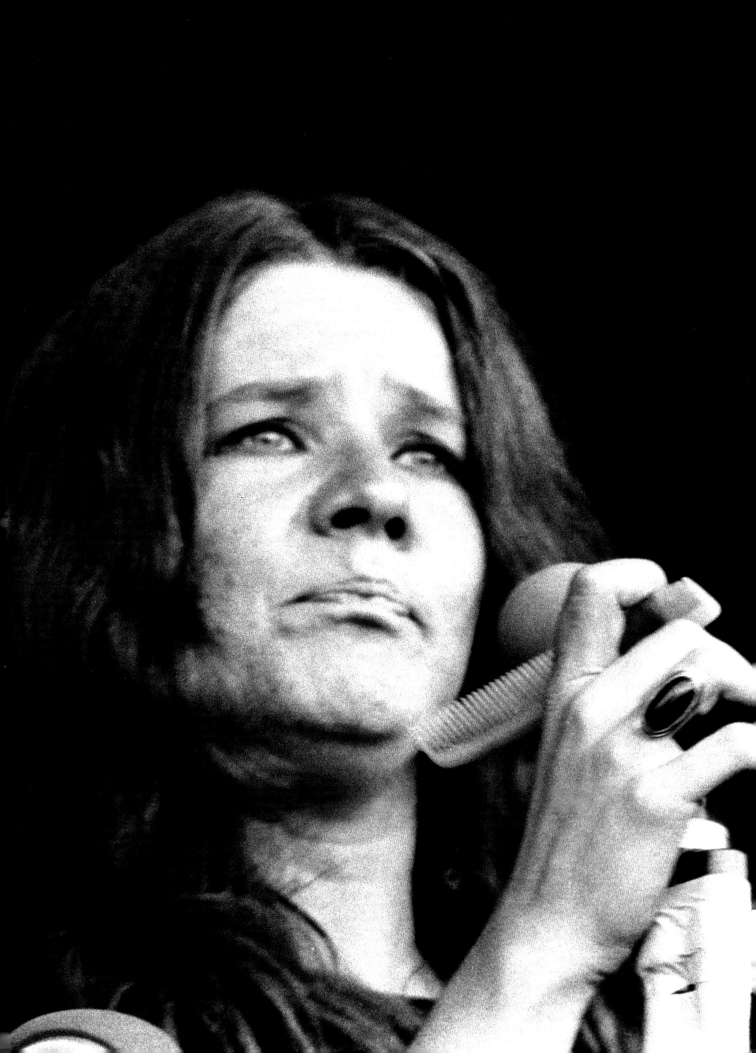

Sensing that anonymity was the better part of valor, GROUP WITH NO NAME followed by hiding in plain sight. A one-off exercise led by guitarist Cyrus Faryar, formerly of the Modern Folk Quartet, they dabbled in feel-good folk with some gypsy ornamentation. John Phillips had arranged for their booking but he did them no favors placing them in the aftermath of the Joplin squall; they promptly expired following their last song.

GROUP WITH NO NAME
Cyrus Faryar: guitar, vocals
Renais Faryar: lead vocals
Gary (aka "Jules") Alexander: guitar
Dick Shirley: bass
Frank Terry: drums

"Rubber Band"
and maybe one other

Below: **Renais and Cyrus Faryar**

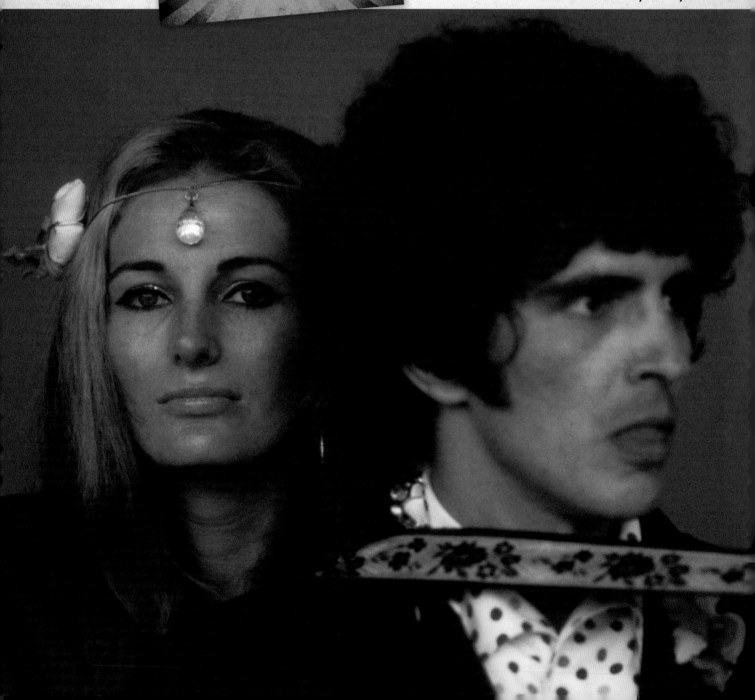

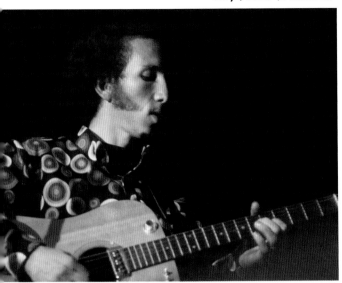

Gary ("Jules") Alexander

RENAIS FARYAR (HILL): We performed for the first time at the Mount Tam Festival. I knew the organizers—Tom Rounds, Mel Lawrence, Henry Diltz—from Hawaii. We were among a handful of bands that played both festivals.

As for Monterey, Cyrus and I knew John and Michelle Phillips. We used to live a couple of doors down from them in Laurel Canyon when they first got into town. We hung out when we were all poor. We would share Presto logs and take them to their house to have a little fire, or they would bring them to our house and eat hot dogs. When it hit for them, they were out of Laurel Canyon in a New York minute. So, for Monterey it was, "Okay, you guys. We'll put you on the bill."

We watched everybody we could see. I was a big fan of the blues, and Janis sounded like a white version of Bessie Smith. And nobody had done that before. So that was great. Wow! I thought, "God, John . . . You put us on after this?" I did think that was a bit snarky. [Laughs.] I know it sounds like typical musician excuses, but to have no soundcheck and no chance of hearing what each other was doing . . . We were like fish in a bowl, you know. We were freaked. By the time we left, the band dissolved as we went offstage. Never saw each other again. Here I was, absorbing this incredible music around a horrendous event happening to us and being in shock the rest of the time. [Laughs.]

CYRUS FARYAR: We came up with a name—just like when the Lexington Three became the MFQ after pages of names, like the Flying Gyros, were

discarded. Frank Terry, the drummer, lived across the street from us in Laurel Canyon. I knew him from Fresno. The guitarist, Gary [aka Jules] Alexander, was in and out of the Association. The bassist was Dick Shirley, who had been in the Travelers Three (whom I met in Honolulu at my coffeehouse, Greensleeves). I was married to Renais at the time. And we were friends with John and Michelle Phillips, who extended an invitation to the festival. And we learned four songs and they were all interesting and different. Jules had a song called "Flashing Memories," which became poetically true.

In a way, it was a fearless and a heroic thing to attempt. From one day rehearsing in Frank Terry's living room, and the next day you are onstage at Monterey. You're a little overwhelmed. "What am I doing here?"

In absolute candor, I will tell you this: we went up there and I think the adrenaline, the novelty and the excitement kind of blew our minds. The song began, and it went in four or five different directions all at the same time. It didn't flow together in one unit. It became five people. We walked off the stage drenched in sweat, not really knowing what had happened but knowing that what we had designed, the egg that we had laid, did not hatch.

I walked offstage, told Lou we were done and got a soda [laughs]. Here we were, surrounded by this huge success, to which we did not really contribute. Now we have become an interesting oddity—a band that no one remembers, not in the programs, hardly in any pictures—not utterly invisible, but that pleases me immeasurably. Because if there were any position I would choose, it is that we were part of this interesting group that people sort of remember but left no footprints in the sand. I love that. We were sort of the ghost of Monterey.

Renais Faryar arriving at the festival

Buffalo Springfield was riding high off their first hit record, *For What It's Worth*, just as the Monterey Pop Festival was coming into focus. For most bands this would have been the proverbial win-win, enjoying all the exposure that comes at the moment of peak radio and press interest. The group's internal dynamics, however, were as unwieldy as their name. Stephen Stills, their crackerjack guitarist from the Confederate South, routinely clashed with the band's Canadian contingent, primarily Neil Young, who wore his brooding defiance like the lining to his ever-present buckskin fringe jacket. Tension between these gifted, though highly-strung individuals did pay ample musical dividends. Their oaken, bittersweet harmonies were smartly countered by the layered guitar interplay—a parfait of Fenders, Gibsons, and Gretsches. At its best, the Springfield delivered the comforts of country music seasoned with some citified slickness.

Alas, as Yeats warned, the center could not hold; Young, unnerved by the onslaught of serious drugs, too-easy girls, and the general mayhem attendant to a band on the rise, bailed out—and not for the first time. But this was one week before Monterey. Bassist Bruce Palmer had just returned to the fold after being deported to Canada over a pot bust.

Journeyman guitarist Doug Hastings filled the lead guitar spot opened by Young's departure. And David Crosby, feeling no pain (that STP sticker proudly displayed on his guitar was *not* a tribute to Indy 500 icon, Andy Granatelli), sidled up next to Richie Furay to add his high tenor embellishments. Reviewers disparaged their workman-like performance. But the Springfield's potential would soon be abandoned in the pursuit of less contentious pastures. Those successes merely underscored what was lost.

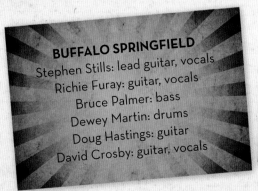

BUFFALO SPRINGFIELD
Stephen Stills: lead guitar, vocals
Richie Furay: guitar, vocals
Bruce Palmer: bass
Dewey Martin: drums
Doug Hastings: guitar
David Crosby: guitar, vocals

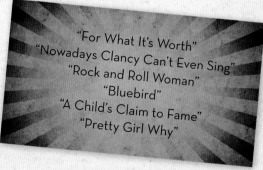

"For What It's Worth"
"Nowadays Clancy Can't Even Sing"
"Rock and Roll Woman"
"Bluebird"
"A Child's Claim to Fame"
"Pretty Girl Why"

RICHIE FURAY: The five players in the Springfield made the magic. Were we the best players? No. Were we the best singers? No. But it worked. As far as Monterey, as a group of recognized musicians, our name was listed among some of the most talented people in the world. I was up at Monterey with my wife and there wasn't a lot of socializing. I still had, or had just gotten over, tonsillitis and was in a bit of a daze.

We tried to do the best that we could, but frankly, it just wasn't that good. We were trying to cover our bases, and we were scrambling: "We can put this together, bring David in from the Byrds and do a unique kind of thing here." But you know what? We knew the difference. I mean, I did. That weekend, I saw the music and the dreams in front of me. "Here we go." There was nothing to stop us, and yet, something did stop us, and it just kind of slammed us into a wall.

BRUCE PALMER: Crosby stunk to high heaven. He didn't know what he was doing and embarrassed us to the max. It was so bad, I blushed into crimson.

DOUG HASTINGS: David had a gorgeous voice but his problem was that he couldn't play rhythm

Above: Buffalo Springfield set list ❊ **Below:** Richie Furay, Stephen Stills, and David Crosby at sound check

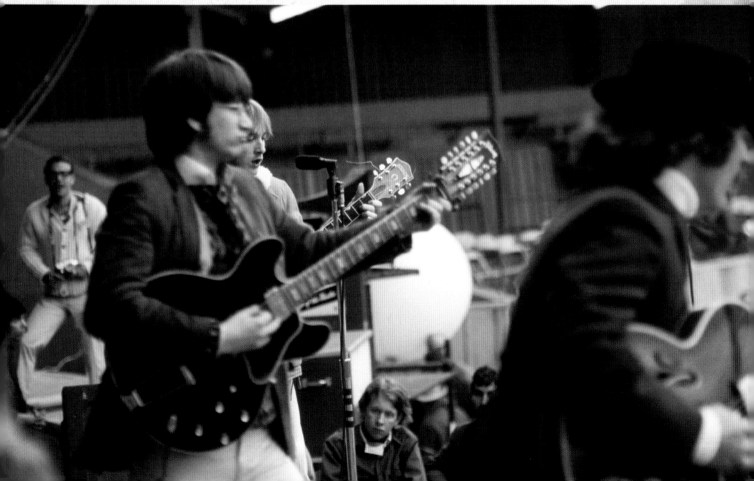

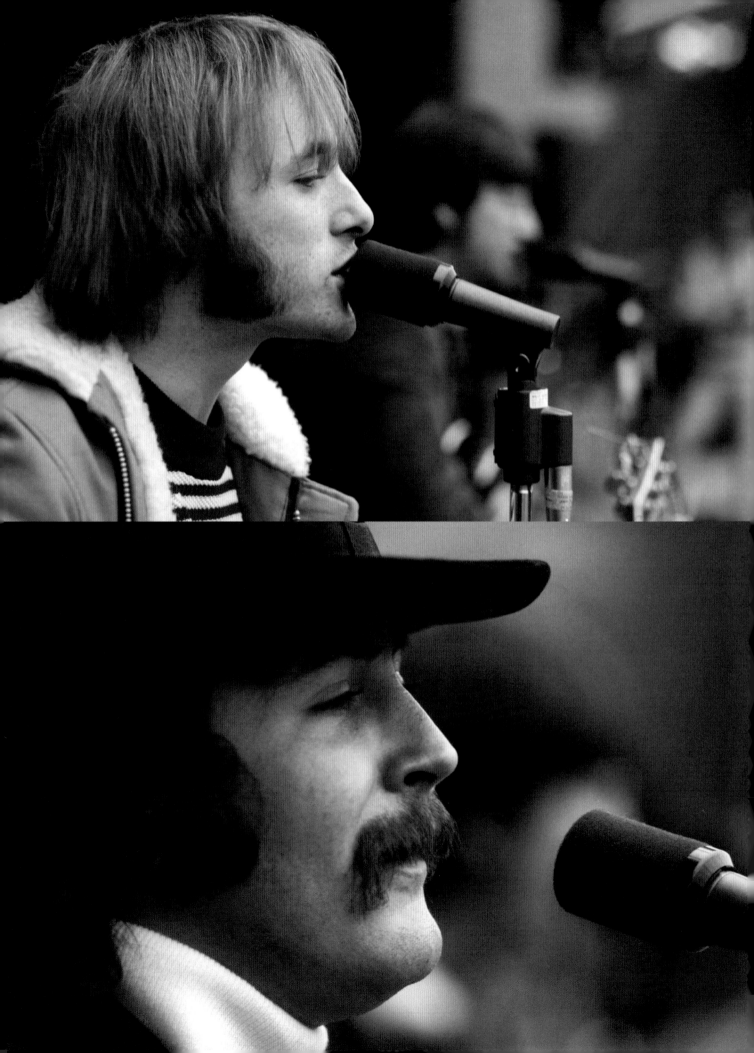

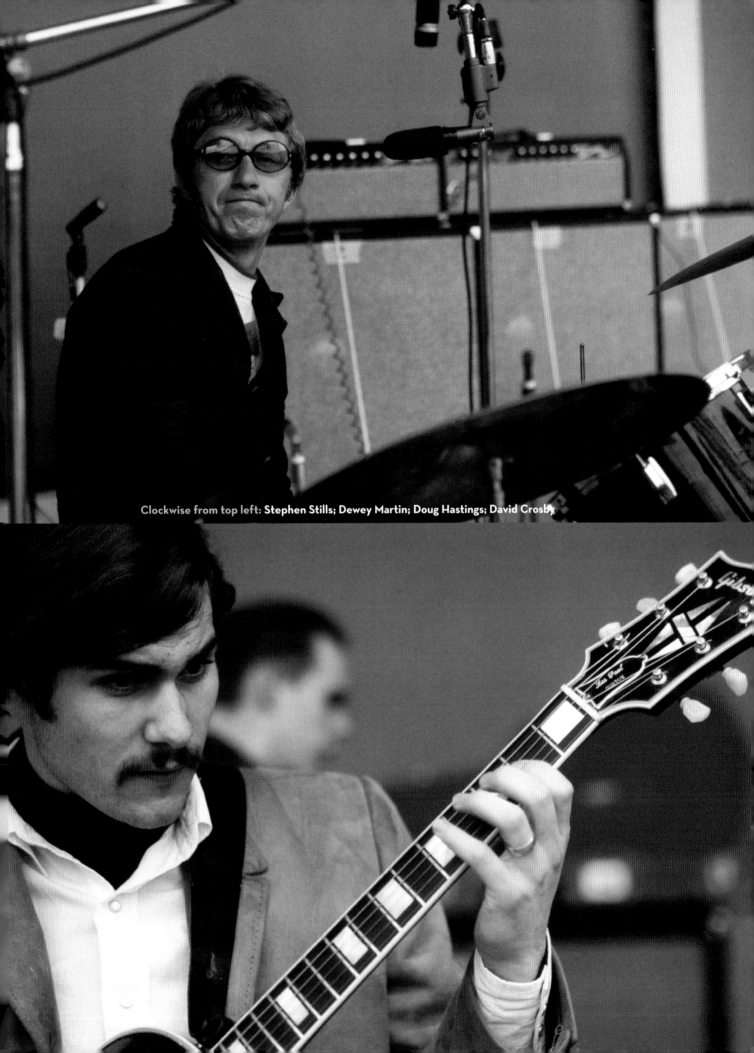

Clockwise from top left: **Stephen Stills; Dewey Martin; Doug Hastings; David Crosby**

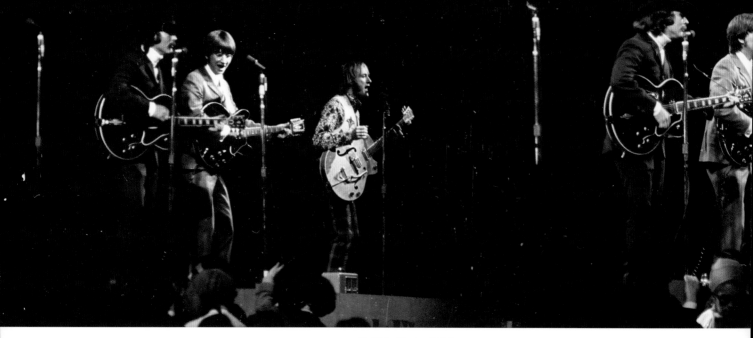

Buffalo Springfield

guitar very well. In his enthusiasm, he would rush the tunes. In "Bluebird," we got off too fast and kept getting faster.

DEWEY MARTIN: I was the one who led us through that show.

JENNIFER STARKEY (Journalist): I was attending the festival for a magazine to be called *LUV*, out of Challenge Publications.

I arrived in Monterey the night before the first show with a friend, Pat Devine, only to find that our reservations for lodging had been lost. We subsequently spent the night on the floor of another friend's motel room. Somewhere en route we spied a lonely Buffalo Springfield steamroller just sitting there on the side of the road, its signs just waiting to be liberated, and we were happy to set them free. They hid out in the motel room while we went to see the group that had adopted their name.

I first met them at a rehearsal at Rainbow Studios in Hollywood on April 9, 1966, and then at the Whisky A Go Go in May, where I did the first interview ever done with them. I spent many hours at Gold Star and Columbia Studios with them and wrote the liner notes for their first album. I worked with [managers] Charlie Greene and Brian Stone, came up with several promo campaigns, from the "I've Been Buffaloed" pins to the "Why Can't Clancy Sing" bumper stickers. I even once arranged for them to be stormed on-stage by a group of teenage girls.

At this point, the group had gone through a myriad of changes, from Neil Young leaving to Bruce Palmer's legal status. David Crosby was going to be doing something with the band; there was a thing called "Davy's Tune" on a handwritten set list (not all of which was used, as they couldn't figure out how to include Neil's vocals without Neil) that had been worked out a few days before. When Crosby showed up onstage with them and began to sing, it was definitely the beginning of something big. You could see it, feel the electricity in the air. Something was going to come of that performance.

Press and judge passes

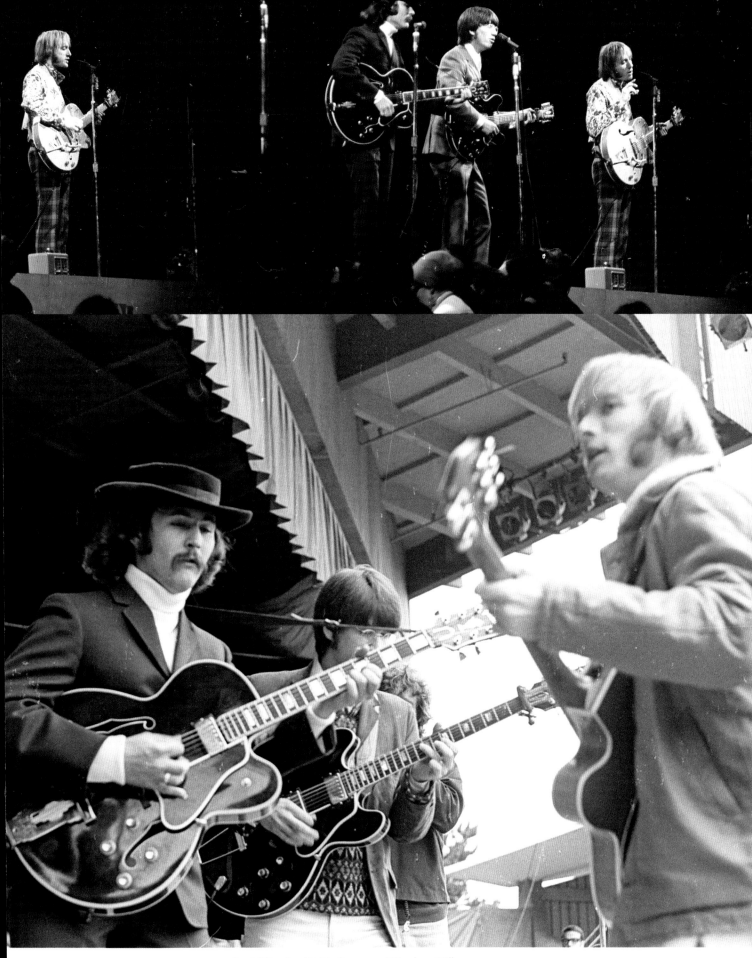

David Crosby, Richie Furay, and Stephen Stills

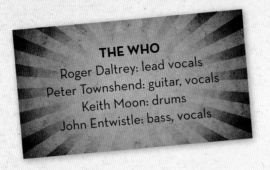

THE WHO
Roger Daltrey: lead vocals
Peter Townshend: guitar, vocals
Keith Moon: drums
John Entwistle: bass, vocals

"Substitute"
"Summertime Blues"
"Pictures of Lily"
"A Quick One While He's Away"
"Happy Jack"
"My Generation"

Roger Daltrey would just as soon punch yer nose as lend you a helping hand. John Entwistle fancied himself a modern "Beau Brummell," spending his dosh on 10 shirts when one would suffice. Keith Moon did not suffer from his attention deficit disorder; no, he reveled in it like a firebug at a Guy Fawkes celebration. And there was Pete "The Beak" Townshend, the sorcerer at the center of this mountain of madness, this primal urge known as THE WHO. Revved on leapers, he worked himself into a right frenzy as shards of his fractured self-image reconstituted themselves into three-minute cacophonies that drove their fans to delirious distraction.

The Who drew much of their early inspiration from the worlds of pop and op art, rather than from contemporary music. Inasmuch as Townshend trained at an art academy, his heroes were such painterly provocateurs as Jasper Johns and Roy Lichtenstein. He once described looking for "visual value for what was going on in the street." The "mod" mindset that was so central to the Who's creation myth arrived from Paris—a mélange of modern jazz, the French New Wave in cinema, and the outré fashion sensibilities of Left Bank designers.

These "style codes from the underground" found common cause with the persistent class resentments infecting British youth like an incurable case of acne. With nowhere to go and nothing to do, frustration vented in the form of "rave-ups," a kind of aural anarchy mixed with a bit of fisticuffs. Throngs of the disaffected congregated at clubs, hotel ballrooms, seaside resorts, or wherever a punch-up would settle a score, support a band, or pull a bird. It was a glorious revolution, all attitude-on-amphetamine, with the occasional sundered guitar neck being brandished like a fretted bayonet.

The Who did not require the adrenaline rush of the mob to ignite; they were combustible all on their own, fueled by sneers, snarls, and sideways glances. And pity the poor amplifiers—they took it in the guts like Coventry during the Battle of Britain. And now, in the summer of 1967, it was the Yanks' turn to get a blast from this big sensation.

They had come to America in March for a one-off in New York, a slot on DJ Murray the K's Easter extravaganza: 10 bands, 10 minutes each, from midday 'til midnight, a meat-grinder of a gig that only the heartiest (or most wired) survived. It was now time for them to headline on their own. After a tune-up at the Fillmore West on Friday and Saturday night, the gig at Monterey demanded their undivided attention. But first there was this little matter of who should play first—the Who or the Jimi Hendrix Experience?

Like so many of the other tales bandied 'round Monterey like dispatches from Brigadoon, the "coin toss" between Townshend and Hendrix looms large. Virtually unknown to American audiences, Hendrix had made a spectacular splash in England, particularly among other musicians. Townshend was well aware of Hendrix's stage antics and both men were loath to relinquish the pole position. In 1995, Townshend discussed his relationship with Hendrix and the events that June day for the documentary *The History of Rock 'n' Roll.*

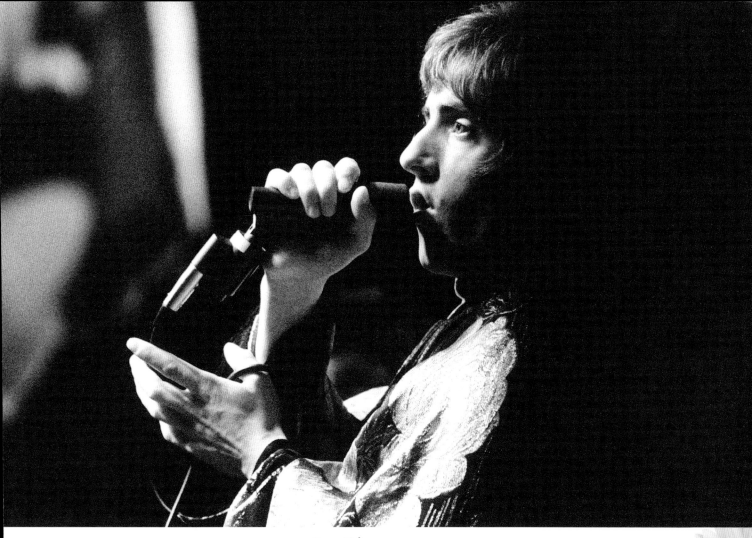

Roger Daltrey

PETE TOWNSHEND: I couldn't deal with the idea that, at this critical concert, we might go on after him. And he said to me from his insecurity, "That's not what you really mean. What you really mean is you don't want me to go on first. You want to be first up there with the guitar smashing." So I said, "Jimi, I swear to you, that's not what it's about." Brian Jones was standing with me and Jimi started to play. He stood on a chair in front of me and he started to play this incredible guitar, and it goes down in history as a jam session. I've heard Roger talk about it as a jam session. But it wasn't a jam session. It was just Jimi on a chair playing at me. Playing at me, like, "Don't fuck with me, you little shit." And then he snapped out of it and put the guitar down and said, "Okay, let's toss a coin." So we tossed a coin, and we got to go on first. I went out to sit with Mama Cass to watch Jimi and, as he started doing this stuff with his guitar, she said to me, "He's stealing your act." And I said, "No, he's not stealing my act. He's *doing* my act." [Laughs.] For me, it was an act, and for him it was something else. It was an extension of what he was doing.

MICHAEL LYDON (*Newsweek*): Then Pete Townshend stepped to the mike and said, "This is where it all ends." Then they began "My Generation," the song that made them famous . . . After about four minutes of the song, Daltrey began to swing his handheld mic over his head, while Pete Townshend smashed his guitar strings against the pole of the mic before him, building up the feedback. Then he ran and played the guitar directly into his amp. The feedback went wild, and then he lit a smoke bomb before the amp so it looked like it had blown up, and smoke billowed on the stage. He lifted his guitar from his neck and smashed it on the stage again, again, again (shades of Gustav Metzger!).

It was known to be a planned act, but like the similar scene in the film *Blow Up* [inspired by the Who], it had a fantastic dramatic intensity. And no meaning. No meaning whatever. There was no passion, no anger, just destruction.

Overleaf: **The Who**

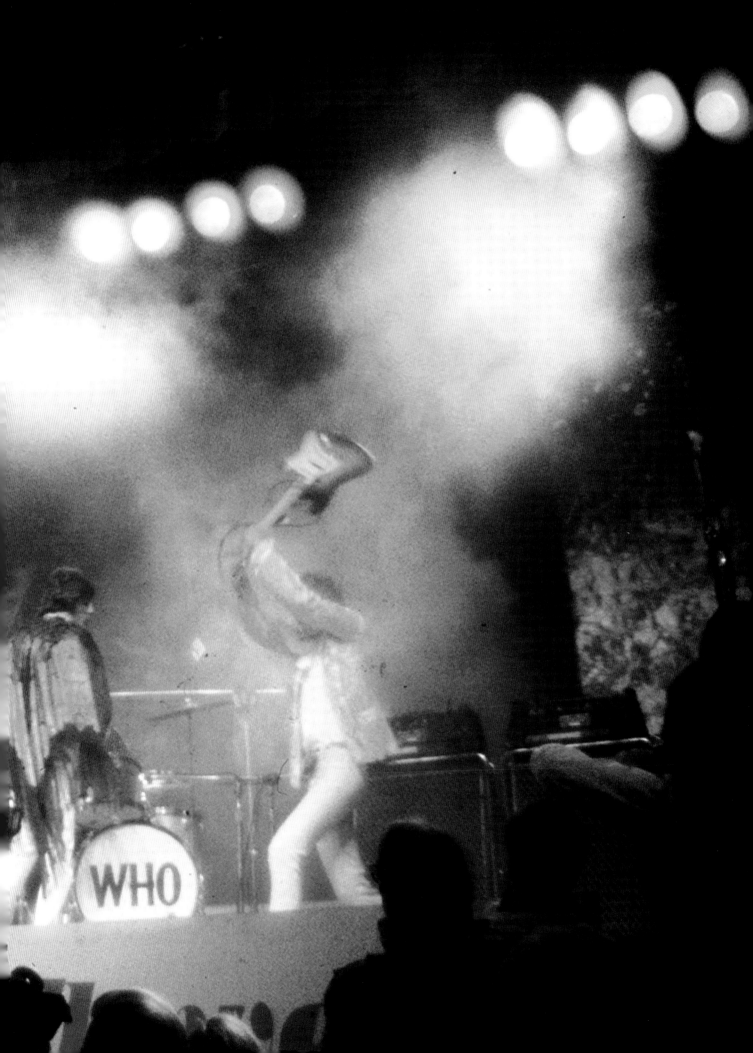

AL KOOPER: I'd been on the bill with the Who at Murray the K's Easter show. So at Monterey's staff meetings I would say, "Just know that they're going to come out and wreck everything. I would suggest that they close."

PETE TOWNSHEND: We were pretty scared. We'd done a package in New York with Cream, and it seemed as though we'd missed a beat. We were still displaying Union Jacks and smashing guitars while Cream played proper music and had Afro haircuts and flowery outfits. Jimi had already hit in the UK.

 This was a divine opportunity. A side issue was that we played at the Fillmore on this trip, and that was probably more important to us, because Bill Graham insisted we play a longer set than we were used to. It was around this time that we began to include songs like "Young Man Blues" and "Summertime Blues." It was exciting to go to San Francisco for the first time, but also quite strange. The music industry people were pretty whacked out by LSD in a way that hadn't happened in the UK—except to Syd Barrett and Robert Wyatt.

 I remember Brian Jones, sweet as ever. Eric Burdon was a good bloke. Jimi was out of his tree. Derek Taylor was frightened to come out of his little box, from where he handed out passes. The beautiful people gazed at each other. But we were keen to stay true to our thesis, which was that this is a crock of shit and the war isn't over yet—we meant World War II, not fucking Vietnam. So, to say the least, we were slightly out of step.

 I couldn't see how Grateful Dead, Janis Joplin, or Country Joe could be taken seriously. Their sound was so ragged, so raw. I was used to a slicker sound. Now I see better what they were doing and, just like the Who, it was not just about music, it was about message and lifestyle and change. The three bands I mentioned all had manifestos that were not just about the music. It took me a while to understand that.

RAVI SHANKAR: The Who started kicking the drums and breaking their instruments. I was very hurt and ran away from there, along with the others who played with me. My feelings were hurt deeply, as well as my respect for music and the instruments. We ran away from the festival.

ROGER DALTREY: I didn't see anyone perform at

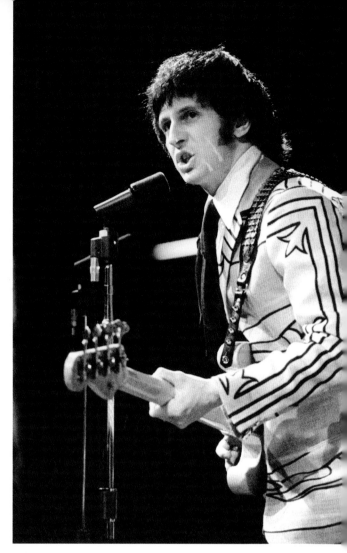

John Entwistle

Monterey. We were just ushered in and put under the stage a couple of hours before we went on. And Hendrix was playing "Sgt. Pepper," which had just been released, and he was doing all the top lines, all the bass notes, all in one. Just a fuckin' genius, you know. Yes, we'd seen how he copied our shows, not musically, but theatrically. A lot of it was stolen from Townshend.

 And then we were kind of escorted out after the set. They weren't pleased with us because we broke the equipment up and they were very worried about their microphones and all that kind of stuff. It was quite funny and we weren't allowed or welcomed to stay. We reminded them that this world was in a shit state, that it wasn't peace and love at all [laughs].

HENRY DILTZ: I was on the side of the stage when the Who played, shooting from the wings. We'd all heard that the Who wrecked their instruments and no one had ever seen that. That was a strange concept and how was that going to work? When

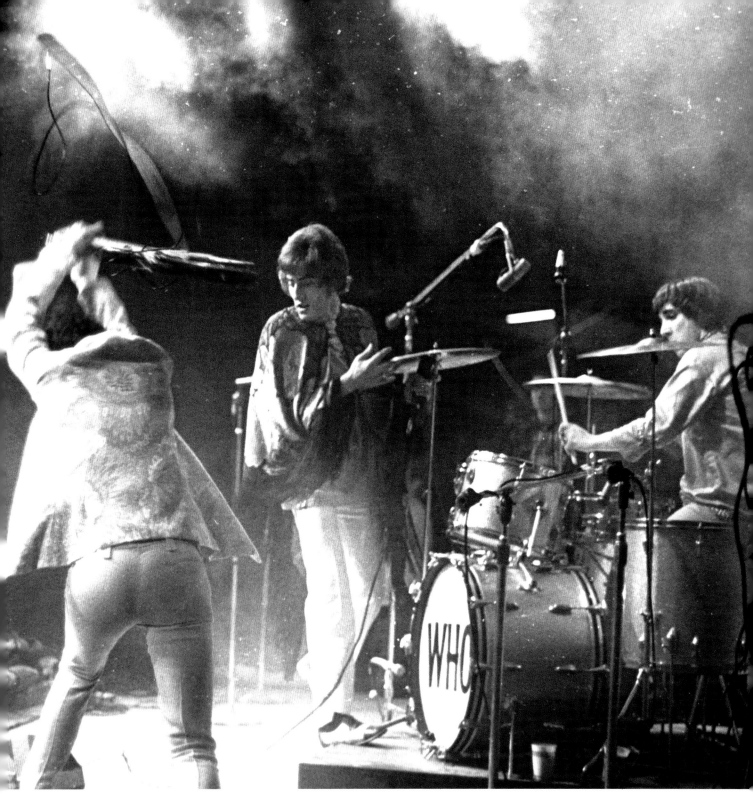

The Who

that happened—wow! It was like they worked up to such a frenzy that the only thing they could do was turn around and whack the amplifier. And then Keith Moon just kicks the drum set over, the cymbals go rolling, and the sound engineer is running around the lip of the stage to save the $500 microphone. It was like a war and a smoke machine, too. Lou Adler remained very calm and kept his hat on while chasing after Moon's runaway kick drum.

MICKY DOLENZ: I was backstage with Henry Diltz, who was taking pictures, and it got pretty crazy. Explosions going on, shit all over. I actually remember, very clearly, being worried about Henry's life. It was the Boy Scout in me. I tried to pull him offstage, because he was going to get nailed.

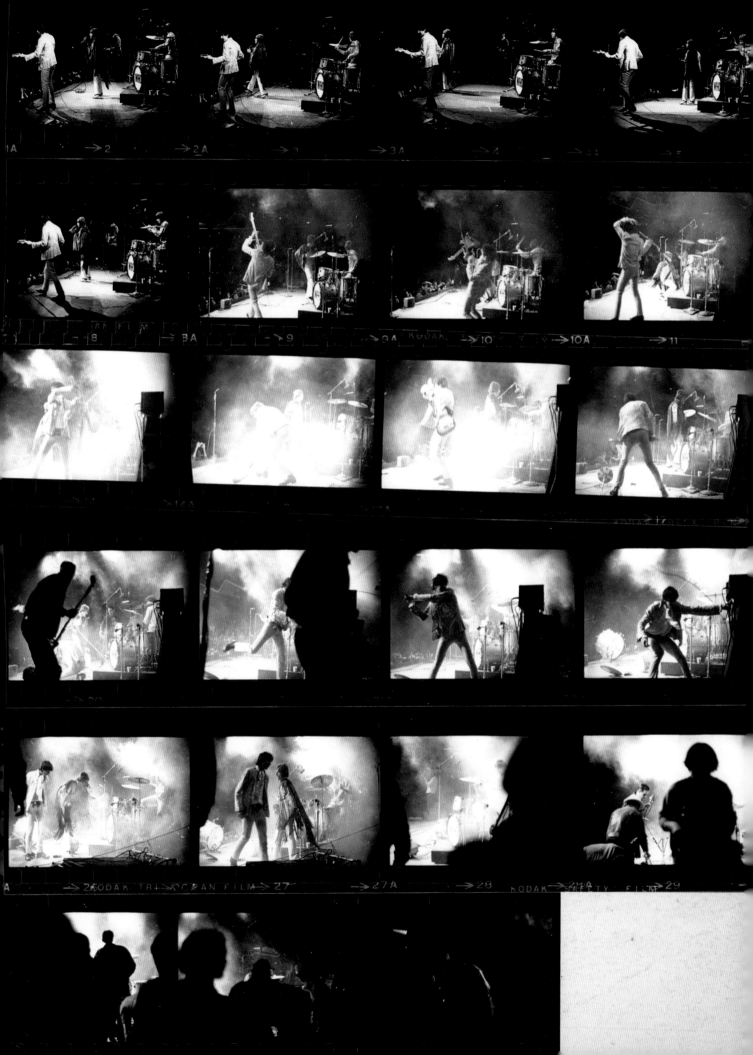

Evening Standard—London, Eng.
June 29, 1967

> **" By this time Pete Townshend decided that his guitar was a crowbar and the stage needed demolition "**

Above: **Photo proof sheet of the Who**

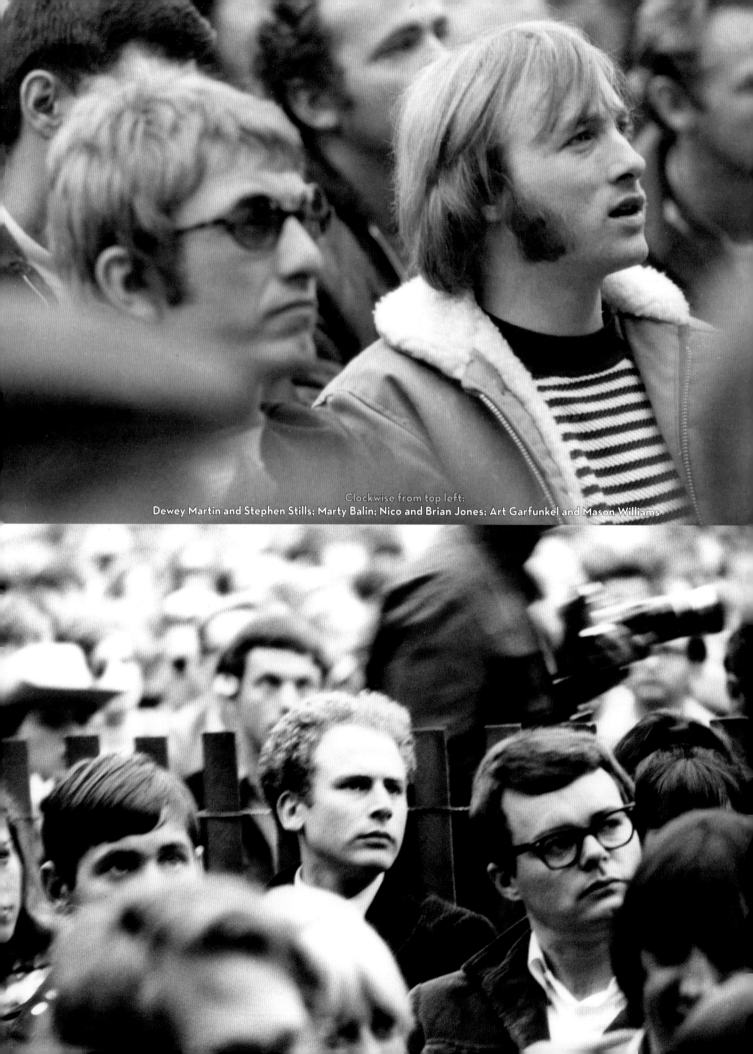

Clockwise from top left:
Dewey Martin and Stephen Stills; Marty Balin; Nico and Brian Jones; Art Garfunkel and Mason Williams

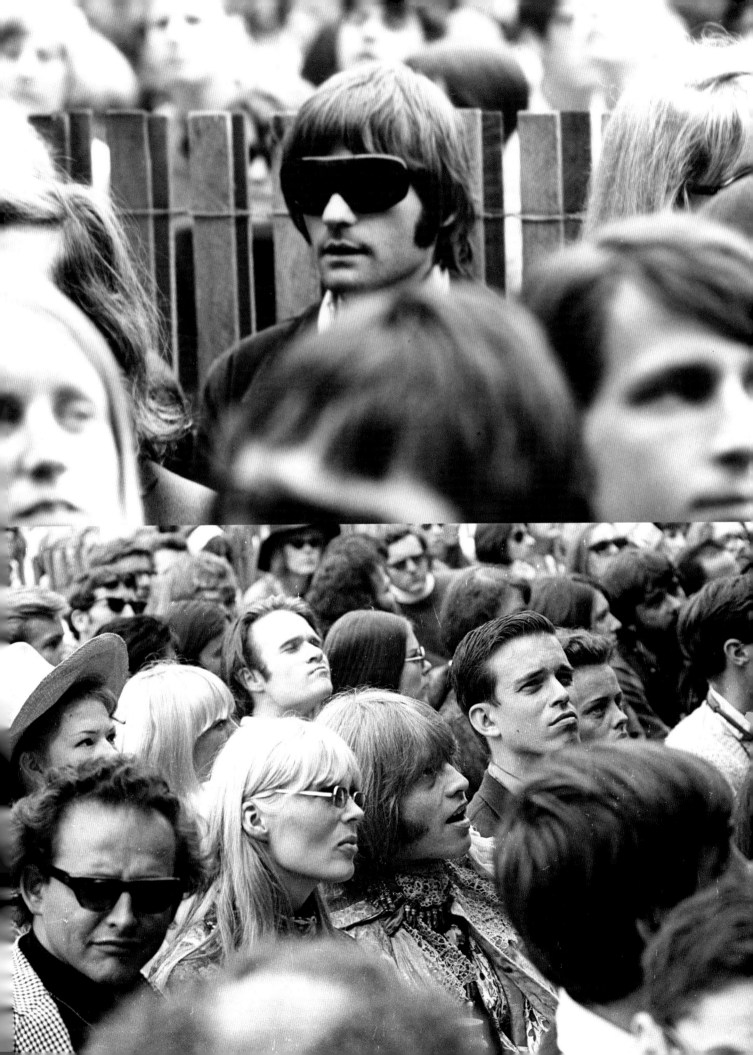

Things slowly settled down, but calm was hardly restored. It was time for the GRATEFUL DEAD to work their acid-rock charm on the antsy audience, uncorking one long, distended jam after another, bringing many to their restless feet, others to mount the stage in their search for ecstasy. That did not sit well with the organizers, who responded in a forthright manner that cleared the rabble and left the "heads" on their asses. Bummer.

It was at this point that the Monkees' Peter Tork was sent like a sacrificial lamb to address the crowd, in order to: 1) implore the folks trying to tear down the fences to stop—not groovy; and 2) remind everyone that the Beatles were not here and that they weren't playing, saying, "Are you people high or what?" (or words to that effect).

The Dead's bassist, Phil Lesh, commandeered the mic and, ever the prankster, attempted to whip the crowd into a froth: "This is the last concert, why not let them in anyway? The Beatles aren't here, come in anyway . . . If the Beatles were here, they'd probably want you to come." The hapless Tork could only mutter, "Uh, carry on" and depart, to the hoots and hollers of those seated and the many in the rear who had successfully crashed the gates. Thank you, Phil.

Above: Peter Tork and Chip Monck
Opposite: Jerry Garcia

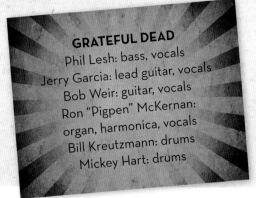

GRATEFUL DEAD
Phil Lesh: bass, vocals
Jerry Garcia: lead guitar, vocals
Bob Weir: guitar, vocals
Ron "Pigpen" McKernan: organ, harmonica, vocals
Bill Kreutzmann: drums
Mickey Hart: drums

"Viola Lee Blues"
"Cold Rain and Snow"
"Alligator"
"Caution (Do Not Stop on Tracks)"

BARRY HANSEN (*DownBeat* magazine): The Dead's shorter arrangements were brilliant, but their longer tunes have a habit of ending up in the same way—uncontrolled cascades of notes over a tonic drone build-up, to the threshold of pain. Then, suddenly, everything stops and they go back to the beginning. Certainly it mesmerizes the freaks (which is what the Dead get paid to do), but it's kind of a slipshod, lazy way to play music.

BOB WEIR: I was a hippie—I was not a flower child. The flower children were peace and love, and we were actually punks. We had a sense of humor about us, but it wasn't peace and love around our house. We may have practiced the love part, but there wasn't a whole lot of peace.

JERRY GARCIA: One of the things you could say about all the bands that came from San Francisco at that time was that none of them were very much alike. I can't say how or why, but I think all the interest in the sense of personal freedom as expressed by all kinds of movements—social, personal, environmental—affected everything, not just the music. All these things were designed to free the human spirit. When the acid tests were happening, I personally felt, "In three months from now the whole world will be involved in this." So, as far

as I'm concerned, it's been slow and disappointing. Why isn't this paradise already? [Laughs.] My personal feeling has been one of waiting around.

BILL GRAHAM: There was never a San Francisco sound or a Boston sound. They may do the same thing to an audience, though, which is to give them pleasure. The San Francisco bands, starting with the Dead, always went to the gigs with the intention of putting it out there. It was the lack of professionalism at the beginning that made that possible. It wasn't that the contract said 45 minutes and "that's what we've got to play." They were the first ones who asked to play longer. They wanted to extend the relationship between the audience and themselves. And that prevails to this day. You can't get them to play shorter sets.

Below: **Jerry Garcia** ✳ Opposite: **Bob Weir**

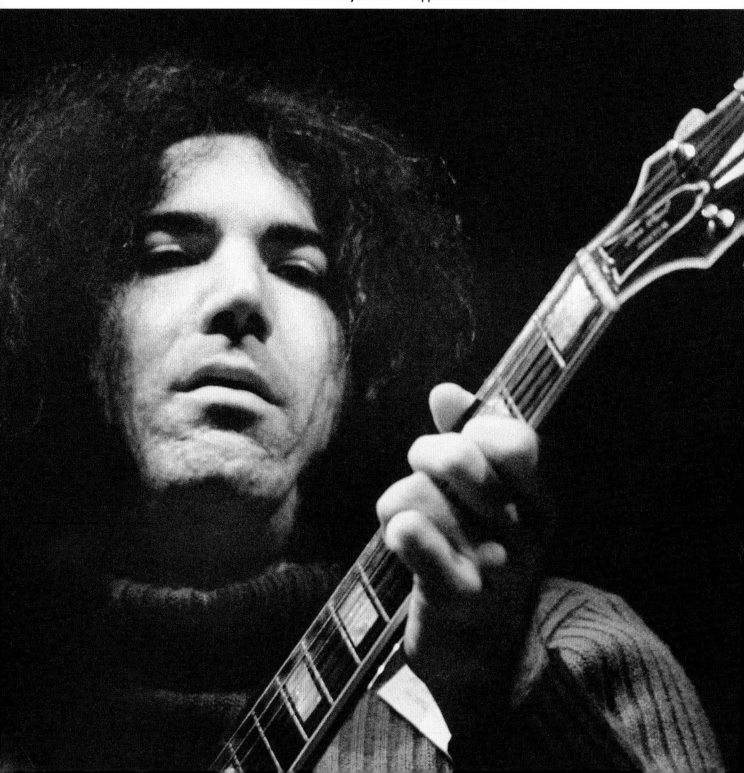

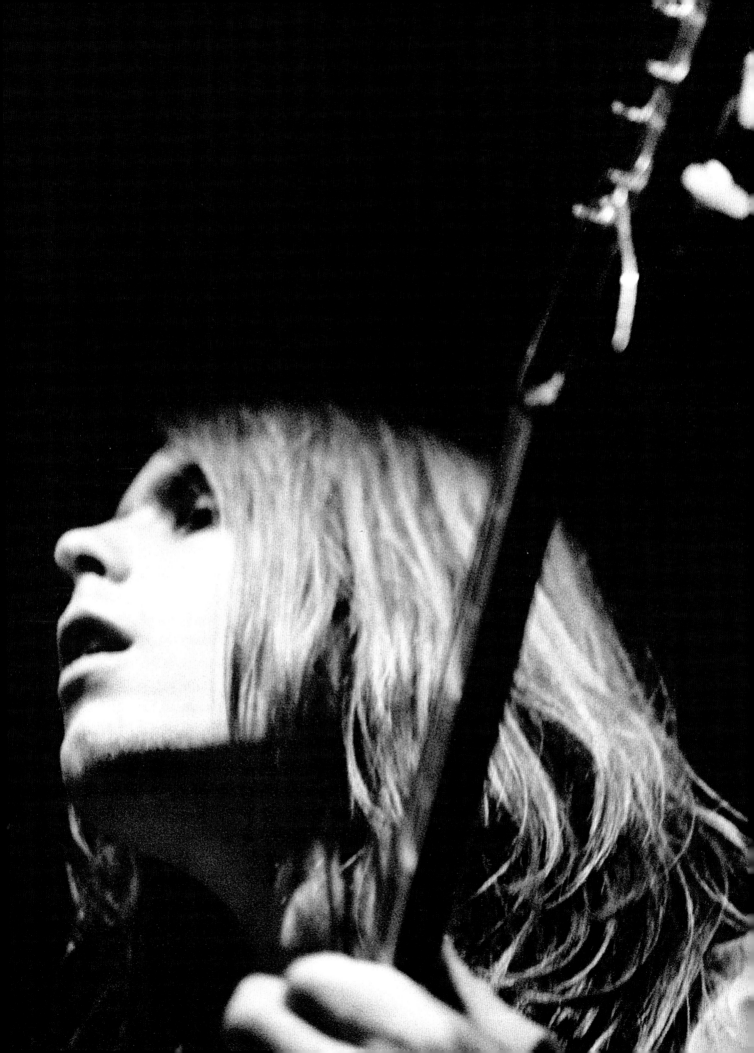

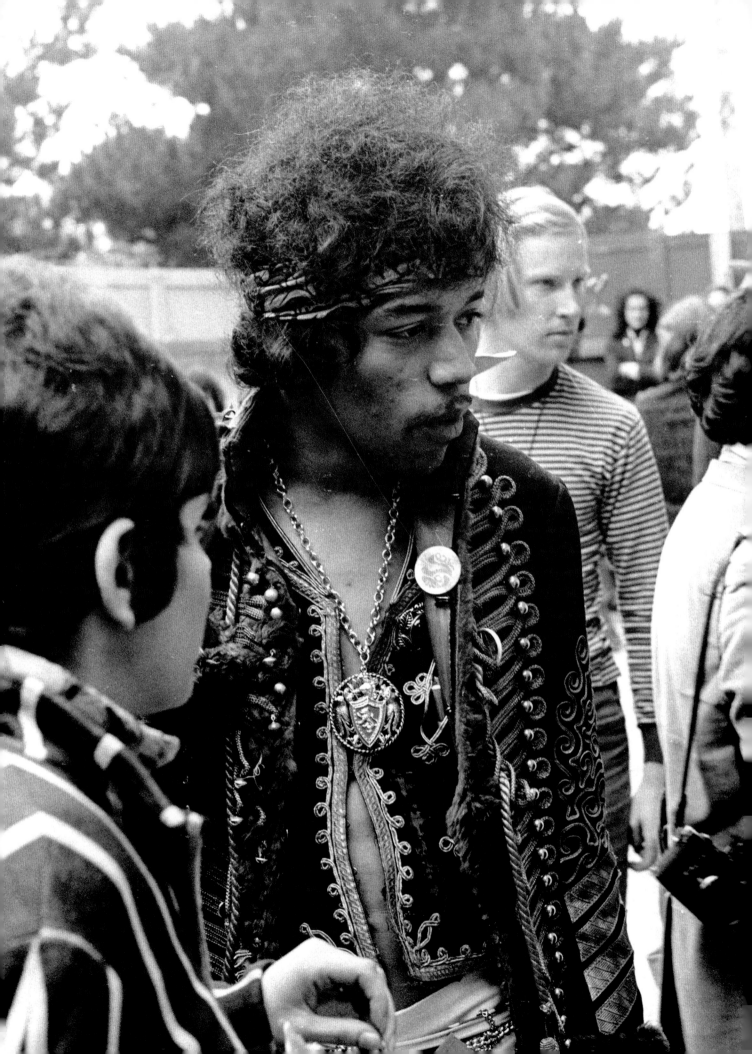

James Marshall Hendrix once jumped out of airplanes on behalf of the United States Army, in search of monsters to destroy. Years later, "Jimi" would take off on another flight of fancy, this time vanquishing the darkness within by releasing butterflies and zebras and moonbeams and fairy tales on an unsuspecting universe. Like the Chimera his music so often evoked, Hendrix became a mythic creature himself; his short, spectacular transit across the whispering skies produced a body of work that confounds and enthralls musicians and listeners alike.

He did not, however, spring fully formed from Zeus's head, all evidence to the contrary. He paid his requisite dues—laying pipe behind Little Richard, the Isley Brothers, and King Curtis, among others. It was a rough apprenticeship, particularly for someone so shy and guileless. When he spoke, it was in blushes and stammers; when he plugged in his guitar, it was like hearing a locomotive's breath.

Settling in New York, he managed to put together his own thing—Jimmy James and the Flames. Good fortune placed English model Linda Keith, whose most recent turn as Keith Richards' girlfriend provided access to the rock aristocracy, at one of his Greenwich Village gigs. She excitedly rang Chas Chandler, the former bassist of the Animals and now an aspiring producer, dragging him to see this wild-haired talisman. No fool he, Chandler had Hendrix on the next plane to "Swinging London" . . . and immortality.

England could not have been more receptive to this black musical savant. Hendrix's dashing admixture of Carnaby Street flash and Delta bluesman struck just the right balance of authenticity and showmanship. And now the time had come for the prodigal son to return to an unwitting America.

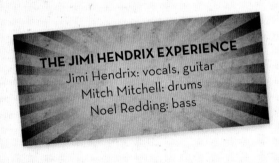

THE JIMI HENDRIX EXPERIENCE
Jimi Hendrix: vocals, guitar
Mitch Mitchell: drums
Noel Redding: bass

"Killing Floor"
"Foxy Lady"
"Like a Rolling Stone"
"Rock Me Baby"
"Hey Joe"
"Can You See Me"
"The Wind Cries Mary"
"Purple Haze"
"Wild Thing"

BRIAN JONES (Introduction): I'd like to introduce a very good friend, a fellow countryman of yours . . . He's the most exciting performer I've ever heard: the Jimi Hendrix Experience.

MICHAEL LYDON (*Newsweek*): I wrote at the time: "Total scream . . . I suppose there are people who enjoy bum trips . . . end of everything . . . decay . . . Nothing louder exists, 2,000 instruments . . . five tons of glass falling over a cliff and landing on dynamite."

BARRY HANSEN (*DownBeat* magazine): If the

Who had not done some of this before, there might well have been a riot. Hendrix's act somehow had a much more personal, less mechanical feel to it, a spontaneous one-man revolution, as opposed to the Who's organized assault on the senses.

ROBERT CHRISTGAU (*Esquire*): With his back to the audience, Hendrix humped the amplifier and jacked the guitar around his midsection, then turned and sat astride his instrument so that its neck extended like a third leg. For a few tender moments he caressed the strings. Then, in a sacrifice that couldn't have satisfied him more than it

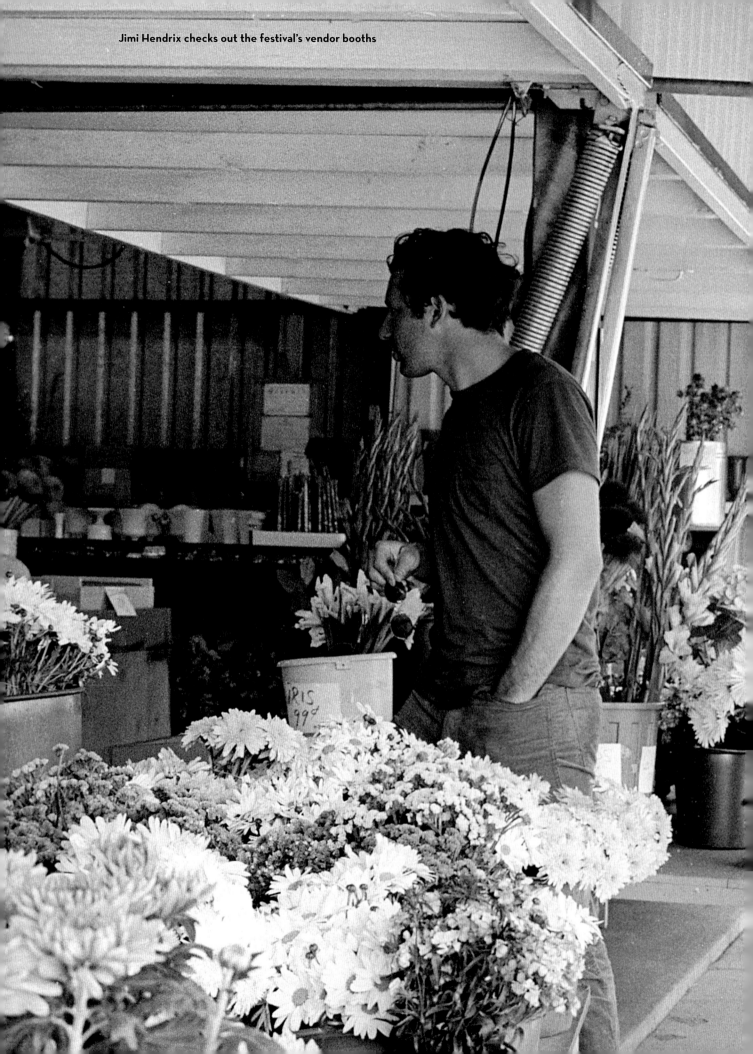

Jimi Hendrix checks out the festival's vendor booths

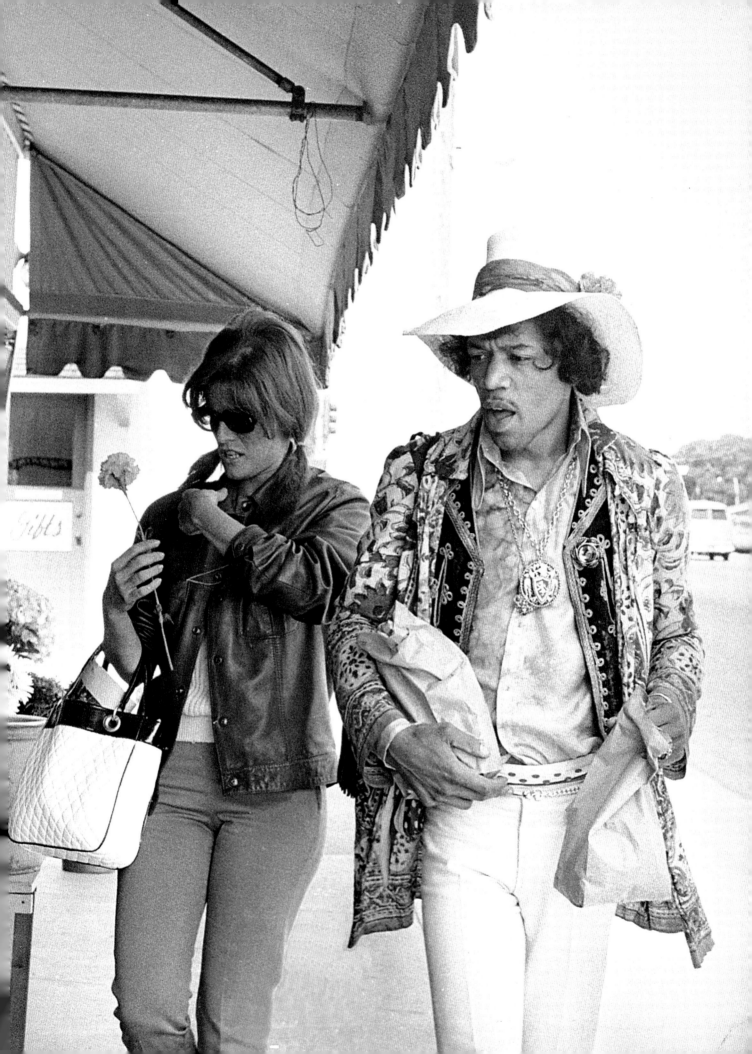

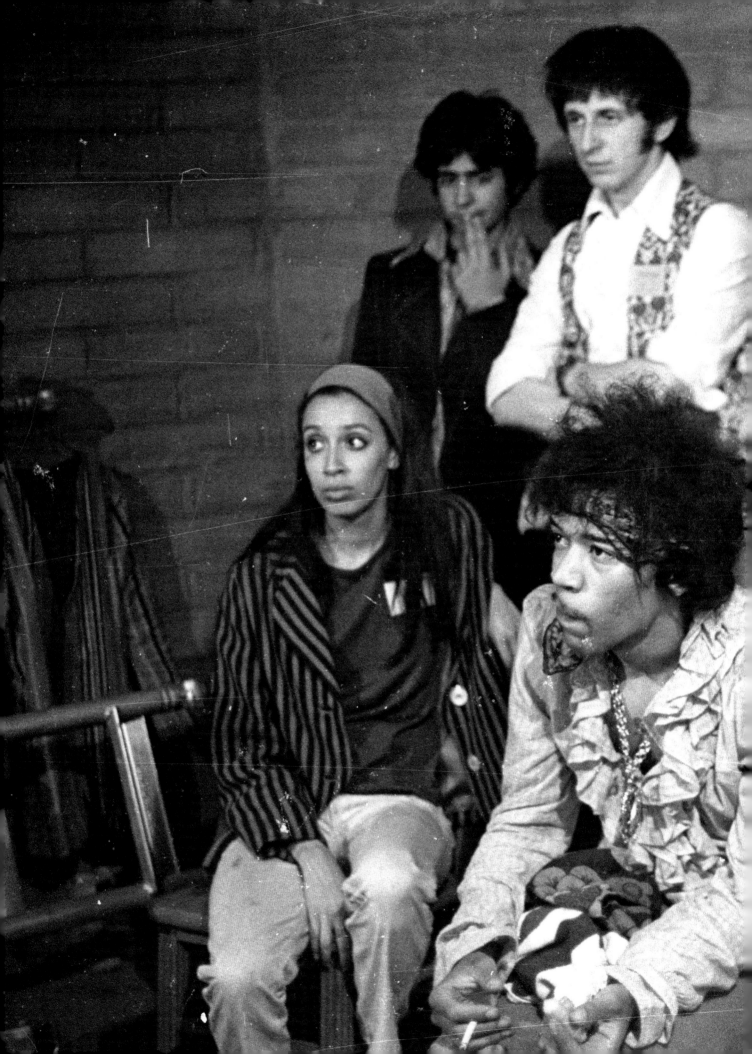

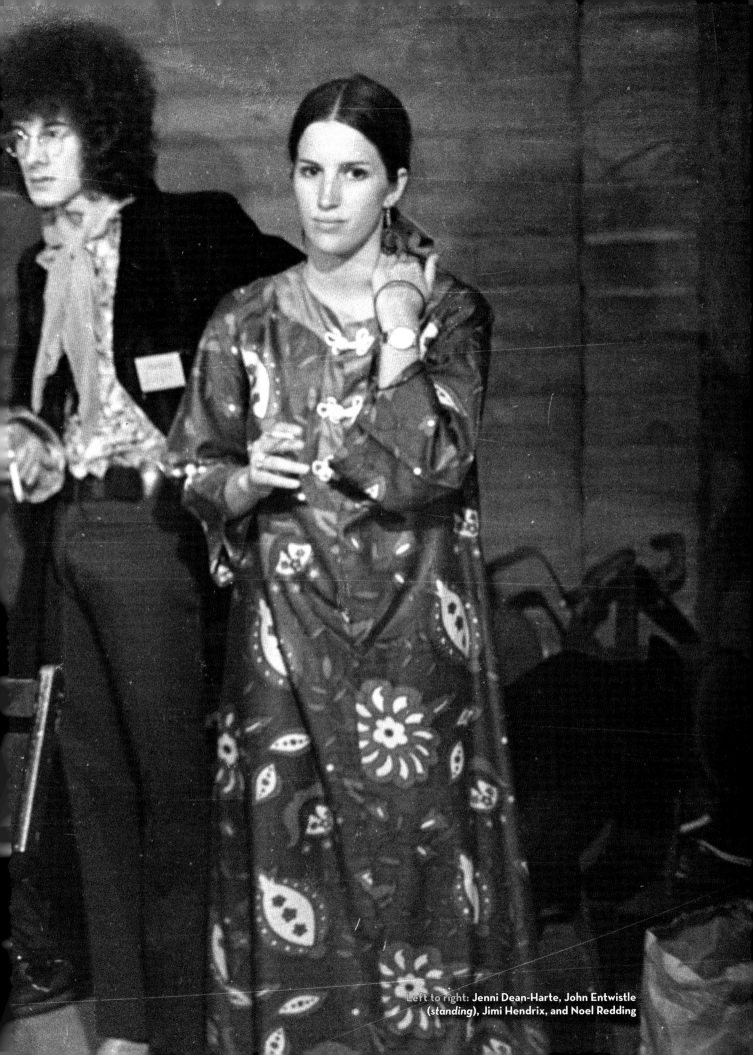

Left to right: Jenni Dean-Harte, John Entwistle *(standing)*, Jimi Hendrix, and Noel Redding

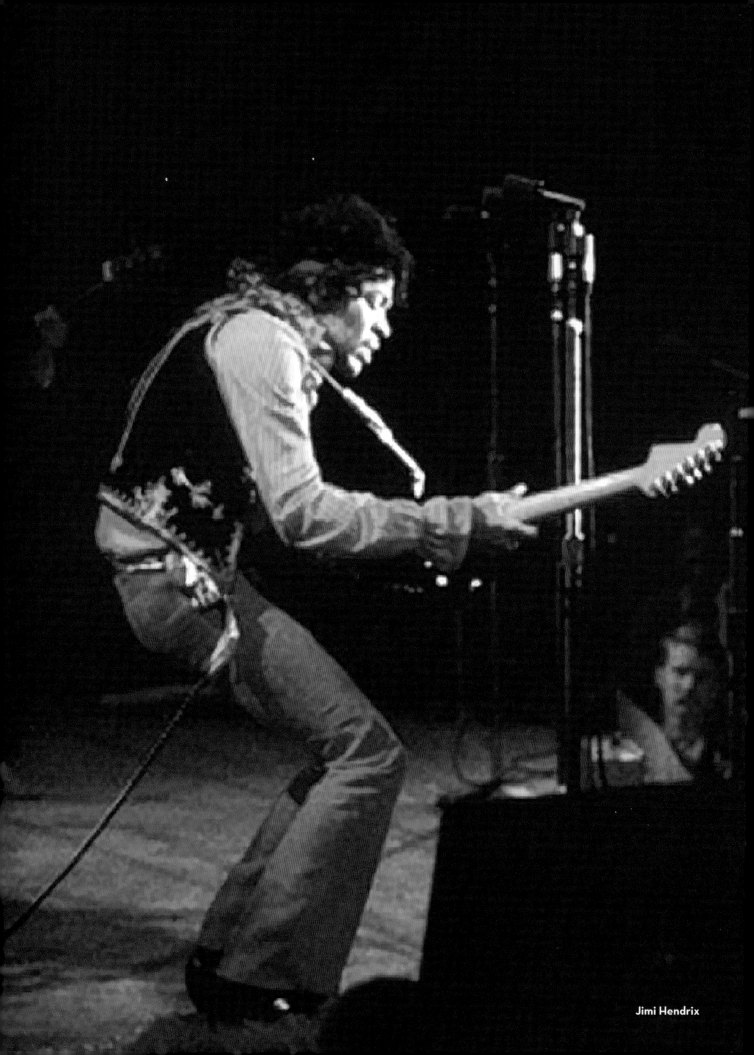

Jimi Hendrix

did me, he squirted it with lighter fluid from a can held near his crotch and set the cursed thing afire. The audience scrambled for the chunks he tossed into the front rows. He had tailored a caricature to their mythic standards and apparently didn't even overdo it a shade. The destructiveness of the Who is consistent theater, deriving directly from the group's defiant, lower-class stance. I suppose Hendrix's act can be seen as a consistently vulgar parody of rock theatrics, but I didn't feel I have to like it. Anyhow, he can't sing.

JENNI DEAN HARTE (Audience Member): I knew Jimi from Greenwich Village before he went to England. Loved him, loved his music. I was with Jimi, driving around Monterey before his performance, trying to find lighter fluid (for you know what!). We had to drive around for a while because most of the stores were closed, but we finally scored. He didn't want to go on after the Who and they didn't want to go on after him. We all knew what kind of impression he was going to make, and it was a fuckin' thrill a minute for everybody.

AL KOOPER: When I was setting up Hendrix for sound check, I knew who he was. Before even reading the English music magazines about him, he played in New York with John Hammond's backing band at the Café Wha! And you could tell that he was pretty special.

Jimi knew who I was, so when we met it was quite nice. "I'm gonna play 'Like a Rolling Stone' tonight, do you want to sit in with us?" I said, "I would love to play with you but I'm working here, I'm the assistant stage manager. I think they would look askance if I did that." Can you imagine what kind of self-control it took to do that? "But I think it's inappropriate to do it here because I'm working." Another of my great career moves . . . [Laughs.]

CHRIS HILLMAN: It was not the burning of the guitar. That part was minimal. He was getting this tone on a guitar no one had heard before. My reaction at first was, that's a lot of noise. Noel Redding was really loud and the drummer [Mitch Mitchell] was playing nine million fills. But then that guitar tone comes in. And let me be honest with you: I didn't appreciate Jimi Hendrix until 15 years afterward. And I started to hear the blues stuff later on that he did after all the show.

Roger, Mike Clarke, and I had seen him earlier at Ciro's, playing guitar for Little Richard. He was a sideman on the end of the stage. Playing lead in an R & B band, you're not the showcase. It's the horn section carrying it. Very few guitar solos, mostly rhythm and stuff. But we said, "Who is that?" Because the guy was so good, and then a year and a half later there he was, at Monterey.

PAUL BODY: He said at the beginning of "Wild Thing" that he was going to sacrifice something that he dearly loved and we didn't know what the hell he was talking about. He turned the Monterey Pop Festival into a Sunday night Cut 'n' Shoot, Texas honky tonk. Jimi's music outlasted Robert Christgau's scathing review of the show.

MITCH MITCHELL: Monterey, for us, was just amazing. Not only was it our first American gig, but the largest audience we'd ever played to. Paul McCartney, bless him, had recommended us to John Phillips for Monterey and we really wanted to deliver. I mean, just 10 months before, Jimi'd been playing in little clubs in New York, largely ignored.

There was a great atmosphere backstage—all the artists waiting in a huge marquee, watching the show on monitors. We'd won the who-goes-last toss with the Who and stood watching them, waiting to go on. They were incredibly good, as usual, but we were too on-edge to enjoy it. When Pete Townshend broke up his guitar—which I seem to remember took quite a while, unusual for him—we thought, how do you top this? Mainly due to their excellence, we decided that it was time to roast-the-fender again. This was only the second time Jimi had set fire to his guitar.

When we came off stage, drenched in sweat as usual, the other musicians and groups crowded round to congratulate us. That meant so much to us, not only the audience approval but that of our peers as well.

JERRY WEXLER: I'm in the wings when Jimi walks up to me just before he's going onstage—he's in full psychedelic regalia, all feathers and boas. And, he looks at me, and almost apologetically, runs his hands all over himself and says, "Hey, man, this is just show business."

JOHNNY RIVERS: When Jimi Hendrix came out, I was standing in the wings next to Lou Adler, and

the fire marshal was there, and that whole entire stage was made out of wood. The walls, ceiling, floor—wood. It's still exactly the same. When Jimi pulled out that lighter fluid, threw his guitar down, and pulled out these matches, the fire marshal started to run out onstage, and Lou actually grabbed him by the arm and told him, "It's okay, it's just part of his act." Lou calmed him, because the guy was just gonna grab Jimi onstage. And the guy kinda stepped back, for a split second, and thought Jimi was gonna fake lighting the guitar, but then when it actually went up in flames, he flipped out! He went running looking for a fire extinguisher. Jimi kind of sat over it like he was having sex with the guitar, and a roadie came out with a big towel and threw it over the guitar and smothered the fire.

MICHELLE PHILLIPS: I was so embarrassed and shocked. I had never seen anyone so sexually explicit onstage. I had never seen anybody treat their ax like that. We were always so careful about our instruments and when we traveled we had the guitars in the plane with us. And then to see him set fire to his guitar, and to slam it to bits on the stage was very upsetting to me. It was a form of expression that I was not prepared for.

STEPHEN STILLS: Jimi blew me away so bad at Monterey that, through sheer force of personality, I just bullied my way past all the security and sycophants to meet him. And he was delighted to meet a Southern boy who knew all the same people from New York and actually knew something about blues. And he was very intrigued by my acoustic guitar playing. So there was a lot to give and take between us. I wasn't that accomplished a player on electric yet, but all that Travis picking

Above: **Mitch Mitchell** ✳ Opposite: **Micky Dolenz in the audience**

stuff—he was interested to know how all that went, how I made the guitar sound like that on record. I'd tell him, "Well, first you get a fifty-year-old Martin."

RON LANDO (Audience Member): For weeks I kept hearing about this festival on the radio. I actually won tickets one night through a local AM radio station in Salinas, KDON. The DJ said the first caller would get tickets to the closing night show. I had to name the five songs they played in a row to win the tickets.

My parents were at Monterey as vendors; they were with the Kiwanis Club, who were selling pastrami sandwiches.

I really wanted to see the Who and Jimi Hendrix. My tickets were right in the front and I was standing next to the stage near the photographer pit for the Hendrix set. It was the most amazing music and show I had ever seen. I could smell the flames from his guitar burning. Pieces of wood whizzed by my head.

HOWARD WOLF: I sat in the front row for Jimi Hendrix. I thought, "What fool manager would have this act follow the Who?" Well, I wasn't going to be foolish enough to miss this opportunity, so I grabbed my Nikon and snapped away like I was on fire.

From Monterey on, it was the money first. The managers started saying things and the money demands started taking precedence I told [promoter] Chet Helms that it was the beginning of the end. I talked to a number of the San Francisco managers and told them that this scene was going to implode because they were hit-and-run guys. They wanted as much money as they could get and would burn anyone in their way. They had little or no concept of building or maintaining a career. As fate would have it, the San Francisco people, who hated L.A., ended up coming to L.A. because the record companies had most of their facilities there.

MICKY DOLENZ: I do remember that, after the Hendrix show that night, I ended up somehow as this sort of mascot to Jimi and God knows who else. I had acquired instruments, amps, guitars, and a generator for electricity, and long after the show was over and the event had essentially ended, everybody was so pumped up it was tough to go away. And there wasn't anybody who was forcing anyone out of the area. It was this ongoing kind of buzz and people would gather in little groups and started jamming. I wasn't playing, there was no drum set, and people were playing on their knees. It was like "Kumbaya" in a psychedelic way. We all sat there for hours until the morning. Everyone was hungry and thirsty. I wanted to contribute to the vibe, so I went out and found a case of oranges. I lugged it back to the tent, and started giving out oranges like I was Little Johnny Orange Seed. I think I might have also heard at the time that oranges, or orange juice, were helpful after an indulgence of chemicals . . .

The Monkees were looking for a great opening act at the time, as we had a tour planned. I had seen Hendrix earlier as a backup guitarist for John Hammond Jr. in New York. Jimi walked out onstage and I recognized him, because he was playing guitar with his teeth. "Hey! That's the guy who plays guitar with his teeth from Greenwich Village." I suggested him for our tour because he was so theatrical. Um . . . It didn't work out. [Laughs.]

BARRY GOLDBERG: I was at the Café A Go Go in New York when Chas Chandler discovered Jimi Hendrix. Chas was with Eric Burdon. I was playing with John Hammond Jr. when Hendrix was playing with us for the whole week and did "Hey Joe." That changed his whole trip. Then at Monterey I saw Jimi, and he called over to me, "Hey, Piano Man"—that's what he called me—"what's happening?" "You are!" I remember that like it was yesterday. Shortly afterwards I wrote a tribute song with Michael Bloomfield about Hendrix, "Jimi the Fox," and we did it on our album, *Two Jews Blues*. Later, when Jimi and Buddy Miles did *Band of Gypsies*, Jimi told Buddy how much he really liked our song about him.

Overleaf: Jim Hendrix douses his burning guitar with lighter fluid.

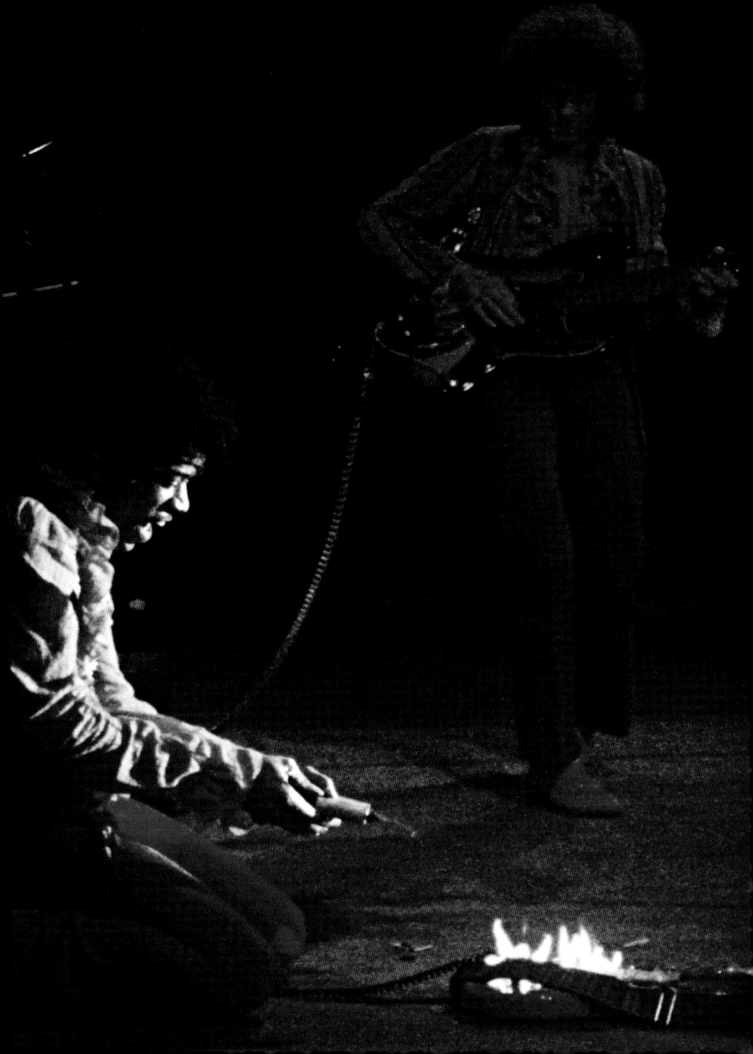

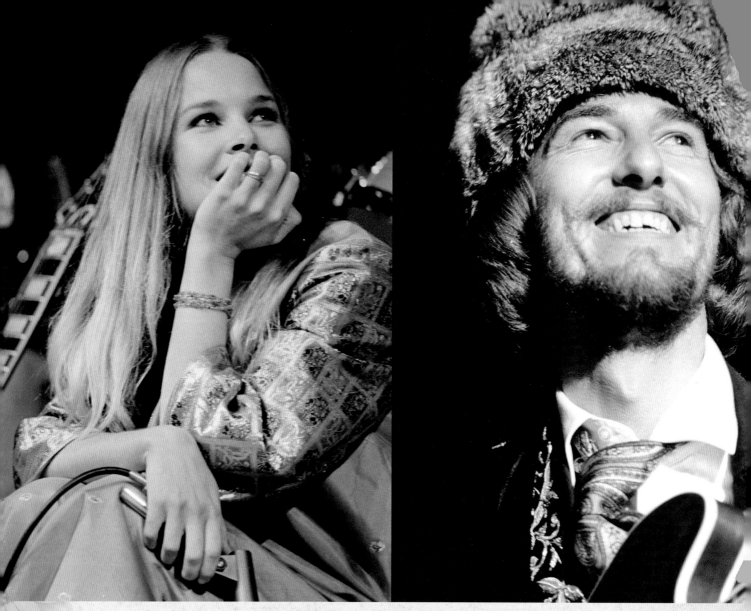

Left: **Michelle Phillips** ✳ Right: **John Phillips** ✳ Opposite: **Cass Elliot**

The festival was drawing to a close with the valedictory performance by THE MAMAS AND THE PAPAS. It may have been an anti-climax to those still recovering from the preceding blitzkrieg, but there was no artist better suited to conclude the event. John and Michelle had helped shoulder the daunting responsibility of bringing the festival to fruition; for months, they had used their "royal" status to lovingly strong-arm resistance into accommodation. And if their birdsong melodies and shimmering harmony seemed suddenly quaint in light of the pop paradigm shift they had just helped engineer, well, only a cynic or scold would deny them the pleasure of serving a light repast before sending their guests home well-sated.

And, with all that, they almost didn't make it to the "altar" on time. Denny Doherty had been on sabbatical in the Virgin Islands prior to the gig. He was becoming a vacillating presence within the band, showing up only for essential rehearsals and recording sessions. The others began to twitch with anxiety as they waited backstage for Denny. It was bad enough that they had not sung together in months, what with the administrative demands of mounting the festival, Cass's recent childbirth, and Denny's Caribbean idle. With moments to spare, Denny arrived, flushed from his breathless sprint to Monterey—flying coast-to-coast to L.A., racing up PCH in a stylish convertible, and then fishtailing

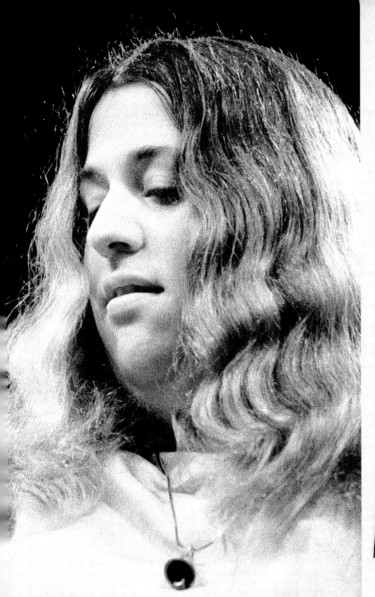

THE MAMAS AND THE PAPAS
John Phillips: vocals, guitar
Michelle Phillips: vocals
Denny Doherty: vocals
Cass Elliot: vocals
Eric Hord: lead guitar
Larry Knechtel: piano
Joe Osborn: bass
Eddie Hall: drums, percussion
Scott McKenzie: vocals*

"Straight Shooter"
"Spanish Harlem"
"Somebody Groovy"
"Got a Feelin'"
"California Dreamin'"
"I Call Your Name"
"Monday, Monday"
"San Francisco
(Be Sure to Wear Flowers in Your Hair)"*
"Dancing in the Streets"*

into the backstage area with the insouciance of David Niven arriving for his evening martini. He would dine on this story for years to come—just another one of the tall tales lurking in the mists of Monterey.

Scott McKenzie came out to join them at the concert's close, the fairgrounds resounding with the "unofficial" song of the festival: "San Francisco (Be Sure to Wear Flowers in Your Hair)." Years earlier, John Phillips was a scuffling folkie in New York who teamed with Phil Blondheim in the Smoothies and, later, the Journeymen. Phil changed his name to Scott McKenzie, hoping, perhaps, that its neatly metered cadence might attract that elusive hit song he so desperately wanted. It finally came in the form of this John Phillips-penned confection that oozed earnestness like a Boy Scout merit badge. It nagged at your ear with just the right proportion of craft and emotional yearning; not a clarion call, but a gentle nudging that proved irresistible.

Unless, of course, you were from San Francisco, and raged yet again at Phillips and Adler (the song's producer and label head) for co-opting the Bay Area's self-styled *hauteur* for their own nefarious ends. Like squabbling brothers, the musical poles of the Golden State would continue to accuse each other of buying in and selling out before reaching their Appomattox sometime in the seventies. If Monterey wasn't exactly Gettysburg, it remains a hallowed ground.

HENRY DILTZ: The dressing rooms were underneath the stage, on dirt floors like a basement. The Mamas and the Papas were backstage doing various vocal exercises, like holding the tip of your tongue with your two fingers and sorta chanting sounds and making all these scales—"oooh-ahhh." Jimi Hendrix, who had just finished playing, was on the other side of the room, sitting in a chair, eating a piece of fried chicken, with people all around him, just checking out these "other" hippies—the Mamas and the Papas doing their "unique" chant harmony. And there was Jimi, chewing on this chicken breast.

MICHELLE PHILLIPS: It was very disconcerting because Denny didn't get there until about 45 minutes before we went on. We had not rehearsed or performed together in three months. We had not rehearsed with Larry Knechtel, Joe Osborn, or Hal Blaine, who were added to our regular band. And although these guys knew our music, we were not used to doing a concert with them. It was very awkward. And, of course, we did the concert, and I knew things were not going well, or great, but the mood of the audience was so good and happy that they bent for us. Scott McKenzie came out and sang "San Francisco" before our last number, "Dancing in the Street."

I know when I came offstage I just cried and cried for two hours. And then I finally stopped. [I thought,] "You know, Michelle, I know it wasn't a great concert, but get over it. What's wrong with you?" And, that's when I realized I was pregnant! [Laughs.]

AL KOOPER: They had a great band, too, Eric Hord on lead guitar and Eddie Hoh on drums, who were great musicians no one had heard of until they played with the Mamas and the Papas. They were the ultimate professionals who just came on and had their thing down. And the fact that the Mamas and the Papas were so instrumental in putting the show together made it like they were the moms and dads of the festival!

Cass Elliot and Leah Cohen (Kunkel) in the audience

The Mamas and the Papas warm up backstage

LEAH COHEN (KUNKEL): There's a photo of Cass and me sitting together at Monterey. I mean, I just love that picture. First of all, there are almost no pictures of me and Cass together. There may be three of them in the world and I'm sure Henry [Diltz] took them. Even on the day that I got married—I was married in Cass' backyard—she was in the hospital having her gall bladder removed. I don't have pictures of her at my wedding.

So when I look at that photo of her and me sitting together, I go, "Wow." Everyone was peaking. Cass was just in a great place and the Mamas and the Papas were riding the crest of their success—but also because of this wonderful festival they were responsible for. A lot of the time, when you go to a show and you're in show business yourself, it's hard for you to be an audience. You think about things like sound systems, getting the right balance, etc. This time we were at one with everyone else. We were really united with that group, watching and experiencing the music together. And that was kind of a rare thing for performers.

RODNEY BINGENHEIMER: We were in the VIP area. I had gone to a lot of the Mamas and the Papas' recording sessions in Hollywood. I thought they were great at Monterey. They had a vibe—the harmonies and the way they were dressed by Toni from Profile du Monde, a Hollywood boutique. I knew Eddie Hoh, their drummer—Fast Eddie from Chicago. I was onstage for their set. The year before, I took the Hollies to a Mamas and Papas session at Western Recorders, and that's where I introduced Graham Nash to Cass and then he got Crosby, Stills and Nash started. Everyone initially wanted to check out Michelle and then got grooving with Cass. Everyone loved her. She was very down-to-earth. Denny [Doherty] was quiet. Lou Adler, their producer, was a master at work; he even left the "mistake" in "I Saw Her Again," and made art out of it. On the playback in the studio, we all thought it should be in.

Overleaf: **The Mamas and the Papas**

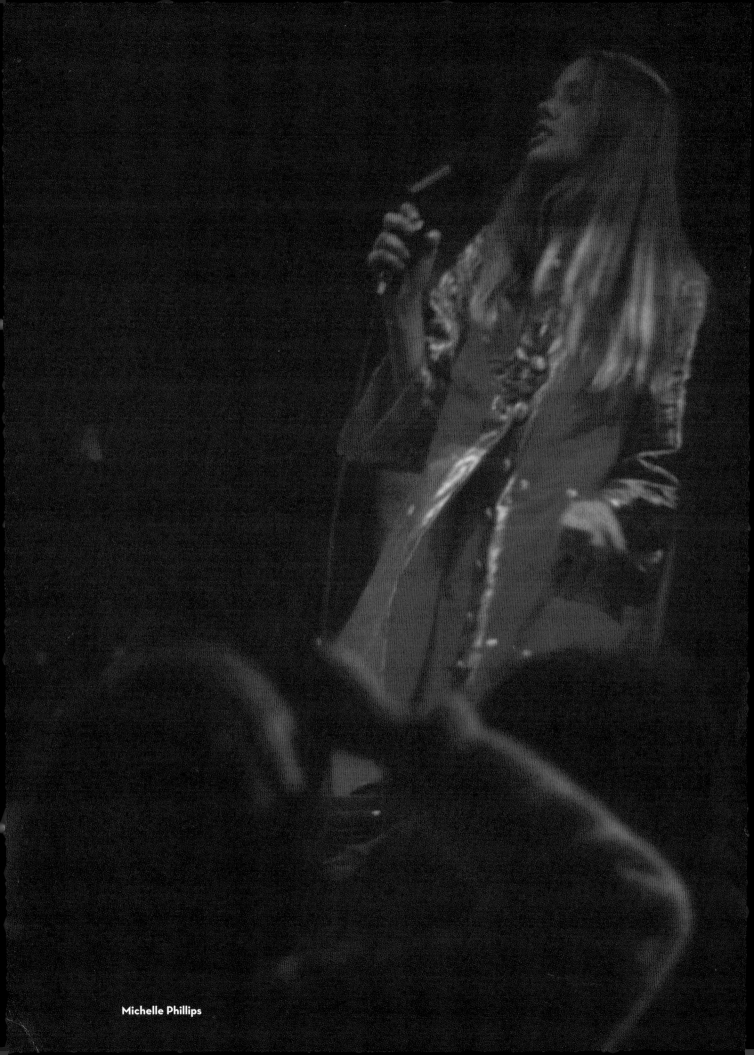

Michelle Phillips

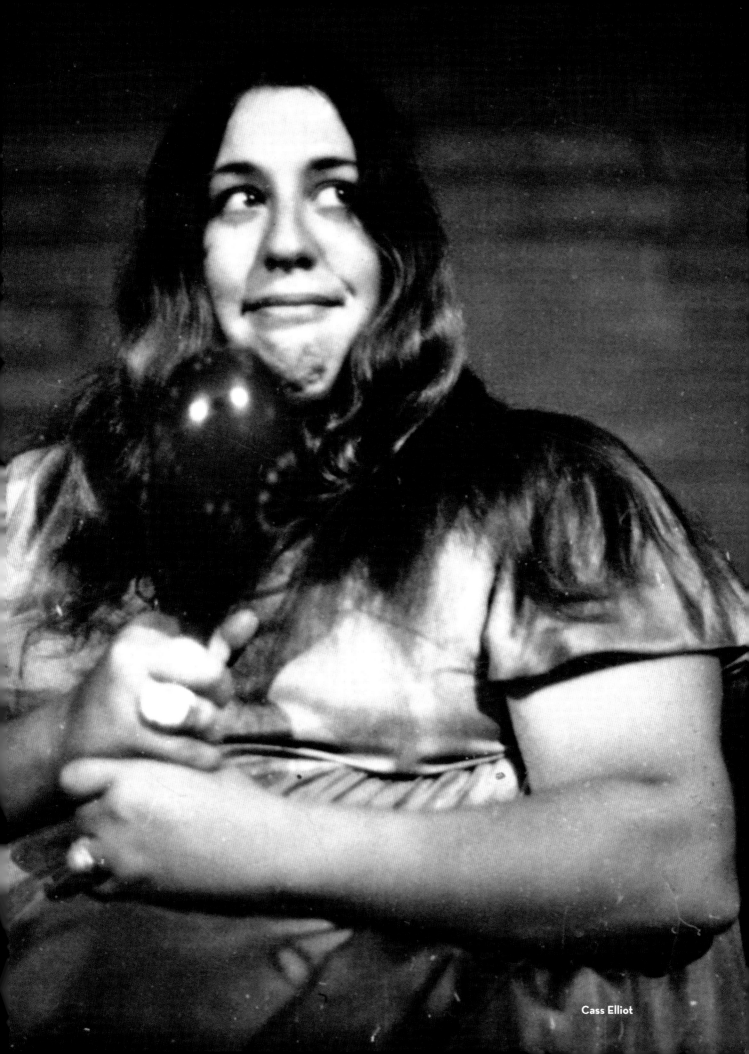

Cass Elliot

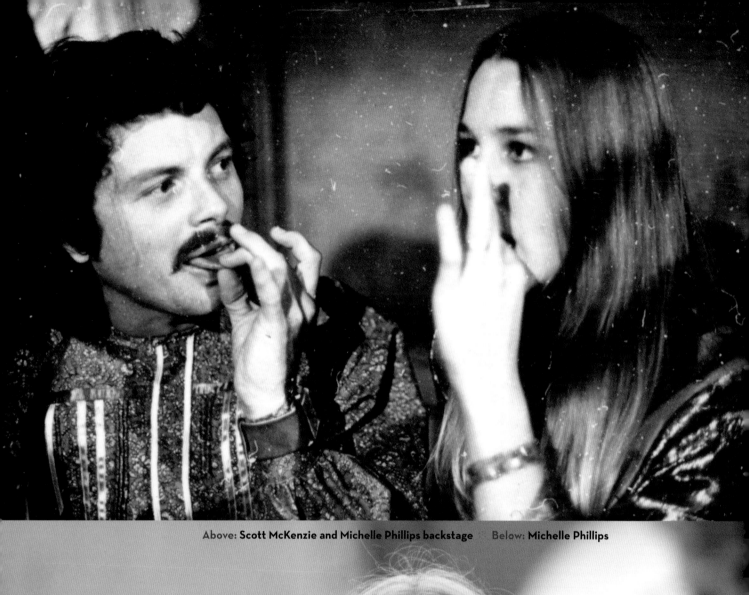

Above: **Scott McKenzie and Michelle Phillips backstage** Below: **Michelle Phillips**

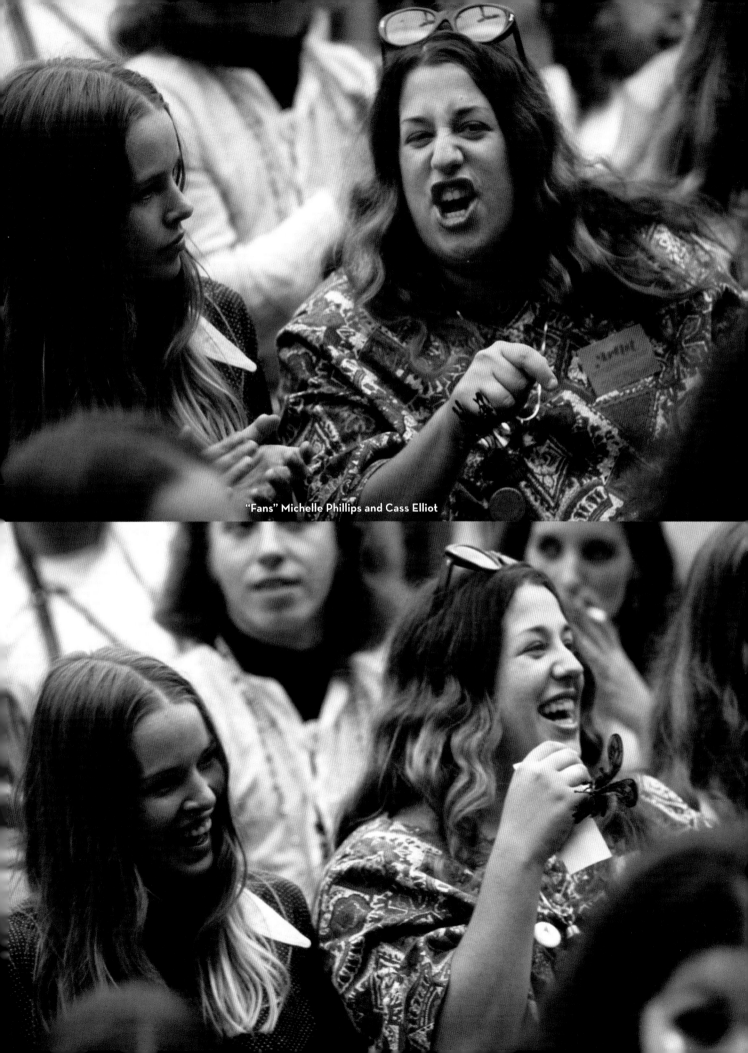

"Fans" Michelle Phillips and Cass Elliot

Keith Altham's Diary for Sunday

SUNDAY

Eric Burdon made the announcement for the Who, who appeared resplendent upon the stage with Roger Daltrey wearing a pink silk poncho, Keith Moon in red mandarin jacket, Pete Townshend in lace ruffs, and John Entwistle in a yellow and red shirt. Burdon had promised the audience that this group would destroy them in more ways than one, and they proved it. Once into their interpretation of Eddie Cochran's "Summertime," Pete Townshend took on the appearance of a berserk British aristocrat and began the guitar gymnastics. "Pictures of Lily" woke up the whole audience to the fact that this was a new British group with something of their own to offer. They were into "Happy Jack," their first big U.S. smash, but surprisingly, there was an even bigger reception for "My Generation," sung with vocal dexterity by Mr. D-D-D-Daltrey.

Pete Townshend's mini pop opera was also featured, and the finale was a "beautiful" explosion of amps, guitars, and microphones. Keith Moon managed to kick another drum set to pieces, Pete destroyed his guitar by smashing it on the stage, and John knocked a mike or two over as a concession. Smoke poured from the amplifiers and the whole auditorium rose to its feet in amazement. Then the applause broke out. It won't take long for the word to go 'round about this episode, and then everyone will know who's Who in the U.S.

Brian Jones came onstage to introduce the Jimi Hendrix Experience. Hendrix then proceeded to completely shatter everyone within "digging" distance. The space around the backstage areas filled up faster with musicians than for any other act. For a man yet to have a big record in the U.S., Jimi created a fantastic impression. His biggest successes were "Foxy Lady," "Rolling Stone," "Purple Haze," and "Hey Joe," but the showstopper was "Wild Thing."

What an extraordinary job he makes of this number. There was a generated excitement right through every bar of this last number and, having extracted the last ounce of life from his instrument, Jimi did the human thing and had it exterminated. This he managed à la Who by smashing the guitar and flinging it to the audience.

It is fitting tribute to the Mamas and the Papas that, not only could they follow "that," but

John Entwistle

they could also top it. In five years of watching top pop groups, I have never been so impressed by four people. Papa John, in his long velvet cloak, bejeweled with stars, looks like a genial wizard; Mama Cass is the kindly fat fairy; Papa Denny, a court jester; and Mama Michelle, the princess. It is impossible to do full justice to the sight and sounds of this group in print—seeing and hearing is believing, and even then it is difficult to believe the beautiful harmonies on numbers like "The Joke's on You" and "Spanish Harlem." To really understand what they were singing about on "California Dreamin'," you have to be here or have been here. "It is to this number," Mama Cass assured us, "that we attribute our enormous wealth."

Cass referred to her "ex-amour" John Lennon, who liked the number she was about to sing—"I Call Your Name." Although one almost expected a leap onstage in a puff of smoke from the devil-Beatle, we were disappointed. No Beatles at Monterey, but many beautiful songs from the Mamas and the Papas, from "Monday, Monday" to the last rousing choruses of "Dancing in the Streets." The festival is now over—a good time was had by all.

Switched-On Monterey

Paul Beaver and Bernie Krause arrived at the Monterey Fairgrounds with a most unwieldy companion: a Moog Series III modular synthesizer, the brainchild of pioneering sound engineer Robert Moog. Beaver, a sound effects specialist, and Krause, a guitarist-turned-synthesist, were eager to demonstrate this Rube Goldberg device to an audience of credulous young rock musicians intent on test-driving the sounds of tomorrow. Micky Dolenz had already made a purchase; the wacky, offbeat sensibility of the Monkees seemed a fitting context for the Moog's whimsical possibilities (Paul Beaver himself played on their tune, "Star Collector"). But they found few takers. Perhaps the tangle of wires and engineer's schematics proved too daunting to those struggling to master a wah-wah pedal.

On the flight back to Los Angeles, however, another Monterey moment struck with unexpected consequence. Jac Holzman of Elektra Records was on board and approached them with an offer. He indeed heard a future that resounded with a cascade of ring-modulated, oscillator-driven, joyful noise and wanted it for his label. *The Nonesuch Guide to Electronic Music* was released to an unsuspecting public in late 1967. Implausibly, it became a worldwide hit among the knob-twirling crowd. In time, the synthesizer would invade every parsec of the musical universe. For some, it was nothing less than a golem to be vanquished. For others, it was the key to the superhighway of the infinite mind. Anything that polarizing had to be doing something right.

MICKY DOLENZ: I can vividly recall seeing the Moog exhibit. It was more than a booth. That was the future. It was like hallucinations for your ear. The sound was really together and tuned for the room. A whole bunch of synthesizers next to a booth with dulcimers.

JIM (ROGER) McGUINN: I found Paul Beaver, the Moog guy, who was demonstrating the instrument inside a tent in the fairgrounds, and I flipped out on it. Later I went back to Los Angeles and bought one from him for $9,000 (I was doing okay then). They used to make effects on tape recorders and the theremin. So this was a big step forward in electronic music, with all the little modules you could program with telephone cords. It was a great machine. I still have it in my family room.

Micky Dolenz with his Moog sythesizer

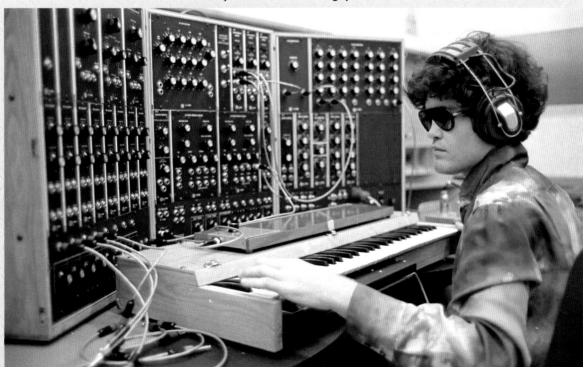

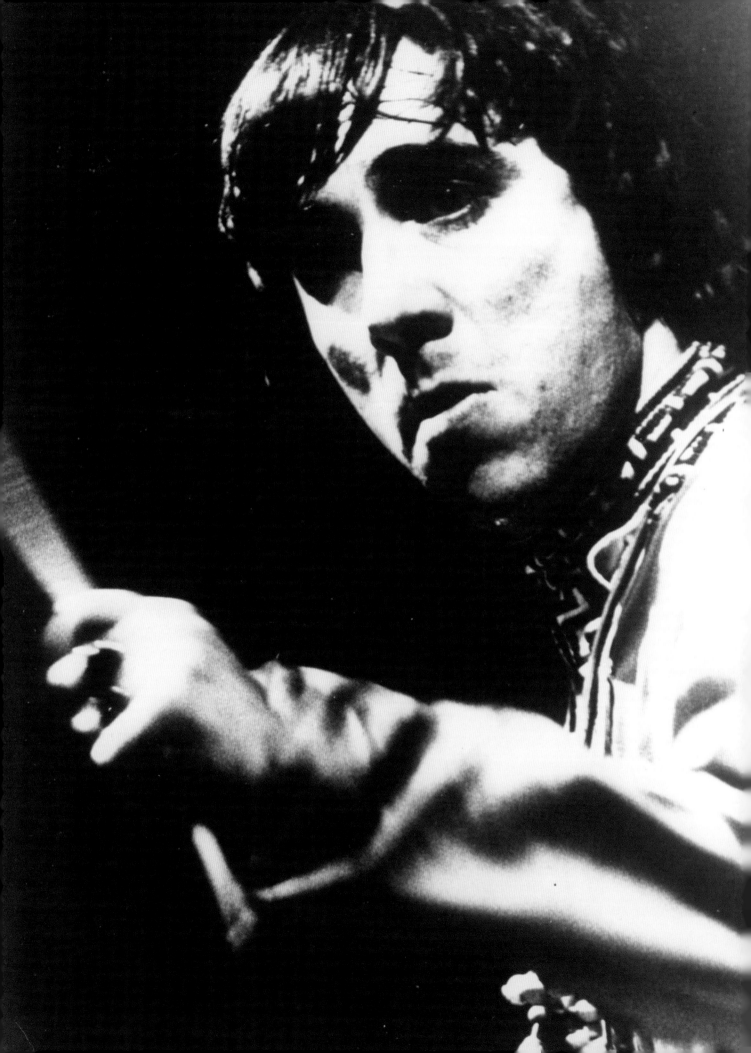

Chapter 7

MONTEREY POP THE MOVIE

D. A. Pennebaker had distinguished himself as a music documentarian of the first order with "Don't Look Back," his cinema verité account of Bob Dylan's 1965 tour of England. Stark and unflinching, Pennebaker captured Dylan's lacerating wit, as well as his ferocious musical vision. This chiaroscuro portrait of an artist as prodigious striver pointed a way forward for filmmakers eager to marry their ambitions to their musical counterparts.

In the spring of 1967 he flew to Los Angeles from New York at the behest of a Hollywood producer who had him in mind for a music project. Pennebaker had just seen the movie *Endless Summer* and said, "It was totally apparent to me that it wasn't about surfing, but about California. At that time, everyone wanted to go to California. So I thought about the offer for about two minutes and then said, 'Yes!'"

The original proposal to film a concert soon grew into the vast, unprecedented undertaking of shooting a three-day event: the Monterey International Pop Festival. Lou Adler and John Phillips had negotiated with ABC-TV for exclusive broadcast rights and used an advance from the network to underwrite Pennebaker's production. While working on a rough cut, Pennebaker and Adler showed some unedited footage to ABC president Tom Moore. He grew increasingly alarmed as he watched a black, threatening presence hump his guitar and then his amplifier, summoning forth the sinister bargain made at the crossroads. "Not on my network!" he thundered, making the world safe for *Bewitched* and *F Troop*.

Clearly relieved, the producers opted for a theatrical release, allowing Pennebaker to tap into a burgeoning circuit of art house and grind house distributors. It was catch-as-catch-can when the film debuted in early 1968. It garnered excellent reviews and performed well at the box office. Covering the film's debut at the Venice Film Festival in September of 1968, *Variety* wrote: "The exuberance, sweat, dynamism, and talents of many of the performers get astute observation by well-placed camera work from all angles, and it is expertly welded into focus by adroit editing." The magic of Monterey had gone viral.

In 1969, financier Joel Rosenman, along with his partner, John Roberts, agreed to meet with two young entrepreneurs who envisioned building a recording studio somewhere in the roving beauty of the Catskill Mountains in upstate New York. Michael Lang and Artie Kornfeld were hustlers with a heightened sense of aesthetics; putting rock music in nature's playground seemed like a no-brainer. Rosenman had recently screened *Monterey Pop*, and his mind danced at the prospect of staging an East Coast version of that California idyll. In August, their mutual dream was realized . . . in nearby Woodstock.

Opposite: Publicity still of Keith Moon from Monterey Pop

D. A. Pennebaker

D. A. PENNEBAKER: I had never seen a music festival at all, not even Newport. So I didn't know what to expect. It had a really nice feeling to it, and I loved Monterey. And I sort of thought, "Well, these John and Lou guys know what they are doing."

The film on Monterey was not going to be *Don't Look Back* part two. It was in color. It was a lot of people and me not having my head inside of a camera. It was five people that I knew who were friends and who were totally into the music. I thought, "That's the way to do a thing like this."

I was attracted to Monterey and the fairgrounds because it wasn't a huge festival place but where you had farm shows, and places for horses. The John Steinbeck feeling was not lost on me. And I remember walking around, thinking, "How should I organize? What should I do?" The thought of taking command of a hoard of filmmakers was ridiculous. I mean, I didn't know how to do that, anyway. So I felt, "I'll just wait and it will settle itself." And it did.

Ricky Leacock and I were the only genuine filmmakers with little cards that said we belonged to a union. Everybody else was invited to come and work with me for a while, like Albert Maysles [laughs]. I gave them all a camera. I was living in Sag Harbor. Nick Doob was a guy who was studying to be a priest and working at the post office in Sag Harbor. He came to me and said, "I want a job." "What can you do?" "It doesn't matter. I'll do anything. But if I stay at the post office . . . The guy next to me just shot himself, and I'm next."

I didn't want to do a lot of interviews for this film. I wanted it to play like putting on a record. The record never talked to you. It just played for you. That was the mindset going into Monterey. Interviews didn't interest me. I didn't want to take the time. I wanted everybody to concentrate on music. And I didn't want them to think about anything except getting film to match that music.

A film is like a Mexican sculpture. You have a lot of shit that you got, and it doesn't matter how you got it—because you weren't thinking about what to do with it. You were just getting it because it was interesting to you. And then if you watch it, think and dream about it, then it will tell you what

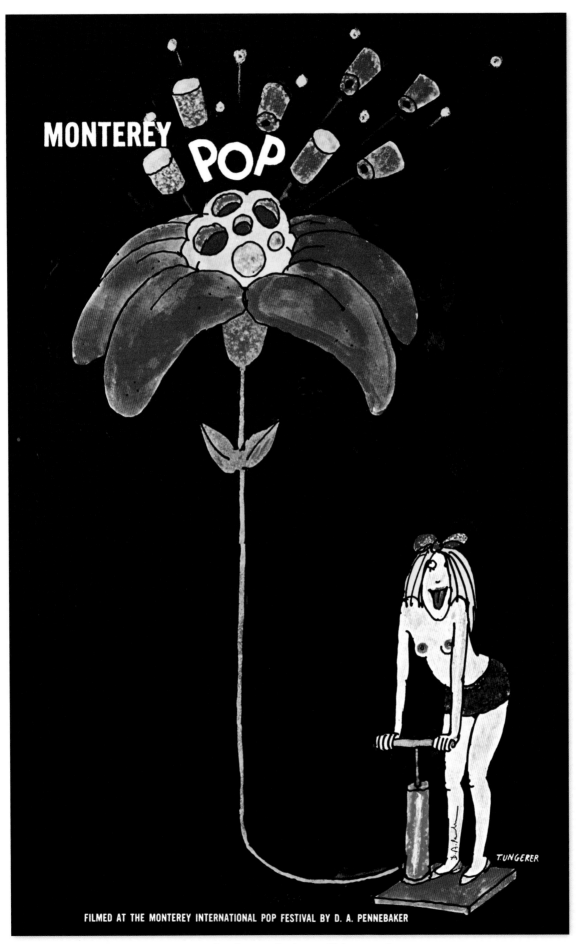

Poster for theatrical release of *Monterey Pop*

Promotional material for *Monterey Pop*

it wants to do. And that film kind of made itself, really. I was sitting down at Max's Kansas City and wrote on the back of a menu what I thought the order of the music should be. It was always clear to me that Ravi Shankar had to be the climax. And a lot of people weren't sure of that, and still feel that way today. But I felt that that was so unexpected, it worked.

I think of these films like *Monterey* much more as if they were plays on a stage. And every play has to build to some sort of climax. Something it was all worth sitting there for. And that's how you decide what comes next. And there was no dialogue. There was music talking to people. It starts with Canned Heat, like the first time you walked into a room with your older family members and you heard music that was a little beyond you, that said, "Come on and try it." It starts with that and it works its way through the most amazing music. I was always sorry about editing out the Electric Flag. Not that it was bad. It just didn't fit.

You have no idea how nervous I was going into that with five cameras that I had built myself, thinking they all are not going to work. Somebody, somewhere was going to be shooting somebody fantastic and the camera was not gonna work. I couldn't stand it. When I see the film now and how it was shot, it all works! And that was amazing. When I look at it now, it's just an amazing display of luck.

JOHN COOKE (Crew Member): In the spring of 1963 I drove to Berkeley with two friends. I met the whole folk scene and had a whole history with Berkeley and California. And when Bobby Neuwirth said, "Hey man, Pennebaker is gonna film the Monterey Pop Festival," it wasn't like exploring a new land. It was like going home. Neuwirth, Penne and me just walked around Haight-Ashbury. Penne wanted to observe what was going on up there. We got to Monterey a couple of days early. Penne got out a day before Bobby, and I flew out with a guy from the Pennebaker office named Tim Cunningham. We were three guys on a plane. We landed at S.F., rented a car, and went down to Monterey. Penne had found the motel. In those days, you didn't look it up on the web. I think he went there and [drove] around. "Oh. This looks like a pretty reasonable place."

The soundtrack for the film performances is all off the PA mix. I was carrying a Nagra, and Bob Neuwirth was sort of helping Penne decide what was hip enough to shoot. Kodak 72-42 film was used. Pennebaker and Ricky Leacock had invented this system that was really radical for the day, whereby the soundman did not have to be connected to the camera by a cord. This was cool. You had a Nagra with a strap over your shoulder. On the strap there was a little light bulb. On the Nagra there was a button. When you pressed the

Promotional material for *Monterey Pop*

button, which illuminated the light, it put a beep on the tape. That was your sync, you see. The cameraman aimed at the soundman. You pressed the button, he got a flash of light, there was a beep on the tape, and he could turn away and film anything in the world as long as I kept the tape rolling and he was rolling and we were in sync. You also got better sound if the cameraman could be where the sound was, but not necessarily in the frame.

Ricky and Pennebaker also modified these Arriflex 16-millimeter cameras. On a standard Arriflex, the 400-foot magazine is on top of the camera and its base is horizontal. They placed it at an angle, the result being that it balanced the camera better. On the hand-held, they put a right hand grip on the front of a camera and you got a very steady base. It was possible to hold it a good deal steadier than the standard Arriflex. So all of this served their film technique, where you were not going to be setting up tripods and lights. Pennebaker just went out and shot life.

ANDREW SOLT: Monterey impacted my life. It influenced it in the sense that it taught me how to capture the music on film and that became my life's work. I wanted to work on projects I believed in. And I was fortunate enough to be able to live out some of those dreams: *Imagine*, the John Lennon documentary; *25x5*, a history of the Rolling Stones; and *This is Elvis*, which I did with Malcolm Leo. And we also did *The History of Rock 'n' Roll*. It also influenced the way I make films in terms of what these different cameras were doing and what were the angles. Things like that. You never think about this stuff until a point in time. Or I never did, I should say. And right after Monterey, I went to Larry Edmunds Bookshop on Hollywood Boulevard and bought a film book about editing. I then learned a little bit about what it took to put a film together—what works and what is a jump cut?

JOHN HARTMANN: I screen the *Monterey Pop* movie every semester in my Rock on Film class at Loyola Marymount University. I confess it was I who placed the Kaleidoscope bumper sticker on the front portion of stage that can be seen. I had an all-access pass, so I could go anywhere, and I was obsessed about putting that sticker there and finally just did it when nobody was looking. When I show *Monterey Pop* at LMU, I chuckle every time I see that sticker. I'm so glad I did it.

The students are fascinated by *Monterey Pop*, especially the whole '60s period. What we had was the fulfillment of the American dream. We had sex, drugs, and rock 'n' roll. We'll never have all those things again. It was a magical time. There was a huge thirst for music.

MONTEREY POP
BY D.A. PENNEBAKER

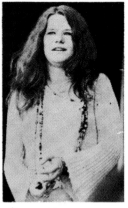

JANIS JOPLIN comes through "with a jolting immediate intensity" (Time magazine) in her rendition of "Ball and Chain," from the musical "Monterey Pop," opening at the Theater.

Scene Mat 1A

(General Release)

"Monterey Pop," which opens at the Theatre, forges "the way to a new kind of musical" (Renata Adler, New York Times). It was filmed at the Monterey International Pop Festival, which erupted like one of California's frequent earth tremors along the beautiful, rugged Monterey Peninsula on a sparkling summer weekend. The Festival, produced by John Phillips of the Mamas and Papas and the group's manager, Lou Adler, was a remarkable composite of some of the most notable popular music talent in the world, including such extremes as Otis Redding singing 'soul,' the Eastern rhythms of Ravi Shankar, the growling of about-to-be blues star Janis Joplin, the musical fantasy of Jefferson Airplane, and the outrageous assurance of Jimi Hendrix.

"Monterey" stars, in addition to the marvelous variety of the 50,000 hippies, flower children, Hell's Angels, music lovers, critics, taste seekers seeking new indulgences, musicians famed and infamous, as well as the most turned on gathering of policemen ever recruited to one place: Janis Joplin with Big Brother and the Holding Company, stamping out her legendary performance of "Ball and Chain," Scott McKenzie singing John Phillips' magic song about going to San Francisco and wearing flowers in your hair, the Mamas and Papas — John, Michel, Denny, and the unforgettable and herself magic Mama Cass — Canned Heat, Hugh Masekela with Big Black on the bongos beating out Miriam Makeba's strange half-jazz, half-African "healing song," Jefferson Airplane driving out "High Flying Bird" — something they've never recorded but should have — and Grace Slick slipping marvelously in and out of Marty Ballen's voice on "Today"; Country Joe and the Fish wrapping their incredible chemical music around everyone's eyes and ears; and Otis, now completely gone, and who can there possibly be that could replace him? — perhaps one or two someday, but that night listening in the Monterey mist which is nearly rain and hearing this last incredible performance, those few must have thought never; Jimi Hendrix, with Noel Redding's base roaring around and under him, his fantastic, never recorded "Wild Thing" that ends in fiery, operatic splendor — Hendrix's guitar engulfed in flames, smashed in perfect musical accompaniment, thrown piece by piece to a stunned audience; and finally Ravi Shankar, holding the overflowing park spellbound for what he has since called his greatest raga performance, bringing to their feet and ending for those 50,000 the historic end now past Monterey Pop Festival. But Monterey Pop still lives on film, in what Life magazine calls "one of the truly invaluable artifacts of our era."

"Monterey" was filmed in free, hand-held style by seven crews, each working independently filming and recording performances and festival. While decisions about which songs to shoot were usually made on the spot and communicated by a system of stage lights, selection of the angles was made by the cameramen themselves, posted strategically around the arena. Director Pennebaker and his soundman stalked the musicians on-stage, catching many of the extraordinary close shots and spectacular lighting effects seen in the film. An additional crew was assigned to roam the audience, recording a kaleidoscope of faces and reactions.

JOHN PHILLIPS of the Mamas and Papas, performing at the Monterey International Pop Festival, which he co-produced. The movie "Monterey Pop" opens at the Theatre.

Scene Mat 1C

Non-performance footage was filmed even more freely. Pennebaker assigned his crews certain events or areas within the Festival grounds, but after that he simply shrugged: "Shoot what catches your eye . . . what you see as the Festival." In his estimation it was a matter of turning loose a lot of people, all with different ideas about what was going on and then putting together a record of what they found. There was plenty to catch the eye — 90,000 feet of it, 45 hours of a 72-hour spectacle which was where it was all happening at that moment.

Filmmaker Pennebaker is most widely known for a more personal feature, "Dont Look Back," in which with his ubiquitous camera he shadowed singer Bob Dylan on a two-week concert tour of England. "Monterey Pop," his second feature, was exhibited in competition at the 1968 Venice Film Festival. Currently Pennebaker is involved in a number of film projects in and out of music. His next theatrical release, through his own distribution company, Leacock Pennebaker, Inc., will be a co-production with French director Jean-Luc Godard in Godard's first American movie, appropriately titled "One A.M." ("One American Movie").

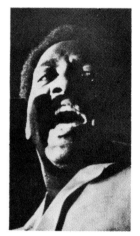

The late OTIS REDDING, "caught at the height of his considerable art" (Life magazine) in "Monterey Pop," film record of the legendary 1967 Monterey International Pop Festival which opens at the Theater.

Scene Mat 1B

RUNNING TIME: 79 MINUTES

MONTEREY POP
 BY D.A. PENNEBAKER

FILMED BY:
 JAMES DESMOND
 BARRY FEINSTEIN
 RICHARD LEACOCK
 ALBERT MAYSLES
 ROGER MURPHY
 D.A. PENNEBAKER
 NICK PROFERES

TITLES:
 TOMI UNGERER

EDITOR:
 NINA SCHULMAN

STAGE LIGHTING:
 CHIP MONCK

LIGHT SHOW:
 HEADLIGHTS

CONCERTS RECORDED:
 WALLY HEIDER

THE FESTIVAL WAS PRODUCED BY
 JOHN PHILLIPS AND LOU ADLER.

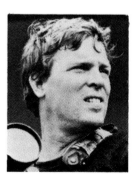

D. A. PENNEBAKER, head of a seven-cameraman team which recorded the 1967 Monterey International Pop Festival. The film "Monterey Pop," proclaimed by the New York Times as "the way to a new kind of musical," opens at the Theater. Director Pennebaker is widely known for his 1967 release "Dont Look Back" starring singer Bob Dylan.

Scene Mat 1D

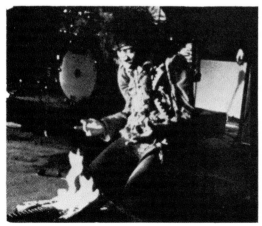

JIMI HENDRIX burns and shatters his guitar, climaxing "Wild Thing," from "Monterey Pop," film record of the 1967 Monterey International Pop Festival, which Judith Christ calls "aesthetically and aurally stunning," "Pop" starts at the Theater.

Scene Mat 2A

LIFE

February 7 1969

MOVIE REVIEW

by Richard Schickel

MONTEREY POP

Directed by D. A. Pennebaker.

Monterey is, of course, a city in California. "Pop" is by now a state of mind as well as the generic term for a form of music, and *Monterey Pop* is a film record by D. A. Pennebaker of what happened when city and state came together one memorable weekend in June 1967.

The first and perhaps most important thing to be said about Pennebaker's movie is that it is one of the truly invaluable artifacts of our era, for the festival's producers were careful to include a representative of what appears to be every significant trend in the new music, which makes the film a remarkably accurate microcosm of vibrant but ill-defined area of contemporary culture.

Which does not mean that *Monterey Pop* bears the slightest resemblance to a survey course. It is full of the most remarkable sights and sounds—some ridiculous, some sublime. Among the former there is an eccentric and musically unpleasant group, the Who, and they end their act by smashing up their instruments and any sound equipment that happens to be in range. Jimi Hendrix, the highly regarded soul singer, does the same thing to his guitar, having previously mimed a sexual assault on it as well as attempting to set it afire. Very odd—and as signs of our artistically anarchical times, instructive.

More to my taste musically, the late Otis Redding, a direct and enormously powerful performer, is caught at the height of his considerable art. And then there is Ravi Shankar, bringing the audience to its feet, and providing Pennebaker's film with an unforgettable climax, by heating his technical brilliance over an emotional flame, yet never allowing his art to boil out of control. Performances of this daring are rare in any art; in pop music, where the premium is on pure emotion ("truthful" or "soulful" or whatever) and form and technique are often mere trivialities, Ravi Shankar's magnificent balance of forces is salutary.

I cannot imagine anyone who cares about the quality of our culture, even distantly, missing *Monterey Pop;* rarely does a movie of any sort provide so much stimulation for thought.

The New York Times

NEW YORK, FRIDAY, DECEMBER 27, 1968

Screen: Upbeat Musical

'Monterey Pop' Views the Rock Scene

By RENATA ADLER

"MONTEREY POP," which was shown last night at Lincoln Center and which will open early in January at the Kips Bay Theater, is a contemporary music film—in the relatively fresh tradition of "Festival" and "Don't Look Back." The movie, filmed by Richard Leacock and D. A. Pennebaker, with the collaboration of Albert Maysles and other independent filmmakers, is an upbeat, color documentary of the 1967 pop-music festival in Monterey, Calif. It stars the Mamas and the Papas, the Jefferson Airplane, Ravi Shankar, the Who and other singing groups. From the moment Scott Mackenzie's "If you're going to San Francisco" comes onto the track and screen, it is clear that this is one good way to do a musical.

●

There is all that shiny hair, orangeade, beautiful

The Program

MONTEREY POP, a documentary of the 1967 Monterey International Pop Festival directed by D. A. Pennebaker; photographed by James Desmond, Barry Feinstein, Richard Leacock, Albert Maysles, Roger Murphy, Nick Proferes and Mr. Pennebaker; presented by Leacock-Pennebaker, Inc. At Philharmonic Hall, Lincoln Center. Running time: 72 minutes.

hands, shades, watermelon, shoeless feet in tights, flowers papers, dogs, the wrinkled bottom of Ravi Shankar's tapping foot, psychedelic blobs behind the podium, smoke effects behind the infernal Who, mouths approaching microphones, eyes in all those various, distinct, serious young faces, which—10 years ago, before the seriousness of Vietnam began—we didn't seem to have. The photography is pretty well coordinated with the sound, sometimes blinded by strobe lights, so that the screen goes absolutely white, sometimes shifting down lines of audience in a kind of "Rosencrantz and Guildenstern Are Dead" focus of attention on characters other than the main.

●

There are the lyrical songs, "California Dream" and "Feeling Groovy," Janis Joplin straining her voice and being to sing black. Then there is a kind of spot, purely visual interview—a beard and a cop laughing, wordlessly teasing each other; a girl from Champaign, Ill., feeling lucky to be allowed to wipe the folding chairs between performances, a Hell's Angel arriving at the Shankar concert that is the long, wound up climax of the film. There are rock violinists and young people dressed like pageant potentates.

"We all love each other, right?" Otis Redding shouts, half ironic, half intimidating. "Right," the audience replies. Jimmie Hendrix goes through his thing of somersaulting, then being irreverently, frantically obscene with his guitar, finally destroying it—presaging in a fairly violent way, the quality of the kisses of Tiny Tim.

●

But the nicest thing about the movie is not its musical or nostalgic qualities, but the way it captures the pop musical willingness to hurl yourself into things, without all the What If (what if I can't? What if I make a fool of myself?) joy action-stopping self-consciousness of an earlier generation, a willingness that can somehow co-exist with the idea of cool. Also, musically and photographically, the harmonies, the resolutions of chaos after everything looks as though it is going to fall apart.

"Once you leave here you may not re-enter," a guard at the festival says to some members of the audience at the gate. It is possible that the way to a new kind of musical—using some of the talent and energy of what is still the most lively contemporary medium—may begin with just this kind of musical performance documentary.

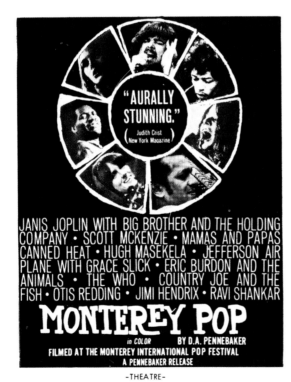

Mat 206

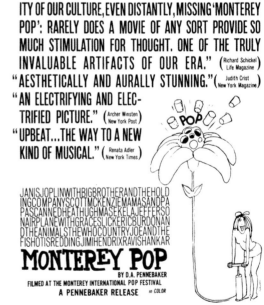

Promotional material for *Monterey Pop*

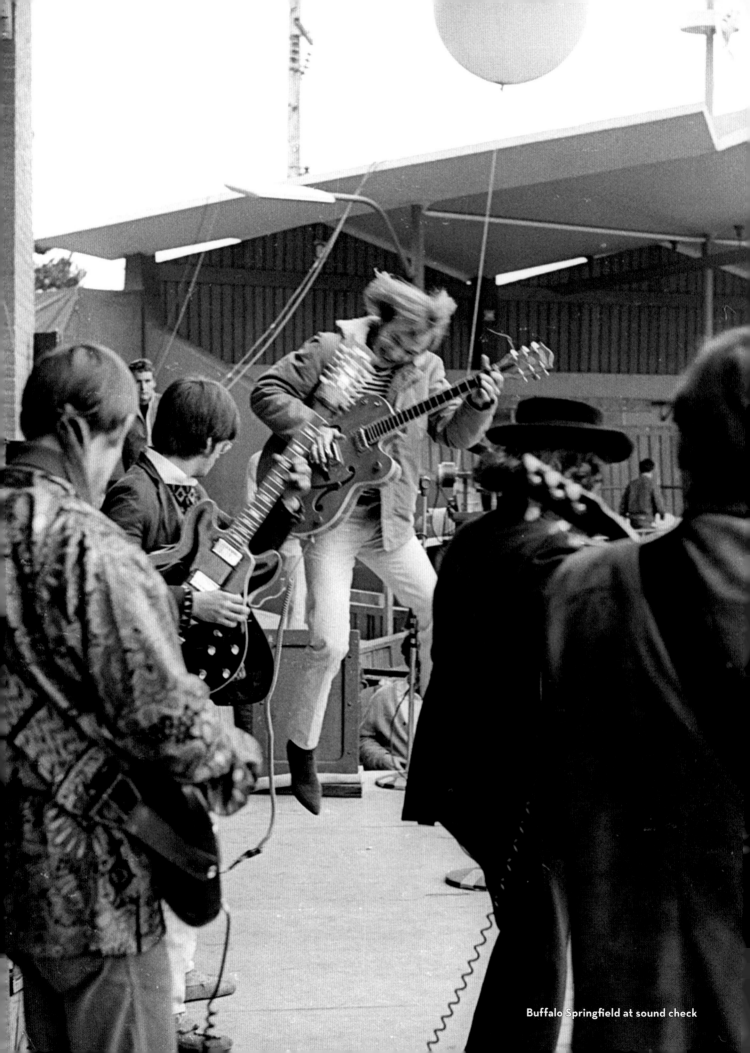

Buffalo Springfield at sound check

Chapter 8

Jann Wenner, having marinated in the crock-pot of UC Berkeley and the radical chic of *Ramparts* magazine, was part of a journalistic vanguard that recognized and reported on the seismic shifts taking place throughout America. As he ambled around the Monterey Fairgrounds in jeans and a corduroy jacket, pen and notebook at the ready, he was alert to the implications of this potent new music, how it shed a coruscating light on the wrenching changes taking place in the culture as a whole. There needs to be a new outlet for these clamoring voices, thought Wenner, as he observed Brian Jones holding court before a clutch of besotted reporters.

Conscientious to a fault, he would soon assign Michael Lydon to investigate the expenditures from Monterey for his brash new magazine, *Rolling Stone*. Appearing in its inaugural issue on

Jann Wenner

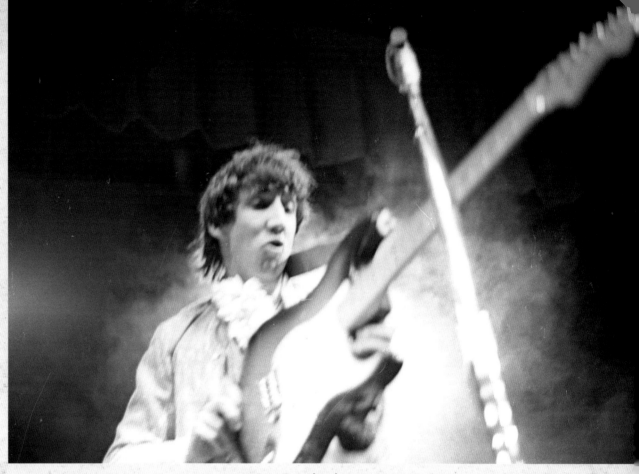

Pete Townshend

November 9, 1967, the bold-faced headline asked, "The High Cost of Music and Love: Where's the Money from Monterey?" Though maybe not the equal of muckraker Upton Sinclair's revelations about the meat packing industry, the story rightly held the principals to account. This being a San Francisco-based publication, there was the inescapable whiff of suspicion directed at those huckstering Angelenos.

The festival grossed $438,955 and cleared $220,129. The majority of the profit came from the advance by ABC-TV for the exclusive broadcast rights. Phillips and Adler made good on their promise: a grant of $50,000 was made to a Harlem-based music and instruction program championed by Paul Simon called "Guitars in the Ghetto." Monies were also disbursed to the Sam Cooke Scholarship and the San Francisco and Los Angeles free clinics.

In fact, for over 40 years, the Monterey International Pop Festival Foundation has never veered from the mandate established in its unprecedented charter. Support for arts organizations, music therapy programs, and health care subsidies for struggling musicians—all have benefited greatly from the MIPF. In 2010, the foundation donated a wall mural to the UCLA Children's Hospital, depicting an underwater concert. The Thelonious Monk Institute of Jazz Studies and the Rhythm and Blues Foundation have also been recipients of the MIPF fund.

In 2011, the Monterey International Pop Festival Foundation established scholarships in the field of rock music at the Clive Davis School of Recorded Music at NYU and the Berkeley College of Music in Boston. In addition, the Music Cares MAP Fund and Steven Van Zandt's Rock and Roll Forever Foundation are benefitting from the ongoing efforts of the festival's legacy.

What began as a lark (albeit with a prodigious wingspan) became the template for an entire culture of charitable undertakings by musicians so often disparaged as unaccountable and irresponsible.

George Harrison (Bangladesh), Bob Geldof (Live Aid), and Willie Nelson (Farm Aid) were among the vanguard of socially engaged artists keen to give back to their communities with a fervor commensurate with their great individual successes. It kind of makes you believe in the power of flowers.

In light of the festival's accomplishments, it didn't take a William Morris agent to recognize that a second Monterey Pop event was lucre, filthy or otherwise. The dates of June 21–23, 1968, were reserved. The board of directors of the Monterey County Fair voted eight to one to grant the festival's application, provided that certain conditions were met. Adler and Phillips were required to deposit $38,000 for police and fire services; an additional $15,000 was requested for sanitation and camping facilities to accommodate 5,000 visitors. Further, a Citizens Advisory Committee, appointed by the board and members of the Monterey City Council, voted 12 to two in favor of the festival. Hearings were held and proponents and opponents made their respective cases. All that remained was for the state, which oversaw the fairgrounds, to grant its permission. By any reckoning, it was a *fait accompli*.

And then . . . nothing. "The best laid schemes o' mice an' men . . ." wrote the Scottish poet, and it seems eerily apt. Instead, June of 1968 would be memorialized by the sound of gunshots and the shattering of dreams—the love children mourning for a lost arcadia.

First Monterey Pop Festival May Be Peninsula's Last One

MONTEREY — The First International Pop Festival held last weekend may have been the last.

Monterey's City Council tonight considers a resolution asking the county Fair Board to get city permission before booking Fairground activities for more than 2,000 people.

The resolution is Mayor Minnie D. Coyle's idea. She said yesterday that, while the music was good, it was excessively loud and went on too late at night.

And, she said, while the crowd was well behaved, there was far too much of it. "The city is at an extreme disadvantage when it does not know in advance and can't prepare adequately for a group this size," Mayor Coyle said.

"The problem is an influx of 60,000 to 80,000 people into a town of 30,000," she said.

The City Council, according to Mayor Coyle, didn't know of the proposed Pop Festival until it was already being advertised.

Monterey Police Chief Frank Marinello also indicated yesterday that he wouldn't be broken hearted if there were no more pop festivals. Although law-breaking wasn't one of the problems attendant upon last weekend's festival, Marinello said the logistics of preparing for trouble were staggering for a community of the size of Monterey.

The festival was just too big, he said.

"We had 12 men in the arena," Marinello said, "It would have been physically impossible to reach them if something had gone wrong."

Neither the Mayor nor the Police Chief like the idea of thousands of festival visitors sacking out in sleeping bags all over the peninsula.

Monterey Pop signaled a tipping point in the way the music industry conducted its business. The Beatles had demonstrated that pop music and its attendant youth culture were formidable agents of change in terms of shaping social mores and generating new markets. Some very smart, very ambitious young movers and shakers within the industry returned to their corporate warrens, inspired by what they had seen and heard. The weight of an entire generation was pressing forward, demanding its appetites be served. It scared the suits, but emboldened the risk-takers. In other words, it was time to follow the new money.

On August 14, 2010, Bob Dylan stepped onto the Monterey stage for the first time since he played the Monterey Folk Festival in 1964. As his guitarist, Stu Kimball, pantomimed the burning of his guitar with a Bic lighter, Dylan spoke to the audience for the only time that evening: "That happened right here. Doesn't seem that long ago."

JOE SMITH (Warner Bros./Reprise Records Executive): First of all, we had never experienced anything like this—a gathering of that many artists outdoors, people lying on the grass, people stoned all over the place. And we went up there, not knowing what we were going to see. And all of a sudden these San Francisco people were up there in great numbers and I had gotten to know them through the Grateful Dead. It was a beautiful place to be. I especially remember the Who coming out, and Jimi Hendrix, smashing guitars. Some pretty dumbfounding things. Here I was, this middle-class, Jewish Yale graduate, out here running a record company that had Frank Sinatra and Peter, Paul and Mary. That was as daring as you got.

Otis Redding tore the place up in this shiny green suit, startling everybody. And he immediately emerged as a star. I was very close with Phil Walden and Capricorn Records, which we later distributed. And Hendrix became an acquisition for North America. In one of our post-festival discussions, I said to the Grateful Dead, "Are you

ever going to make a record that somebody can play on the radio that's less than 12 minutes?" Then they came to me with the *Workingman's Dead* LP, and we had some great things out of that.

But Monterey had changed our record company. We were heading in that direction anyway. This story I've told about Mike Maitland, my boss . . . After I signed the Dead, then had talked to everybody up there, for another $250,000 I could have signed six bands. But Maitland said, "Let's see how we do with this group the Dead." And I said, "It will be too late." I could have signed Big Brother, Country Joe, about five bands. Nobody was mining San Francisco, a scene that lasted about two years and then got nasty up there. As Phil Lesh said, "My grandmother taught me good manners but I never showed them to Joe Smith." [Laughs.] We knew there was something happening here. And I knew very well [DJs] Tom Donahue and Bobby Mitchell from their AM radio days.

There was camaraderie at Monterey. The labels didn't look at each other as competition then. There's pressure on the labels now that

Left to right: Roger Willis, Merry-Go-Round drummer Joel Larson, and Laurel Canyon hair stylist Manny Garcia

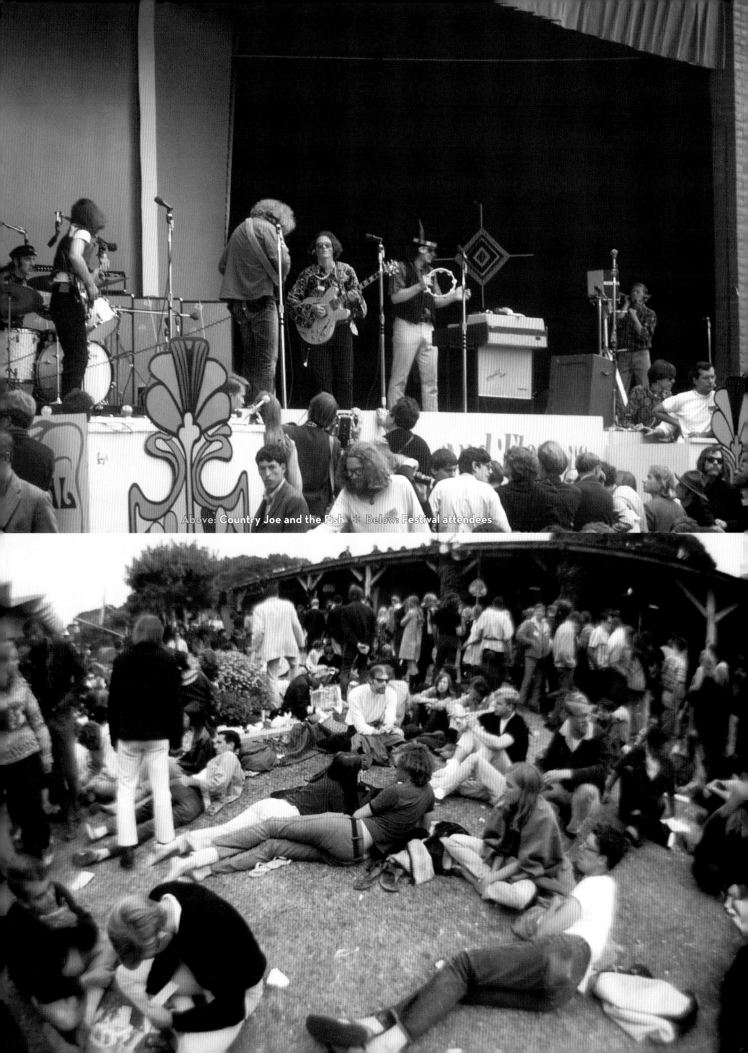

Above: **Country Joe and the Fish** ※ Below: **Festival attendees**

didn't exist. We were always hoping someone would have a hit because that would create traffic and interest in the business.

CLIVE DAVIS (then-Vice President/General Manager, Columbia Records): Columbia [Records] at the time was preeminent in the field of classical music and Broadway, middle-of-the-road music coming out of the Mitch Miller era, with artists like Tony Bennett and a young Streisand, and Andy Williams, among others. I was seeing the business change. There was certainly some evidence of rock 'n' roll. Clearly the Beatles had arrived, and [Elvis] Presley. The only rock that Columbia was in was more of Bob Dylan as a writer, with some of his hits being popularized by Peter, Paul and Mary, and the Byrds. I was seeing music change, but I was waiting for the A&R staff to take the lead.

I was really going to Monterey as a friend of Lou Adler, and we had Scott McKenzie's *San Francisco*, which was the first record under our Ode Records distribution deal. Lou and Abe [Somer] were on the board of directors, and I was really going for a music enjoyment weekend. I had no idea what awaited me. I had no knowledge of what was going on in San Francisco, for example. So I really was going with my wife to spend a three-day weekend enjoying what I believe was the first pop music festival. When I saw the crowd, it was visually stunning, the dress and the attitude.

When Big Brother and the Holding Company took the stage, it was a totally unknown group to me, and right from the outset it was something you could never forget. Janis took the stage, dominated, and was absolutely breathtaking, hypnotic, compelling, and soul-shaking. You saw someone who was not only the goods but was doing something that no one else was doing. It was that, coupled with everything around me: the way people were dressing, what was going on in Haight-Ashbury, the spirit in the air. I thought, "You know, I am here at a very unique time. I'm feeling this sense of excitement; it's not only musical changes, but changes in society." And although it sounds hokey or cliché, I said to myself, "I'm gonna have to make my move."

There's no question that the primary signing was Big Brother and Janis Joplin, but the Electric Flag was very powerful, with Buddy Miles on drums and Mike Bloomfield on guitar. Laura Nyro was not great at Monterey and I didn't come away

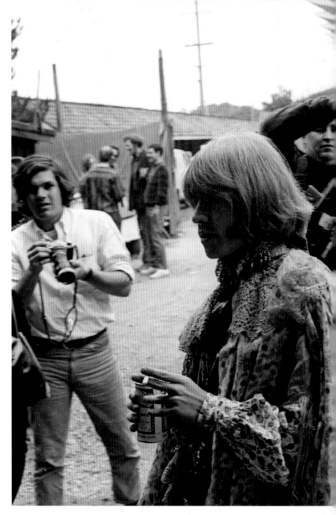

Jann Wenner (*left*) and Brian Jones

with the feeling that I must sign her now. It really was the simple act of listening to her songs that overcame what had been a negative impression at Monterey.

In a sense, it all began for me at Monterey. The success of the artists I signed at Monterey gave me confidence that I had good ears. I had no idea I had "ears." Monterey is without question the most vivid memory from a career point of view, from an emotional point of view, and from a character-affecting point of view that I've ever had.

JANN WENNER: Everything we cared about in music, in creating community and camaraderie and fellowship, all flowed out of the Monterey Pop Festival, and Monterey Pop flowed from San Francisco. It was the spirit, the mood, the vibe, the hippies. I think Lou and John and the people who organized it saw that spirit in San Francisco, that communal spirit. The bands were all there in a way they were not in L.A. This was pre-Laurel Canyon, and they tapped into that vibe. Maybe they saw it from the outside better than the people on the inside saw it at Mount Tam, and that was preceded

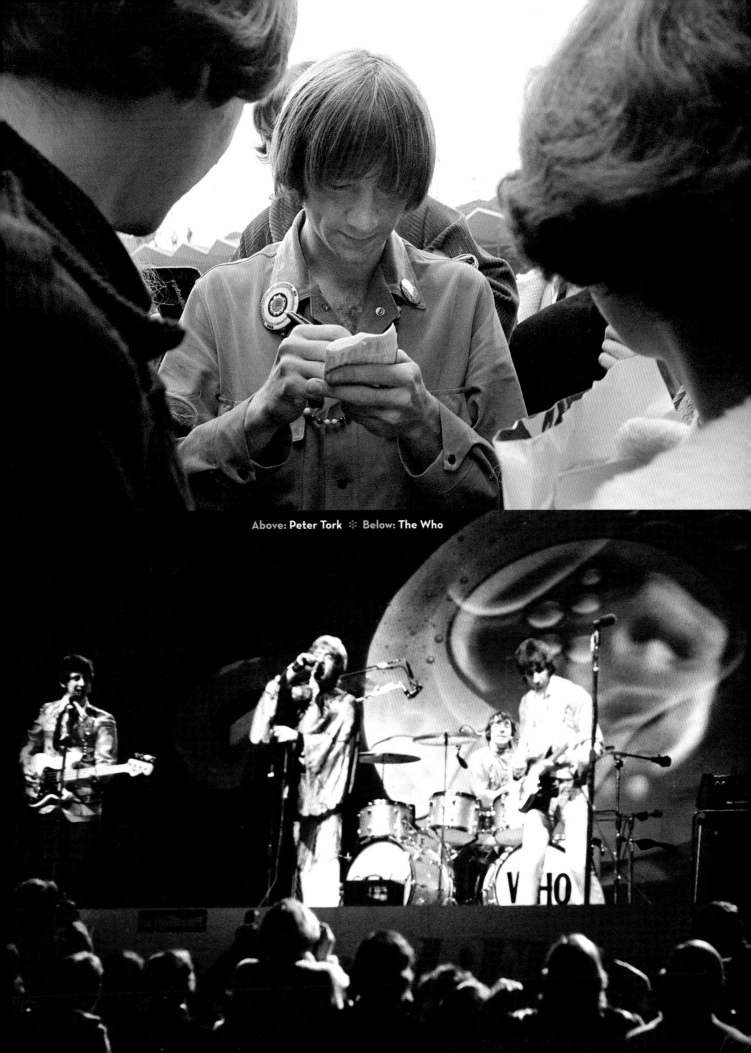

Above: **Peter Tork** ✳ Below: **The Who**

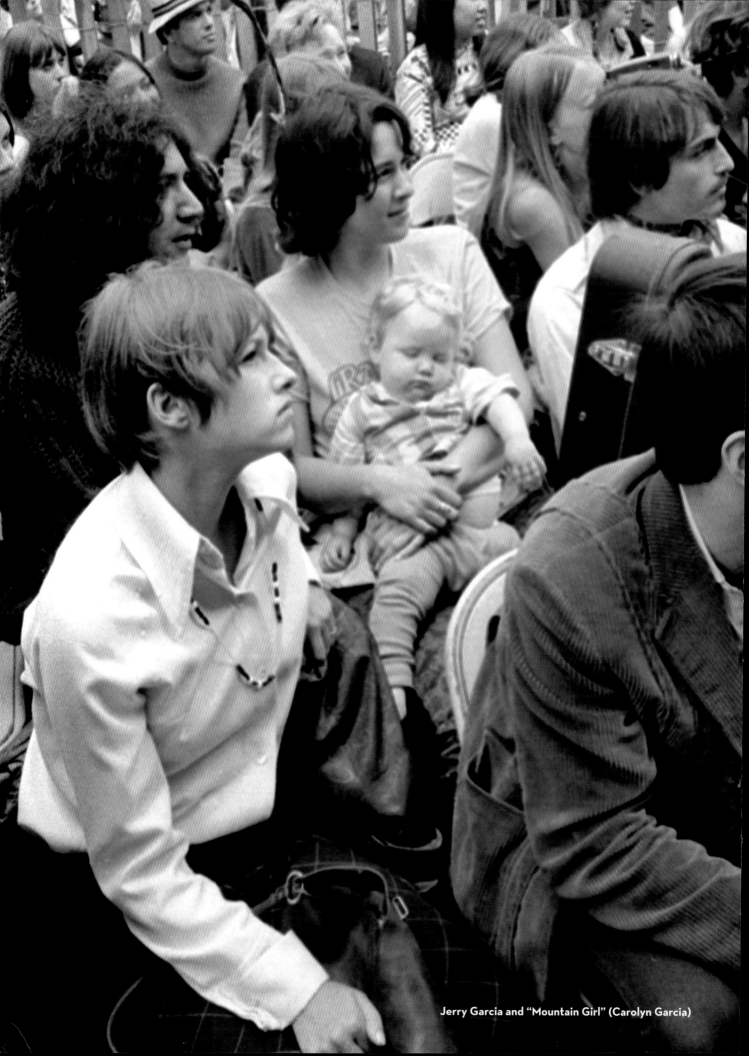

Jerry Garcia and "Mountain Girl" (Carolyn Garcia)

by the acid tests. That whole kernel came right out of San Francisco, as does Burning Man, for example. Lou and those guys just did a great job of conceptualizing and presenting it and bringing the Bay aboard, then internationalizing it by getting like-minded spirits that we didn't see at the time. We didn't associate Simon and Garfunkel with what we were doing with San Francisco. They fit right in. And the Mamas and the Papas were totally at the core of it. Talk about hippies and drugs making a living.

After Monterey, Lou and John earned respect. I walked away feeling wonderful and happy over what they did—connecting it to a larger world. Janis got signed. There were showcases there. It really brought world attention to the San Francisco scene. Shortly thereafter I started *Rolling Stone*. The first issue had a story about the money from Monterey. Our job as journalists is to keep everybody honest and report on things; or, if there is a hint of wrongdoing, to look into it, whether it be the fourth estate of government or the fourth estate of rock 'n' roll.

By the time we started several months later, Monterey was still a central event of our lives, as big an event to ever happen in the San Francisco music scene. It was just one of those periods in the history of art where a dozen revolutionary artists were all around and on the stage at the same place and at the same time. The '60s were one of those time periods equivalent to the '20s, where you had Picasso, Modigliani, Leger, and Matisse, all working together. All knew each other. Hemingway, Fitzgerald, the writers—the same kind of thing was taking place in San Francisco, and then in that larger Los Angeles and London community.

Monterey was in a different time and a different era. Woodstock took place in the media capital of the world, and that is all the difference right there. Whereas Monterey took place far away from even local media. And then you have the number of people involved at Woodstock. It was far more dramatic in that sense. On a simple musical level, however, Monterey was far more important. Also, on a historical level it was far more important

Seeing the Pennebaker film *Monterey Pop* a few years ago brought me back to that time and place, and I loved it. I still have my ticket stubs from Monterey.

LOU ADLER: Over the years I've heard constant comments about Monterey from a lot of the performers. They were thrilled about the event and especially about the sound system we employed. The acts were beginning to accrue power, to promote their records, to control advertising, album covers, and promotional money. For right or wrong, in 1967 or 1968, they got what they wanted. Also, FM radio exploded. Artists wanted to express themselves and perform in places where the music meant something. Shortly after Monterey, they did.

A lot of it had to do with the San Francisco groups, their mentality of what the record industry was, the way they looked at the industry, the way they were skeptical of the industry—"If you're gonna sign me, here's what I want." And that set a pattern. "I'll tell you what my album cover is, no matter what it costs to make it. This represents me." And those label heads had not dealt with this before, and said, "Yes, yes, yes." And, that went on for years to come.

Sometime in the 1980s it switched back again. Certainly through the entire 1970s, the power and muscle went to the artists.

LOU RAWLS: What can I say to try and sum it all up? That was a great time to be alive. So many changes going on. So many great things that came out of there are still very important to this day. It wasn't so much a revolution as an awareness, being made aware and awakening to what was going on. There was a lot going on politically at that time. Many factions—the Black Panthers, the students at UC Berkeley—were making statements, but the statements didn't get serious press, only superficial attention. The press never focused on the counterculture until the festival. The festival did it. Statements were made there that musically got the message across without violence, anger, and confrontation. Monterey Pop was like a forum, a stage, a place where they could speak their piece, say what they had to say, and the message would get across. You could equate it to a seminar. People were not only there for the music, but also for the commentary being made through the music. It was the first chance for all of us to really get together and touch, actually physically see, and communicate. So it was a special thing. This was something that the majority of these people had never participated in before and perhaps never did again. It was a special moment in time, and I

think everybody was aware of that. A lot of stars were born, but this special moment in time gave them that recognition. Nobody there thought of it as being any kind of historical moment.

TOMMY SMOTHERS: It was an exception to the rule of confrontation and contradictions between different lifestyles. We sat there side-by-side, rubbing up against different viewpoints, and it was wonderful.

DAVID CROSBY: It was all a joyous party. Somehow the police were very restrained, and the vibe was very good. There was no violence that I remember. It went off remarkably well, considering that nobody had any experience in pulling off this kind of thing. That's much to the credit of people who put it on, particularly Lou Adler and Alan Pariser. What happened at Monterey was the flowering of an entirely different set of values.

The Byrds

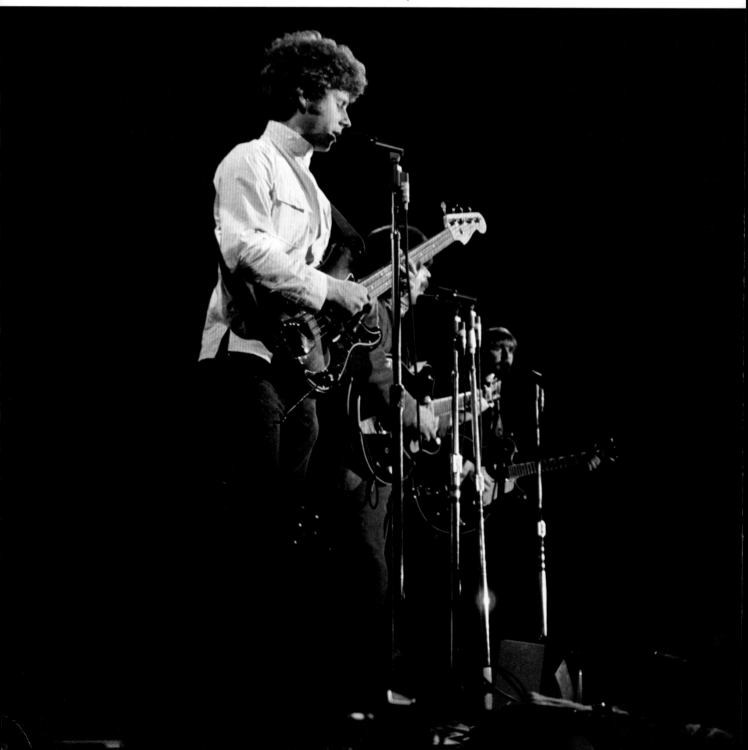

XERB magazine's Monterey International Pop Festival special edition issue

Tommy Smothers

CASS ELLIOT: The audience came to participate in a "happening," as they used to call it in the '60s. It was their music. It was for all the people, the musicians, the performers, the audience, everybody. It was the first public statement that rock 'n' roll was here to lighten the load a little, but to have a good time without hurting anybody.

LEAH COHEN (KUNKEL): Cass went on to have great success after Monterey. I was proud of her as a person and I was proud of her music. She took joy in other people's successes. Even before Monterey, and just before the Lovin' Spoonful got their shot, the Mamas and the Papas hit it really big. She bought all those guys color TVs for Christmas. Back then, that was a big deal. We didn't have a color TV in my family at that point. We grew up barely hanging on to the middle class. We lived in little apartments.

They never dreamed of the success that they had and the money that they had. It never occurred to the Mamas and the Papas that they would ever have that level of monetary success. Never. It really took them by surprise. But when we talked about what the music means, Cass would be the first to endorse the things that rock 'n' roll has always stood for: inclusion, challenging society, and not accepting and speaking up for things that were wrong, like racism and the [Vietnam] war. When you strip everything away, there was a spirit about Monterey, and the people who were making it in the '60s and '70s—that was a cultural phenomenon.

DENNIS HOPPER: Monterey was a giant musical love-in that galvanized the crowd of students, hippies, straights, soldiers from Fort Ord, the rock 'n' roll press, music industry execs, police, vegetarians, and weirdos like me.

It was a perfect experience. To many of us, it was the first and the last. I can't think of anything as special as that moment in my life. It was a tremendous up on every level. We weren't laying numbers on people. We weren't making fun of the cops, either, who were amazed by it. It was a magical, pure moment in time.

One year later, in 1968, I made a movie called *Easy Rider* that was a reflection of what I'd left at Monterey.

PAUL KANTNER: I enjoyed just the overall thing of Monterey Pop. There were great moments, like Hendrix and Otis Redding. Jimi was impressive. You can't define it. You don't have to. If you saw it, you knew what it was.

Monterey was just a step . . . then Miami Pop, Woodstock. Monterey was just a booking. Another step. No one viewed it as something momentous. But it became more than that, as many things did in those days. It became what it became. Monterey was a scrapbook of all sorts of music. That encouraged Bill Graham to book all those strange combinations of acts on a bill. We didn't think of them as opening acts. We just thought of them as other acts that were really good. And that eventually led to Monterey. No chains. And that was what was so glorious about San Francisco in those days. A lot of people fucked things up, too. It took it too far—these big huge gatherings that were not very interesting.

We did not know what was going to happen. And there was all that L.A. stuff versus San Francisco. I didn't pay any attention to it. I enjoyed bands from both towns.

We were in a place that encouraged and nourished that kind of thinking, and still does to this day, and we took full advantage of it. We weren't up on soapboxes, complaining like the Berkeley people. And we need those people, too. Those people are very valuable, but that's not what we did. Our message was subtler. We just tried to show, by example, what you could get away with. You could enjoy your day—hedonistic or Dionysian on some levels. And God knows why we got away with it 90 percent of the time, if not more. We

Janis Joplin and Paul Simon backstage

should have been in jail, dead, run over by trucks, and a number of things over the years.

SAM ANDREW: Everything changed for the scene at large, and for Big Brother in particular, at Monterey. We acquired Albert Grossman as our manager, Columbia Records for a recording company, and we began to live in New York and Los Angeles at that point. There was a big shift of gears. We were off into our new life, and Monterey marked the beginning of that.

Big Brother rehearsed for a week before we played the festival. For some reason, we knew that Monterey was going to be a signal event, one that we would remember for a long time. Commercial considerations, networking, career moves, things that seem of paramount importance today, were almost beside the point at the time. There was a messianic feeling that all of us—musicians, photographers, artists, filmmakers—were in this together, and that our togetherness was going to solve effortlessly many of the problems that had plagued human beings for an eternity. What can I say? It was the '60s, but we actually believed for a brief, shining moment that we could make a difference.

GARY DUNCAN: My memories of Monterey are vivid. I remember Otis Redding's performance, Jimi Hendrix burning his guitar 15 feet away from me, the Who smashing their instruments. I remember that it wasn't quite "complete" without James Brown, Ray Charles, or Bobby Bland. As far

Sam Andrew (Big Brother and the Holding Company), Rita Bergman, and Alan Pariser (*top right corner, in glasses*)

233

KRLA BEAT

Volume 3, Number 9 July 15, 1967

MUSIC LOVE and FLOWERS

Enter the Young

BEAT *Photo: Rick Schor*

Words and Music by Terry Kirkman

Here they come
Here they come
Here they come
Some are walkin' some are ridin'
Here they come
Some are flyin' some just glidin'
Released after years of being kept in hidin'
They're climbin' up the ladder rung by rung

*Enter the young . . . Yeah they've learned to think
Enter the young . . . More than you think they think
Not only learned to think but to care
Not only learned to think but to dare

Here they come
Some with questions some decisions

Here they come
Some with facts and some with visions
Of a place to multiply without the use of divisions
To win a prize that no one's ever won
Enter the young*

Here they come
Some are laughin' some are cryin'
Here they come
Some are doin' some are tryin'
Some are sellin' some are buyin'
Some are livin' some are dyin'
But demanding recognition one by one
Enter the young*
*Chorus
Reprinted by permission: ©1966 Beechwood Music Corp.

BEAT *Photo: Ed Caraeff*

BEAT *Photo: Ed Caraeff*

BEAT *Photo: Ed Caraeff*

BEAT *Photo: Rick Schor*

TEN FULL PAGES OF EXCLUSIVE INTERVIEWS AND PHOTOS FROM MONTEREY

BEAT *Cover Photo (Cass; Hendrix): Ed Caraeff* BEAT *Cover Photo (Crowd Shot): Rick Schor*

KRLA *Beat* magazine's Monterey International Pop Festival special edition issue

as Quicksilver's performance . . . We were scared . . . I was scared . . . I had never been in front of that many people in my life. The whole set went by in a flash, and it was finished. Within three years, *all* the "major players" in the show were dead, but I got to see them perform and eat with them. That's what I remember, 40 years later.

PETER TORK: The real power of those performances at the Monterey Pop Festival is best understood in retrospect, for the most part. Janis Joplin made my hair stand on end. But Jimi I didn't understand because he set fire to his guitar immediately following the Who, who blew their amps up. I said, "Don't they understand? This is lousy staging . . . It's just been done." And that was my take on Jimi Hendrix at the time. The Airplane were magnificent. How come? Well, I asked Marty Balin and he said, "Well, we went up to a mountain top and took acid for a week beforehand, so that we'd be in shape for this. So that we'd be concentrated for it." And they were. They were concentrated. "White Rabbit" is a ferocious piece of music. *Bump, bump, bump.* Boy, it just pounded. There's a lot of stuff at Monterey, very, very peak. I had about a quarter of Owsley purple in me when I heard Ravi Shankar. God, what a time! What an event! What a wonderful, wonderful event Monterey Pop was.

BARRY HANSEN: Pete Welding, who had written a lot for *DownBeat* and was my fellow student in UCLA's master's degree program in folk music studies at the time, talked *DownBeat* into hiring me and (with no difficulty) talked me into making the trip. I had not been to anything that could be called a "festival" before. I read some things about the venue and the programming, and I thought that I'd be sitting in an assigned seat in a pleasant outdoor arena and be treated to a whole lot of wonderful music. By and large, that's what happened. Monterey was the most life-changing music I witnessed in any one weekend of my life.

Offstage highlight: with my backstage pass I got to introduce myself to various musicians, first and foremost Jimi Hendrix. We had a nice chat for a couple of minutes. I dropped a few blues names and told him why I was there, and mentioned that I'd bought the first Experience album as an import a couple of months before it came out in the U.S. Hendrix was extremely soft-spoken and very

courteous, and thanked me for my compliments. I met him one other time, a year or so later, and he was so out of it he could hardly speak.

DJINN RUFFNER (Audience Member): Dewey Martin saved me at Monterey Pop. Some friends of mine asked me if I wanted to go cruise up the coastline, so I got in their car. I didn't know where we were going. Next thing I know, I'm at Monterey Pop in a summer dress, a pair of sandals, and no purse! It was a trick, and I ended up going to Monterey. We got there and nobody had any tickets, and everybody piled out of the car and went in a hundred different directions. Finally, I saw a friend of mine named Candy. And along comes this skinny guy in tight pants and he said, "You birds want to go backstage?" So he got us backstage passes and that's where I spent the weekend. Backstage, there was food and booze and pot and acid. I was very high on acid on Sunday night, and all of a sudden one of the guys who took me up there said, "We're leaving to go back to L.A. now." I didn't want to leave—I wanted to go with Brian Jones and the Who and Hendrix and all the others to the parties on Motel Row. Candy and my other friends had gone and I just started crying. Dewey came over and said, "What's the matter?" I told him and he said, "That's all right. You can come home with us. Come on to the party with us." I felt very safe with him. He found me a place to sleep where no one would bother me. I rode home with Papa Denny and Mama Cass. Dewey was a gentleman.

JIM (ROGER) McGUINN: I had a camera with me, shooting some movies that we were planning to project behind us. They actually used that film later, when we played the Whisky.

It was new for me, in terms of it being a rock festival. I had been to Newport before that with Judy Collins. I had been to big gigs—we had opened up for the Rolling Stones in 1965. This was a different thing entirely. It was almost like it wasn't about the music business. It was about the music and friendships, joy and camaraderie. It was almost a religious thing. The sound system was a big departure from what we had. We were using little McIntosh amps, and I don't know what kind of speakers, for our sound as the Byrds. So to have these massive speakers and big amplifiers was a big thing. And having monitors for the first time, too.

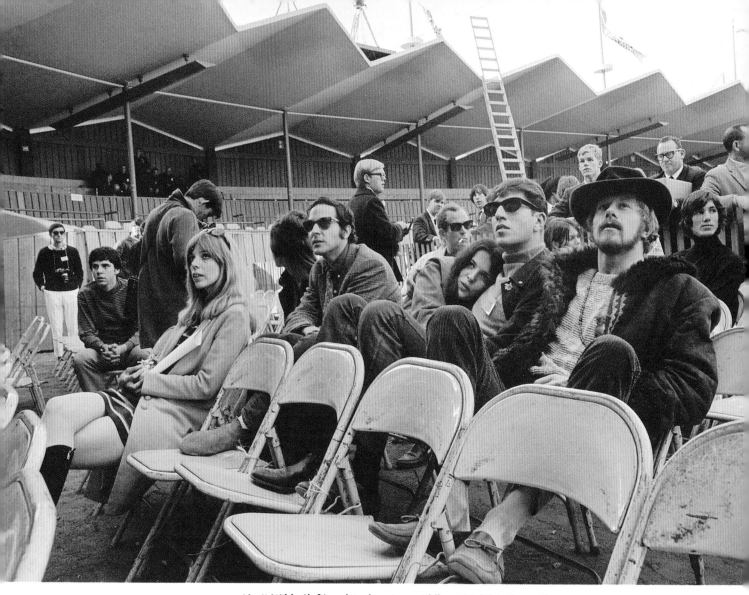

Nurit Wilde (*left*) and Andrew Loog Oldham (*right*) in the audience

CHRIS HILLMAN: Jerry Moss was there. One of the nicest people I've ever dealt with. I can give you a list of guys I wouldn't walk across the street to talk to, but Moss was an A-1, stand-up guy. I ended up on A&M (with the Flying Burritos) due to Tom Wilkes, who was my neighbor, and the art director at A&M. Gram [Parsons] and I talked to Warners and almost had a deal with Mo Ostin, but we went with A&M instead. End of story.

At Monterey, everyone started to get a little smarter. After Monterey, the ethics took a little bit of a slide. What was a little cottage industry run by music people—Jerry Wexler, the Chess brothers, Ahmet Ertegun, and Mo Ostin—became big business. In the '70s, Jerry Wexler was my brother-in-law for a few years, and Jerry gave me an unbelievable education and would tell me these war stories.

After Monterey we did the Philadelphia

Folk Festival with the Burrito Brothers. I didn't do Woodstock, and I remember Gram Parsons and I were sharing a house in the San Fernando Valley

Chris Hillman

and Woodstock was on the television news—all the muck and mire. We were laughing, and I said, "That's no Monterey." And it wasn't!

Then the thing that really upset the apple cart came in: drugs. As we entered the '70s, which was the dumbest decade ever, there were a lot of casualties.

ANDREW LOOG OLDHAM: The wonderful thing about the Monterey Pop Festival is that you can remember anything about it and it will sound as if it were true. The event was a first, and over the years one realizes how many people were there that you either forgot about or didn't meet at the time.

The festival was incredibly busy, productive, life-changing, exhilarating, and relaxed. I do not think that ever happened again. The focus was incredible; the mission was God-given. We had never been given that type of responsibility before, and there was no way our side was going to be let down.

Monterey Pop gave service. It still does. I remain oh-so-proud I was there and was a small part of it. Otis, the Who, Jimi Hendrix . . . Every time I think of the music, I remember the sea of faces and the rhythm of the crowd.

I remember Derek Taylor placing beads around the neck of the local sheriff—now that was a very important moment. That was crossing the Nile. I remember the Monterey Pop Festival as the last time I saw Brian Jones truly happy and carefree, as free and high as a bird. He dropped the luggage for that short while. Were the Byrds there? Must've missed them. Didn't see many of the music business folks. I was too busy following

Brian Jones and Dennis Hopper

the music and staying reasonably ripped.

KEITH ALTHAM: For me, the Monterey Festival represented a seismic shift during the '60s in the way that rock music was perceived and presented as a serious and artistic art form onstage, to a generation vainly hoping that "peace and love" might replace hate and war, and their music was to be a mirror. It was a forlorn hope, as we can see now from Iraq and Afghanistan. But if you went to Monterey in 1967, you hoped that Scott McKenzie, with his silly little ditty, might just be a harbinger of better times to come.

It was also the first time I had heard the magically honeyed voice of Otis Redding and the last (and never to be forgotten) lung power of Janis Joplin with Big Brother and the Holding Company. I told her later backstage she was the best female vocalist I had ever heard, and she looked me up and down with my funny English accent and hippie-dippy scarf and grinned lopsidedly. "You get out much, honey?"

Bruce Palmer

Pop Festival by Derek Taylor

The festival was people and it was joyful because the people were so beautiful. All of them, nearly enough. There were those who had less than a good time but then it is an imperfect world and in that context it was truly marvellous that so many of us were able so substatially to shed our egos and float downstream on people, music love and flowers.

The people are the lingering memories. The colors were the people-- the carry-on of color from the people into the streamers and the flags and the fantastic richness of the avenue of booths; like nothing any of us had experienced.

People were Jimi Hendrix, a one-man rainbow of fire and delight. Hendrix, forgotten negro muddling through frustration and debt and redundancy in the East, found by the lovely ex-Animal Chandler and warmly embraced to England where he showed what he had always been showing except that for once and forever it was seen and illuminated by those with the power to illuminate.

Hendrix was greatly moved and sadly grateful to have been invited to return to America as a festival Star. But it was nothing to do with gratitude. He came because he belonged. The Who too, the Furies of rock 'n' roll. Wonderfully robed in silk and satin and bathed in a mystique born out of being famous without having been seen in America, the Who were splendidly successful because they too were the people for the event. The event was for the people too as Eric Burdon proved with his new Animals, when he spoke of bygone days when booze was the thing, when gin was the support. We all knew what he meant, all of us. As he knew we would. Eric sang gently of San Francisco and Scott McKenzie sang of the same city in yet more delicate terms and there was a rightness about each singer and each song. Pure music. Pure people with eyes clearer than yesterday.

Another Eric from the Avalon came down a couple of days before the festival opened and some of the Diggers arrived. They brought San Francisco with them in their flowers and hair and beards and clothes of no known ethnic origin, out of no indentifiable period in history or attitude. Just of now and of them. Themselves, they know now to be enough. It always was but now they know themselves to be sufficient.

There was a girl who was on a beautiful trip who was deeply involved with a toy car, a tiny broken down thing without wheels. She held it like a communion offering and gave it to one of my children who were on their own purity-trips without chemical help and the handing over of the toy was totally real and equal. Strange that children can reach those who are on acid. LBJ and his friends, for all their sophistication, seem unable to do so.

People. People like the Grateful Dead so in touch with each other on stage and far beyond the performance level. Deeply moving. . . .Garcia talking to Pig Pen in music. Pig Pen himself, the antihero huge and black and immobile in everything but his leaping soul dancing on the organ, through the air and into the organisms of many minds. People like Lou Adler, whose control of the festival was so lightly imposed, so powerfully sensed, so mightily complete. People like the Mamas and Papas, Cass newly out of defiant delivery of a freeborn infant, eyes bright and body firm and Michelle, darting darling of the final show, so much a symbol of the beauty of the Monterey weekend. Denny who wasn't seen until the final day and then was so much a part of the light, bright scene which he and John Phillips make seem so easy. It's easy doing anything because there's nothing you can do that can't be done.

There were other people, short-haired with guns and sticks but it didn't matter because there's nothing in a gun and a stick if they're not used. Flowers, guns, sticks, helmets, bells, they're all one. Only matter.

The police were majestic--they responded as people to people because the police too are people. They have a point in them which can be reached. They may not have known they could be reached, but reached they were. Chief Marinello, old man long on the road of law enforcement, he was reached and he himself stretched out his arm to touch others with the warmth which was in him when he was born and begged thereafter to be allowed to spread. We gave him a necklace of leather and glass. He wore it and enjoyed it.

People. The Byrds, led newly by David Crosby. Were never more the Byrds than at Monterey, freewheeling jetstream they were strong and

significant. Crosby made a statement on LSD and lost a little direction by taking us on a mixed trip into the Warren Report, but he was being Crosby and he wanted us to know where he was at for which in terms of communication and honesty, cannot be faulted.

There was a delightful button salesman who baked them in the oven--finding in the baking colors so fantastic that they could scarcely be believed except that there is nothing you see that isn't shown. It was always there.

Alan Pariser was also people. He had the idea of having a festival and it must have been overwhelming for him to experience the reality. An emotional affectionate man, much misunderstood, he loved the Happening and it was good to see him happy. Tom Wilkes, one of the real festival heroes--hero is not the right word for there were no villains, but let it pass--was the visual designer whose mind was reflected in all that we saw that was not people. Yet he too knew what was right for the people who would come in the designs. So did I, though I could have been wrong. We threw our press badges to allcomers the first two days and only Life, Time, ABC TV News, the Los Angeles Times objected. They didn't, however, carry their dismay into what they wrote which shows that they too were people and there were times when in the past one might have doubted that.

No arrests, no bullying. Nothing but happiness. An amazing festival. David Wheeler, bearded and in buckskins, head of security with guards recruited from the flowerchildren. Jerry Moss, head of A & M slipped away from the concerts starring Herby Alpert, his friend and partner, to sensate with the people at Montereylikewise, from his duties elsewhere, Goddard Lieberson, head of CBS. A fine turned-on man.

So many people, 60, 000 of them. Who knows how many. It doesn't matter. A million, 1000 million or one. All one.

I miss the people now. We had a matchless team down in Hollywood, in the spring all in whirling private pockets of activity planning the festival without collisions. Some of us are left, the others have scattered to other scenes. Voss the adman, Gardner the transport chief. Jim Chubb, Monterey Public

Photo by JAY THOMPSON

Relations, wartime fighter pilot, I miss him too. He always believed he was a square. He warmly found he wasn't , ever. He was real and discovered it at the age of 50.

Chris Hill, Jackie Ingle, Carol Cole, Julie Gray, defenders of the badge-room. All spread out now but bound for all of time. We are all one and life flows on within us and without us.

We had a festival and it is for ever.

photo by JACK GOLDEN

MICKY DOLENZ by CYRIL MAITLAND

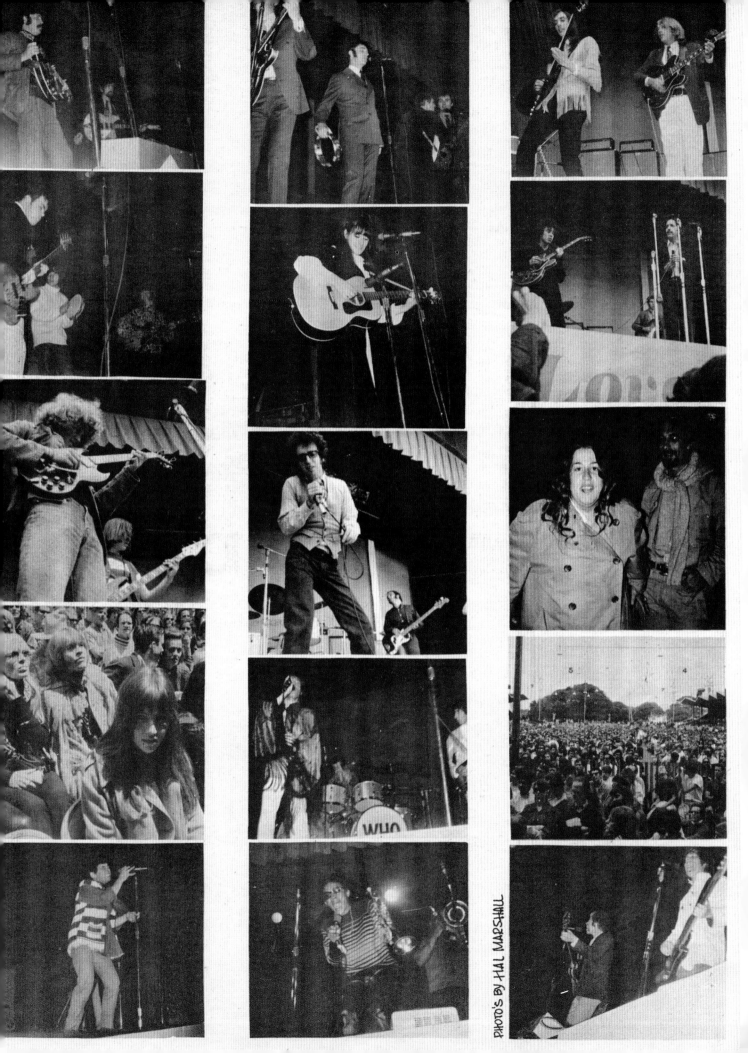

PHOTO'S BY HAL MARSHALL

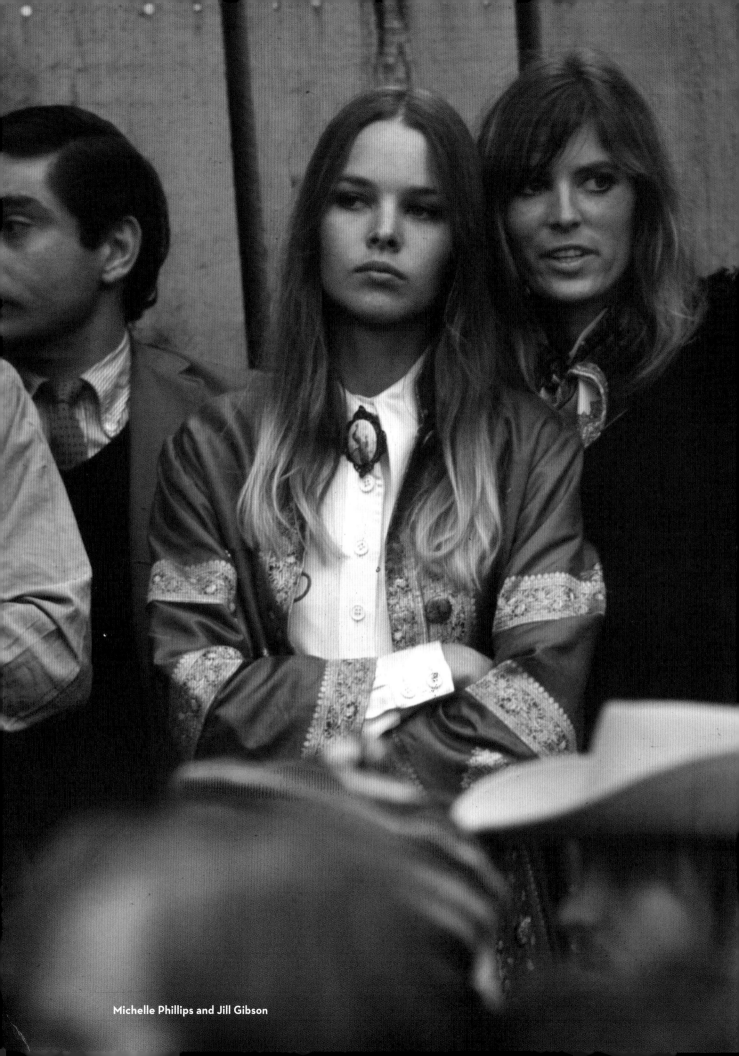

Michelle Phillips and Jill Gibson

AFTERWORD

Sometimes it's just better not to think about it too long. If we had, we would have known it was impossible to put together, in two months, a three-day music festival with the most-established, the up-and-coming, and the unknown…Thirty-one acts representing contemporary American rock, British rock, folk rock, weird, progressive, jazz, African, torch songs, East Indian, and the blues—and they would all perform for free.

The board of governors looked pretty impressive. It consisted of Paul McCartney, Donovan, Andrew Oldham, Smokey Robinson, Alan Pariser, Mick Jagger, Paul Simon, Terry Melcher, John Phillips, Lou Adler, Johnny Rivers, Jim (Roger) McGuinn, and Brian Wilson.

In truth, only two of these luminaries were actively involved. But hey, it looked great on the stationery. It was all Lou and John pulling the strings. A whirlwind of excitement, gentle strong-arming, calling in every chip imaginable, confronting the San Francisco groups' managers, charming the city council and Monterey Police Department, and getting it all done for charity—giving something back.

It was to be known as the Monterey International Pop Festival.

We hired D. A. Pennebaker to film all aspects of the festival: the mad goings-on in the offices; the arrival of psychedelic-painted vans from all over the country; hippies erecting teepees on the fairgrounds; colorful, long-haired people setting up their stalls to sell tie-dyed scarves, homemade scented candles, and jewelry; and, of course, the *music*. Penne filmed it as no one had done before and many would try to do after.

Fifty thousand little orchids had been flown in from Hawaii—one for every seat, more scattered on the stage, and hundreds left over for the police (by now totally on board and in the groove) to wear in their helmets.

The day before the festival was to begin, jets started to arrive at the tiny Monterey Airport, bringing in our very cool and talented stage manager, Chip Monck, tons of speakers, drum sets, guitars, mikes, and, of course, the performers.

For the performers it was first class all the way. The sound system, the travel, the accommodations . . . and then there was the food. Backstage we had a 24-hour green room with a menu that included lobster, crab, steak, and champagne.

And the sun was shining.

Friday, June 16th, kicked off one of the most spectacular events in music history. The performances represented all genres of the past, present, and future of rock, including the hit pop sounds of the Association singing "Along Came Mary" and Johnny River's "Memphis," the blues of Lou Rawls, the Paupers from Canada, and the first of the English invaders—Eric Burdon and the Animals, electrifying the assembled with their "Paint It, Black."

The evening closed with the pure harmonies of Simon and Garfunkel, mellifluously giving

the speech of angels to "Homeward Bound" and "The Sounds of Silence."

The happy festival crowd slept under the stars in tents, sleeping bags, vans, cars, and surrounding hotels and motels, readying their senses for two more glorious days of music.

On Saturday, the 17th, the silence was broken and the festival really got "Rollin' and Tumblin'" with Canned Heat, Country Joe, Al Kooper, Quicksilver, and the Butterfield, Bloomfield, and Steve Miller Bands. But it was Big Brother and the Holding Company that brought total shock and awe. Few were prepared for Janis Joplin, the young white singer doing her version of Bessie Smith's blues. She seemed possessed, swinging a bottle of Southern Comfort and being more than a little menacing. She was gut-wrenchingly honest in her exquisite performance of "Down on Me" and "Ball and Chain." I, frankly, was scared to death of her, while Cass found her exhilarating, an independent force much like herself.

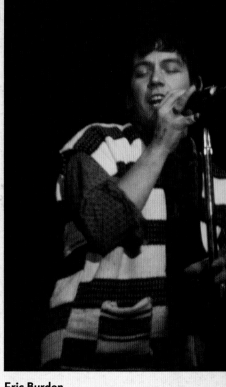

Eric Burdon

The group's manager had forbidden filming her. But after the overwhelming audience response, Janis insisted—in fact, begged—for another set. Lou and John happily complied, and she was filmed the following day. Thank God!

Saturday night we saw San Francisco's Moby Grape and Jefferson Airplane perform, with the sultry Grace Slick singing "White Rabbit." Hugh Masekela, the then-unknown African trumpet player, wailed on the Beatles' "Here, There and Everywhere." The Byrds rocked on with "So You Want to Be a Rock 'n' Roll Star."

Laura Nyro, who felt hopelessly out of step and style, sang "Poverty Train" beautifully in a long black evening gown more suitable for a club date at the Fairmont Hotel. She left the stage in tears, thinking she had been booed. A recent analysis of the tapes, however, revealed that it was in fact a fan screaming, "I looove you."

Scott McKenzie

Otis Redding yelled out, "So this is the love crowd" to the audience, the likes of which he had never played for before. He brought down the house with "Shake" and "Respect" and then brought them to tears, wrenching every emotion and passion with "I've Been Loving You Too Long." He left the stage exhilarated. He died in a plane crash six months later.

Sunday, June 18th, featured a three-hour, uninterrupted musical feast by Ravi Shankar with drums, sitars, and instruments totally unfamiliar to us all. He mesmerized; the result was endless, grateful applause, tears of joy, flowing flower petals, and, if you were looking for it, a religious experience.

Bob Hite

Neither wanted to follow the other, so it was decided by the flip of a coin: Jimi Hendrix would take the stage after the Who. The latter delivered a historic set to a now orgasmic audience—Peter Townshend playing and destroying his guitar, both captivating and frightening, and Keith Moon manically beating and demolishing his drum set as the stage crew tried to keep everything else from being destroyed. They closed with the appropriately descriptive "My Generation."

Hendrix took the stage with a performance that none would soon forget, playing his left-handed strung guitar with his teeth and seemingly making love to it before setting it ablaze and attacking his amp. The majority of America and I had never heard of Jimi Hendrix until Monterey, but we would never forget the flame he ignited that magical night.

We invited Scott McKenzie up to sing that summer's unofficial anthem, written by John Phillips: "San Francisco (Be Sure to Wear Flowers in Your Hair)." That was John, turning everything into publishing.

Wrapping up those three extraordinary days of music, love, and flowers . . . As a part of our closing set, the Mamas and the Papas sang the now seminal "California Dreamin'." Cass, as always, had the audience in the palm of her hand with her delightful repartee and off-the-cuff humor: "You know we're going to do this next year. You can all stay if you want to. I am."

We closed, singing "Dancing in the Streets," a Motown gem originally sung by Martha and the Vandellas. And, if not in the streets, they were certainly dancing in the aisles.

Late on the night of June 18th, the curtain came down on what history would record as "the first major rock festival."

I am so proud to have worked on, and been a part of, this once-in-a-lifetime musical and cultural epiphany, knowing that 44 years later the Monterey International Pop Festival Foundation continues to help young musicians, health clinics, music rooms for critically ill children, and more, all funded by the sales of records, tapes, CDs, and VHS and DVD box sets of the Pennebaker film.

The sun has never stopped shining.

MICHELLE PHILLIPS
Los Angeles

Michelle Phillips and Scott McKenzie

Chicken Hirsch (*left, in hat*) and Jim Dickson
(*right, with "artist" badge*) in the audience.

GLOSSARY

LOU ADLER: Acclaimed record producer/songwriter and label executive, who co-directed the drive to make the Monterey Festival a reality.

PETER ALBIN: Bay Area bluegrass musician who handled the bass for Big Brother and the Holding Company.

KEITH ALTHAM: Correspondent for England's pop music weekly, *New Musical Express*. His long associations with many of the musicians allowed him access that imbued his reporting with unique color.

SAM ANDREW: Guitarist and guiding sensibility of Big Brother and the Holding Company.

BEVERLEY: Young English folk singer swept up by Paul Simon and unexpectedly dropped into the Monterey lineup.

MIKE BLOOMFIELD: The "great white hope" of white, American blues guitarists. His tone and phrasing remains a standard for electric blues. His drug-related death in 1981 stilled an essential musical voice.

TED BLUECHEL JR.: Drummer for the Association, the festival's opening performers.

VIC BRIGGS: Guitarist of the Animals, whose reaction to the sights, smells, and sounds of the festival changed his life in dramatic and unimaginable ways.

HARVEY BROOKS: Bassist for the Electric Flag. His resume includes vital contributions to such iconic artists as Bob Dylan and Miles Davis.

ERIC BURDON: Lead singer of the Animals. "The best blues vocalist in England," according to the Rolling Stones' Brian Jones. This Newcastle native emoted with an earthiness that was the musical equivalent of mining for coal.

PAUL BUTTERFIELD: A leader in the burgeoning white blues movement of the mid-'60s. His gruff vocals and impassioned harmonica playing secured him a large and enthusiastic following.

JACK CASADY: Behind ever-present, cobalt-blue shades, he supplied the incisive bass duties for Jefferson Airplane.

MINNIE COYLE: The mayor of Monterey, California, her blessing was essential for the festival to proceed. She had many reservations but ultimately was charmed by heaping doses of good vibrations.

STEVE CROPPER: Guitarist for Booker T. and the MGs who backed Otis Redding. His guitar licks were the secret ingredient to countless Memphis session hits. His skills as a producer and writer are evident from his co-write of Redding's immortal "Sitting on the Dock of the Bay."

DAVID CROSBY: Rhythm guitarist, songwriter, and harmony vocalist in the Byrds. A key figure in the nascent Sunset Strip music scene who has remained an acclaimed pop presence for over forty years.

ROGER DALTREY: The template for the swaggering young lead vocalist as a rock god. Festooned like a psychedelic peacock, he stuttered with a devilish leer and pranced with a punk's bravado.

CLIVE DAVIS: Fresh from the business affairs department of Columbia Records, Davis ventured from New York to Monterey in search of new talent. His ear for hits and the artistry of the deal is legendary, and it began backstage at the festival, where he signed Janis Joplin and Laura Nyro.

ALEX DEL ZOPPO: A sometime college student, Army enlistee, and earnest young rock 'n' roll pianist, he headed north for a weekend that changed his life. His dream of being onstage with his musical

heroes eventually materialized with the success of his band, Sweetwater, who also performed at Woodstock.

JIM DICKSON: Recording studio denizen who worked with Lenny Bruce and Lord Buckley. He caught the pop beat infection and took over as manager of a group of Beatle wannabes, the Byrds. He rode shotgun as they zoomed up the charts.

HENRY DILTZ: Founding member of the Modern Folk Quartet who parlayed some personal relationships into a portfolio of revealing photographic images. In short order, his banjo was replaced by a Pentax, and one of rock's most storied photographic careers began in earnest.

MICKY DOLENZ: The "Circus Boy" from early television came of age as the drummer and co-lead singer of the Monkees. For a brief, dazzling moment, he was at the center of what was happening, the gracious host to a new generation of pop aristocracy.

GARY DUNCAN: San Diego-born bassist/vocalist and polestar for the especially mercurial Quicksilver Messenger Service.

CASS ELLIOT: "Mama Cass," the honey-toned vocal heft behind the chart-topping Mamas and the Papas. Her "earth mother" sensibility and disarming, self-deprecating wit made her a favorite with both the young and the middle-class. Her death from a heart attack while performing in London in 1974 was an unexpected and devastating blow to her legion of fans.

CYRUS FARYAR: Multi-instrumentalist and purveyor of world-beat music before the genre even existed, Faryar was recruited by John Phillips to put together an act for the festival—Group With No Name. Although this was their only gig, Faryar had already established himself by virtue of his work with the Modern Folk Quartet and sessions

with Donovan, among others.

RICHIE FURAY: Guitarist and vocalist for Buffalo Springfield. Furay would become one of the prime movers of "country rock" in bands to come, like Poco. But it never sounded sweeter than it did at the festival.

JERRY GARCIA: The fabled lead guitarist of the Grateful Dead, Garcia's shambling deportment defined both his improvisational approach to music-making as well as a catch-as-catch-can approach to life. He burned hard, onstage and off, to his fans delight. His Herculean escapades came to an end in 1995, too much of everything finally taking its deadly toll.

ART GARFUNKEL: One half of the great American pop vocal duo of the twentieth century. With his boyhood pal, Paul Simon, Garfunkel conveyed in song the paradox of teeming optimism and clenching disappointment that shrouded a generation in flux. They joined the Monterey bandwagon early on, and their presence assured other acts that the festival would be a groovy thing.

RALPH J. GLEASON: The owlish voice of reason of the Bay Area music scene. From his journalistic post at the *San Francisco Chronicle*, Gleason weighed in on all the social, political, and cultural events quaking the region. His mediation between the festival's producers and the northern California bands was essential to realizing the event's full potential.

BARRY GOLDBERG: What's a nice Jewish boy from Chicago doing playing the devil's blues music? Deeply steeped in the South Side sound, he handled keys for Mike Bloomfield and the Electric Flag. He played Hammond B-3 with Dylan when the bard's mood turned electric, jammed with a very young Jimi Hendrix in Greenwich Village, and then figured prominently in the Electric Flag's debut at Monterey.

BILL GRAHAM: Concert promoter at San Francisco's Fillmore Auditorium who handled artists with the sensitivity of Josef Stalin. He survived the hellish landscape of war-torn Eastern Europe as a child, but even that was insufficient preparation for a life dealing with preening pop stars and their management. He died in a helicopter crash after attending a Huey Lewis concert in the Bay Area.

ALBERT GROSSMAN: Poached the rising folk music movement of its most creative and profitable stars to fill the corral of his management empire. He then turned his sights on rock and walked away from Monterey with Janis Joplin. A formidable, indefatigable presence, Bob Dylan (a client) wrote in his memoir, *Chronicles: Vol. One*, that Grossman was "loud like the booming of war drums. He didn't talk so much as growl." It's not surprising, therefore, that he named his record label "Bearsville Records." Grossman died on a Concorde flight to England in pursuit of a new client; it is uncertain whether his briefcase carried on to close the deal.

BILL HALVERSON: As first mate to legendary recording engineer Wally Heider, Halverson handled the delicate task of capturing the festival's music for posterity. No one had done concert recording at this scale before. Halverson had the musical background (high school big band) and technical chops (he would shortly relocate to San Francisco's Fillmore Auditorium and the Winterland venue to record Cream's live side on *Wheels of Fire*) to ensure the magic was preserved for posterity.

JOHN HARTMANN: A former William Morris agent who, with Skip Taylor, co-managed Canned Heat. They doubled as proprietors of the influential Kaleidoscope nightclub in Hollywood.

JERRY HELLER: A top Hollywood booking agent who moved seamlessly from representing movie stars to rock acts. Marvin Gaye, Grassroots, and the Standells ("Dirty Water") were his first; he was responsible for bringing Pink Floyd and Elton John to the United States for the first time. Heller booked a host of talent in Monterey.

JIMI HENDRIX: Guitarist, vocalist, songwriter, candidate for Mount Rushmore. Monterey was his American debut, one so electrifying that it is still parsed with the rigor of physicists probing Einstein's General Theory of Relativity. He died at age 27 in London, suffocating on a toxic cocktail of alcohol and sleeping pills. The wind cried.

CHRIS HILLMAN: A bluegrass and folk music practitioner recruited to play bass for the Byrds. Stoic and deeply immersed in his instrument, Hillman provided the base to a band top-heavy with high-maintenance individuals.

BONES HOWE: Legendary recording engineer (Elvis Presley, Shelley Manne) who later was closely associated with Lou Adler's stable of artists (Jan and Dean, Johnny Rivers) He arrived at Monterey to handle the live sound mix for the Association and the Mamas and the Papas.

WAYNE JACKSON: Handled the trumpet parts in Otis Redding's horn section, the Mar-Keys.

BOOKER T. JONES: He rode the Hammond organ for Otis Redding, a groove player whose instinct for laying back generated the tension to drive the band at a rousing gallop.

BRIAN JONES: Resplendent in his fluorescent Chinese robe and princely mane, Jones was the quintessence of English rock nobility, treated like an emissary from the Vatican or someplace even higher; he was, after all, a member of the Rolling Stones. In July 1969, Jones was found at the bottom of his swimming pool in Sussex, England. The coroner described it as a "misadventure." Jones may well have countered by describing it as a journey within.

JANIS JOPLIN: Ostensibly the lead singer of Big Brother and the Holding Company, she quickly emerged as the "find" of the festival—a voice as jagged as a broken glass, with a heart and soul as expansive as the Texas plains. But the pain and heartache that accompanied her vast talent required copious amounts of medication; heroin eased her exit from this mortal coil in October of 1970.

PAUL KANTNER: Rhythm guitarist, vocalist, pilot of Jefferson Airplane. Takeoffs were often bumpy, but Kantner made sure the band always landed in one piece.

AL KOOPER: That's him playing the organ on "Like a Rolling Stone," composing "This Diamond Ring" for Gary Lewis and the Playboys, forging the Blues Project in the Village, and West Coasting when the call came to help manage the stage at Monterey. Afterward, there was Blood, Sweat and Tears to form and super sessions with Stills and Bloomfield. Slow down Al, you move too fast!

PETER LEWIS: Principal songwriter, guitarist, and vocalist in Moby Grape. A short-lived cult favorite, worshipped by Robert Plant.

FRANK MARINELLO: The chief of police of Monterey. A stern, forbidding presence, Marinello's gruff exterior was disarmed by the legion of young people armed only with flowers in their hair. He did, however, keep the nearby National Guard on his speed-dial.

HUGH MASEKELA: The man with the horn from Johannesburg. His lively marriage of African rhythms and American pop added a dash of international *savoir-faire*.

COUNTRY JOE McDONALD: A Berkeley fifth columnist with a flair for spinning caustic yarns scored for acid-addled rock group and audience accompaniment. Yeah, it's a little goofy, but they can really make a joyful noise.

JIM (ROGER) McGUINN: Picking at his Rickenbacker 12-string while peering out over those granny glasses perched on the end of his nose, McGuinn carved as indelible a presence in '60s rock as anyone. A plugged-in folkie who rode the zeitgeist to the top of the charts. Essential member of the Byrds.

JERRY MILLER: Innovative guitarist and vocalist for Moby Grape. He came to the band from another outfit called the Frantics. He pursued order and arrangement with his new outfit.

STEVE MILLER: They call him the "Space Cowboy," but at Monterey he was trafficking in the blues, albeit with a slightly celestial bent. Armed with a truckload of analog hardware, he strove mightily to contort the tyranny of the 12-bar form.

MITCH MITCHELL: A journeyman drummer in London's blooming R & B scene, he answered the call from producer Chas Chandler to sit in with his latest discovery, a cat from the States named Hendrix. Mitchell got the gig, rode the tiger for the next four years, and took decades to recover. He died in a Seattle hotel room in 2008 while touring in a Hendrix tribute project.

CHIP MONCK: The art of stage lighting for rock concerts belongs wholly within the purview of Mr. Monck. Part Picasso, part lens crafter, Monck transformed the rock stage into a rollicking visual Arcadia. After Monterey came Woodstock ("watch out for the brown acid"), the 1972 Stones tour, and countless other tours and triumphs. Even Lady Gaga must curtsey before the man who flipped the switch from mere spotlights to eye-popping alchemy, always in service to the music.

BOB MOSLEY: Bassist for Moby Grape, a San Franciscan band that eschewed endless jams for tight song structure. Alas, the structure was missing offstage and the band devolved into a random amalgam that produced the odd record and gig when mental and physical well-being allowed.

LAURA NYRO: The dark lady of the pop sonnet. She arrived at Monterey as the teenage tyro, a singer/songwriter of exceptional gifts who sashayed through her set to reputed catcalls. Not true; she mistook shouts of "beautiful" for boos. No matter—another Monterey myth was born as Nyro pursued a career fraught with feints and false starts. She died in 1997 at age 49, her modest body of work looming larger than ever.

ANDREW LOOG OLDHAM: Record producer and visionary manager of the Rolling Stones, Oldham is part Hollywood hustler, part milk bar droog, personifying the merry madness that is "Swinging London." A longtime confidant of Lou Adler's, he enlisted most of the British bands to make the trek over.

ALAN PARISER: Imagineer without portfolio, Pariser was omnipresent in the Sunset Strip scene, had time and money, and needed an outlet for his rambunctious ambitions. He conjured the Monterey Festival out of whole cloth and went off in pursuit of realizing his dream. He succeeded beyond his wildest reckoning. In later years he

worked with Delaney and Bonnie, Dave Mason, Eric Clapton, and George Harrison. He died in 2001.

D. A. PENNEBAKER: He turned his documentary film skills on Monterey and produced the first rock concert film. Following on the heels of his Bob Dylan profile, 1965's *Don't Look Back*, Pennebaker established the ground rules for capturing the cinematic qualities that elevated rock music from a simple adolescent indulgence to an epic visual narrative.

JOHN PHILLIPS: A troubadour who could spin musical gold from his calamitous encounters with friends, lovers, and other strangers ("Always turn tragedy into publishing," he said), he masterminded the Mamas and the Papas into America's pop sensations for about 18 months until the bills came due—physical, emotional, and financial. It was a wild ride that culminated at Monterey, with Phillips as the grinning, madcap host. He died in 2001 after a life of reckless indulgence, mitigated by moments of gifted creative insight.

MICHELLE PHILLIPS: The lithesome blonde "Mama" foil to John Phillips' lacerating musical pen, and pop princess of sun-dappled Southern California who brought a generation of impressionable young boys to their quaking knees. Michelle had more range and character in her voice than is usually assumed. When pushed, she could emote with genuine affection; mostly, though, her beauty added a fairy-tale quality to her brief but successful travels across the pop music firmament.

SKIP PROKOP: Drummer for the Canadian band the Paupers, who followed the Association on the festival's opening night. Managed by Albert Grossman; great things were expected out of them. They imploded after a couple of albums, but Prokop kept his cool and went on to a life as a successful gigging musician. He's the drummer on *The Live Adventures of Mike Bloomfield and Al Kooper*, and co-founded Lighthouse.

LOU RAWLS: With a voice as smooth as an aged single malt whiskey and mentored by Sam Cooke, Rawls brought a measure of showbiz panache to the hippie sensibilities of Monterey. Not an obvious fit, but he had a soulful gravitas that sustained a long and fruitful career. He continued to work right up to his death in 2006.

OTIS REDDING: A middle linebacker masquerading as an R & B soul shouter, Redding came to Monterey, uneasy about appearing before the vastly white, middle-class audience that might not dig his black-eyed sound. He couldn't have been more mistaken. He killed them. And then they wept a torrent of tears as his small plane went down outside Madison, Wisconsin on a winter's night in December of 1967.

JOHNNY RIVERS: There was a bit of Southern moonshine in his buoyant, rockin' pop sound. Born in New York and then relocated with his family to Baton Rouge, Louisiana, Rivers could sing and play guitar with an ingratiating swagger reminiscent of his black heroes, earning him several Top Forty hits. Some audience members were actually miffed when he took the stage on Friday night— too pop—but those who were willing to listen came away as believers. He still delivers.

RAVI SHANKAR: The master of the Indian sitar, Shankar brought a taste of the Asian subcontinent to the proceedings. An exotic yet tranquil base from which he mesmerized the audience with a sustained intensity that required a heroic level of sobriety from the performers, if not from the listeners.

BEN SHAPIRO: A figure around Hollywood since the fifties, Shapiro managed nightclubs and artists and booked concert dates, updating his talent roster as the culture around him changed. In the spring of 1967, he was introduced to Alan Pariser and a plan was hatched; Pariser had deep pockets and Shapiro the musical contacts. They decided to produce the first pop music festival. Their professional relationship didn't last, but their leap into the breach continues to resonate to this day.

GRACE SLICK: The red queen of acid rock, Ms. Slick fronted Jefferson Airplane with a witchy malevolence that could arouse and chill at the same time. She could drink like a sailor on shore leave and yet find the telltale emotion in her poetical verses. She paints now, with equal verve.

JOE SMITH: A corporate man sent by the home office (Warner/Reprise Records) to see what all the ruckus was about, Smith returned to Burbank with a fund of new relationships and a plan to reinvent the label by committing to the volatile new music scene without equivocation. Beneath the Arrow shirt beat the heart of a wily rebel.

ANDREW SOLT: He came to Monterey as a teenager, flush with excitement at seeing his musical heroes. The bliss never faded. He became a top producer and distributor of music for television and films, including the Ed Sullivan archives, featuring the Beatles' iconic debut.

DON STEVENSON: Drummer for Moby Grape, co-writer of their most popular songs, and the only member to sustain a career in music, releasing his first solo album in 2010.

STEPHEN STILLS: Guitarist and singer with Buffalo Springfield. His lacerating lead lines and sophisticated compositional sense imbued the band with a tensile strength that set them far apart from the madding crowd. Add to that the incendiary nature of the various personalities involved, and you had the makings of a soap opera as well. In 2010 the remaining members of the band (Stills, Neil Young, and Richie Furay) reunited for their first concert in 42 years. According to witnesses, they still deliver. The operetta continues.

DEREK TAYLOR: An English gentleman first, Fleet Street publicist only later. He worked closely with the Beatles before relocating to Los Angeles to handle press for the Beach Boys and Paul Revere and the Raiders, among others, when the call came to put the Monterey Festival in the public eye. He handed out press passes like Snickers bars on Halloween and garnered coverage around the world. He later returned to the Beatles' fold, working on behalf of Apple Records on a variety of projects. He died in 1997.

LARRY "THE MOLE" TAYLOR: Bass player for Canned Heat, a lifelong road dog who continues to play the blues with tireless enthusiasm. Tom Waits, an artist who can croak with exquisite aplomb, recruited the Mole for his touring band. He knows the value of a good bottom.

PETE TOWNSHEND: What happens when a shy but slyly ambitious young corker is handed an electric guitar and all the wattage in a stack of Marshall amps? You turn it up to eleven, of course, thrust your tormented teen angst on a mob of equally damaged youths, and stand back. If you are lucky you make it out alive, having survived the Who. At Monterey they went into full Battle of Britain mode, and the shattered remains of their arsenal of equipment were singed into the stage and its surroundings. From this auspicious debut to halftime at the Super Bowl, Townshend has tilted at more windmills than Don Quixote.

JOHN WEIDER: Guitarist and violinist for the Animals. His swooping legato lines from an instrument long associated with the concert hall transfixed the audience; were they hallucinating Jascha Heifetz? He went on to play with such acclaimed '70s bands as Family, and, later, explored the more sonically-challenging aspects of New Age music.

BOB WEIR: A mere stripling when he joined the band, Bob Weir sang and played guitar with the uber-Bay Area act—the Grateful Dead. Their long and strange trip continued; at Monterey, they were pitted between the Who and Jimi Hendrix. They didn't even blink.

JANN WENNER: A student at UC Berkeley, aspiring journalist, and stringer for England's "Melody Maker," Wenner had an epiphany: what if a new magazine covered the music world with depth and passion commensurate with the quality of the artists themselves? In other words, what if we take our art seriously? Can we make it happen? He named it *Rolling Stone*, and it arrived that fall with little fanfare from the mainstream media. In time, it subsumed the mainstream media and became the arbiter of popular culture.

JERRY WEXLER: With the Ertegun Brothers, he headed the estimable Atlantic Records. Blues, jazz, soul, R & B, and rock at its finest found their home here. At Monterey, record producer and talent scout Wexler was sniffing for signings, but came up empty. Even Sandy Koufax had a bad outing.

BIBLIOGRAPHY

A word about sources: Although the overwhelming majority of "voices" heard from in this book came from interviews conducted by the authors, in an effort to provide the most comprehensive overview of Monterey possible, we drew upon other works to fill in any significant gaps. The following titles provided deep insights and lively investigations of the cast of "characters" that made Monterey the legend it has so deservedly become. We encourage all students of rock music history and those besotted with the '60s to investigate the contributions of these writers. The more you dig, the deeper the hole gets.

Brant, Marley. *Join Together: Forty Years of the Rock Festival.* New York: Backbeat Books, 2008.

Christgau, Robert. "Anatomy of a Love Fest." *Esquire*, January 1968.

Einarson, John. *For What It's Worth: The Story of Buffalo Springfield.* New York: Cooper Square Press, 2004.

Fiegel, Eddi. *Dream A Little Dream of Me: The Life of Cass Elliot.* Chicago: Pan Books, 2006.

Farber, David, ed. *The '60s: From Memory to History.* University of North Carolina Press, 1994.

Gaines, Steven. *Heroes and Villains: The True Story of the Beach Boys.* New York: De Capo Press, 1986.

Gary Strobl Archives. Los Angeles, California.

Gilliland, John. *The Pop Chronicles.* Los Angeles: KRLA Radio, 1969.

Gold, Jeffrey, ed. *A&M Records: The First 25 Years.* 1987.

Greene, Joshua M. *Here Comes The Sun: The Spiritual and Musical Journey of George Harrison.* Hoboken, NJ: John Wiley & Sons, 2007.

Hansen, Barry. "Monterey Pop Festival." *DownBeat*, August 1967.

The History of Rock 'n' Roll Vol. 4. Andrew Solt Productions, 1995. Film Documentary, Television.

Hopper, Dennis. *1712 North Crescent Heights: Dennis Hopper Photographs 1962–1968.* Los Angeles: Greybull Press, 2001.

Keenom, Bill, and Jan Mark Wolkin. *Mike Bloomfield—If You Love the Blues: An Oral History.* New York: Backbeat Books, 2000.

Monterey International Pop Festival [30th Anniversary Box Set]. CD-ROM. Rhino Records, 1997.

Kubernik, Harvey. "California Dreaming." *MOJO*, 2007.

——. "Hendrix and the Summer of Love." *MOJO*, 2007.

——. "Monterey! Inside Rock's First Festival." *MOJO*, July 2007.

———. "'Murder . . . ' in Their Hearts." *Goldmine*, August 2007.

Lou Adler Archives. Provided by Howard Frank.

Lydon, Michael. "Monterey Pops! An International Pop Festival." *Newsweek*, June 1967.

McNally, Dennis. *A Long Strange Trip: The Inside Story of the Grateful Dead*. New York: Broadway Books, 2003.

Mitchell, Mitch, and John Platt. *Jimi Hendrix—Inside The Experience*. New York: Harmony Books, 1990.

Neill, Andy. "Hedonism on the Hill." *MOJO*, 2007.

———. "Hendrix and the Summer of Love." *MOJO*, 2007.

Schneider, Gary, ed. "KRLA Airchecks, June 16, 1967." Radio Broadcasts.

Selvin, Joel. *Monterey Pop: June 16–18, 1967*. San Francisco: Chronicle Books, 1992.

———. *Summer of Love: The Inside Story of LSD, Rock and Roll, Free Love and High Times in the Wild West*. New York: Cooper Square Press, 1999.

Steck, Jim. "Brian Jones: Interview." KRLA *Beat* 3, no. 9 (1967).

Variety. April 26, 1967.

PHOTO CREDITS

Note: *All uncredited photos and graphics were culled from the author's personal collection. All appropriate lengths were taken to secure proper photo credits and permissions. Any omissions or errors are deeply regretted and will be rectified upon reprint. Additionally, any images credited to Lou Adler are credited and reproduced by permission of the Monterey International Pop Festival.*

Page 1: Lou Adler
Page 7: Kubernik Collection
Page 9: Fred Arellano
Page 10: Fred Arellano
Page 11: Chuck Boyd Photo Collection
Page 12: Henry Diltz
Page 13: Henry Diltz
Page 14: Lou Adler
Page 15: Lou Adler
Page 16: Chuck Boyd Photo Collection
Page 17: Henry Diltz (left); Lou Adler (right)
Pages 18–20: Lou Adler
Page 21: Lou Adler
Page 22: Lou Adler (top); Henry Diltz (bottom)
Page 24: Lou Adler
Page 25: Lou Adler (top); Henry Diltz (bottom)
Page 26: Jill Gibson (top); Pennebaker Hegedus Films (bottom)
Page 27: Lou Adler (left); Henry Diltz (center); Henry Diltz (right)
Page 28: Rodney Bingenheimer Collection (top); Mike Morgan (bottom)
Page 29: Guy Webster
Page 30: Gary Strobl Archives
Page 31: Chris Darrow Archives
Page 32: Gary Strobl Archives (top left); Ron Lando (top right); Gary Strobl Archives (bottom)
Page 34: Marin County Herald
Page 35: Lou Adler
Page 36: Tom Rounds
Page 37: Lou Adler
Pages 38–39: Lou Adler
Pages 40–41: Tom Rounds
Pages 42–43: Lou Adler
Page 44: Harvey Kubernik Archives
Page 45: Jerry de Wilde
Page 46: Henry Diltz
Page 47: Henry Diltz
Page 48: Nurit Wilde (top); Bones Howe (bottom)
Page 49: Henry Diltz (top); Henry Diltz (bottom)
Page 50: Gary Strobl Archives
Page 51: Alex Del Zoppo (top); Peggy Lipton (bottom)
Page 52: Monterey History and Maritime Museum
Page 53: Lou Adler
Page 54: Tom Rounds (top); Henry Diltz (bottom)
Page 55: Helie Roberston (top); Henry Diltz (bottom)
Page 56: Helie Robertson (top); Henry Diltz (center); Henry Diltz (bottom)
Page 57: Helie Robertson (top); Helie Robertson (bottom, all)
Page 58: Henry Diltz
Page 59: Henry Diltz (top left); Henry Diltz (top right); Helie Robertson (bottom)
Page 60: Tom Rounds
Page 62: Nurit Wilde
Page 63: Fred Arellano
Page 64: Henry Diltz (top); Monterey History and Maritime Museum/Lisa Law (bottom)
Page 65: Henry Diltz

Page 66: Henry Diltz (left); Henry Diltz (right)
Page 67: Lou Adler
Pages 68–69: Elaine Mayes
Page 70: Lou Adler
Page 71: Nurit Wilde (top); Elaine Mayes (bottom)
Pages 72–73: Henry Diltz (top); Chuck Boyd Photo Collection (bottom)
Page 74: Elaine Mayes
Page 75: Elaine Mayes
Page 76: Chuck Boyd Photo Collection (left); Chuck Boyd Photo Collection (right)
Page 77: Nurit Wilde
Page 78: Henry Diltz (top); Henry Diltz (bottom)
Page 79: Henry Diltz (top); Howard Wolf (bottom)
Pages 80–81: Nurit Wilde
Page 82: Henry Diltz
Page 83: Henry Diltz
Page 84: Jill Gibson
Page 85: Gary Strobl Archives
Page 86: Elaine Mayes
Page 87: Elaine Mayes
Page 88: Henry Diltz (top left); Elaine Mayes (top right); courtesy of *DownBeat* (bottom)
Page 89: Nurit Wilde
Page 90: Howard Wolf (top); Howard Wolf (bottom)
Page 91: Elaine Mayes
Page 92: Nurit Wilde
Page 93: Howard Wolf (top); Henry Diltz (bottom)
Pages 94–95: Pennebaker Hegedus Films
Pages 96–97: Fred Arellano
Page 98: Elaine Mayes
Page 99: Elaine Mayes (top); Elaine Mayes (bottom)
Page 100: Henry Diltz (top); Henry Diltz (bottom)
Page 101: Howard Wolf (top); Henry Diltz (bottom)
Page 102: Jerry de Wilde
Page 103: Howard Wolf
Page 104: Nurit Wilde
Page 105: Elaine Mayes
Page 106: Howard Wolf (top); Howard Wolf (bottom)
Page 107: Henry Diltz (top); Nurit Wilde (bottom)
Page 108: Elaine Mayes
Page 109: Chuck Boyd Photo Collection
Page 110: Fred Arellano
Page 111: Elaine Mayes
Page 112: Elaine Mayes
Page 113: Elaine Mayes
Page 114: Henry Diltz (top); Henry Diltz (bottom)
Page 115: Henry Diltz
Page 116: Henry Diltz
Page 117: Pennebaker Hegedus Films
Page 118: Elaine Mayes
Page 119: Gary Strobl Archives
Pages 120–21: Tom O'Neal (top); Howard Wolf (bottom)
Pages 122–23: Howard Wolf (left); Chuck Boyd Photo Collection (right)
Page 124: Henry Diltz

Monterey International Pop Festival Photographers' Websites:
Fred Arellano: www.vintagerockphotography.com
Chuck Boyd: www.chuckboydgalleries.com
Jerry de Wilde: www.dewildephotography.com
Henry Diltz: www.henrydiltz.com
Jill Gibson: www.gibsonarts.com
Lisa Law: www.flashingonthesixties.com
Elaine Mayes: www.elainemayesphoto.com
Tom O'Neal: www.tgophoto.com
D. A. Pennebaker: www.phfilms.com
Guy Webster: www.guywebster.com
Nurit Wilde: www.wildeimages.com

Overleaf: Back cover of the Monterey International Pop Festival annual

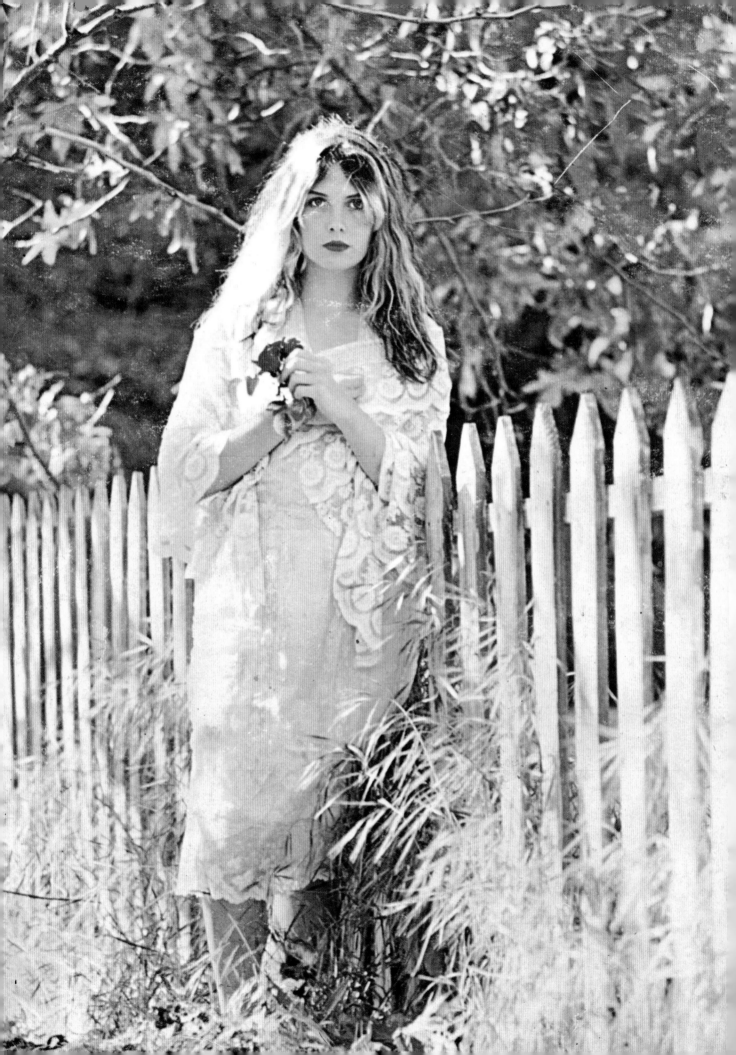